D1591879

Art and the Crisis of Marriage

Vivien Green Fryd

ART AND THE CRISIS

of MARRIAGE

Edward Hopper and Georgia O'Keeffe

THE UNIVERSITY OF CHICAGO PRESS

Chicago & London

VIVIEN GREEN FRYD is associate professor of art history and American studies in the Department of Art and Art History at Vanderbilt University. The recipient of fellowships and grants from the American Council of Learned Societies and the Smithsonian, she has published and lectured on such diverse subjects as nineteenth-century American sculpture, images of Native Americans, westward expansion, gender, and American painting. Prior to this, her second book, she wrote *Art and Empire: The Politics of Ethnicity in the U.S. Capitol, 1815–1860.*

The University of Chicago Press, Chicago 60637
The University of Chicago Press, Ltd., London
© 2003 by Vivien Green Fryd
All rights reserved. Published 2003
Printed in China

12 11 10 09 08 07 06 05 04 03 1 2 3 4 5
ISBN: 0-226-26654-0 (cloth)

The University of Chicago Press gratefully acknowledges the support of the Vanderbilt University Subvention Grant, the Vanderbilt University Research Scholar Grant, and the Society for the Preservation of American Modernists Publication Grants.

Library of Congress Cataloging-in-Publication Data

Fryd, Vivien Green.
 Art and the crisis of marriage: Edward Hopper and Georgia O'Keeffe/
 Vivien Green Fryd.
 p. cm.
 Includes bibliographical references and index.
 ISBN 0-226-26654-0 (cloth: alk. paper)
 1. Hopper, Edward, 1882–1967—Marriage. 2. Hopper, Edward, 1882–1967—
Criticism and interpetation. 3. O'Keeffe, Georgia, 1887–1986—Marriage.
4. O'Keeffe, Georgia, 1887–1986—Criticism and interpretation. 5. Artist couples—
United States—Biography. 6. Painters—United States—Biography. I. Title.
 ND237.H75 F79 2003
 759.13—dc21
 2001001935

This book is printed on acid-free paper.

To Emma Renee Fryd

CONTENTS

ILLUSTRATIONS

Black and White Figures

Color Plates (following page 152)

ACKNOWLEDGMENTS

This book loosely evolves from the first class I ever took on American art:
American Art between the Two World Wars, taught by Barbara S. Grose-
close at The Ohio State University in 1975. At that time, I wrote a rather
naive and uninformed paper about the image of women during this pe-
riod. Much later, in 1992, I audited a graduate seminar in the English De-
partment on critical theory with Valerie Traub at Vanderbilt University
which led to my teaching and studying in greater detail feminist art, art
history, and theory, as well as gender constructions. After three years of
floating amid a flood of disconnected ideas, this current project took
shape. I realized that my focus had become the period between the wars;
issues of sexuality, gender, and heterosexual relationships of that period;
and modernism. I am thus grateful to Barbara S. Groseclose for planting
the seeds that would grow into this book, for introducing me to the sub-
ject of American art, and for providing an excellent model in the
methodology of American Studies.

Vanderbilt University enabled me to take a yearlong sabbatical in
1998, an opportunity to complete the research and to write the book
manuscript. The University Research Council at Vanderbilt awarded me a
stipend that enabled my time away from the rigors of teaching. I feel for-
tunate to teach at an institution that has such a liberal leave policy. I am
also grateful for the Vanderbilt University Subvention Grant coordinated
by Russell G. Hamilton, former dean of the Graduate School, for funds
that helped to defray the cost of publishing the color photographs in this
book; and for the Vanderbilt University Research Scholar Grant Program

under the guidance of Dennis G. Hall, associate provost for research, that provided partial support for the purchase of photographs and the permission to publish them. The Society for the Preservation of American Modernists Publication Grants also assisted with the cost of purchasing and publishing the photographs. Two "art angels," Ruthie Cowan and Judith Hodges, provided additional financial support to assist me in defraying the cost of the photographs, for which I am thankful.

Friends and colleagues provided assistance through discussions and reading portions of the manuscript, assisting me in formulating and coalescing the ideas manifest in this book. I am grateful for their contributions, questions, and responses: Michele H. Bogart, Sarah Burns, Wanda A. Corn, Erika Doss, Melissa Dubakis, Charles C. Eldredge, William E. Engel, Barbara S. Groseclose, Susan Hegeman, Gregg Horowitz, A. J. Levine, Barbara Buhler Lynes, Angela Miller, Annette Stott, Ellen Wiley Todd, Alan Wallach, and Cécile Whiting. Cecelia Tichi once again provided invaluable assistance, advice, and support throughout the writing of this manuscript; she is a good friend, an invaluable colleague, and a mentor who has guided me through varied academic terrains during my years at Vanderbilt and who continually pushes me to go beyond my original ideas to embrace the connection between American culture and specific artworks. Others who provided invaluable advice and questions are Janice Coco, Larry Griffin, Leonard Folgarait, Gail Levin, and Ronnie Steinberg; they, like Cecelia Tichi, took time from their busy schedules to read and critique the manuscript. I am grateful to be living among this community of scholars whose work I admire, whose friendship I value, and whose constructive criticism enables me to push the envelope of my own thinking. All the colleagues I mention here fit into this category. I also want to thank Jane Barry and Sandy Hazel for their copyediting, which enabled me to strengthen and tighten the writing of this manuscript. I feel fortunate to have such a supportive editor, Susan Bielstein, whose faith in the project and whose guidance enabled the book's publication in its current format. Her good humor and efficiency in dealing with the difficulties related to photographic permissions helped me to keep my spirits up, especially when the book's publication was delayed because a third party refused permission to publish three photographs Alfred Stieglitz had taken of Georgia O'Keeffe. Editorial Associate Anthony Burton also contributed to the book's completion and assisted with the arduous task of obtaining photographs and the permission to publish them. His assistance proved invaluable.

This project resulted in my interaction with another community of scholars whose interests intersect with my own and whose publications contributed greatly to my work. Their names and publications can be found in my footnotes and bibliography, but I especially want to thank

those who generously shared their expertise, provided assistance, gave advice, and served as sounding boards: Charles C. Eldredge, Sarah Greenough, Gail Levin, and Barbara Buhler Lynes. Gail Levin was especially supportive and helpful, providing friendship throughout the project. My work on Edward Hopper would have been impossible without her groundbreaking scholarship and the Hopper archives she created for the Whitney Museum of American Art in preparation for her catalogue raisonné. I also thank those who assisted me in negotiating the labyrinth of primary and secondary documentation in various institutions: Colleen Becker, assistant archivist, Whitney Museum of American Art, New York City; Jennifer Belt, photography and permissions coordinator, Whitney Museum of American Art; Bonnie Coles, senior search examiner, Library of Congress; Anita Duquette, manager of rights and reproductions, Whitney Museum of American Art; Sarah Greenough, curator of photography, National Gallery of Art, Washington, D.C; Maureen Heher, public services, Beinecke Rare Book and Manuscript Library, Yale University, New Haven, Connecticut; Judy Lopez, director, The Georgia O'Keeffe Foundation; Mike Myer, art handler and supervisor, Whitney Museum of American Art; Carlotta Owens, assistant curator of modern prints and drawings, National Gallery of Art; Lauren Panzo, collections manager, Whitney Museum of American Art; Bridgette Saylor, library assistant, Whitney Museum of American Art; LiPing Song, associate librarian, Whitney Museum of American Art; Bernice Spandorff, library assistant, Whitney Museum of American Art; Julia Thompson, assistant curator of photography, National Gallery of Art; April M. Watson, Department of Photography, National Gallery of Art; Patricia C. Willis, curator of American literature, Beinecke Rare Book and Manuscript Library, Yale University; and Barbara C. Goldstein Wood, photographic rights/reproductions, National Gallery of Art.

I want to thank the graduate students in various seminars at Vanderbilt University, especially Nanette Bahlinger, Jessica Crouch, Jennifer Harris, Laurie Ann Robinson, and Peter Schultz. I am especially indebted to Laurie Ann Robinson, whose insights on O'Keeffe's series of cityscapes and their relation to photographic imperfections formed the basis of an argument in chapter 4. Other graduate students worked as research assistants: Stephanie Gilbert, Michelle Hagg, Jennifer Harris, and Joy Phillips helped me in numerous ways by tracking down resources, checking footnotes, and ordering photographs.

Others provided friendship and support during the writing of this manuscript. Thanks go to my cheerleaders, both inside and outside academia: Patricia and Richard Abelson, Daniel and Joanne Bregman, Susan Brooks, Linda Fenelson, Mona Frederick, Susan Kay, Willie Luis and Linda Garceau-Luis, Mary Margaret McDonough, Carol and Douglas Milam,

Carol and Robert Mode, William and Ruth Smith, Arleen Tuchman, Dan Cornfeld, and Hedy Weinberg. Special appreciation also goes to those who provided a home away from home during the time I did research in other cities: Michele H. Bogart and her family, Philip J. Pauly and Nicholas Pauly, Gregg Horowitz and Ellen Levy, and my brother, Kenneth Martin Green. Tay Gillepsie enabled me to experience anew the joys of summer camping by inviting me to be a scholar-in-residence at her Strong River Camp in Mississippi during the summer of 1998. On the porch of the infirmary I wrote portions of this book, watching children engage in a range of activities with joy, self-confidence, and cooperation. She also provided me with an opportunity to enjoy the outdoors, including blueberry picking, canoeing, swimming, horseback riding, and white-water rafting. I never anticipated that while writing this book I could relive my best childhood memories.

I extend special thanks also to Harry Mills, who taught me how to live with multiple sclerosis and to continue my career as a professor and scholar; Dr. Thomas W. Campbell, who helps guide me in remembering and coming to terms with some painful childhood memories; Annette Stott and her family, the Pierces, who provided love and a safe haven while I was in graduate school in Madison, Wisconsin, struggling with childhood demons and the rigors of writing a dissertation, and who continue to provide unconditional love and acceptance; and my brother, Kenneth Martin Green, whose friendship, love, and concern assist me in a multitude of ways as I attempt to find a path of harmony and inner peace.

This book is dedicated to my daughter, Emma Renee Fryd, who joined me in the summer experience at Strong River Camp, growing more independent and self-assured before my eyes. She has enriched my life in ways I never could have imagined and has become a wonderful companion. Emma has expressed disappointment that this book does not contain any of the images of Native Americans that appeared in my first book, but I hope she finds later in life that the material is not as boring as she considers it now. My husband, Martin, remains the anchor of my life. His support and encouragement are the armature that helps to sustain me.

Earlier versions of some of the material in this book appear in "Shifting Power Relations: Edward Hopper's *Girlie Show*," *American Art* 14 (summer 2000): 52–75; and "Georgia O'Keeffe's *Radiator Building*: Gender, Sexuality, and Urban Imagery," *Winterthur Portfolio* 35 (winter 2001); 269–89. I thank the publishers for permission to reprint these materials here.

Art and the Crisis of Marriage looks at marriage through the window opened on that institution by the marital relationships and works of two of America's most familiar and beloved twentieth-century artists: Georgia O'Keeffe (1887–1986) and Edward Hopper (1882–1967). The view is fascinating, not only because of the appeal of O'Keeffe's and Hopper's powerful paintings, but also because of the insights this particular perspective brings to the debates over marriage, family, sexuality, and gender that helped shape modern American culture and that continue to the present day. We will see these conflicts played out on the terrain of the artists' marriages, and also their impact on selected paintings, but always with an eye to a larger picture of American society between the two world wars. In a vibrant, fluid culture, the institutions of marriage and family were undergoing transformations that continue to challenge, alter, and shape us today.

Although Hopper lived until 1967 and O'Keeffe until 1986, *Art and the Crisis of Marriage* focuses primarily upon the thirty-year period from 1920 to 1950. O'Keeffe's husband, Alfred Stieglitz, died in 1946, leaving O'Keeffe to continue her career in New Mexico. Edward and Josephine Nivison Hopper lived together longer than O'Keeffe and Stieglitz, but his work, like O'Keeffe's, underwent few transformations in terms of style. For both artists, these three decades were an important and definitive period. This book focuses on a select group of their paintings that embody, crystallize, and reinforce issues related to their marriages—works that, at the same time, intersect with the changing concept, actually the

crisis, of the modern family within the white middle class in the United States.

Despite the rhetoric of companionship that prevailed during this period, marriage evolved into a domain in which social, sexual, and personal conflicts were played out both in public and in private. Focusing on how and why O'Keeffe's and Hopper's marriages gained expression in their art, in the context of the discourse in American culture about marriage during the interwar years and the artists' participation in the cultural transformation of that period, provides a way to understand their work that goes beyond O'Keeffe's sexualization of flowers and love of nature, beyond the solitude of Hopper's modern men and women.

Works by O'Keeffe and Hopper normally manifest polar opposites in style and subject matter, resulting in surprise to some that I consider two such seemingly disparate artists in one study.[1] Whereas Hopper "bridge[s] most of the important phases of realism in twentieth-century American art," according to John Wilmerding's survey of American art, for example, O'Keeffe exemplifies the "presence of abstract form and space" among the early American modernists that occurred simultaneously during the first few decades of the century.[2] O'Keeffe's formally experimental abstract paintings of flowers, skyscrapers, and landscapes placed her at the forefront of the avant-garde movement in the United States, with its challenge to traditional subjects, styles, and compositions. Hopper, on the other hand, working within a figurative manner, represents a continuation of the realist strain in American art that evolved from the colonial period through Thomas Eakins and Hopper's teacher, Robert Henri. Lloyd Goodrich in 1927 dubbed Hopper "a pioneer in ... realistic painting," and his "realistic," commonplace images of contemporary American hotels, highways, gas stations, restaurants, theaters, offices, suburban homes, and urban apartment buildings identified him as an American Scene painter who represented an alternative to modernism.[3] That same year, Helen Appleton Read assessed him as "probably the most successful interpreter of the American scene,"[4] rendering recognizable genre scenes of everyday life in American small towns and cities.

Matthew Baigell's survey of American art identifies another distinction between these two painters. He presents O'Keeffe as an artist who reflected "a loosening of the country's puritanical sexual mores and a willingness, induced by increasing awareness of Freud's theories of repression, to create works containing suggestive erotic symbols." Hopper, on the other hand, reveals "the persistence of sexual repression in American society" through his *Evening Wind* (see fig. 49), in which a nude woman conveys both compassion and sexuality as she "seems barely able to control her emotions" in response to "the warm breeze streaming through the open window" that arouses her.[5] Baigell juxtaposes O'Keeffe and

Hopper, but only to underscore their differences, especially in relation to the expression or repression of female sexuality in particular artworks. Contrary to Baigell's perception, however, in this book I will demonstrate a greater convergence in attitudes as manifest in their art and lives.

Differences in style and subject matter sometimes obscure the fact that Hopper and O'Keeffe were almost exact contemporaries. O'Keeffe was born five years before Hopper and lived nineteen years longer, yet they both first achieved fame during the 1920s. Both studied with William Merritt Chase at the Art Students League (Hopper between 1900 and 1903; O'Keeffe in 1907).[6] Both lived and worked in New York City, and they established their mature styles after having worked in the commercial sector.[7] Both rendered scenes of the metropolis. Goodrich's assessment of Hopper's fascination with the city, in fact, could also apply to O'Keeffe: "Hopper has concentrated on the city itself, that huge complex of steel, stone, concrete, brick, glass and asphalt."[8] O'Keeffe, however, highlighted the newer commercial skyscrapers, usually in a vertical format, while Hopper focused upon apartment dwellings within horizontal compositions. At the same time, as Goodrich explained, Hopper centered on "the phenomenon of life seen through windows," providing a "more intimate" view "of the city dweller," which did not concern O'Keeffe.[9]

Both artists continued their styles with little variation throughout their lives. Once they had established their reputations, both periodically left what was then considered the center of the art world, New York City, for more remote locations. O'Keeffe began to visit Taos, New Mexico, in 1929, and settled permanently in Abiquiu, New Mexico, in 1949, to become "an icon of Southwestern modernism."[10] Hopper, beginning in 1930, commuted between the city and South Truro, Massachusetts, where he stayed during the summer and fall seasons. (Visiting Santa Fe in the summer of 1925, he found the landscape unattractive and uninteresting.) Although Hopper studied in Europe three times between 1906 and 1910 and had assimilated the influence of impressionism, he nevertheless "remained," according to at least one art historian, "essentially unaffected by European movements," ignoring especially the abstractions by Picasso and other modernists.[11] O'Keeffe similarly disregarded European abstraction (with the exception of Kandinsky and perhaps Rodin).

Although most consider O'Keeffe and Hopper to illustrate distinctly different styles, some critics in the 1920s and 1930s viewed Hopper as "a modern American painter" whose compositions "can be reduced to as carefully arranged geometric patterns as any cubist ever indulged in."[12] *The Arts* magazine in the 1920s argued that modernism combines realism and abstraction, while Alfred Barr in 1931 placed Hopper within the broader context of international modernism.[13] Both artists, in other words, were concerned with form and design, and both were distinctly modern

artists. Hopper's images of Americana depended upon careful formal considerations in which geometric patterns indeed prevail. O'Keeffe's simplified images of flowers and skyscrapers succeed because of her effective integration of abstract design and realistic form. Her tendency to understand objects in spiritual terms, influenced by Kandinsky, or in sexual terms, influenced, as we shall see, by Freud, adheres to the strain of modernism represented by the Stieglitz circle.

A fluidity in fact existed among the artists living and working in New York City during the first three decades of the twentieth century. The realists in the Henri circle, who formed the locus for Hopper early in his career, joined the modernists in the Stieglitz group to plan in varying degrees of participation the Armory Show of 1913.[14] Ironically, Hopper, and not O'Keeffe, was represented in this notorious exhibition, which introduced European modernism to New York, Boston, and Chicago.[15] The Whitney Studio Club and Gallery connected artists from various groups known today as the urban realists (John Sloan), the Stieglitz circle (Charles Demuth), the New York Dada movement (Marius De Zayas), the American Scene painters (Edward Hopper), the Precisionists (Charles Sheeler and Joseph Stella), the Fourteenth Street School (Kenneth Hayes Miller and Reginald Marsh), and the Regionalists (John Steuart Curry).[16]

Given all these connections, fostered by solo exhibitions, group shows, galleries, and dealers, it seems surprising in hindsight that the paintings by O'Keeffe and Hopper seldom were included together in exhibitions.[17] Although both artists showed works at The Anderson Galleries, for example, they did not participate together in a group show.[18] This gallery for Stieglitz formed a showcase or venue for the art of O'Keeffe after he closed "291," while it also acted as a sponsor of Hopper. Stieglitz never included Hopper in his circle and galleries, while O'Keeffe never participated in the popular Whitney Studio Club and Gallery—not even in its 1930 exhibition of flower paintings, which was intended to underscore the correspondence between "the modern revival" of this subject and "one of the leading aesthetic tendencies of our times—the purification of art from 'literature' and the concentration of intrinsic elements of form and design."[19] This assessment easily applies to O'Keeffe's well-known floral imagery and her continual insistence that she painted this subject to force viewers to see them in new ways, thereby freeing them from narration and philosophical concepts. Hence we might consider her absence from the exhibition an anomaly except that O'Keeffe and Hopper existed in two distinct artistic circles that did not overlap. Hopper never visited Stieglitz's galleries nor the salon of Mabel Dodge Luhan, and hence did not know personally any of the members of the Stieglitz circle.[20] He was aware that his friend John Sloan was disgusted by O'Keeffe's elected membership in 1949 to the Institute of Arts and Letters.[21] Whether Hopper

shared Sloan's condemnation of O'Keeffe and her work is not known, but his affinity with and admiration of Sloan, whom he praised for his "chief interest" in "humanity" and "true realism," suggests that he probably agreed with his appraisal.[22]

More significant to this study is the fact that O'Keeffe and Hopper both married in 1924, relatively late in life given the norms of that period. Hopper married Josephine Nivison on 9 July of that year, when he was forty-one and she was forty-two. O'Keeffe married Stieglitz on 11 December at the age of thirty-seven (Stieglitz was sixty). Both spouses were artists in their own right. Jo had studied with Henri at the New York School of Art beginning in 1905, and at the Art Students League in 1915. Like O'Keeffe, she taught art in elementary school until an illness resulted in her early retirement in 1921. The year before, Jo had identified herself for the census as an artist; two years later she began exhibiting watercolors, although her career became subordinate to her husband's by the 1930s.[23] Gail Levin attempted to recover Jo's art and reconstruct her early life and later career through extensive research, but learned to her dismay that the Whitney Museum (under the advice of Lloyd Goodrich and John I. H. Baur) had discarded most of her work—a great loss for women's history and art history, no matter what the quality of her art.[24] As a result, it is difficult to study her as an artist in her own right today, something that Jo herself feared would be the case. By contrast, at the time of O'Keeffe's marriage to Stieglitz, he was already known as a champion of photography as an art form, having founded the Photo-Secession group in 1902. He was also a magazine publisher (*Camera Work*, 1903–17), an early promoter of European and American modernism, and a gallery owner ("291," 1905–17; the Intimate Gallery, 1925–29; and An American Place, 1929–46).

Both Jo Hopper and Alfred Stieglitz became business managers for their spouses. Jo launched Edward's career before they were married by suggesting that he submit his work to the Brooklyn Museum show of 1924, in which she was already an exhibitor. After their marriage, she dedicated herself to maintaining a detailed record that catalogues Hopper's works with descriptions, their dates of completion, prices, and buyers, and also lists exhibitions, articles, and awards. She handled his correspondence (commenting in a letter that "Mr. Hopper makes me his secretary") and gave advice (whether solicited or not) on how best to exhibit his paintings. She acted, as she herself admitted, as the manager of his affairs, and claimed that she had elected herself to this position, probably because it was the only "professional" role she could reconcile with her marriage.[25] Stieglitz's role as O'Keeffe's manager began in 1916 with his first exhibition of her works at his gallery. From 1923 until his death, he continued to show O'Keeffe's new paintings annually. He took credit for exhibiting

her canvases even in 1923, when "291" had closed and their friend Mitchell Kennerley showed her works in The Anderson Galleries, which Kennerley owned. After Stieglitz's death, O'Keeffe became the promoter of her husband's art and collection, placing them in certain museums throughout the United States with a consideration of region and race (thus donating part of his collection to Fisk University). Thus the marriages of both O'Keeffe and Hopper were intertwined with their professional careers, and the success of both artists depended at least partially upon partners who functioned as their business agents, although Jo's position could not have had the same power as that of Stieglitz, given her gender and subject position as a wife. As Griselda Pollock, T. J. Clark, and others have argued, modernism is linked to capitalist conditions and relations in which "the dealer and publicist, the critic are in constant and unpredictable negotiation with the buying publics."[26] In the cases of Hopper and O'Keeffe, their spouses significantly participated in such negotiations.

The mid-1920s saw the emergence of the New Woman, overt discussion of sexuality, and increased industrialization. Women entered the workforce in greater numbers and increasingly remained single as well as economically autonomous. Many Americans were searching for a redefinition of marriage that defied Victorian prudery and patriarchal, procreative family structures. The discourses and controversies surrounding marriage during this period turn up in articles in the popular press (such as *Harper's Monthly,* the *Literary Digest, American Mercury, Ladies' Home Journal,* and *Readers' Digest*), the writings of Sherwood Anderson, D. H. Lawrence, Floyd Dell, and Stephen Vincent Benét, among others, and the widely discussed scholarship of sociologists, psychologists, anthropologists, social workers, and other professionals, who applied scientific modes of inquiry to the modern family for the first time.

The prevalent discourse in American culture about employment for married women, contraception, divorce, extramarital affairs, and modern marriage can be related directly to the marital experiences of both artists. So can the conflict between older notions of marriage, which entailed the imposition of patriarchal authority, the repression of female sexuality, the control of male sexuality, and the occurrence of unplanned pregnancy, and the newer ones, which were yet to be fully formulated but which included affection, comradeship, and mutual sexual gratification. Industrialization, urbanization, the increased presence of the automobile, and the more open discussion and expression of female sexuality that prevailed during this period became central themes in the art of Hopper and O'Keeffe. Their art during this period consequently represented and participated in the breakdown of Victorian morals and manners that resulted

in this first sexual revolution, and led to a sense of marriage in crisis in white middle-class society.

The cultural meaning of family life in the United States thus began to change in the 1920s, under pressure from modernization and the first sexual revolution. This is the subject of chapter 1. Young people during the 1920s, 1930s, and 1940s did not abandon the concept of the family, but revised it and adapted it to new circumstances through a new emphasis upon companionship and a greater value on affection, friendship, and individual happiness. During the 1920s, rising divorce rates, falling birthrates, changing roles for women, and the new sexual morality led to a sense of family in crisis in the middle class that defined the norm in the United States. As the sociologist Arlene Skolnick has pointed out, the middle class of this period comprised a diverse group of people from various economic strata, including bohemians like Stieglitz and O'Keeffe and more conservative people like Jo and Edward Hopper.[27] Their relationships indicate the types of fissures that would expand during the 1960s and continue to the present day, in which the institution of marriage remains a focus of contention and debate.

Hopper and O'Keeffe initially appear to represent two different marriage paradigms, and the striking contrast between her radical and his traditional artistic style seems to find parallels in their lifestyles and mores. Reexamining the intimate details of their respective marriages during the interwar years, the subject of chapter 2, is central to understanding this aspect of their work. Moreover, their paintings negotiate and embody the cultural discourse of marriage during this period. O'Keeffe and Stieglitz's relationship began when Stieglitz was still married to his first wife. O'Keeffe played the role of the bad girl, the defiant New Woman, who, along with Stieglitz, rejected society's conventions.[28] Edward and Jo Hopper's marriage, on the other hand, grew out of a more traditional courtship, and they continued throughout their lives together to exhibit a public persona of traditional and stable companionship. What is more interesting than this broad contrast, however, is the tension it disguises, for, according to Jo's diary, there was much conflict in the Hoppers' private life, including physical abuse on both sides. And discord surfaced between O'Keeffe and Stieglitz, especially in 1927, when he began an affair with Dorothy Norman. O'Keeffe was unable to paint for nearly a year and had a nervous breakdown.

In chapter 3 I explore how Hopper's many representations of Victorian homes with high mansard roofs and expansive porches set in sunny and tranquil landscapes take on additional meanings within the context of a marriage that was far from tranquil, and within the context of marriage debates that proclaimed the modern industrial and urban era to be

destructive to the family. In his day, critics of the modern marriage saw the old-fashioned single-dwelling home that he painted in an almost iconic and nostalgic manner as representative of the stability of the Victorian family, a unit they feared had been fatally destabilized in the modern era. Hopper's paintings exposed the unease many expressed about the new, urban, multidwelling homes, which they suspected would contribute to the breakdown of the family; his work relates as well to the general consensus among social scientists, popular journals, and others that the automobile would erode the family structure. His frequent images of roads located in desolate, lonely settings evoke the concern many Americans expressed at this time that the motorcar encouraged sexual experimentation without the controls of family, clergy, or other institutions. The hotel, another common subject in Hopper's oeuvre, similarly became coded with fears about unrestrained sexual encounters among youngsters and extramarital affairs engaged in by adults.

Chapter 4 examines Hopper's *Girlie Show* (see plate 5)and *Office at Night* (see plate 7). Jo modeled for both of these paintings and assisted in the creation of their sexualized female masquerades. These works evidently reveal a power struggle between husband and wife that played out in their lives and fueled tensions in their marriage. The two paintings do more than merely transcribe these conflicts, however. They also demonstrate and participate in a dialectic between male and female, husband and wife, artist and model, beholder and subject, and painter and manager, thus reflecting and embodying cultural debates over the modern marriage in crisis by representing sites (the strip show, the office) that illuminate the struggle over the meanings of those contexts. This chapter will address how the viewer of *Girlie Show* and *Office at Night* can understand the paintings' underlying erotic tensions between men and women.

Stieglitz's photographs of O'Keeffe, his critical interpretations of her work, and his influence upon other critics who employed the same Freudian vocabulary in interpreting O'Keeffe's art form the basis of chapter 5. Here, I acquaint the reader with how, during the first two decades of the twentieth century, Freudian psychoanalytic theories permeated American popular culture. Articles about Freud and his theories pervaded not only cultural circles, but also American popular magazines, including *Time, The Nation, American Mercury, Scribner's Magazine,* and *Literary Digest,* and contributed to the psychoanalytic discourse employed by critics concerning O'Keeffe's art. O'Keeffe also participated in this greater awareness of sexuality, especially female eroticism, through her collaboration in the creation of Stieglitz's nude photographs of her and through her nonobjective charcoals and paintings of flowers that embody her passionate feelings about specific relationships with men. I argue that Stieglitz with O'Keeffe's collaboration made public the private sexual intimacies

of their relationship through his nude photographs, which capture her various personae: artist, carnal woman, androgynous person. O'Keeffe both contributed to and resisted these erotic images, ultimately reversing the sexual politics of looking by objectifying her husband in her emblematic portrait: *The Radiator Building: Night, New York* (see plate 9).

Chapter 6 focuses exclusively upon the meanings of this work, showing how it functions as an object in which discourses about modernism, urbanism, gender, and sexuality intersect. I explain how O'Keeffe appropriated the Freudian discourse that critics had applied to her charcoals and flower paintings (and which she found so distasteful) in *The Radiator Building* as a means to control her art and image and to distinguish her work from both Stieglitz and his patriarchal power. She employed strategies used by other New Women to avoid simply assuming the male vocabulary, and instead to invest male images with female political intent. Moreover, she used male myths to repudiate male power. By creating this emblematic portrait of her husband, O'Keeffe turned the tables of the male world upside down. She made him the subject of an artwork rather than existing solely as his model. Just as Stieglitz recorded many sides of O'Keeffe, including her female sexuality and androgyny, chapter 6 reveals that in *The Radiator Building,* O'Keeffe rendered the many aspects of Stieglitz. This painting powerfully and singly embodies the concept of marriage in crisis that engaged social scientists, judges, authors, popular magazine journals, and the public at large in the United States between the world wars, and resonates yet today with the same meanings.

In the conclusion of *Art and the Crisis of Marriage,* I examine the direction that Hopper and O'Keeffe took in their art after the close of the Second World War. I argue that O'Keeffe's paintings of skulls and crosses embody themes of death and rebirth and were the artist's response to her husband's affair with Dorothy Norman that began in the summer of 1927 and lasted until 1933. This affair, their disagreements about the Radio City Music Hall commission for a mural in 1932, and O'Keeffe's hospitalization that same year for "psychoneurosis" led her to establish her independence from Stieglitz and to more emphatically assert her own voice. She continued her fascination with bones and the southwestern landscape as a means to enable her own rejuvenation and independence.

After World War II, Hopper continued to paint views of theaters, railroads, hotels, offices, estranged couples, female nudes, and Victorian houses, all evoking his theme of the isolation of humans in modern society. *Two Comedians* (see fig. 119) makes clear, however, that toward the end of his life, Hopper thought more overtly about himself and his wife in his painted fantasies. The painting also suggests some type of resolution within their marriage. During the 1960s, when baby boomers challenged their parents' ideology of domesticity, Hopper's painting indicates that

he and his wife, despite their continued differences and conflicts, formed a team.

In this study, I combine the art-historical techniques of formal and iconographic analyses with biography to explore that intersection between public and private lives which is of interest to cultural historians. In recent years, the concept of authorship has been challenged in some academic circles and disciplines, beginning with Michel Foucault and Roland Barthes, who first introduced it as a culturally produced and historical formation.[29] I share with Griselda Pollock, however, the belief that "paintings, drawings, and letters . . . are not reflections or expressions of a given and coherent subjectivity prior to the work," but "rather their status becomes that of unforeseen and yet complex texts generated from a subject position [of the author/artist]," in this case Hopper and O'Keeffe.[30] "The 'author' is not an origin," as Mieke Bal and Norman Bryson assert, "but one link in a chain," an "usher gathering in the various causal strands . . . before the work."[31] This book focuses especially upon the "causal strands" that involve gender, family, marriage, and sexuality, showing how these two American painters' histories and art merge with the culture at large.

I thus argue that the meanings of artworks are determined both consciously and unconsciously by artists influenced by social and cultural factors. I interpret paintings as visual texts that participate, according to semiotics, in "a plurality of contexts."[32] Rather than separating formalism and biography from cultural context, then, I insist upon the intersection of all three—and upon the relevance of such feminist concerns as the status of women artists; the institutional, cultural, and social factors that affected their careers; and the ways in which the male and female bodies are constructed.[33] I consequently combine women's studies with feminist art history to address what Pollock identifies as the "feminist intervention in the histories of art" that "demand recognition of gender power relations, making visible the mechanisms of male power, the social construction of sexual difference and the role of cultural representations in that construction." This involves the recognition that "sexual difference is *produced* through an interconnecting series of social practices and institutions of which families, education, art studies, galleries and magazines are a part."[34] I thus consider both masculinity and femininity as social constructs manifest in various texts that include paintings, and I share with other feminists in art history the concern that the notion of "the death of the author" corresponded to the 1970s feminist movement that began to reinsert women artists such as O'Keeffe into art history.[35] I thus reclaim the author/artist, whether a man or a woman (O'Keeffe, Stieglitz, Jo and Edward Hopper), as participants in a "series of causation" that results in a work of art. The work of art, in turn, has amorphous boundaries in which meanings circulate among other texts and between other sites of social

formation, participating in and negotiating among various ideologies—in this case, those involving marriage, gender, sexuality, the body, and the gaze.[36]

Psychoanalytic theory also comes into play. As Elizabeth Wright explains, "[F]eminist applications of the insights of psychoanalysis have developed a systemic critique of the function of the image, the gaze, the spectator," who is both the viewer of an artwork (of the past and present) and the artist.[37] I am especially influenced by Laura Mulvey's analysis of the "traditional exhibitionist role [of] women" who "are simultaneously looked at and displayed . . . to connote to-be-looked-at-ness" in which the male functions as the active possessor of the gaze and the female acts as the passive object of male desire.[38] What makes Hopper and O'Keeffe so fascinating is that this simple binary opposition between passive female and active male becomes less stable when their marital relationships are examined, especially within the context of Hopper's wife as his model and O'Keeffe as the model for her husband's photographs.

Pollock, like Mulvey, employs psychoanalytic theory to recognize the unconscious in the sexualized pleasure in looking. As she explains, rather than privileging the individual artist, it exposes "historical and social structur[al formations] which function at the level of the unconscious" that is "represented not merely as object of personalized interrogation but as a site of social inscription of gender/class formations operative through social institutions such as the family."[39] Americans during the 1920s and 1930s understood this on some level, given that Freud's ideas became omnipresent in the United States during this very period when the modern family became a subject of study among scholars and the general public. My use of psychoanalytic theory thus results from its pervasiveness in American culture at this time when two types of meanings in artworks arose: on the one hand, personal meanings that may have been consciously or unconsciously intended by the artists and are knowable to us by having access to their letters and diaries; and on the other, meanings constructed by critics at the time. Sometimes these two meanings overlapped, but more often they did not.

Despite the seemingly open discussion of marital discord during this period, it is often impossible to determine whether a couple's relationship was a success or a failure. Some of their shared intimacies, joys, losses, and conflicts can be known, but many remain hidden. Even if one person reported aspects of a relationship, the spouse may have interpreted them differently. In the case of O'Keeffe and Stieglitz, letters to friends and reminiscences of acquaintances and family members address some details of their association. But their correspondence remains under seal at the Beinecke Rare Book and Manuscript Library at Yale University until 2006.[40] Even then, scholars will be able to discern only what the

authors of these letters wanted to express verbally and privately to each other, some of which may not be clear to outsiders. Similarly, acquaintances of Jo and Edward Hopper have revealed some aspects of their personalities that affected their relationship, and Jo's unpublished diary contains numerous intimate passages concerning their sex life, disagreements, and codependent, coabusive relationship. Yet this document offers only one person's perception of events; her husband's sense of what occurred may have been different. The diary, comments by interviewers and friends, letters to other people, and visual images nevertheless reveal aspects of their relationship that can be analyzed and understood within the context of their marriage in particular and the public discourse about the institution of marriage in general. The same applies to O'Keeffe and Stieglitz. Only by examining the evidence available in various sources can an attempt be made to understand how particular artworks relate to the artists' marriages and inscribe and reinforce elements of the debate about marriage during the period between the two world wars.

Concerns about families in crisis predate our own era, were widely debated, and inspired art. Marriage then, as today, was an arena in which social, sexual, and personal conflicts were played out. O'Keeffe's and Hopper's marriages and the art these relationships inspired enable us to study these complex and compelling social phenomena.

Marital Dynamics

The Making of the Modern Marriage

Two years after O'Keeffe and Hopper married their respective spouses, a physician concluded that she had met only one happily married couple during the twenty years she had practiced medicine.[1] The truth of this statement cannot be discerned; however, that this comment appeared in the *Ladies' Home Journal* in 1926 indicates concern about the state of marriage in the United States. Indeed, during the period between the two world wars, many white middle-class Americans considered marriage and the family institutions in crisis. Articles such as "The Chaos of Modern Marriage" in *Harper's Magazine* (1925), "Dire Dangers Threatening Family Life" in *Literary Digest* (1927), "What Is the Family Still Good For?" in *American Mercury* (1930), and "Fighting Breakdowns in Marriage" in *Literary Digest* (1936) addressed what their authors called the "threatening dissolution of the family," "the weakening of the symbolism of the home."[2] By 1939, one author proclaimed the family a vanishing institution that had to be saved;[3] otherwise, warned another, "the degeneration of American civilization" or "the ultimate disintegration of our civilization"[4] would result.

These comments from a variety of popular magazines indicate the confusion and anxiety about the family that was prevalent in American culture during the modern era. Their vocabulary of "chaos," "dire dangers," "threat," "breakdown," and "dissolution" raised alarms over the institution of marriage in particular and American civilization in general. To preserve the nation, their authors argued, Americans had to fortify the ties of family life. Both existed in a state of crisis. As the marxist author of

various texts on marriage, Victor F. Calverton, concluded in 1928, the family was disintegrating because "the marital institution of the modern world" was in a state of decay.[5]

These concerns expanded beyond the popular press into the academic realm. Beginning in the 1920s, the social sciences became differentiated into the independent disciplines of home economics, psychology, sociology, social work, and anthropology.[6] Sociologists and anthropologists who had written about prehistoric and primitive family life now, along with other social scientists, turned their attention to modern family life and marriage in an attempt to understand, define, and redefine this social institution. Their scholarly voices joined the popular press's chorus of distress, and book titles such as *Love and Marriage, The Family and Its Members, What Is Right with Marriage, Marriage and the Family,* and *Marriage for Moderns* helped place concerns about the modern family within the forefront of American consciousness.[7]

Creating and Managing the Marriage in Crisis

Churches, the federal government, and other social organizations also addressed this compelling topic. The annual meeting of the American Sociological Society had its first session on the topic of the modern family in 1924.[8] That same year, the Bureau of Social Hygiene hired G. V. Hamilton, M.D., and Kenneth MacGowan to investigate whether marriage in itself was a faulty institution that impaired or destroyed the congeniality and sexual feelings experienced by couples before marriage.[9] In 1927, the Federal Council of Churches of Christ in America created a Committee on Marriage and Home to study the changes within the modern family and to consider how to reenforce the Christian concept of monogamous marriage.[10] President Herbert Hoover in September 1929 formed a committee of leading scholars and experts to examine and report upon recent social trends in the United States, including problems within the family.[11] Pope Pius XI even wrote an encyclical on the subject of marriage in 1931, instructing his bishops to "restore matrimony to its proper place in modern society."[12] In 1938, the National Conference on Family Relations held its first meeting in New York, and declared that the state and federal governments needed to assist in democratizing knowledge about marriage. This organization met annually throughout the 1940s and 1950s.[13] Related to this meeting were regional conferences on marriage and the family held in New York, Chicago, Michigan, and Washington.[14]

In the 1920s, colleges and universities began to offer courses on the family. Sociologist Ernest R. Groves taught the first course on this subject at Boston University in 1922; a social worker, Anna Garlin Spencer, presented a lecture, "Social Problems of the Family," during the summer of

1919 at Columbia University and taught this popular subject over the next thirteen years. Groves instituted a similar course at Columbia during the summer of 1924. His *Social Problems of the Family* (1927) was the first college text to deal with the problems of modern family life.[15] By 1939, more than one hundred colleges offered courses on marriage and family relationships, covering topics such as petting, problems of courtship, mate selection, the honeymoon, marital adjustment, birth control, and child-birth.[16]

Academics thus became the new arbiters of convention, seeking to bring youth's experience in courtship and marriage under the authority of educators and experts, thereby removing it from the auspices of family and church.[17] Their expertise reached the general public through mass-circulation periodicals such as the *American Magazine,* which in 1937 published an article on college marriage courses that prompted thousands of letters to the editor; and *Good Housekeeping,* which offered in the same year a college course on marriage relations.[18]

Colleges were not alone in shifting the locus of authority from the family and the church into the public sphere. The Child Study Association, the American Social Hygiene Association, the Extension Service of the U.S. Department of Agriculture, the YMCA, and the YWCA began offering public-education courses on preparing for marriage and parenthood. At the biennial conference of the National Council of Parent Education in Washington, D.C., in 1934, a curriculum for preparing high school students for marriage was drafted. Even a Bride's School in New York was designed to assist new wives in learning how to develop a household budget, plan menus, shop, and decorate the home.[19] The Philadelphia Marriage Council, established in 1933, focused on counseling and education as a means to assist couples in achieving "companion-ship in married life."[20] By 1937, one hundred marriage-consultation centers and institutes existed throughout the country.[21] By the Second World War, some argued that national security demanded strengthening the family so that courage, fortitude, and confidence would be exhibited by parents and children alike, and they urged high schools to institute a curriculum that would prepare adolescents for marriage as a means to strengthen the national defense.[22]

As secular organizations and social sciences claimed ownership of the marriage-in-crisis problem, churches attempted to participate both in the debate over the institution and in education for family life. In 1929, the Protestant Episcopal Church introduced marriage instruction into every parish, focusing on sexual relations, mental hygiene, home economics, and spiritual living. The following year, the Presbyterian Church established a commission to examine the changes within modern marriages, recommending that seminaries teach courses to assist parishioners

in maintaining a Christian home of "mutual love, honor, and comrade-ship."[23] The Federal Council of Churches of Christ in America and the International Council of Religious Education began offering courses on marriage, contributing to the attempt to mold and control expectations and experiences of family life.[24]

Marriage counseling became institutionalized and professionalized during this period as psychologists, social workers, child-guidance centers, and mental hygiene clinics began to replace or overlap with the advice of ministers, lawyers, and teachers.[25] Three central locations for marriage counseling had been established by the early 1930s: the Marriage Consultation Center in New York City, the American Institute of Family Relations in Los Angeles (1930), and the Marriage Council of Philadelphia (1931).[26]

By the 1940s, colleges began instituting curricula for marriage counseling while the National Conference on Family Relations provided guidance for training in this new area. Groves, now at the University of North Carolina, developed the first academic program for marriage counseling in 1944. In addition, he wrote several books on mental hygiene, explaining that this subject focuses on the "conservation of marriage and the family" through counseling and education. Psychologists as well as sociologists recognized the connection between childhood experiences and marital happiness, and studied how attitudes toward courtship, conflict, and sex affected relationships.[27] Practitioners of mental hygiene believed that counseling would enable marriage and monogamy to survive. Thus the religious, government, and academic sectors, and many professional and private organizations, endeavored to provide marriage counseling as a means to heal the wounds within the institution of marriage and consequently save American civilization, which many believed was threatened by the crisis in families.

A contemporary sociologist, the late Christopher Lasch, argued that the "helping professions" of social work, psychology, and mental hygiene "intensified the very 'crisis'" to which they claimed to hold the solution. He suggested that the social sciences contributed to the public's doubts about its ability to maintain family units without expert intervention and advice; these experts invaded the family, taking over some of its traditional functions, convincing parents that they required their services, and transferring the education of children to the control of the state and the school. For him, this development represented the imposition of capitalist controls within the family, once the last bastion of privacy in the competitive world of commerce.[28]

Regardless of whether these "helping professions" augmented the crisis in marriage and the family, they nevertheless provided scientific evidence that this crisis existed, and coined phrases that the public under-

stood. Scholarly discourse entered the public arena through popular magazines and books as social scientists and others looked for ways to define and theorize changes within the family structure.

The Causes of the Marriage in Crisis

Sociologists, psychologists, and social workers attributed the changes within the modern family to prevailing social conditions: the effects of the two world wars; accelerated industrialization and urbanization; the increased education of middle-class women and the growing economic independence of working- and middle-class women; the wider use of birth control and the decreased birthrate; the increase in divorce; the challenges to patriarchal authority within the family; the rejection of Victorian prudery; and the movement of leisure activities from the private sphere of the home to the public sphere of movie theaters, dance halls, amusement parks, and the like.[29] Five of these factors especially became the focus for social scientists and commentators: urbanization, mechanization, working women, divorce, and contraception. Other threats—including the car and the apartment house—were also addressed.

By 1912, James Quale Dealey, professor of social and political science at Brown University, judged that urban living weakened "conjugal ties" and the "stability and unity of familial life."[30] The Chicago school of urban sociology founded by William F. Ogburn and Ernest W. Burgess concurred, as did sociologists like Ernest R. Mowrer at Northwestern University. They argued that traditional patterns of family life had broken down under the impact of urbanization, and they cited statistics demonstrating that fewer urban dwellers marry than their rural counterparts. "It has been estimated," explained Ogburn, "that the urban community (of 2,500 inhabitants and over) acts as a deterrent to marriage to the extent of about 10 percent."[31] Mowrer similarly concluded in 1932 that "city life has a disorganizing effect upon the family" because it bred "discontent with the traditional family."[32] These sociologists theorized that urbanization (along with industrialization) resulted in competition, not cooperation, and in individualism, not kinship among family members. As a result the home, once "a haven in a heartless world," was transformed into a harsh environment in which domestic tensions were inevitable.[33]

Many Americans believed that the machine age in general and the machine in particular adversely affected relationships. Groves argued in *The American Family* (1934) that industrialization forced the traditional modes of behavior within families to change, especially in regard to marriage and parenthood.[34] Calverton had gone further in *The Bankruptcy of Marriage* (1928), suggesting that industrialization "destroyed the unity of the home, and brought the family to a rapid ruin."[35] Charles W. Wood,

writing in 1929, blamed the city: "When man moved out of the family and began to live in the machine [i.e., skyscrapers and the city], matrimony began to lose its holiness."[36] Sherwood Anderson's *Poor White* (1920) had been more literal: his main character, Hugh McVey, is unable to consummate his marriage because of the overwhelming interference of the machine. Only when he destroys his mechanical inventions can he and his wife conceive a baby. As his wife concludes, "Thinking of machinery and the making of machines had . . . been at the bottom of [his] inability to talk with [me]," as well as his inability to have sex.[37] These social scientists and authors attributed incredible power to mechanization, believing that it had a direct and adverse impact upon lives, inspiring marital conflict, preventing physical and emotional closeness, and precipitating divorce, social disorganization, and juvenile delinquency.[38]

One aspect of the modern marriage that captured the attention of many Americans was that of the married woman as a working, equal partner. The percentage of married women working outside the home increased from 4.6 in 1890 to 15.2 in 1940.[39] Their numbers increased faster than those of single women in the workforce in the 1920s and grew even larger during the Great Depression, while the number of single women declined.[40] "Readjustment of familial patterns in terms of companionship and mutual affection is necessitated by women's actual or potential economic independence and by their educational and social equality," declared Burgess and Locke.[41] Mowrer agreed: "The rôle of the modern wife has been radically changed within a century from a subordinate housewife and child-bearer to a partner in a common enterprise, sharing equally with her husband in the privileges and responsibilities," resulting in her becoming a "more desirable companion."[42] Groves also concurred: the First World War had contributed to the end of "the old idea that women's place is in the home. Today women's place is in the world side by side with the men."[43]

Single women, too, began working in greater proportions. Working-class women had always worked for wages, but college-educated women were increasingly remaining single and supporting themselves, while middle-class daughters took jobs before marriage. Between 1890 and 1920, the proportion of single women pursuing gainful occupations grew from 19 percent to 24 percent. With more women working within the public sphere, the Victorian distinction between the outside "male" world of work and the "female" domestic world at home broke down.[44]

Although divorce was relatively uncommon in the nineteenth century, public debate over its causes began during this period among clergymen and moralists. The issue entered the public consciousness during the twentieth century because the divorce rate, which had accelerated between 1889 and 1906, dramatically increased during the ensuing

decades.[45] By 1924, one in about every seven marriages ended in divorce. The Census Bureau in 1926 reported a decline in the marriage rate and a rise in the divorce rate.[46] In 1931, the latter reached a peak of 17.3 divorces for every 100 marriages; while the rate declined somewhat in 1933, it thereafter rose to 17.5 divorces per 100 marriages in 1937.[47] Nine years later, it reached its highest record: 18.2 per 1,000 existing marriages.[48]

As Ogburn concluded in his 1933 presidential report to President Hoover, "increased divorce is due to the weakening of the functions which served to hold the family together." Dr. Caleb R. Stetson, rector of the Trinity Episcopal Church in New York City, worried about its consequences: "[E]asy divorce," he warned, "destroys the permanence of the home and provides no way for the proper care of children."[49] *Free Press* expressed great alarm over the decrease in marriages and the increase in divorces, fearing greater "animalism and [the] failure of natural affection for children and their consequent neglect."[50] The intense feelings aroused by this subject are further manifested in the personal account of one divorced woman, published in both *Harper's Magazine* and *Reader's Digest*. She expressed her dismay over her earlier decision to leave her husband, describing divorce as a surgical procedure that resulted in agonizing pain for herself and her son.[51] Despite these concerns, Robert S. and Helen M. Lynd reported that by 1937, children of high-school age in "Middletown" (now known to be Muncie, Indiana) considered marriage no longer permanent, "since divorce is no longer a serious disgrace."[52]

Contraception especially altered expectations of marriage among the middle and upper classes by enabling couples to remain childless, removing the economic burdens of child bearing, separating the sexual act from reproduction, and valorizing heterosexual eroticism, especially that of women.[53] Parenthood by choice rather than by chance became a radical and prevalent concept that challenged traditional expectations. Margaret Sanger, a nurse who worked with poor people on the Lower East Side in New York City, first promoted birth control in 1912 to allow married couples to enjoy conjugal happiness without fear of pregnancy. Four years later, at the time when the Comstock Law classified birth control information as obscene, she opened the first birth control clinic in the United States, resulting in her arrest. In 1921 she founded the American Birth Control League, which became the Planned Parenthood Federation in 1942. The Comstock Law was modified in 1936, and one year later the American Medical Association officially recognized birth control while the Food and Drug Administration decided for the first time to scrutinize birth-control devices, thereby providing official government sanction for their use. The U.S. Public Health Service actively initiated contraceptive programs in 1942, but much of the public was ahead of the

government: the number of birth-control clinics had already grown from 28 in 1929 to 746 in 1941.[54] A *Ladies' Home Journal* survey of 1938 found that 79 percent of women of all ages and from all regions of the country favored the use of birth control.[55] In turn, the freedom to have sex without the fear of pregnancy radically changed the definition and expectations of marriage.

The Ideology of Companionship Marriage

Models for the modern marriage were proposed, debated, rejected, and accepted. The one that captured the attention of many white middle-class Americans was companionate marriage. This was the invention of Ben B. Lindsey, a juvenile and family court judge in Denver, Colorado, who envisioned a legal marriage that included legalized birth control and, for childless couples, the right to divorce by mutual consent, usually without payment of alimony. Lindsey had first addressed the sexual revolution among youngsters in his popular *Revolt of Modern Youth* (1925). This book, along with his *The Companionate Marriage* (1927), made Lindsey's theories well known in the United States, reinforced by his participation in public debates in communities throughout the nation and by media popularizations.[56] *Redbook,* for example, serialized *Companionate Marriage,* ensuring that it was widely read and discussed in the 1920s, especially among the educated and urban middle class.[57]

Through anecdotal case studies based on his own interviews with couples considering divorce, Lindsey exposed the failure of Victorian morality among middle-aged couples. He not only acknowledged the importance of sex for both men and women, which he called "a spiritual hunger" that must be gratified, but also believed that misunderstandings and disagreements over this topic caused most divorces and separations. For him, the flapper's open acknowledgment and discussion of sex, the more widespread acceptance of intercourse before marriage, and the loosened restrictions on petting and casual intimacies among many youngsters established a new social code and necessitated the creation of a new form of marriage.[58]

Lindsey's suggestion that couples experiment with their relationship before deciding whether to form a family unit provoked the prevalent belief that this practice would promote "experimental" or "trial" marriage, represented a rejection of monogamy, encouraged licentious behavior, and threatened the social fabric.[59] Conservatives viewed his concept of companionate marriage as "the quick road to national oblivion," endangering the "propagation of the race."[60] The Boston Chapter of the Daughters of the American Revolution blacklisted his second book; religious conservatives condemned it. One minister called Lindsey's concept

"barnyard marriage," while William T. Manning, Episcopal bishop of the Diocese of New York, alarmingly concluded that it encouraged "lewdness, promiscuity, adultery and unrestrained gratification."[61] Pope Pius IX, in his encyclical on marriage, had denounced "the new species of unions," which, he feared, would "reduce our truly cultured nations to the barbarous standards of savage peoples."[62] Even social liberals found problems with Lindsey's model. Groves, for example, critiqued it as an "arrested type of family life" because it failed to involve "parental affection."[63] John Levy and Ruth Monroe in *The Happy Family* (1938) condemned it as a utopian and unrealistic solution to problems that required psychological analysis.[64]

Despite its many critics, "[c]ompanionate marriage was designed to control the social problems reformers saw in the behavior of youth, not to transform the system of marriage in a radical way," as historian Christina Simmons has observed.[65] Lindsey himself cautioned against sexual excess: "The unmarried union is dangerous because it is subject to no recognized control; and because, being secret, it has no inducements and no social helps toward moderation, and toward reasonable stability and restraint."[66] Many failed to recognize Lindsey's own conventional belief that a successful companionate marriage would eventually result in children and a nuclear family in which the parents remained together.[67] This new legal form of matrimony was intended actually to tighten the bonds of marriage and reduce the number of divorces.

Lindsey and his controversial model did not stand alone, however. Calverton's *Bankruptcy of Marriage* (1928) addresses "the disintegration of the family, and the decay of the marital institution of the modern world." Like others, he attributed this decay to the "New Woman and the New Morality" that rejected Victorian prudery and the old patriarchal model of the family. Both Calverton's book and the leftist journal he founded in 1923, *Modern Quarterly,* address the connections among sex, psychology, and radical politics, championing sexual freedom. His marxist approach condemned the bourgeois marriage as "bankrupt" because of its basis in private property. He advocated instead the working-class family structure found in Russia, where it coexisted with abortion, contraception, easy divorce, and the equality of women.[68] Calverton's ideas, especially his emphasis upon the importance of sex in modern culture, were popularized by the press, while his frequent lectures and debates on college campuses, in churches, and before private clubs in Baltimore, New York, and Boston made his beliefs well known.

Lindsey's proposal of the companionate marriage and Calverton's theory about the bankruptcy of bourgeois marriage may have captured the attention of many Americans, conservatives and radicals alike, during the 1920s, but neither model ever became institutionalized. Nonetheless,

the judge and the leftist journalist identified aspects of marriage that had become the norm during the 1920s: easier divorce, greater emphasis upon sex, and egalitarian roles for men and women.[69] As Malcolm Cowley summarized about the attitudes in bohemia that soon would become the norm throughout the United States, "Women should be the economic and moral equals of men" with "the same pay, the same working conditions, the same opportunity for drinking, smoking, taking or dismissing lovers."[70]

By the 1930s and continuing into the next decade, sociologists and the media appropriated the term *companionship marriage* to define the new type of marriage that they perceived as becoming the norm. Mrs. Franklin D. Roosevelt recommended the model in 1930, advising wives to focus upon partnership more than homemaking and motherhood.[71] The new advocates dropped Lindsey's notion of easy divorce and emphasized even further the idea of union and mutual support. As the Lynds discovered in 1929, middle-class Americans believed that "romantic love" was the "only valid basis of marriage," one that involved intimacy, openness, mutual sharing, partnership, respect, and equality.[72] *Ladies' Home Journal* concurred in 1940, declaring that in such a marriage, "a beautiful and lasting affection can be established" that involves "friendship, sensuality and respect."[73] Most Americans seemed to recognize and accept the transformation of marriage into the companionship form, using terms such as *intimate companionship* and *rare companionship* to summarize modern marriages.[74]

Beginning in the 1920s, novels of the youth culture promoted the ideology of companionship marriage, replacing the Victorian patriarch with the male flapper, a New Man who advocated democratic relations with women. Floyd Dell advocated companionship and friendship in *Moon-Calf* (1920), in which his hero desires a woman that he can sleep with and talk to, while the couple in his *Janet March* (1923) are intellectual equals "engaged in humanizing the ancient institution of family life."[75] Stephen Benét in *The Beginning of Wisdom* (1921) promoted a similar type of relationship, establishing the male flapper's "genius for comradeship" based on "spiritual kindred . . . wish and thought."[76]

As companionship marriage entered the public consciousness through novels, magazine articles, and popular discourse, academics attempted to explain its history and evolution. Sociologists theorized that marriage in the early twentieth century underwent a transition from its earlier institutional form, which had prevailed for centuries in a predominantly rural society. Then marriage was characterized by "tradition, the authority of the family head, rigid discipline, and elaborate ritual," resulting in a sense of duty, permanence, and unplanned parenthood.[77] This contract of progeny and economic need was based on maintaining the

separate spheres of men and women, controlling male sexuality, and repressing female sexuality. On the other hand, the new form of marriage, called the companionship marriage, achieved unity through "such interpersonal relations as the mutual affection, the sympathetic understanding, and the comradeship of its members."[78] This modern form rejected the former patriarchal and procreative model while it encouraged male and female sexuality and mutual sexual gratification, and the increased independence of women both inside and outside the home.

Burgess and Locke theorized in 1945 that a new form of marriage had evolved from the chaotic marriage in crisis described earlier. Now intimate, interpersonal association prevailed: "More and more the American family is becoming a union of husband and wife, parents and children, based upon the sentiment of love, common interests, and companionship."[79] This type of marriage "becomes a success," another sociologist argued, "not through compromising masculine and feminine characteristics, but by consolidating the interests of man and woman in a coöperation that provides individuality for both persons."[80] Phrases like "a functioning unit[;] a complementary relationship," "a lifelong social relationship of mutual obligations and services," "a union of bodies, souls, hearts, and minds in a single collectivity," "a substantial bond," and "spiritual oneness of mutual love and consideration" prevailed in describing this model.[81]

Women and Work

Yet the patriarchal, domesticated household remained the norm, especially during the Great Depression.[82] This economic crisis opened the way for a new type of family based on shared breadwinning by both parents along with the equality of the sexes. Even so, most often it was the men who held jobs (if they could find work) while the women remained at home, caring for the children, cooking, cleaning, and mending.[83] In this period of financial hardship, the marriage rate plummeted to an all-time low, in part because men doubted their ability to provide for a family. The birthrate also declined, while the number of divorces increased partly in response to financial burdens, although women in Middletown tended to "remain in the marital frying pan rather than to jump out into the economic fire."[84] Single young women often worked if they could to support their parents, delaying their own entry into marriage and motherhood. A 1933 federal report on social trends compiled at the request of President Herbert Hoover asserted that although "the tradition lingers that woman's place is in the home . . . 26 million women . . . have part or full time jobs as housewives and where there is a housewife there is a home."[85]

Others cautioned against women working outside the home, expressing the fear that it would inevitably result in "the loosening of family bonds" as well as the increased unemployment of men.[86] In 1931, Pope Pius XI declared that the emancipation of women "who follow their own bent and devote" themselves to business and public affairs debased "the womanly character and the dignity of motherhood, and indeed of the whole family."[87] Paul Popenoe, director and founder of the Institute of Family Relations in Los Angeles and author of a series of publications on marriage, argued passionately that "big business spoils a woman for love and marriage." He joined the pope in advocating homemaking as a wife's primary occupation and interest.[88] Vassar College in 1923 began a course on Euthenics with the aim of producing "college women who will be better citizens, better wives, and better mothers," while home economics as an academic discipline focused on preparing women to be efficient and productive housewives, but also institutionalized women's place within the domestic realm through education.[89] In 1924, Lorine Pruette studied three hundred men from a "lower social scale" who expressed the belief that married women should stay at home, especially to care for children.[90] Thirteen years later, in 1937, a Gallup Poll survey asked one hundred thousand people whether they approved of a woman earning money in industry or business if her husband could provide financial support.[91] Eighty-two percent said no. This survey corresponded to the values that the Lynds discovered during their second study of Middletown published in 1937, where a majority of inhabitants believed that "a married woman's place is first of all in the home" and that other activities must be subordinate to "making a good home for her husband and children."[92]

Hollywood stars both on- and off-screen during the 1930s and early 1940s encouraged women's independence and the equality of sexes, but they also indicated in their lives and movies that career and marriage did not mix. Films such as *Blonde Venus* (1931), *His Girl Friday* (1940), and *Gone With the Wind* (1939) convey the message that domestic tensions are inevitable when women are independent. Because these popular films suggest that emancipated women must be tamed by domesticity, they contributed to the conservative backlash against working women by glamorizing the role of women in the home.[93]

Even the New Deal failed to promote the possibility of a new family structure based on the equality of the sexes. Federal policies supported unemployed men but discouraged married women from working. World War II brought an end to the depression; the eventual Allied victory resulted in a rising marriage rate, an increase in the birthrate, and a decrease in age at marriage, sowing the seeds of a renewed social ideology of domesticity that became the norm during the nuclear age.[94]

Anxieties over Companionship Marriage

This gap between theory and practice indicates that when it came to the institution of marriage, Americans had one foot in the old era and the other in the new. People professed to adhere to modern values, yet the traditional ones were too ingrained to allow radical change. Moreover, people were looking for answers to very important problems. The language used to theorize about marriage itself was vague, indicating a search for new ways to describe a modern phenomenon that had not yet been fully defined and realized.

Middle-class readers became familiar with the marriage reformers' theories through accounts in the *Ladies' Home Journal, Reader's Digest, Literary Digest,* or *Forum;* popular books about the modern family or novels about youth culture; public lectures or college courses; or participation in marital therapy. Such Americans understood on some level that the institutions of marriage and the family were changing. The ideology of companionship marriage encouraged them to adapt to these changes by marrying younger, practicing contraception, and engaging in freer sexual expression.[95]

What remained unclear, despite the amount of ink spilled over this topic by experts and laypeople alike, was how these changes affected individuals' intimate lives. What exactly was a companionship marriage, and how did couples negotiate their own lives to fit with the changing times? At least one man understood the anxieties that this new type of marriage created for men, writing that "man, with his unconscious feeling of superiority, his ignorance of women's subtle sex life, his repression and shame at the art of love, his insistence on domination by force or by infantile methods, is undergoing a severe emotional strain that is causing him to break down with an actual neurosis."[96] Max Eastman expressed similar concerns in his *Enjoyment of Living* (1948). In his autobiography, he lamented his inability to realize "daily companionship" coupled with "romantic exaltation."[97]

Sherwood Anderson embodied these misgivings and uncertainties in his best-selling novel *Many Marriages* (1923), in which he addressed the shift from procreative to companionship ideologies, what he discerned as "the strange . . . [newer] notions of marriage." In this book, John Webster, a prosperous middle-aged washing machine manufacturer with a grown daughter, ends his long, sterile, silent, and passionless marriage, "an ordinary unsuccessful marriage," as an act of liberation for himself, his daughter, and even his community. Webster's wife fears intimacy and believes that husbands and wives should have sex only for childbearing. Webster has controlled and repressed his "animal impulses" except for brief interludes with prostitutes. He finally allows himself to release his sexual desires

through an affair with his secretary, Natalie. Their "love-making" was "but a symbol of something more filled with meaning than the mere act of two bodies embracing, the passage of the seeds of life from one body to another."

In this book, Anderson assaulted the older ideologies of marriage and sexuality along with the social conventions in gender, advocating a new structuring of marriage and domesticity, and the separation of the public and private spheres in which "a pure thing, based on companionship" and intimacy would enable participants to feel alive.[98] He exposed the sexual shame that underlies modern life despite the changing ideologies of marriage: Webster had married his wife out of shame through their embarrassing and accidental first meeting, when he had entered a friend's bedroom and discovered his future wife nude in a bed. His own nude state contributed to this unusual and shameful situation, which he felt had to be rectified through marriage. Shame again occurs when Webster tells his daughter about this encounter. He refuses, however, to feel shame over his affair with his stenographer.[99]

Anderson wrote this book while he was married to his third wife, with whom he had moved to Marion, Virginia, to pursue a newspaper editing and publishing career, as well as to continue writing fiction. He had abandoned his first wife, his three children, and his successful manufacturing business in 1912 to dedicate himself to writing literature. In 1916, he had divorced his first wife and married Tennessee Mitchell, whom he divorced in 1924 when he married again. While in Marion, Anderson fell in love with Eleanor Gladys Copenhaver, twenty-five years his junior and active in the YWCA. They married in 1933. In his memoirs, the author of *Many Marriages* confessed that "none of the women were to blame when our marriage failed" because artists, due to their travels and emotional detachment while writing, try at marriage, yet fail. "There are months and months when you [the wife] are merely dust under his feet," Anderson admitted, explaining that "for him [the artist or writer] you have no existence. As well, during such times, [you might as well] be married to one of the dummies in a store window." Eleanor, however, enabled Anderson to experience "real" love and a companionship marriage: "That I have found a woman who, after ten years with me, can still laugh at me, who understands my wrinkles, who is there beside me, smilingly willing to forgive my idiosyncrasies, who after seeing through the years we have lived together my worst and my best—that is my good fortune." He thus dedicated his autobiography to his fourth wife, who provided the love and companionship that he had yearned for in his previous marriages in a situation similar to his main protagonist in *Many Marriages.*[100]

Anderson was not the only American to address the anxieties over the modern marriage in crisis in his own life and in his art. Floyd Dell, editor of *The Masses,* could not realize the companionship marriage that he constructed in his popular novel, *Moon-Calf,* until he divorced his first wife, had a number of affairs, and finally settled down with B. Marie Gage, who gave up her career to become a housewife and mother. He thus concluded in *Love and the Machine* that "sentiments of loyalty, exclusiveness and permanence were expressed in masculine friendships; elements of sexual passion, of rivalry and of free choice were separately expressed in relationships with prostitutes; and social aspects of domesticity and family life were again separately expressed in legitimate arranged marriages."[101]

As contemporaries of Anderson and Dell, Georgia O'Keeffe and Edward Hopper embodied in some of their paintings the tensions of their own marriages and addressed the same prevailing issues and confusions discussed by academics, legal and medical professionals, journalists, and novelists of their time. To understand exactly how their works relate to the contemporary marriage debates and how their sense of comradeship or dissatisfaction influenced the formation of particular artworks, we must first examine their own marriages.

Two Marriages: Edward and Josephine Nivison Hopper, and Georgia O'Keeffe and Alfred Stieglitz

As social scientists, essayists, clerics, and novelists probed the modern marriage and declared it a precarious institution, Hopper and O'Keeffe launched their own unions and soon experienced their own forms of marriage in crisis. O'Keeffe's and Stieglitz's letters to friends, Jo Hopper's diary, interviews with the Hoppers, and particular paintings by O'Keeffe and Hopper reveal anxieties similar to those expressed in books and popular magazines of the day.

Stieglitz admired Sherwood Anderson's *Many Marriages* and was familiar with *The Book of Marriage* (1926), a sociological work edited by Count Herman Keyserling. Both texts confirmed his own experiences. For Keyserling, "conjugal happiness" entailed continuous suffering, conflict, and "a durable state of tension between two distinct poles," attributes that he considered crucial for the dynamic quality in a marriage that results in a sense of unity.[1] Stieglitz agreed with Keyserling's romantic notion of marriage, expressing his belief that it necessarily entailed "a state of tragic tension."[2] Stieglitz could testify that couples often found it difficult to negotiate needs, address feelings, work through different sexual expectations and desires, balance work with family demands, form a congenial partnership of shared interests, and control sexual desires for others. He believed that "any true relationship is tragic."[3] This certainly was the case with his first marriage, as it was for John Webster in *Many Marriages;* and like this character, he finally found compatibility through an affair with another woman, Georgia O'Keeffe.

Stieglitz and O'Keeffe both read and enjoyed *Many Marriages* one year before they wed.[4] Stieglitz probably would have agreed with Anderson's explanation twelve years later that *Many Marriages* "was a book written to bring flesh, the feel of flesh, as far as I could go with it, into prose. I am always making marriages. We all are. . . . In my book I wanted to represent a man simply struggling to escape that feel of dirt. To do it he felt he had to go to rather extreme lengths. He wanted not only to free himself for his daughter. He knew his wife past freeing. He sacrificed her."[5]

First Marriage

Stieglitz, too, had sacrificed his first wife (as well as his daughter) upon meeting and falling in love with O'Keeffe. He met Emmeline Obermeyer in the spring of 1893, when he joined a friend, Emmy's brother, on a picnic. Although Stieglitz considered Emmy materialistic, obnoxious, selfish, and spoiled, he nevertheless felt compelled to marry her that November. They had engaged in a public display of affection that others interpreted as the announcement of their betrothal, and he plunged into what he saw as a lifelong commitment so as not to compromise her reputation;[6] Stieglitz, from an upper-middle-class professional family, adhered to society's still-prevalent Victorian codes of conduct. The couple apparently could not consummate their relationship for at least a year after the wedding (or four years, according to one account by Stieglitz), indicating sexual dysfunction and additional anxieties.[7] These aspects of Stieglitz's first marriage are reflected in *Many Marriages* where Webster marries his wife after mistakenly entering her bedroom in a friend's house when both were naked. But the initial passions that this incident had sparked failed to inspire a passionate marriage, a situation not unlike that of Stieglitz and his first wife.

Both were unhappy. Emmy in 1914 lamented in a letter to her husband, "You cannot think how bad it is for me and what horrible thoughts I get. Have you ever thought it over what little joy you bring into my life?" She continued, "You are either entirely taken up with your work and those interested in it or else in deep gloom," complaining that as a result they seldom "go out."[8] Three days later she asked, "What good is the advancement of art or any other thing to a woman when she feels that it takes away the family life and all pertaining to it[?]"[9] Emmy was lonely, angry, unhappy, and jealous of Stieglitz's attention to the arts and participation in the avant-garde art world, expressing concerns similar to those of her husband's friend, Sherwood Anderson, that artists could not provide time for wives because of their commitment to their work. Yet Emmy also provided the financial backing necessary for Stieglitz's gallery, publications, photography, and even his luncheons with fellow artists,

thereby enabling him to continue interests that she did not share and that she considered responsible for their domestic discord.

Stieglitz felt equally dissatisfied. He wanted his first wife to pose nude for his photographs, which she refused to do. Emmy disliked the places in Europe that he loved to visit and did not share his passion for literature. She even found their conversations boring. Emmy never enjoyed Stieglitz's professional activities and friends, preferring more traditional upper-class social activities—entertaining, traveling to posh European sites, and wearing proper and fashionable clothes. Even the birth of their daughter, Kitty, in 1898, did not bring the two closer. Emmy became the primary caretaker (with a full-time governess), whose self-doubts and anxieties about motherhood became a constant source of concern for her, while Stieglitz continued to focus on his work, keeping his parental involvement to a minimum.[10] By about 1912, Stieglitz had moved into his study, leaving their nuptial bedroom and solidifying their passionless relationship.[11] When their daughter was older, she frequently confided in her cousins about her parents' long silences and disagreements.

In their sexual, personal, and professional lives, Stieglitz and Emmy participated in the "tragic tension" that he and Keyserling had theorized was central to conjugal love. Emmy considered their interaction normal, while Stieglitz attributed their problems to pressures of work, financial difficulties, his health problems, and other external factors.[12] He nevertheless remained for thirty-one years in what he considered an oppressive and unsatisfying union. As he wrote to his friend Paul Strand in 1917, "[M]y own trouble is purely the family question—the same trouble I've had for so many years." He saw no solution.[13]

Sociologists during the interwar years would have identified Stieglitz's marriage to Emmy as the old-fashioned institutional type. He assumed patriarchal authority, both members felt a sense of duty to stay in their passionless and estranged marriage, the husband and wife occupied the separate spheres of public business and private domestic matters, and they raised a child. Their marriage, in fact, followed the same pattern as that of Stieglitz's brother, who, according to his niece, could not "sense the unity—the simplicity of human relationships."[14] Emmy's repressed sexuality and Stieglitz's resorting to extramarital affairs also adhered to this old-fashioned model. Only Emmy's financial support of her husband (through her inheritance) departed from this tradition. Given the era in which they married, it is not surprising that they followed these codes.

Stieglitz and O'Keeffe

O'Keeffe entered Stieglitz's life after twenty-three years of intellectual, sexual, and emotional discontent with Emmy. The story of their meeting

has been recounted many times, but still deserves a brief summary here. In January 1916, Anita Pollitzer showed O'Keeffe's abstract drawings to Stieglitz. He adored them for their excellence, frankness, self-expressiveness, and feminine sensibility.[15] O'Keeffe and Stieglitz began corresponding and then had a confrontation in May when he exhibited her works at "291" without her knowledge; she demanded that he dismantle the exhibition, but he persuaded her to allow them to remain on view through July. O'Keeffe had been teaching at West Texas State Normal College until she became ill in February 1918. Stieglitz sent Paul Strand to persuade her to come to New York to recuperate. She did so, arriving in June and moving into the apartment of Stieglitz's favorite niece, Elizabeth. One month later, Stieglitz left Emmy to live with O'Keeffe. In this aspect of his life, Stieglitz again paralleled Anderson's John Webster, who finds freedom and pure love with a younger woman.

Emmy would not grant a divorce, however, until September of 1924.[16] Three months after the divorce was finalized, O'Keeffe married Stieglitz with great reluctance. She had felt excited and inspired during their early years together, explaining that she "had a kind of belief in Alfred that made those days especially fine" and that she felt a "need" for him "that I had never seemed to feel for anyone else before."[17] They shared a dedication to modern art and a love of hiking, classical music, and literature.[18] As their friend Herbert Seligmann summarized, they had an "extraordinary relationship" based on creativity, which formed a powerful bond between the two, who in addition shared similar worldviews.[19] "I was interested in what he did and he was interested in what I did," O'Keeffe reminisced later in life.[20]

Yet she feared losing her freedom and recognized the differences in their personalities: she preferred solitude, whereas he surrounded himself with relatives and friends.[21] As O'Keeffe stated later about her marriage to Stieglitz, "What does it matter? I know I didn't want to."[22] She refused to change her name, which was unusual at that time, and their wedding lacked any formalities; they were married before a justice of the peace without a reception or honeymoon. Stieglitz, on the other hand, wanted to legitimize their relationship for the sake of his schizophrenic and hospitalized daughter, whose doctor (incorrectly) believed that Kitty's anger toward her father and her emotional difficulties might thereby be ameliorated. As O'Keeffe later reminisced, "The relationship that Stieglitz and I had was very good . . . you do your best [however] to destroy each other without knowing it. . . . But if you have a real basis, as we did, you can get along pretty well despite the differences."[23]

Stresses occurred in this marriage too. During their annual summer visits to Lake George, in upper New York State, O'Keeffe was frustrated by the intrusions of Stieglitz's family and visiting friends who interfered

with her work. Stieglitz resented the publicity his wife received in the summer of 1928, after he sold some of her artworks for a large sum to a supposed anonymous Frenchman[24] (described more fully below). When he had a heart attack shortly thereafter, he felt both guilty over requiring her assistance and resentful that she did not exhibit more sympathy. Two years later, O'Keeffe became impatient with his harangues about the decline of American culture as a result of the First World War and bored with the greenery and hills of Lake George, especially after her two sojourns without Stieglitz in the New Mexican desert. He resented her leaving him, sometimes lost his temper with her, and felt increasingly panicked over his own health. O'Keeffe, on the other hand, gained increased independence during her annual visits to Taos and Abiquiu, especially evident in her purchase of an automobile in 1929, a house in 1940, and a second home in 1945.

O'Keeffe and Stieglitz also disagreed about children. While teaching in Texas in 1916, she had confided to a friend that she felt compelled "to have a baby," admitting that if she did not, her life just would not "be complete."[25] One year earlier, she had fallen in love with Arthur Macmahon and admitted to him that she hoped they could have a child in the future.[26] After Stieglitz's niece, Elizabeth Davidson, gave birth to her second child in 1922, she tried to convince her uncle that he and O'Keeffe should have children.[27] But Stieglitz worried about financial matters and felt too old. His favorite sister had died in childbirth in 1890, contributing to fears that became solidified when Kitty began to exhibit severe emotional problems after she gave birth. Kitty's illness itself had inspired a sense of his failure as a father.[28] Later, another relative stated that although O'Keeffe wanted children, Stieglitz would not allow it, arguing that they would interfere with her work.[29] "Women can only create babies, say the scientists," he proclaimed in 1923, "but I say they can produce art—and Georgia O'Keeffe is the proof of it."[30] O'Keeffe ultimately agreed that she could not combine painting with motherhood and realized that she did not have the temperament for it, but friends believed that later in life she sometimes regretted this decision.[31]

Hopper and O'Keeffe's childlessness was consistent with an emerging notion of marriage that entailed the use of birth control and rejected the ideology of marriage for the sake of progeny. As the sociologist Ray E. Baber explained in 1939, "the feminine revolution" ended the expectation that women must bear children.[32] The marriage of these two artists thus gave credence to Ernest R. Mowrer's assessment in 1932 that the modern wife shared equally the responsibilities and privileges of her husband, subordinating the duties of housewife and mother. But this change did not occur without doubts and anxieties, and O'Keeffe, the liberal New Woman, apparently forfeited childbearing with some resistance and regret.

Having abandoned the idea of parenthood, Stieglitz claimed responsibility for "the child," O'Keeffe, becoming an artist. In "Woman in Art" (1916), he proclaimed that "the Woman receives the World through her Womb [which] . . . is the seat of her deepest feeling"; thus her "creative sphere was childbearing." O'Keeffe, however, represented a change in the "Social Order" in which "the potential child [Woman and O'Keeffe] brings about its equivalent in other forms . . . Color . . . Line—Form—Painting," thereby overpowering "the Male Shackles" and men's over a woman's artistic creativity. "In O'Keeffe's work we have the Woman unafraid," Stieglitz declared, "the child—finally actually producing Art!"[33] Stieglitz attributed this advance to his influence—he had succeeded in giving the world a woman artist.[34] Having nurtured her creativity and helped to mold her as an artist, he reasoned he had given birth to his wife as an artist. Stieglitz thus considered O'Keeffe's paintings their offspring.

Fewer tensions existed during the latter part of their lives together. Stieglitz eventually accepted her desire and need to spend more time in the Southwest and away from him in New York, recognizing the "incredible" results in her paintings and rationalizing, "How can I be jealous of a place?" He reluctantly admitted to their friend Rebecca Salsbury Strand that "Georgia is always a different person when she is free—with none of the . . . responsibilities—& in congenial surroundings (country & life) & where she really feels stimulated." He continued, "I knew the Southwest—just where she is—was *the* thing for her."[35]

After Stieglitz's death, O'Keeffe often expressed sadness that she could no longer share her life with him, although she also recognized that their relationship had entailed frustration as well as stimulation. "You try arguing with him and see where you get," O'Keeffe recalled in 1977, concerning Stieglitz's refusal in 1916 to dismantle the exhibition of her charcoal drawings when she insisted that he did not have her permission to exhibit them.[36] Stieglitz's "power to destroy was as destructive as his power to build," she reminisced in her old age: she had experienced both "and survived." "I think," O'Keeffe continued, "I only crossed him when I had to—to survive." She described living with him as "a constant grinding like the ocean," concluding that he "was much more wonderful in his work than as a human being." "It was the work that kept me with him—though I loved him as a human being."[37] This assessment suggests that the connection between these two artists was both inspirational and oppressive for O'Keeffe and that she viewed her own marriage as filled with tragic tensions—as predicted by Keyserling and Stieglitz, who believed this was a necessary component of heterosexual relationships.

Sociologists would have categorized the Stieglitz-O'Keeffe union as a "companionship marriage" of mutual affection and shared interests, equal partners engaging in the common enterprise of creating art. Stieglitz and

O'Keeffe seemed to have a complementary relationship that entailed mutual love and consideration, a spiritual oneness. As the sociologists predicted (and also feared), some working women would earn more money than their spouses—as O'Keeffe did. Eventually, it was she who paid their rent and their living expenses, and helped support An American Place financially.[38] Stieglitz apparently felt content with this situation, which echoed his financial dependence upon his first wife. Sociologists feared that married working women would experience conflict between wifely obligations and careers, but O'Keeffe disliked household duties and dedicated herself to her art (and, when in Lake George, to gardening). Her insistence that their marital vows omit the promise to honor and obey her husband indicates her independence,[39] and also the rejection of patriarchal authority. But, as we have seen, O'Keeffe was reluctant to give up the opportunity of having children, and therefore could not fully accept the newer codes of marriage.

Stieglitz's Extramarital Affairs

O'Keeffe's biographer Roxana Robinson speculated that Stieglitz had a brief affair with Rebecca Salsbury Strand during the summer of 1923 when he was still married to Emmy but living with O'Keeffe (Beck had been married to Paul Strand for only one year).[40] Some letters suggest this possibility, as does the fact that O'Keeffe left Lake George to visit Maine for nearly a month shortly after Rebecca's arrival. She had informed Stieglitz's niece, Elizabeth Davidson, who also stayed at the family summer home, that it would be "much pleasanter for you than my staying there would have been."[41] In a letter to his confidante, Elizabeth, Stieglitz referred to his relationship with Rebecca as "messy" without explaining why, although Elizabeth commented in July 1928, "Even in the case of stupidity—Beck or such—it should not go deep," suggesting that such interludes should not interfere with his marriage to O'Keeffe.[42] Apparently it did not, for Stieglitz confided in Elizabeth that he and O'Keeffe (now his wife) had had some "real talks" and that "[t]he days of adolescence are over & the relationship reestablished finely free. . . . It is all working out."[43]

Elizabeth's reference to his "stupidity [with] Beck or such" alludes also to his relationship with Dorothy Norman. This began in late 1927, three years after his marriage to O'Keeffe.[44] As Laurie Lisle reported in her biography of O'Keeffe, "People gossiped that Stieglitz and the young Mrs. Norman were having a love affair, and, indeed, their feelings for one another were strong. When asked many years later if her relationship with Stieglitz was romantic, intellectual, or spiritual, Dorothy responded, 'It was all of those.'"[45] O'Keeffe herself commented that Norman "was one

of those people who adored Stieglitz, and I am sorry to say he was very foolish about her."[46]

As the wife of a wealthy Jewish gentleman (he inherited the Sears, Roebuck and Co. fortune), Norman initially had adhered to society's expectations. She became the mother of two children and worked on behalf of such liberal causes as the American Civil Liberties Union, the New York Urban League, and the Women's City Club, which advocated better housing, public education, health services, and equal opportunities for employment. She became a strong advocate of birth control, assisting Margaret Sanger in starting a clinic in Harlem and in engaging the ACLU's assistance in establishing a physician's right to maintain the confidentiality of patient information.

Norman was also active in promoting the arts. Having first visited the Intimate Gallery in 1926, she soon became Stieglitz's secretary and manager of the gallery.[47] She also helped establish, finance, and administer Stieglitz's third and final gallery, An American Place, and the journal *Twice a Year* (1938–48), which contained essays about literature, art, and civil liberties. Stieglitz taught her photography, which was a hobby to her at first and then became her profession. During the summer of 1931, when O'Keeffe went to the H & M Ranch in the Rio Grande valley, Stieglitz invited Norman to Lake George. Because she could not leave her husband and two young children, Stieglitz visited her for three weeks in July at her home, where he photographed her nude. One day O'Keeffe returned unannounced to their residence at the Shelton Hotel and found Dorothy there, resulting in her decision to stay away from New York City for a while longer.[48] Thereafter, O'Keeffe phoned before arriving at their apartment. This other woman in his life, Stieglitz wrote, was "the only one who does or ever did—or ever will—completely" be in his thoughts— a sentiment amazingly similar to those he had expressed in his earlier correspondence with O'Keeffe.[49]

Stieglitz's letters to friends and O'Keeffe suggest that he experienced anguish, doubts, and guilt over this affair and his wife's consequent distress. In October 1928, he confided to his friend Jean Toomer that O'Keeffe was having a difficult time "because of the foolishness of me."[50] On 17 May 1929, one month after her departure for the Southwest, Stieglitz admitted to Rebecca Salsbury Strand that it was good that O'Keeffe was "escaping all this."[51] Two months later, he expressed the desire to give Georgia time to discover her real feelings and admitted that he had failed to spare her anguish.[52]

Norman herself expressed bewilderment over "the miraculous frenzy of awakening" and the sense "of being fulfilled," which must be hidden in order to maintain the equilibrium "of each of us—of society." "But our relationship is different," she proclaimed. "No day is complete

without communication, contact, repetition of the magic words that join us." And she argued that their relationship did not injure anyone because it contributed to other relationships: "We are nourished by and nourish them." Stieglitz wrote to Norman, "Yes, you love me. And I love you. And I know it is not a crime. Not before God. Not before right thinking Men and Women, [because we are] one."[53]

Norman and Stieglitz justified their affair because of their mutual love and spiritual affinity. Social scientists and writers of their day articulated similar ideas. In 1928, the year after Stieglitz and Norman began their affair, G. V. Hamilton and Kenneth MacGowan theorized in *Harper's Magazine* about relationships among "liberal-to-radical groups living in New York." "An extra-marital love affair is considered a gesture of freedom," they reported, "from what they consider a stupid and restrictive marriage code that went out of fashion with ground-sweeping skirts and corsets." Some believed "outside love affairs . . . enrich the common lives of the couple," but love affairs and unhappy marriages often coincided.[54] Stieglitz might not have initiated his affair with O'Keeffe unless he had felt unfulfilled in his first marriage, but was the same motivation behind his later affair with Norman? This is less clear, and Stieglitz and O'Keeffe experienced a complex range of emotions over this situation.

Norman remained committed to her problematic marriage until 1953, despite her sexual and emotional satisfaction with Stieglitz, claiming that neither he nor she even considered ending their marriages. He remained equally attached to O'Keeffe, struggling to assuage his guilt and her anger. Perhaps Stieglitz and Norman believed, like those interviewed by Hamilton and MacGowan, that being open about their affair made it acceptable to all involved and to society. Although he considered himself a "right thinking man," however, Stieglitz could not overthrow Victorian codes of marital fidelity without ambivalence, guilt, and anxiety. He also felt torn because of his genuine love and affection for both women.

It remains unclear how Edward Norman and his children responded to the intimate relationship that Dorothy and Stieglitz conducted in their house while they were present. O'Keeffe clearly had difficulty accepting it and chose to visit her family in Wisconsin in the summer of 1928, where she discussed the situation with her sister.[55] She also was upset about the commotion made in the popular media about Stieglitz's sale of her six calla lily panels to a supposed Frenchman for the exorbitant price of $25,000 (Stieglitz supposedly had asked for a high price assuming it would not be accepted and claimed to be shocked when the buyer agreed to the amount). The press made a big deal about the amount of money O'Keeffe made—more than any living artist for so small a group of paintings—and the fact that a European purportedly patronized an American artist. O'Keeffe felt uncomfortable with the situation.[56] She consequently

traveled alone to Maine in May 1928; escaped to Santa Fe in the summers of 1929, 1930, and 1931; and went to Canada in August 1932. Judging from her actions, she would have agreed with the assessment of the sociologists Ernest W. Burgess and Harvey J. Locke, who argued in 1945 that extramarital affairs shattered the conception of faithfulness between spouses, threatened society's conception of the couple in unity, and contributed to a family in crisis.[57] O'Keeffe may have considered her own marriage to be in crisis during this long-term affair.

Yet O'Keeffe attempted to rationalize Stieglitz's actions. When her friend Mabel Dodge Luhan expressed her fear that her Pueblo husband, Tony, was having an affair, O'Keeffe attempted to assure her that it did not matter if he slept with other women. It was "a little thing" that resembled a "spiral debauch," O'Keeffe reasoned, involving only his body, not his emotions or his soul.[58] "Even if he goes out and sleeps with a woman it is a little thing,"[59] O'Keeffe explained. "I am sure that you are the center for him [Tony Luhan] as I am the center for Stieglitz, and he for me. . . . Something you are—and something Tony is—is helping me much with something between Stieglitz and myself—it is smoothing away many things for me." She continued that "surface things" such as "one's vanity" become hurt, but believed that this is nothing because of what the two share. "What worries you is that the World sees—Well—let it go to Hell."[60] As liberated females, O'Keeffe suggested, she and Luhan should not worry about society's judgments but instead focus on the strengths of their marriages despite the extramarital affairs.

Luhan's pain and O'Keeffe's assurances reveal the discrepancies between the newer concept of marriage and women's actual sentiments and experiences. Both probably would have labeled their marriages as modern ones and their spouses as New Men who accepted and even advocated sharing, partnership, and equality. Both had had affairs with their spouses prior to their marriages, reflecting the more open attitude that prevailed in opposition to Victorian prudery. And both of these New Women struggled to convince themselves and each other that their husbands' infidelities could not harm them or their partnership. Although O'Keeffe herself had had an affair with a married man, responding spontaneously to her passionate feelings for Stieglitz, she now argued that the infidelity of Tony and Stieglitz was just "a little thing" of no long-term consequences.

By September, O'Keeffe had returned home. Stieglitz asserted that "our relationship is sounder than before," and O'Keeffe declared that "it all seems perfect," wondering how she could have lived apart from him for so long.[61] Stieglitz captured O'Keeffe's happiness in a photograph of this time in which she smiles, one of two smiling portraits of her in his oeuvre (the other one dates to 1931). Yet in February of 1933, she was

hospitalized for psychoneurosis because of the situation at home and her inability to complete a mural for the Radio City Music Hall (see chapter 7). This liberated New Woman, in other words, could not accept the modern codes of behavior that she herself had practiced earlier.

Her illness helped to end Stieglitz's affair with Norman, who nevertheless continued to work in his gallery. During the winter of 1934, however, O'Keeffe fell in love with another man, the Harlem Renaissance writer Jean Toomer, with whom she and Stieglitz had been friends since the mid-1920s. "I like you much," O'Keeffe wrote Toomer in January 1934. "I like knowing the feel of your maleness and your laugh."[62] A few days later, she admitted, "I wish so hotly to feel you hold me very very tight and warm to you." Yet O'Keeffe ultimately could not allow herself to become involved with Toomer, because she needed to find a new sense of balance and confidence: to stand up alone "before I put out my hand to anyone."[63] "I want you—sometimes terribly—but I like it that I am quite apart from you like the snow on the mountain—for now I need it that way. What next I do not know."[64] And although Toomer attempted to persuade O'Keeffe not to "cling to the results of these past shocks," and "to let go of the past,"[65] she replied in February that she wanted to lie in the "hot sun and be loved—and laugh—and not think," but that she could not be the kind of woman he needs: "The sort of thing I am is no use to you."[66] Toomer's references to "shocks" and the "past" allude to her pain and her own ideas of fidelity. By March, O'Keeffe was explaining that she needed to be alone, "not because I wish it so but because there seems to be no other way."[67] Subsequent letters indicate that Toomer fell in love with a mutual friend, Marjorie Content, and that O'Keeffe embraced this development as good for them both.[68] She attended their wedding in Taos in September 1934.

If nothing else, this platonic relationship enabled O'Keeffe to feel healthy again. As she wrote Toomer in early January 1934, "You seem to have given me a strangely beautiful feeling of balance that makes the days seem precious to me—I seem to have come alive in such a quiet surprising fashion—as tho [sic] I am not sick anymore."[69]

O'Keeffe ultimately could not realize her love for another man because of her commitment to Stieglitz. At the same time, she probably felt too emotionally drained to attempt another close relationship that might impose other problems. While single, she had allowed herself to have an affair with a married man. Once married, she adhered to older notions of marital fidelity.

Despite their difficulties, O'Keeffe and Stieglitz loved each other and stayed together until his death. Stieglitz understood what constituted a companionship marriage even if he could not realize it fully in his own

relationships. As he explained in 1926, "Marriage, if it is real, must be based on a wish that each person attain his potentiality, be the thing he might be, as a tree bears its fruit—at the same time realizing responsibility to the other party."[70] O'Keeffe reminisced later in life that their relationship "was really very good, because it was built on something more than just emotional needs." "Each of us was really interested in what the other was doing."[71] Still, she said ruefully, "you do your best to destroy each other without knowing it."[72]

As in his analogy between marriages and trees, Stieglitz favored organic paradigms for human relationships. Explaining how he communicated with O'Keeffe, he said, "Some men express what they feel by holding a woman's hand. But I have wanted to express the more, to express the thing that would bring us still closer. I would look at the sky, for the sky is the freest thing in the world, and when I would make a photograph from clouds and the sky and say to O'Keeffe, 'Here is what we were talking about,' she would say, 'That's incredible, it's impossible.'"[73] This statement suggests that his *Equivalents,* photographic cloud studies as seen in *Songs of the Sky No. 2* (fig. 99), formed one way for these two artists to convey their feelings and ideas to each other. Images of nature successfully replaced words as their vehicle of communication in a romantic use of metaphor and symbolic correspondence.

This imagery suggests that Stieglitz shared the fears expressed by some sociologists and writers at the time that the machine contributed to marital problems. "Human beings," he commented, are "very queer bits of mechanism," not unlike the intricacies of complex watches that also require "loving workmanship."[74] As with machines, things can go wrong with emotions and relationships.

Both Stieglitz and O'Keeffe periodically agonized over the concept of love. "When I said I didn't know what love was I meant in plain English that I had not yet found any one who knew," the photographer admitted to Rebecca Salsbury Strand. "Great God I wish I never knew what Love is.—But you do not, can never, understand as the little Self consumes you."[75] He admitted that he did not know "what love is when people prattle about love & friendship & the like."[76] O'Keeffe similarly feared that love could be all-consuming, could destroy one's peace, could "eat you up & swallow you whole."[77] This fear contributed to her hesitation to become involved with suitors, including Stieglitz.

The tangled webs created in the romances involving Emmeline Stieglitz, Rebecca Salsbury Strand, Dorothy Norman, Alfred Stieglitz, Jean Toomer, and Georgia O'Keeffe would have provided Judge Lindsey with ammunition on behalf of his "companionate marriage." He argued just three years after Stieglitz and O'Keeffe married—and the same year the Stieglitz-Norman liaison had begun—that individuals needed freedom to

explore their sexuality with different people before making a lifelong commitment. He advocated that childless couples live together in his new form of marriage that could be dissolved through mutual agreement rather than through a court of law.

Sociologists, too, would have found material here. They believed that disorganization within the family resulted from outside factors as well as internal ones when individual aims took precedence over the family. In Stieglitz's first marriage, his dedication to art and his affair with O'Keeffe broke down his tenuous ties to his wife and daughter. O'Keeffe and Stieglitz faced their own marital difficulties because of outside factors like his family, his extramarital affairs, and internal battles over financial matters and control over O'Keeffe's art and identity (see chapters 5 and 6). Stieglitz's affair with Norman solidified their marriage in crisis, resulting in O'Keeffe's flight to New Mexico and, as we shall see, works of art that embody these tensions.

Jo and Edward Hopper

An acquaintance assessed Jo and Edward Hopper's marriage as "close and good."[78] They fell in love after making watercolors together out-of-doors; shared a fascination with art, literature, theater, and movies; chose to be childless; and seemed to support each other in their interests. Unlike O'Keeffe and Stieglitz, they apparently did not engage in sexual relations until their marriage in 1924, adhering to more traditional courtship practices. Neither, as far as we know, had extramarital affairs or subscribed to the newer experimental codes of conduct, but their lack of children adhered to the newer type of marriage in which compatibility replaced progeny as the reason for tying the knot.

Like O'Keeffe and Stieglitz, Jo and Edward had different personalities. Friends and acquaintances characterized Edward as a reserved, contemplative, and "economical man" whose comments and writings were sparse and unhurried. According to his neighbor and fellow student in the New York School of Art, Walter Tittle, he suffered from "long periods of unconquerable inertia" when he could not paint, and exhibited a "semi-funereal solemnity" interspersed with a sophomoric humor.[79] Jo, on the other hand, was talkative, acerbic, and opinionated. "Mostly, his wife did the talking for him, and he watched her curiously as if to discover what she thought he thought," artist and writer Brian O'Doherty recalled. "When he disagreed with something she said, he spoke in a flat monotone that fell across the conversation like a roadblock which had to be removed before further progress could be made."[80] As he also recalled, "She chattered against her husband's silence, a silverpoint writing against a boulder."[81] O'Doherty's wife, art historian Barbara Novak, described

Edward as a "tall, dignified, self-contained man, who expressed himself with the laconic economy of his paintings; he was always accompanied by a small, hyperactive, voluble wife, who usually spoke *for* him, often voicing fierce and violent opinions." As Novak assessed her, "She saw the world through a barbed-wire screen of resentment."[82]

O'Doherty concluded that Jo "reserved for herself the privilege of attacking her husband as energetically as she defended him, often surrounding his inertia with a dazzling series of provocations. He and she were so opposed to each other in temperament [that] they were a continual source of life and dismay to each other." Some believed that she "persecuted her husband," while others claimed that "she stung him to life." In short, O'Doherty thought, "it was an unusual marriage."[83]

One difficulty, as Jo admitted, was her inability to compromise. Jo felt that Edward continually disagreed with her (that was "her point of view," he said), while he concluded that "living with one woman is like living with two or three tigers."[84] "Can't you see why?" Jo replied. "This everlasting argument. He'd be up first to watch for the first thing I'd say in the morning and then be ready to disagree with it." As she concluded, "Marriage is difficult. But the thing has to be gone through."[85]

Edward's comments conveyed hostility toward women in general and his wife in particular. Jo in turn made disparaging comments about men. During an interview, Edward told O'Doherty that "Freud says the devil is a woman" and "Aristotle says women are undeveloped men." Jo countered that "men are ungrateful creatures," incapable of showing the gratitude that women exhibit throughout their lives for little and big things.[86] Novak recalled Jo's frequent complaints that "men are so ungenerous," "repressive," "mean," and responsible for holding women back.[87] Both Jo and Edward made sweeping generalizations about the other sex as a means of passive criticism of their partner.

Hopper's self-presentation through the published interview with O'Doherty is consistent with the private feelings about his marriage that inspired his degrading caricatures of Jo. Never exhibited, these undated drawings convey his caustic wit and exaggerate his perception of himself as inferior to his selfish, impervious mate. In *Meal Time* (fig. 1), Jo, seated on a cloud, reads a book, ignoring an emaciated Edward, who begs for food. In *Status Quo* (fig. 2), tiny Edward, crouching on the floor, begs for food like a dog. Ignoring him, Jo joins her cat (Arthur), whom she adored, at the table for a meal. In another caricature, *The Sacrament of Sex (Female Version)* (fig. 3), Edward bows down to his commanding wife, who relaxes in bed while he, wearing an apron, waits on her. In his caricature of "Non-Anger Man" and "Pro-Anger Woman" (fig. 4), a tall, angelic man, his hands folded in prayer and his eyes cast heavenward, sings while a tiny, berating woman in a dress and heels tries to snatch him with her claws.

Hopper suggested this man's innocence and goodness and the woman's rancor and danger. Like the man in the cartoon, Edward was tall and quiet in public, in contrast with his smaller, outspoken wife.[88]

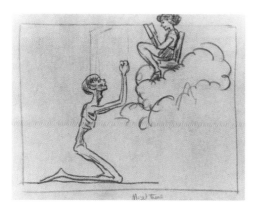

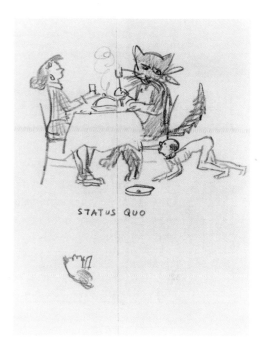

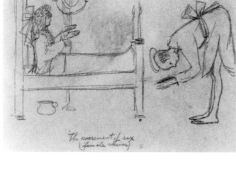

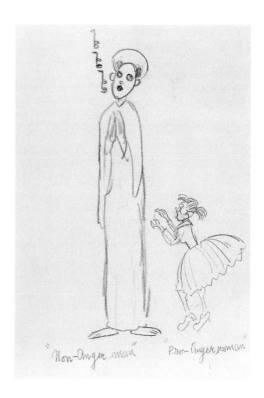

Figure 1. *(top left)* Edward Hopper, *Meal Time.* Pencil on paper, 1932. Private collection.

Figure 2. *(top right)* Edward Hopper, *Status Quo (The Great God Arthur).* Charcoal pencil on paper, 1932. Private collection.

Figure 3. *(above)* Edward Hopper, *The Sacrament of Sex (Female Version).* Pencil on paper, circa 1935. Private collection.

Figure 4. *(right)* Edward Hopper, *Non-Anger Man and Pro-Anger Woman.* Charcoal and pencil on paper, circa 1925–35. Private collection.

Hopper's caricatures reflect his anxieties over the newer kind of marriage. *Meal Time* and *Status Quo* indicate his belief that Jo should handle the domestic chores and care for him, duties that she performed reluctantly and with resentment. Later in life, when Edward had been ill, Novak visited him and was "shocked at his appearance"—he was "a cadaver." She and her husband brought food, which Jo "refused to allow [them] to cook . . . saying it would 'dirty the kitchen.'" "Her refusal," Novak claimed, "was accompanied by a full-scale tantrum."[89] What exactly caused this situation remains unclear, but Jo refused to fulfill the role of passive housewife and, as seen in her husband's *Sacrament of Sex,* also became the New Woman in the bedroom, demanding sexual satisfaction.

Jo expressed her anxieties about the relationship through her diary. Numerous passages confirm that the Hoppers had a combative relationship that entailed not only bitter verbal exchanges, but also physical abuse. For example, Jo recorded in 1942 that an argument resulted in "a good slap in the face & having [her] head banged up against a shelf in the kitchenette." She feared that "he'll kill me." In 1946, Jo wrote, "[I] kicked, he swatted, I stretched for a weapon to augment the length of my arm reach & he dragged me across the studio by my wrists & continued to swat while I struggled & bit, bit hard right into one of the 2 hands that held me tight & bit til he let go," drawing blood. O'Doherty in 1973 quoted Jo's comment that she "once bit him to the bone," so deeply that she "felt the bone under her teeth," an episode that Edward bragged about the next day, perhaps with a kind of Ernest Hemingway masculine bravado. Since she made this comment in front of her husband, who did not contradict her, we may assume that this event actually occurred.[90]

These admissions of battering are quite shocking, surprising, and disturbing, especially given our tendency to place artworks on the pedestal of "High Art." No one feels comfortable knowing that the artist who created such paintings participated in marital abuse. Not surprisingly, then, the veracity of Jo's diary has been debated since the publication of Gail Levin's biography of the Hoppers, which was based in part upon this unpublished manuscript. Novak's review condemned the biographer for accepting as factual Jo's assessment of the Hopper marriage. In Novak's opinion, Edward "was a kind and tolerant man, gifted with a unique patience that enabled him to live with Jo and put up with her resentful bitterness, her childish tantrums, her hunger and days-long talking strikes, and (conversely) her endless monologues." She portrayed Edward himself as the "victim" and "abused partner," who "stretched her canvases . . . and often cooked and cleaned as well," far from the "self-centered 'user' set forth in Levin's biography." Since Jo usually began the fights, Novak argued, this is "not a case of a wife being abused without provocation"; in fact, she controlled and manipulated these confrontations.[91] As Jo admitted

in her diary, "I never scratch and bite when there is a picture coming and I feed him patiently."[92]

It seems unlikely, however, that Jo invented these episodes, which Edward did not deny. Jo and Edward each appear to be both the victims and the perpetrators of abuse; the relationship, in other words, was complex and filled with moments of aggression and passivity on both sides. It is dangerous to suggest that domestic violence can be condoned if the wife provokes the husband; even if a spouse "controlled and manipulated" confrontations, as Novak suggested, it does not warrant physical abuse.

Burgess and Locke theorized about the economic factors that contribute to the success of a marriage, and had observed that "gainful occupation before marriage, particularly as a teacher and perhaps also in skilled office positions," enabled greater adjustment in marriage.[93] This rule, however, rarely applied to the Hoppers. Jo forfeited her career as an artist for her husband's sake. Although she also worked at his side as his business partner and manager, as well as his model, she did not give up her artistic career willingly, nor did she enjoy (like O'Keeffe) cooking, cleaning, and other household duties. Throughout her life, she considered herself an artist and felt frustrated that her husband's career and demands forced her to paint less often and less successfully. She blamed Edward for her lack of success as an artist, believed he was partly responsible for the rejection of her works from exhibitions, and accused him of being jealous when she worked. She also felt that he demanded too much attention, interfering with her artistic productivity.[94] If modeling interfered with her own painting, she would "make it up" by avoiding domestic chores.[95] When critics visited the Hoppers, Jo often commented upon her own works, making it clear that she was indeed an artist who painted "what [Hopper] doesn't."[96]

One could argue that Hopper indeed failed to promote his wife's art. Stieglitz, on the other hand, promoted O'Keeffe's work, for he owned a gallery and sponsored as well as financially supported other modernist American painters. In addition, critics embraced O'Keeffe's art from the outset; Jo Hopper seldom experienced positive feedback from the art establishment yet did so early in her career when, for example, she showed her watercolors at the Brooklyn Museum show in 1923.[97] Although she painted the same kinds of landscapes and architectural views as her husband, she also rendered still lifes, interiors, and cats with what Gail Levin called "a rather naïve quality . . . often demonstrating strange multiple perspectives."[98] Before Jo and Edward married, when both exhibited in a group show in 1923, the Brooklyn Museum purchased his *Mansard Roof,* while Jo sold nothing. Critics ignored her watercolors, but praised Hopper's as "exhilarating" and as "one of the high spots of the exhibition."[99] Jo thus experienced difficulties with her career even before her marriage,

although she afterwards blamed her husband for interfering with her success.

Nothing is ever simple in a relationship; Jo was both a victim, as she perceived herself, and an active agent who chose to focus on her husband's career and to become his business agent. As Novak concluded, Jo was "trapped between the role of a supportive wife who participated in her husband's 'greatness' and a desire for her own creative success." She represents a familiar "saga of a wife giving up her selfhood for her husband and then resenting it."[100] As a 1925 article astutely observed, "it is not easy for any woman to lose her identity in the shadow of a great man."[101] The author, Heywood Broun—a well-known newspaper columnist and sportswriter—knew from experience about the problems of creative and intelligent women overshadowed by their husbands. His wife, fellow journalist Ruth Hale, resented his success and her inability to achieve the same recognition. She divorced Broun, and six months later died of self-imposed starvation.[102] Jo did not starve herself, although she frequently threatened hunger strikes (if we are to believe Edward's cartoons and Novak's reminiscences, however, she also starved *him*); but she resented Edward's success, and regretted her own failure as an artist.[103]

Judging from their public behavior and private records, Jo and Edward Hopper failed to achieve a companionship marriage. The Hoppers' verbal and physical abuse of one another (whoever initiated the fights) represents in an extreme form the difficulties that professionals and journalists of the period identified within modern marriages. Edward's drawings were his private means of coming to terms with and characterizing his marriage. Their caustic and witty tone differs only slightly from his public references to abuse and his degrading comments to O'Doherty about women. His public and private modes of communication operated according to certain social conventions and expectations about personal revelation and public confession. Such communication became more intimate and open during this period as social scientists and popular magazines examined conflicts within modern marriages and details about sexual relations.

Different Marriage Models

Jo and Edward Hopper, on the one hand, and O'Keeffe and Stieglitz, on the other, represent different resolutions to the marital crisis that pervaded white middle-class American culture and society. Both couples experienced the tragic tensions that Keyserling considered central to the modern marriage. Both women were trying to escape very real constraints on their self-expression and ability to have careers; both men were expressing

their own anxieties and emotions about sexuality and their wives' independence during this period of transition and crisis. The Hoppers lived in Greenwich Village, surrounded by bohemians who challenged sexuality and gender roles. They, however, did not experiment with newer lifestyles. Although Jo assumed a dominant role as the manager of her husband's career and an initiator of their fights, she also occupied the passive roles of unhappy housewife and victim of abuse. To complicate matters, Hopper harbored rather Victorian notions about woman's roles at home and in the bedroom. In contrast, although Stieglitz and O'Keeffe did not live in Greenwich Village, they practiced the more radical, bohemian lifestyle whose attitudes toward sexuality had filtered into the middle class and begun to erode Victorian notions of marriage.[104] Yet O'Keeffe could not accept her husband's free love with another woman or allow herself to act on her own intense feelings for another man because of her marital status and tenuous emotional state. Both couples, then, embodied contradictions in their attitudes toward and behavior within their marriages. These contradictions intersected with the epoch's irresolvable clash between the older and newer value systems. Not surprisingly, works of art by O'Keeffe and Hopper embody these tensions.

Edward Hopper

The Home, the Hotel, the Road, and the Automobile

The Isolation of Modern Man

Hopper's paintings of homes—set in New York City, small towns, and rural areas—contain relatively few human figures or none. Most critics see in them a desolate loneliness, and pathos, and a sense of solitude in their impersonal locations.[1] As one German art historian observed, "The houses he depicted are American houses, their interiors are American, and the people who inhabit them are certainly American—restlessly on the move and tired of being restless, lonely and quietly despairing at their loneliness."[2] Critics in the 1920s and 1930s already had discerned these themes, discussing his "lonely country house[s]," "lonely, even deserted houses," "drabness of suburban Main Streets," and "empty and silent" streets.[3]

Despite Hopper's protest that the "loneliness thing is overdone,"[4] the compositions of his paintings support this interpretation. *Early Sunday Morning* (plate 1) depicts a row of storefronts topped by apartments in an urban setting. Inspired by Seventh Avenue shops in New York City and the stage set of the exterior of a two-story apartment house in Elmer Rice's Pulitzer Prize–winning *Street Scene,*[5] Hopper created a work filled with profound emptiness and quietude, what Lloyd Goodrich called "the monotony and vastness of the modern city."[6] Noticeably absent are human figures, litter, and automobiles. He instead captured, in Goodrich's opinion, "clear morning sunlight, stillness, and a sense of solitude that is poignant yet serene."[7] As Ernest Brace wrote in 1937, "[W]ithout the use

of a single figure he is able to impart to a row of commonplace buildings
. . . a haunting sense of life and heedless human activity."[8] The darkened
windows of the commercial and residential units suggest that on this early
Sunday morning, the residents are still asleep. Hopper emphasized the
sense of isolation in this urban environment through the stasis in the rec-
tilinear lines of the structure and the absence of human activity.

Manhattan Bridge Loop (fig. 5) also evokes urban emptiness, alien-
ation, and loneliness. Here a solitary man walks along a barren loop with
slumped shoulders, lost in thought, and both physically and psychologi-
cally removed from the apartment buildings and industrial bridge in the
background. Hopper claimed that he created "the very long horizontal
shape of this picture . . . to give a sensation of great lateral extent. Carry-
ing the main horizontal lines of the design with little interruption to the
edges of the picture, is to enforce this idea and to make one conscious of
the spaces and elements beyond the limits of the scene itself."[9] He thus
suggested that the lateral expanse of the composition and frame serve
compositional purposes: to reinforce the horizontality of the picture and
to suggest the scene's extension beyond the picture frame. He also estab-
lished this immense, empty space to underscore the solitary man's isola-
tion, utilizing the compositional format to reinforce the work's content
in this and other works.

Hopper's evocation of modern man's alienation was not confined
to urban views, but extended to small towns and the countryside. These
locations were mostly eastern, but were interpreted during the 1920s and
1930s as quintessentially midwestern, evoking the title of Sinclair Lewis's

Figure 5.
Edward Hopper, *Manhat-
tan Bridge Loop*. Oil on
canvas, 1928. Addison
Gallery of American Art,
Andover, Massachusetts,
gift of Stephen C. Clark,
Esq. Accession no.
1932.17. Gallery of Amer-
ican Art, Phillips Academy,
Andover, Massachusetts.
All Rights Reserved.

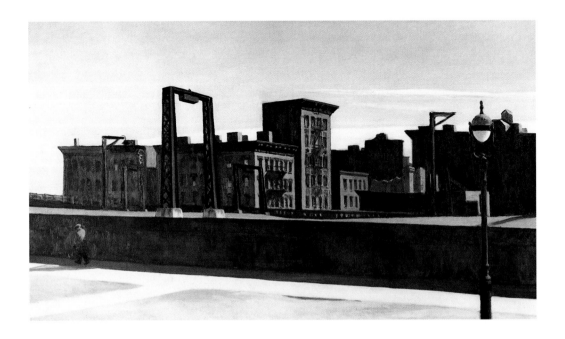

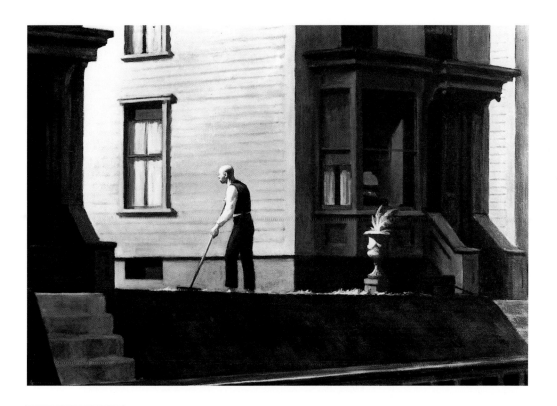

Figure 6.
Edward Hopper, *Pennsyl-*
vania Coal Town. Oil on
canvas, circa 1947.
Courtesy The Butler
Institute of American Art,
Youngstown, Ohio.

novel of 1920, *Main Street*.[10] In *Pennsylvania Coal Town* (fig. 6), a lone man
rakes the lawn between two houses. The side wall of his home; the shadow
at his feet, which forms a ledge to the grass; and the house next door func-
tion as frames and enclosures, making his isolation appear more acute.
Hopper deliberately placed the vanishing point (created by the lines of
the two houses) at an invisible location between the two homes. This,
combined with the darkened windows and the absence of other people,
underscores the landscaper's separation, even though Hopper implied by
the row of houses that he resides in a larger community, presumably a
small town, as signified by the title.

The rural setting in *House by the Railroad* (plate 2) places modern
humans' isolation in the country as well, implicating technology as one
cause. This painting ironically juxtaposes the flamboyant architectural
style of the nineteenth century with an icon of nineteenth-century
modernity and industry, the railroad; but it also seems to make a com-
mentary upon modern times. The absence of people and other buildings,
darkened windows and doorway, and the great expanse of land and sky
evoke this sense of alienation. Through the presence of the railroad tracks
directly in front of the Second Empire mansion and their placement lat-
erally across the picture surface, the painting suggests that industrializa-
tion contributed to the modern dilemma, a theme that prevails in other
works such as *Compartment C, Car 293* (fig. 7) and *Gas* (fig. 8).

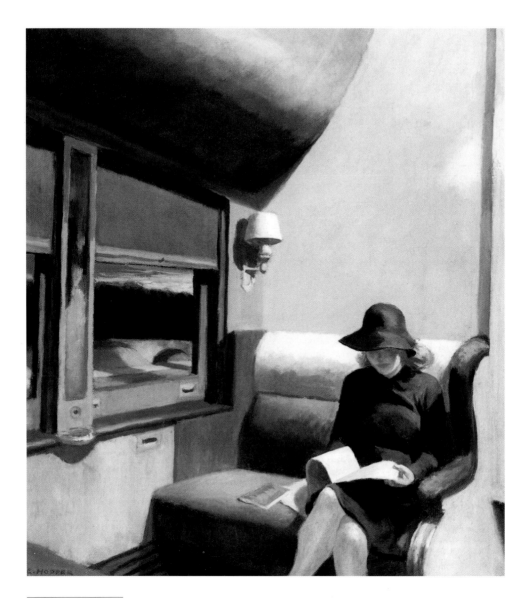

Figure 7.
Edward Hopper,
Compartment C, Car 293.
Oil on canvas, 1938.
Private collection.

The train in the one painting and the gas pumps in the other separate the solitary individuals from nature and other people. The seated passenger in *Compartment C* appears trapped by her seat, the back wall, and the side window through which a barren landscape is visible but inaccessible. Her fashionable broad-rimmed hat covers her downcast eyes, which focus on a sheet of paper in her hands; her posture, with crossed legs and arms at her side, suggests a self-contained individual imprisoned within the locomotive and separated from nature as well as humanity.[11] Hopper employed similar compositional strategies in *Gas,* in which a gas station attendant appears trapped and attached to the looming red pumps. The vast, desolate landscape behind him appears ominous, with its dark tonalities and trees massed together, closing off any possibility of entry on the

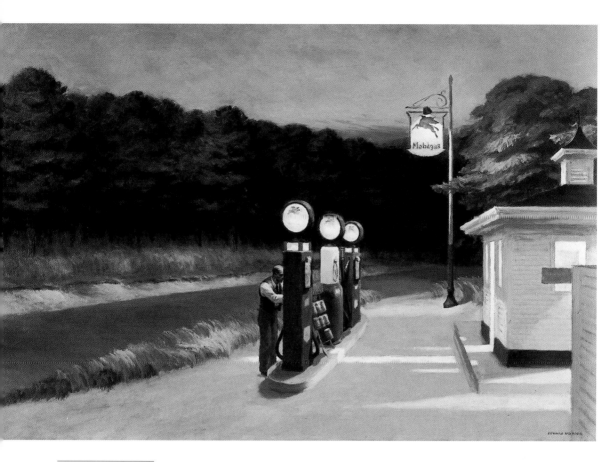

Figure 8.
Edward Hopper, *Gas*.
Oil on canvas, 1940. The
Museum of Modern Art,
New York, Mrs. Simon
Guggenheim Fund.
Photograph © 2001 The
Museum of Modern Art,
New York.

part of a person; no path, no clearing, no open space exists. The empty road curves into the forest, with trees and shadows obscuring its destination. The gas station also evokes emptiness; the blazing electric light emanates outward without shadows from furniture or people, giving the sense that it is a vacant shell.[12]

Hopper, of course, does not stand alone in focusing on the isolation of modern humans in industrialized America. Charles Sheeler conveyed a haunting sense of dehumanization in *American Landscape* (fig. 9), where a single worker from the River Rouge automobile plant in Michigan appears alone and powerless in this industrial setting.[13] George Ault in *Construction Night* (fig. 10) similarly represented a barren industrial and urban landscape, conveying his assessment of the city as "the Inferno without the fire" and skyscrapers as "tombstones,"[14] while Stefan Hirsch suggested horror at the omnipresence of the towering skyscrapers dominating the New York City skyline in *New York, Lower Manhattan* (fig. 11). Here the windowless buildings embody his "recoil from the monstrosity that industrial life had become in 'megapolitania.'"[15] The absence of landscape communicates this artist's awareness upon returning to New York from Europe after World War I that the expansive American wilderness had been demolished

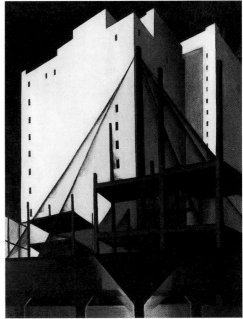

Figure 9.
Charles Sheeler,
American Landscape.
Oil on canvas, 1930. The
Museum of Modern Art,
New York, gift of Abby
Aldrich Rockefeller.
Photograph © 2000 The
Museum of Modern Art,
New York.

Figure 10.
George Ault, *Construction
Night.* Oil on canvas,
1922. Curtis Galleries,
Minneapolis.

Figure 11.
Stefan Hirsch, *New York,
Lower Manhattan.* Oil on
canvas, 1921. The Phillips
Collection, Washington,
D.C.

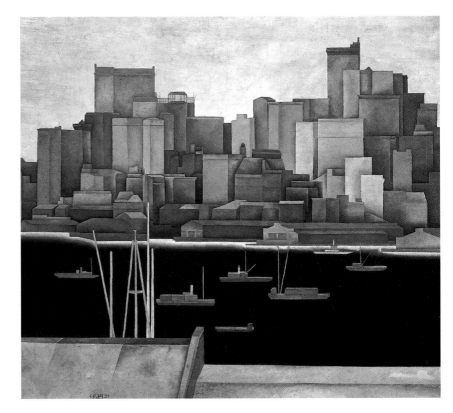

by "the piles of steel and concrete."[16] Given that many Americans while in Europe yearned, according to Malcolm Cowley, for the hills of Kentucky, woods of Michigan, or farmhouses of the Midwest, the sense of shock, disorientation, and confusion upon returning to the transformed countryside seems a reasonable response. "New York, to one returning from Paris or London," Cowley reminisced, "seems the least human of all the babylons. Its life is expressed in terms of geometry and mechanics: the height and cubical content of its buildings" result in people who "have purely numerical function."[17]

Hopper rendered views of New York City in similarly ominous terms, although he focused more on apartment buildings than on the commercial areas that interested Sheeler, Hirsch, Ault, and, as we will see, O'Keeffe. *Apartment Houses, Harlem River* (fig. 12) and *Manhattan Bridge Loop* contain rows of multidwelling homes for urban dwellers. The multitude of windows indicate that these apartments contain many people who can look out their windows at the trees and water, but who seem shut off from the outside, caged in their individual cubes.

Some viewed Hopper's houses as actual portraits. As Helen Appleton Read noted in 1927, "Houses have a personality . . . because of some human emotional quality they possess."[18] This critic noted elsewhere that Hopper represented "suburban villas, the frame houses of sordid side streets, the flamboyance of certain types of American dwelling houses,

Figure 12.
Edward Hopper, *Apartment Houses, Harlem River*. Oil on canvas, circa 1930. Collection of Whitney Museum of American Art, New York, Josephine N. Hopper Bequest. Accession no. 70.1211. Photograph copyright © 2000, Whitney Museum of American Art.

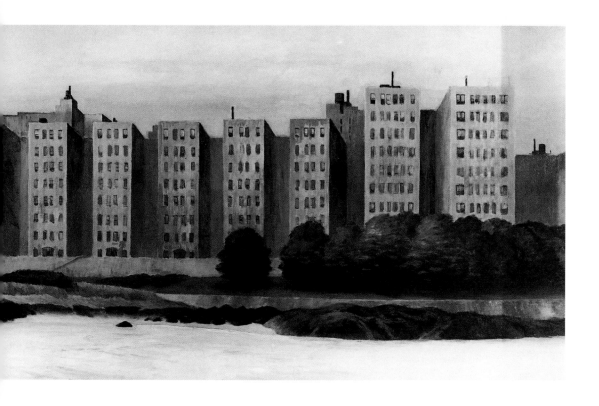

notably the mansard roof period, the dinginess of run-down apartment houses as well as the shining whiteness of a light house lower in the sun or the violet shadows of a white painted New England farm house."[19] Goodrich concurred, viewing Hopper's "pretentious flamboyant mansions . . . with their mansard roofs, jutting dormers and bow windows, wide-spreading porches and flapping awnings" as having character, like "a portrait painter's sitter." For this promoter of Hopper, who organized a number of shows at the Whitney, the artist captured the character of the American people through his representations of American architecture.[20] Matthew Baigell similarly suggested that the "greater individuality" that Hopper conveyed in his buildings as opposed to his people resulted from his considering them as surrogates for humans. Robert Hobbs concurred, saying that "his buildings are protagonists that personify cultural and social concepts."[21]

British art historian Margaret Iverson recently interpreted Hopper's evocation of the melancholy within the context of the Freudian uncanny, a term that conveys the interest of psychoanalysis in traumatic loss, repressed desires, and the death instinct. She furthermore suggested that Hopper's Victorian Gothic mansions and New England Cape Cod cottages

Figure 13.
Edward Hopper, *Solitude #56.* Oil on canvas, 1944. Private collection.

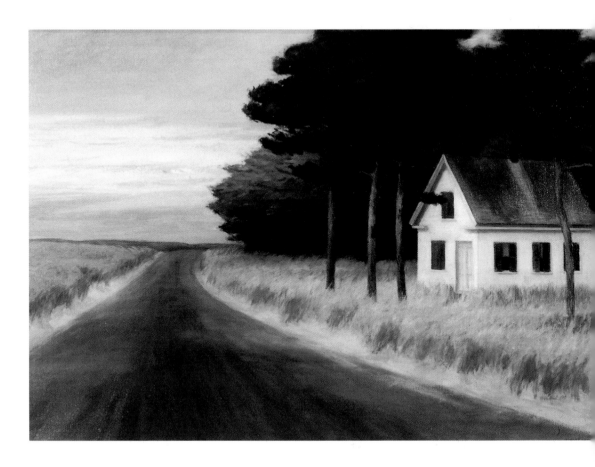

are unstable because they generate *heimlich* and *unheimlich* associations: cozy, homey, and intimate as well as hidden, secret, and concealed. For Iverson, *House by the Railroad* and *Solitude #56* (fig. 13) represent haunted houses filled with blanks, voids, and, in the case of the latter, perspective distortions to represent the "impressions left after a quick glance at an inexplicably peculiar, isolated house."[22]

Others have employed psychoanalytic theory to analyze the reasons for Hopper's sense of isolation and loneliness. Stephen Safran and Monty Kary, both clinical psychologists, proposed that Hopper's empty rooms "could represent the womb in which a subject . . . is returned to the body of the mother." They suggested that Hopper continually represented his wish to possess the pre-Oedipal mother in his lonely rooms and houses. Observing that many of Hopper's buildings have darkened windows and solitary female figures located in a room, they suggested that the building itself can signify the ego, while the window "is analogous with the 'eye to the mind' in which the female is housed." The voluptuous women within rooms, they hypothesized, represent "a projection of the incorporated object: Mother."[23]

Suppose, however, that we extend the frame for the discussion of Hopper's alienation beyond generalizations about technology's destructive role in American culture, beyond the possibility that his buildings capture personalities, beyond Iverson's Freudian uncanny, and beyond Hopper's desire for reunion with his mother. Suppose that we also consider his own marriage along with the ideology of marriage in crisis. This different focus provides yet another lens for understanding Hopper's representations of detached houses and apartment buildings. Within the context of marriage discourse, Hopper's second-story apartments in *Early Sunday Morning* and his solitary mansion in *House by the Railroad* take on additional layers of meaning. This new frame augments our ability to comprehend why Hopper evoked a pervasive sense of *angst* in his urban, rural, and small-town landscapes, establishing a sense of both *heimlich* and *unheimlich* in his paintings of homes that, as we shall see, relates to his own life.

Single-Family Homes versus Multidwelling Apartments

Following World War I, sociologists began to study how the change from a predominantly agrarian economy to an industrial one affected the individuals and families who moved from rural to urban areas. The country, they argued, fostered tight-knit communities where single-dwelling homes prevailed; distances between houses collapsed within a broader community of support and friendship among neighbors. Lewis Mumford painted a bleak picture of lower-middle-class families, who lived in apartments where the "walls . . . have contracted" and where a man had no place to

play with his children.[24] Thus the "theme of a lonely house by the railroad tracks"[25] in Hopper's *Railroad Crossing* (fig. 14) and *House by the Railroad* evokes, according to this contemporary discourse, the threat of industrialization to a community where fellowship once reigned. Hopper's single-dwelling homes located in small towns and in the country also suggest isolation, but they convey as well an almost nostalgic longing for the individuality amid community enabled by such structures. *Sun on Prospect Street* (fig. 15) and *MacArthur's Home "Pretty Penny"* (plate 3) contain houses

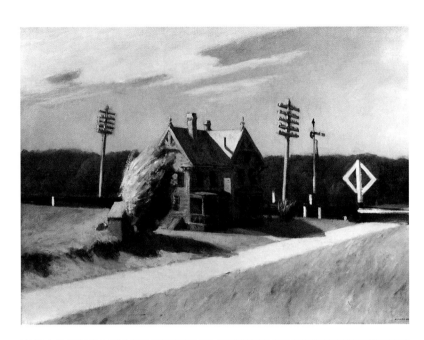

Figure 14.
Edward Hopper, *Railroad Crossing.* Oil on canvas, 1922–23. Collection of Whitney Museum of American Art, New York, Josephine N. Hopper Bequest. Accession no. 70.1189. Geoffrey Clements Photography. Photograph copyright © 2000, Whitney Museum of American Art.

Figure 15.
Edward Hopper, *Sun on Prospect Street (Glouces-ter, Massachusetts).* Oil on canvas, 1934. Cincinnati Art Museum, The Edwin and Virginia Irwin Memorial. Acces-sion no. 1959.49.

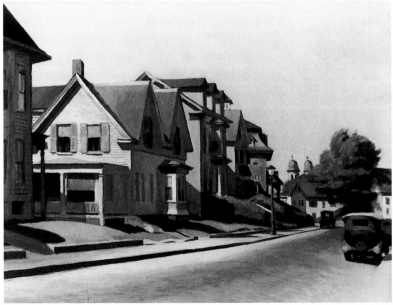

of tranquility glistening in the sun amid quiet, landscaped communities. Hopper painted the latter as a commission from the playwright Charles MacArthur and his actress wife, Helen Hayes. Although he claimed to find nothing interesting about the building and refused to accept another commission, the home in the painting, like his others, is elevated above eye level, as if on a pedestal.[26]

Within the context of the marriage-in-crisis discourse, these buildings function as icons of an idealized close-knit community of individual families whose homes—surrounded by grass, trees, and flowers—evoke tranquility, peace, and nostalgia for a lifestyle threatened by industrialization and urbanization. As James Dealey cautioned as early as 1912, young couples "must substitute for the cottage home an apartment flat or the hotel with their lack of privacy and their prohibitions against children . . . radically affecting home and kinship ties."[27] Seven years later, *The Farmer's Wife* published a short story about a husband and wife's desire to move into a larger Southern Colonial house with a conservatory. When their hopes are dashed because Billy failed to receive the promotion he had anticipated, they rejoiced that they still had their "bright little house" with its "dainty orderliness." Any home, this story suggests, is sufficient for a companionship marriage. Hopper, who did the illustration for this narrative of domestic tranquility within "a little crooked house," would have read and understood its message.[28]

Whether located in small towns or in the country, Hopper's stately mansions indicate either an era before urbanization or a setting far from the city. Sociologist Ray E. Baber, writing in 1939, provides a framework in which Hopper's meanings can be further understood. "In the city," he argued, "the art of neighboring, a powerful family cohesive force in the country and small town, is reduced to a minimum." He identified various factors within the city that threatened family solidarity: lack of fellowship among families, crowding in apartment buildings, increased irritation and discomfort within the home environment, lack of privacy, and a sense of hopelessness. The home-based recreation of the countryside was replaced by commercial public amusement areas such as movie theaters and dance halls, thereby robbing the family "of one of its most cohesive forces." Moreover, the city interfered with the ability of youngsters to find suitable mates and encouraged prostitution and "illicit unions" which offer "temporary, and sometimes permanent, substitutes for marriage and family life." Americans living in cities thus became, according to Baber, "modern 'cliff dwellers,' who live in little concrete cubicles" without flowers or sunlight, replacing fellowship with anonymity.[29] His description of "little concrete cubicles" recalls the images produced by Hopper, Hirsch, and Ault with their vertical buildings that seem oppressive and that overwhelm nature, creating a sense that people remain anonymous amid these

lifeless structures of urban blight. Although Baber's critique refers to a different social class than that painted by Hopper and seems a projection of his own class prejudices, Hopper's paintings nevertheless suggest similar implications.

In Muncie, Indiana, in the 1920s, Robert S. and Helen M. Lynd discovered that 86 percent of the homes in the community—which they named "Middletown" for the sake of confidentiality—were one-family units with a yard that formed the locus of the families' lives: the "most 'sacred institution,' the family, work[ed] out its destiny" in this setting; there, marriage, births, child-rearing, death, and the "personal immensities of family life [went] forward." The Lynds concluded that ownership of such homes affected families in positive ways, establishing a sense of independence, respectability, and belonging. In this environment, a community of individual families was interconnected through such public institutions as the church, the state, and the schools.[30]

The move from what Ernest R. Mowrer called "family-selfish[ness]" in the country to "individual-selfish[ness]" in the city contributed, in his opinion, to the disorganization of the modern family.[31] Ernest W. Burgess and Harvey J. Locke concurred, providing statistical evidence that a higher divorce rate existed among apartment dwellers and that more single persons, childless couples, and professional and business men and women lived in apartments or residential hotels. "The so-called normal family of husband, wife, and children constituted 47 per cent of the households in apartment-house[s] and 66 per cent in single-home neighborhoods," reported these two sociologists, who concluded that multiple-unit living arrangements fostered impersonal relationships.[32] Ernest R. Groves agreed that urbanization "lessened the frequency of marriage, increased the proportion of childless families, encouraged a relatively low birthrate, stimulated the mobility of family life, made possible the decision not to marry, influenced standards within the family, and provided anonymity which has influenced sex morality."[33] Apartments in cities destroyed the modern family and thus threatened the very fabric of American culture, these social scientists argued.

Sociologists compiled additional statistics to demonstrate that although the one-family dwelling had always been the dominant type of housing in the United States, apartments had become the norm after World War I. During the building boom of the 1920s, the percentage of new multifamily dwelling units increased from 24.4 percent in 1921 to its peak of 53.7 percent in 1928. Although this percentage declined over the next three years, it nevertheless dropped to only 16.3 percent during the depth of the Great Depression and rose to 45 percent in 1945. Construction of one-family dwellings declined between 1922 and 1931, but then increased between 1932 and 1940 in smaller cities and in towns.[34]

These quantitative data provide a new perspective on the nostalgia that surrounds Hopper's pristine, beautiful, elevated, luminescent homes, in contrast with what Goodrich called "the drab monotony of rows of identical red brick tenements, the faded splendors of demodé apartment houses."[35] His frame houses, such as the one in *Cape Cod Sunset* (fig. 16), belong to a previous period or else to small towns and cities.

Hopper's works support academic claims that apartments contributed to the breakdown of the modern family, whereas Second Empire abodes with mansard roofs, turrets, and elaborate decorations provided a nurturing environment that fostered family and community cohesion. At least one contemporary of Hopper's recognized this impulse. Helen Appleton Read observed in 1933 that "in his architectural themes, notably the houses of the Garfield and McKinley periods, he is able while giving a straightforward presentation of his subject to suggest the vigor and abundant life that created and preferred such types of dwelling houses as well as suggesting the continuity of family life that has been lived behind their shining white walls, ample verandas and flamboyant porticos."[36]

Popular magazines disseminated the scholarly critique of the city. Anthropologist Edward Sapir attributed the dissolution of the family to, among other things, cramped urban living quarters. He concluded in an article published in *American Mercury* (1930) that "the family no longer dwells; it occupies quarters," and the street, movie hall, and hotel lobbies "have become the backyards of the modern home."[37] Charles W. Wood in *The Nation* (1929) blamed the urban environment and industrialization for matrimonial problems: "When man moved out of the family and

Figure 16.
Edward Hopper, *Cape Cod Sunset*. Oil on canvas, 1934. Collection of Whitney Museum of American Art, New York, Josephine N. Hopper Bequest. Accession no. 70.1166. Geoffrey Clements Photography. Photograph copyright © 2000, Whitney Museum of American Art.

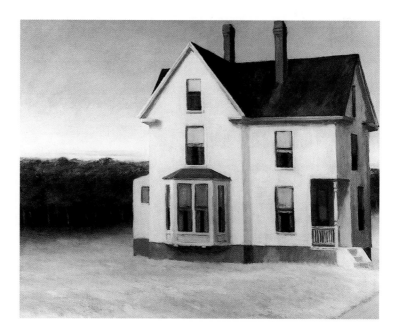

began to live in the machine [apartment houses], matrimony began to lose its holiness."[38] That year the *Ladies' Home Journal* asked, "What Makes a Home?" Although this essay addressed the issues that couples should consider before matrimony, the title and its accompanying illustration (fig. 17) with its single-family house nestled between trees and bounded by a fence suggest that only the detached home integrated with nature could foster a young couple's love and harmony—and, by implication, that an apartment building might destroy them.[39] This is the type of house that the couple in *The Farmer's Wife* longed to inhabit. Hopper had illustrated this earlier article and also could have illustrated this *Ladies' Home Journal* essay. By this point in his career, however, he was executing only oils and watercolors.

The representation of the home in these paintings fulfilled the belief that such an abode would nurture and enable companionship marriages. Dr. James L. McConaughy, president of Wesleyan University and author of a *Good Housekeeping* article about college courses on marriage relations, concurred, recommending in 1937 that newly married couples live in small towns, where friendships come easier, life is simpler and cheaper, and the divorce rate is lower than in cities. The urban apartment house, "the most impersonal form of dwelling," could cause havoc within marriages.[40]

Sapir and Baber, as we have seen, cited the impact of commercialized public amusements upon family cohesion, in contrast with the self-contained, grassy, and sun-filled backyards of single-family homes. Lewis

Figure 17.
Anonymous illustration from Anna Garlin Spencer, "What Makes a Home? The Problem as Youth Faces It," *The Ladies' Home Journal* 46 (October 1929): 131. Photograph by Herbert Peck.

Mumford verbalized similar concerns, observing that "the urban worker escapes the mechanical routine of his daily job to find an equally mechanical substitute for life and growth and experience in his amusements." To him, the movies, entertainment venues along the Great White Way, and amusement parks such as Coney Island provided "sensations of the direct experience of life—a sort of spiritual masturbation" that resulted in the dehumanization of the population.[41] How could such dehumanized workers break out of their concrete cubicles of factories or office buildings, or the multidwelling domiciles that Mumford saw as "grim, dreary, genteely fusty?"[42] This environment would encourage, in Mowrer's assessment, the "individual selfish[ness]" of alienated and unhappy apartment dwellers whose connections with other family members would be short-circuited by their mechanically controlled work environments, leisure activities, and home lives.

Some reformers, however, praised commercial amusements—especially the movie theater—as a cohesive venue for families. Parents and children could attend picture shows together, without, it was hoped, being distracted by dating youngsters exploiting the movie house's darkness to engage in freer forms of sexuality. Cheap amusements provided an arena for dating outside parental control, as did the automobile.[43]

The Automobile and the Road

Sapir argued that "the American family is not only cramped and insecure in space [i.e., in its multi-unit home]; it is also unstable in time." The cause was the automobile, which he considered the most powerful force behind the destabilization of the family. "In all this coming and going," Sapir continued, "the automobile is of course the most potent factor . . . by enlarging the confines of the home and giving its members new avenues of escape from the home's dullness."[44] Burgess and Locke agreed: "The home and the road are contrasting symbols of settled residence and of mobility."[45] As we have seen, however, the concept of "settled residence" existed only in rural areas or in "Middletown," where families lived in detached homes within cohesive neighborhoods and communities. The road and by implication the automobile, on the other hand, symbolized mobility, a theme that *Time* magazine recognized in 1948 in Hopper's work: "A road cuts across the foreground of most of Hopper's paintings. Sometimes it becomes a city street, or a railroad embankment, or a porch step, but it is there—a constant reminder of transience."[46] Hopper, in fact, often places the viewer in the position of a commuter en route, viewing fragments of towns, landscapes, railroad tracks, tourist homes, gas stations, intersections, and streets.[47]

Not everyone condemned the automobile. Some believed that it enabled families to participate in recreational activities away from their homes, a positive effect. John C. Long in *Motor* (1923), for example, advocated the motorcar "as a means for holding the family together, for raising the standards of living, for providing recreation and social advantages for the children."[48] He, of course, wanted to persuade middle-class Americans to take advantage of this mass-produced form of transportation, which his magazine advocated as central to modern life. But Baber, too, viewed the car both as the most potent force for social change invented by humans and one that could infuse positive experiences within the increasingly alienated family.[49] The Lynds reported similar findings: "The automobile appears to be an important agency in bringing husbands and wives together in their leisure, counteracting . . . the centrifugal tendency in the family." From their observations, the motorcar united the family during a period when its cohesion was being threatened. As one businessman reported to them, "I never feel as close to my family as when we are all together in the car."[50]

The automobile, according to manufacturers' advertisements, broadened women's daily contacts and enabled them to shop, thereby assisting them with their domestic pursuits. These ads countered the anxieties expressed by some about the entry of women into the public arena, fostered by the motorcar and its perceived threat to the hierarchical family, which prior to World War I had consisted of the husband in control behind the wheel, the wife beside him in the passenger seat, and their children in the back. During the war, women moved into the driver's seat on behalf of the war effort; and as manufacturers expanded their marketing strategies to appeal to women, advertisements attempted to assuage fears that the motorcar would further emancipate women and remove them from the domestic sphere. Women at the wheel posed a threat to traditional roles and ideas about them, for they were thought to be endangering the structure of family life by driving to areas away from the local community and the watchful eyes of friends and family.[51] As one woman rejoiced about her newfound freedom, "Learning to handle the car has wrought my emancipation, my freedom. . . . The auto . . . binds the metropolis to my pastoral existence; which brings me into frequent touch with the entertainment and life of my neighboring small towns,—with the joys of bargains, library and soda-water."[52]

Nonetheless, the automobile could play a destructive role within the family. The Lynds discovered that it served as a major source of disagreement between children and parents. Interviewing more than seven hundred boys and girls about parent-child conflict, they found that the use of the automobile was the most volatile subject, surpassing financial matters, school grades, and domestic chores.[53] The automobile especially

became a locus of dissension between parents and children because it affected youngsters' expression of their sexuality. The car helped to replace "calling" with dating, accelerating a process already under way, and it provided an arena for courtship in the public sphere, away from parents and their limitations on sexuality.[54] As Burgess and Locke observed, "The transition from living in a single dwelling to smaller quarters in a multiple dwelling was accompanied by the change from the spooning of a couple in the parlor to petting in an automobile." The car, they argued, extended "the radius of mate selection," enabling courtship to occur away from the home and in the car.[55] In Henry A. Bowman's opinion, the automobile "replaced the family parlor as the scene of courtship activities," functioning as a roving parlor removed from "direct parental influence."[56] Victor F. Calverton agreed; kissing, necking, and petting, he observed, had become common practices: "The automobile has given to them the convenience of expression that the fire-side parlor . . . would never have permitted."[57] Even more disturbing, automobiles travel quickly, placing greater distance between parents and teenagers and enabling the latter to participate, the Lynds discovered, in "unchaperoned automobile parties as late as midnight" halfway across the state.[58] "Keeping Up with the Crowd," published in the popular magazine *True Story* in 1923, embodied many parents' fears: its heroine becomes pregnant as a result of a moonlit encounter, precipitated by liquor, in an automobile.[59]

As some women in Los Angeles complained, "school boys' and girls' promiscuous use of the auto is one of the greatest menaces of the age."[60] Burgess and Locke reported that of the thirty girls brought before juvenile court for sex crimes in 1924, nineteen were "listed as having committed the offense in an automobile," which thus functioned as an "'enemy' of the home and society."[61] The automobile ultimately contributed, in their opinion, to the "marked decline in familism" and in the disorganization of the family.[62] It thus not only threatened the innocence or purity of young women, but also the social fabric of American families and ultimately American culture.

Dating and the automobile affected not only the dynamics between parents and children, but also those within a couple. Dating shifted power from women to men, moving courtship away from the feminine, domestic arena into the masculine, public sphere. At the same time, this newer type of courtship altered the initiation process. Under the older "calling" system, a woman requested a man's visit. Under the dating system, men did the asking. Yet women now became the ones who controlled how far the couple went in necking and petting.[63]

The car also contributed to changes in American domestic architecture that were related to the issue of parental guidance. Such social spaces as the parlor and front porch disappeared with the addition of the

garage, which dominated the façade by 1936. In this decade, some Americans viewed the house as "little more than a dormitory," contributing to the sense of displacement caused by the automobile. Yet these ubiquitous garages do not appear in Hopper's New England country cottages, except for one—*October on Cape Cod* (fig. 18)—where a gravel driveway leads to the adjacent garage.[64] More common in Hopper's oeuvre is the old-fashioned home with front porch. *Summer Evening* (1947) provides such an out-of-date liminal space between the domestic and public spheres where courtship can take place. In this painting, Hopper closely cropped the composition, focusing on a portion of the lighted porch where one figure leans against the side benchlike structure while the other sits upon it. These two figures—a voluptuous girl with long blond hair, darkened eyes, large breasts (partially visible because of her low-cut halter top), exposed stomach, and extremely short skirt, and a boy with short-sleeved blue shirt and brown pants—are framed by posts against a rectangular black background. The intense interaction between this couple, along with the girl's sexualized dress, pose, and demeanor, suggests the potential for more than just talking. However, the slightly open curtains of the door and parlor window permit parental awareness and guidance of the young couple's activities.[65] *October on Cape Cod,* on the other hand, contains no such intermediate space between public and private life. This more ominous landscape underscores the threats that such homes contained as the garage replaced the front porch, signifying mobility and the sexual experimentation that the couple on the porch of

Figure 18.
Edward Hopper, *October on Cape Cod.* Oil on canvas, 1946. Private collection.

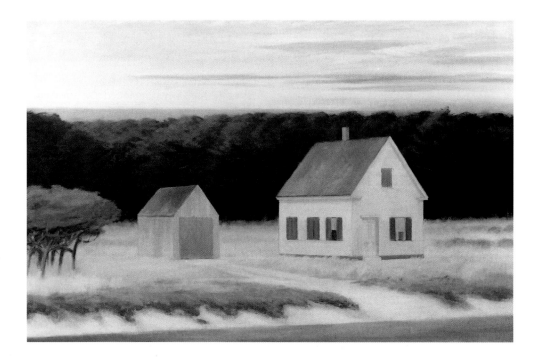

Summer Evening cannot engage in. This couple's overt sexuality makes it clear that if the boy and girl left the confining space of the porch and its electric light, the reticence expressed through their body positions and gestures would disappear.

Burgess and Locke went beyond teenage sexuality in addressing the effects of what a contemporary called the new "living room on wheels."[66] Besides "freeing the individual from the control of the family and the neighborhood" and increasing "the opportunity for casual contacts and irregular sex relationships," this machine provided "a place for extramarital relations" and facilitated "the use of the hotel ... for the same purpose."[67] A resident of Muncie, Indiana, concurred, identifying autos as "houses of prostitution on wheels."[68] Consequently, cars were often viewed as a cause of divorce and family disintegration.

Within this context, the man's isolation in *Gas* takes on additional meanings beyond the sense of "the loneliness of the traveller on a strange road at nightfall."[69] His marital status is unknown and perhaps unimportant. But the emptiness that pervades the painting and the man's solitary condition not only suggest the generalized threat of industrialization, but more specifically the automobile's function in undermining the family. Although the modern mobile parlor cannot be seen, its presence is implied by the gas station and the attendant who supply the fuel it needs. The positive influence that Mowrer and some others observed (family vacations, for example) seems impossible in this setting, where the ominous forest forecloses any thought of hiking, camping, or picnicking. Community and family involvement are also ruled out, for homes are noticeably absent. Couples and individuals can travel along this road free from family constraints to engage in whatever sexual activities they desire.

Hopper seldom rendered automobiles. *Prospect Street, Gloucester* (fig. 19) and *Sun on Prospect Street,* similar compositions executed in watercolor and oil respectively, are his only works in which cars line a street. This residential neighborhood contrasts the safe parlor where parental control exists and the mobile parlor that is free from constraints. The contemporary discourse about marital difficulties infuses these tranquil views of American small-town life with potential conflict between parents and children and between husband and wife. Within this context, the sidewalk and shadowed road form symbolic barriers between the safety of the single-dwelling home on one side and the closed and open sedans located on the other. The highlighted buildings appear as stable and enduring monuments of domesticity that the automobiles threaten; youngsters have the means to leave the family and its controls to experiment with sexual activity, while husbands or wives can similarly travel elsewhere to hotels or motels to engage in illicit affairs. *Cars and Rocks* (fig. 20) shows two seemingly abandoned sedans elevated above eye level on boulders.

These parked cars could contain a couple, or they could be empty because the passengers have stopped to view the landscape. The absence of people from the scene, however, is suspicious, especially because its rocky terrain and high cliffs do not encourage casual strolling.

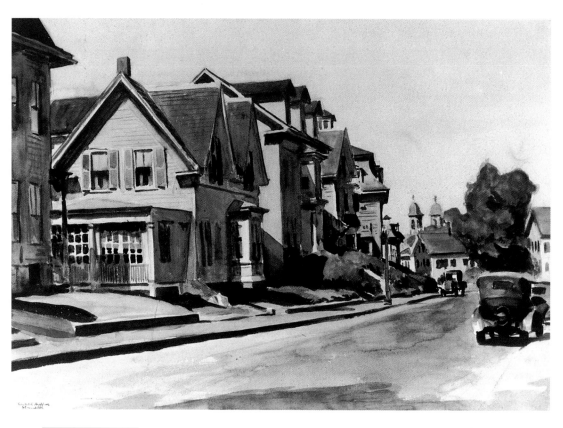

Figure 19.
Edward Hopper, *Prospect Street, Gloucester.* Watercolor on paper, 1928. Private collection.

Figure 20.
Edward Hopper, *Cars and Rocks.* Watercolor on paper, 1927. Collection of Whitney Museum of American Art, New York, Josephine N. Hopper Bequest. Accession no. 70.1104. Photograph copyright © 1989, Geoffrey Clements Inc., New York.

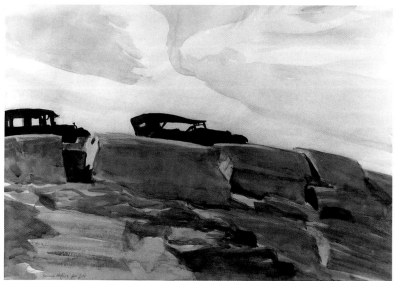

Hopper more frequently painted the road and the home without the automobile. In *House by Squam River, Gloucester* (fig. 21), *House in Province-town* (1930), and *High Road* (fig. 22), a distant road passes through a small community of single-family homes. In Hopper's *Solitude #56,* the road extends almost across the foreground, placing the viewer in the position of a motorist. We pass by the solitary home on the right; it is nestled between trees in front of a gloomy forest. The contrast between the home and the road that extends into the distance takes on significance within the context of Burgess and Locke's equation of the former with settled residence and the latter with mobility and potential family disorganization. The "solitude" of the title may very well be a result of family disintegration brought on by the mechanical mobilization that this road signifies.

Figure 21.
Edward Hopper, *House by Squam River, Glouces-ter.* Watercolor on paper, 1926. Museum of Fine Arts, Boston, bequest of John T. Spaulding, 1948. Courtesy, Museum of Fine Arts, Boston. Repro-duced with permission. © 2000, Museum of Fine Arts, Boston. All Rights Reserved.

Figure 22.
Edward Hopper, *High Road.* Watercolor and graphite on paper, 1931. Collection of Whitney Museum of American Art, New York, Josephine N. Hopper Bequest. Accession no. 70.1163. Photograph copyright © 2000, Whitney Museum of American Art.

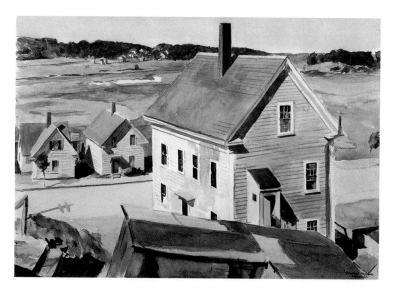

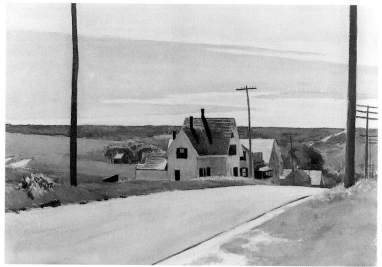

Jo in Wyoming (fig. 23) indicates the complexities of Hopper's paintings and the various levels of meanings that encompass his relationship with his wife, the marriage debates, and the alienation of modern man in an industrialized, mobile world. Hopper presented Jo seated on the passenger side of the front seat of their car, sketching a landscape from life. Here the automobile is a roving studio, enabling Jo to study the wide-open vistas of the western wilderness. At the same time, it separates Jo from the outdoors, enclosing her within its glass and steel frame. The seat forms a barrier between the painter and viewer while the empty driver's seat further emphasizes her aloneness. Jo's presence in the car suggests her ability to escape the confines of the home, exploring different vistas. Whereas automobile manufacturers' advertisements suggested that the car would enhance women's domestic efficiency, for Jo, within the context of her own marriage, it symbolized her emancipation. This was a possibility that the advertisers attempted to downplay and that Hopper, too, tried to repress—although in this image, he somewhat surprisingly seems to espouse the companionship marriage and Jo's professional emancipation in the front seat of the car. The two of them engage in the pleasurable pursuit of sketching directly from nature and Jo seems to be enjoying what a contemporary loved about the automobile: "The consciousness of power

Figure 23.
Edward Hopper, *Jo in Wyoming*. Watercolor on paper, 1946. Collection of Whitney Museum of American Art, New York, Josephine N. Hopper Bequest. Accession no. 70.1159. Geoffrey Clements Photography. Photograph copyright © 2000, Whitney Museum of American Art.

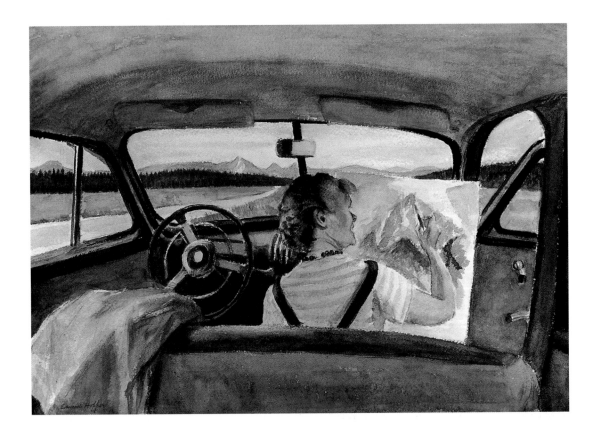

that comes with successful handling of an automobile might even prove an important antidote for personality quirks. . . . After all, an automobile is the largest piece of machinery that we women currently operate. It can make us feel infinitely more important than managing an electric egg beater."[70]

Yet this car served as a site for bitter disputes between Edward and Jo, who significantly does not sit before the steering wheel in the painting. Jo recorded in her diary in 1937 that her husband wanted to take the wheel to park the car, but she refused to move from the driver's seat. He consequently "hauled me out by the legs while I clutch the wheel—but he clawed at my bare arms & I all but sprawled on the road."[71] Nearly a year later, another fight ensued in their Buick when Hopper shouted directions, causing Jo to nearly drive into a post. Edward went "wild," like a "gorilla," and threw her out of the driver's seat.[72] Six years later, Jo was attempting to back the car into their garage, and it stalled: "while stalled . . . he leap[s] thru [sic] the door after me & drags me out onto the grass with threats of extermination."[73] Barbara Novak explained Edward's behavior by noting that Jo was an unlicensed driver for at least nine years, and "was in and out of the courts with her various violations."[74]

The conflict the Hoppers enacted in their car is an extreme example of marital stress. Their fights do not correspond precisely to the issues addressed by the press and in academic books, but the problematic dynamics that Hooper captured in his works relate both to his own marriage and to the difficulties the press and academia saw within the ideology of marriage in the interwar years.

The road and the automobile in Hopper's paintings thus may also resonate his own marital discord. His painted automobiles reflect the shift in power between males and females, in which women attempted to take over the driver's seat, but not without resistance on the part of their spouses, as is evident in the lives of Edward and Jo and all the automobile advertisements that portrayed women only as passengers. Just as the automobile was a site of bitter dispute, physical abuse, and battles over control for the Hoppers, it also became a point of departure in the debate over the proper place of women within modern society: in the home or in the passenger seat.[75] As Burgess and Locke had predicted, the automobile became a major factor in the modern family's disorganization. The ubiquitous road in Hopper's paintings could thus refer to his own marital conflict, played out within the Hoppers' roving studio.

The Hotel

In 1940, Federal Bureau of Investigation Director J. Edgar Hoover examined the social impact of motels, condemning these "camouflaged

brothels" for encouraging fast turnover in the "couple trade."[76] Some sociologists had already identified the hotel as a threat to family stability and cohesion, an interpretation providing one context for understanding the meanings of Hopper's *Hotel Room* (plate 4), *Hotel Lobby* (fig. 24), and *Rooms for Tourists* (fig. 25). The representation of a single-dwelling home turned into a bread-and-breakfast type of accommodation in *Rooms for Tourists* takes on additional implications in the light of Hoover's allegation that many of these establishments refused the traveling public on weekends, giving prostitutes (in the guise of entertainers, hostesses, and waitresses) a venue. Hopper's seemingly tranquil home appears more sinister within this broader context of the sex trade. Thus the dark street and the darkened windows on the second floor, with their awnings that prevent the viewer from seeing inside—clearly possible on the first floor—take on more ominous tones. Jo Hopper's observations in her record book about

Figure 24.
Edward Hopper, *Hotel Lobby*. Oil on canvas, 1943. Indianapolis Museum of Art, William Ray Adams Memorial Collection. Accession no. IMA47.4.

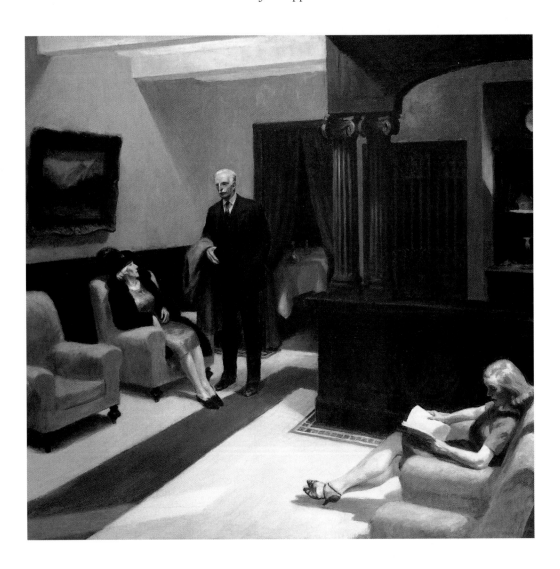

Figure 25.
Edward Hopper, *Rooms for Tourists*. Oil on canvas, 1945. Yale University Art Gallery, New Haven, Connecticut, bequest of Stephen Carlton Clark, B.A. 1903.

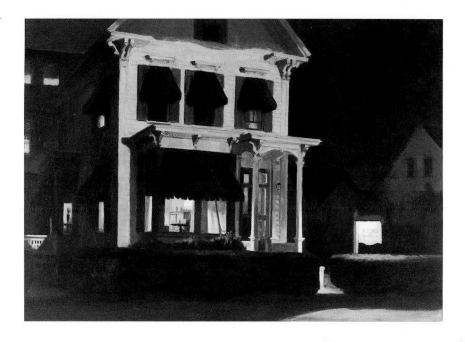

this painting's "black night," "dark green awnings, green shutters," and "frame of screen door" emphasize the features that close off the interior to the outside.[77] What occurs within these private spaces becomes more ambiguous. The darkened windows of Hopper's domiciles not only suggest alienation, but now also evoke the possibility of prostitution and extramarital affairs.

Susan Alyson Stein suggested that Hopper's mansard roof houses could be "relic[s] of time-gone-by" that suggest not domestic security, but the insecurity of a rootless society constantly on the move. These homes, according to Stein, could be boardinghouses.[78] Hopper's ubiquitous Second Empire mansions thus may not reflect solely his nostalgia for the peaceful, free-standing home and tight-knit family of the past, but may also express society's uneasiness about roving men and women who meet in rented establishments for illicit affairs.

Similar possibilities inform Hopper's representation of hotels. The solitary woman in *Hotel Room* looks at a timetable, underscoring her mobile existence, further emphasized by her suitcases. Why this woman exists in this liminal space is unknown. Is she a married woman traveling apart from her husband and family? Is she a single woman? Is she employed and commuting for a job? These questions cannot be answered, but her isolation within the hermetically sealed space of the hotel room indicates her inability, at least in this moment, to interact with other people. Or perhaps she is a married woman waiting for her lover to arrive? Her décolleté and tight-fitting chemise support this possibility, although the pervasive loneliness of the scene seems to eliminate it.

Hotel Lobby further accentuates the alienation that Hopper connected with temporary public lodging. One woman sits alone, reading a book, while an older couple occupies a separate space (notice that the green stripe in the rug defines these areas). Although the elderly woman looks toward her companion, he looks away, contributing to an overall sense of estrangement. This hotel lobby does not encourage interaction between married people themselves, let alone between them and others in the room. Instead, the foyer functions as a vacuum, discouraging human fellowship and fostering alienation—a different message from Hopper's preparatory drawing, which shows this couple looking at each other and engaging in a conversation while the man rests his arm on the back of the woman's chair, underscoring their emotional and physical closeness. Hopper eliminated the sense of companionship found in this drawing, probably derived from life, to create instead, in Gail Levin's words, "non-communication" and "a poignant lack of emotional interaction."[79]

Estranged Couples

Estranged couples are a leitmotif in this artist's oeuvre.[80] *Room in New York* (fig. 26), *Cape Cod Evening* (fig. 27), *Nighthawks* (fig. 28), and *Summer in the City* (fig. 29) include young people and old, male and female, located in the city and the country, in private and public places—all occupying compositionally and emotionally separate spaces from one another. In *Room in New York,* Hopper employed the colors of red versus white and black, the table between the couple, the man's and the woman's poses, and their activities of reading and playing the piano to establish the psychological distance within a comfortable middle-class parlor, a space traditionally coded for intimacy that is noticeably absent here.[81] The woman in *Cape Cod Evening,* looking downward with arms folded beneath her breasts, stands within the confines of the bay window as she ignores her husband, who is equally isolated by the doorway as he plays with a dog. The uncultivated field of grass surrounded by locust trees underscores the sense of disarray within this family, who fail to tend their domestic garden and seemingly cannot cross the space within the overgrown field.

Summer in the City similarly locates an estranged couple within the domestic setting, in this case the supposed intimacy of a bedroom. Here the man lies prone upon a bed, his head buried in a pillow, while the woman sits beside him yet with her back turned, her crossed arms resting on her knees. *Nighthawks* expresses the separation between a man and a woman in the public space of a restaurant, whose blazing fluorescent lighting evokes a sense of alienation and dehumanization.[82] Again Hopper employed colors (red and dark blue); a space between the figures of the couple, whose hands barely touch; and separate, solitary activities to

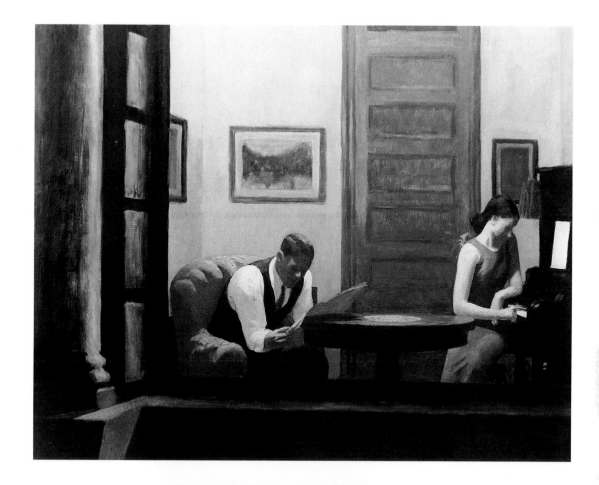

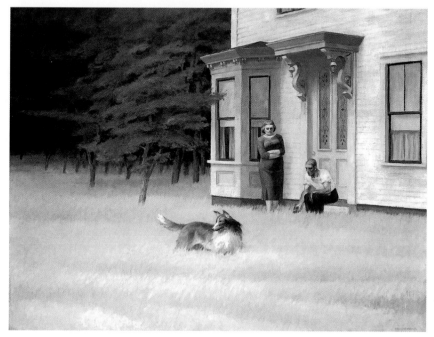

Figure 26.
Edward Hopper, *Room in New York.* Oil on canvas, 1932. Sheldon Memorial Art Gallery, University of Nebraska-Lincoln, F. M. Hall Collection.

Figure 27.
Edward Hopper, *Cape Cod Evening.* Oil on canvas, 1939. National Gallery of Art, Washington, D.C., John Hay Whitney Collection. Accession no. 1982.76.6. Photograph © 2000, Board of Trustees, National Gallery of Art, Washington.

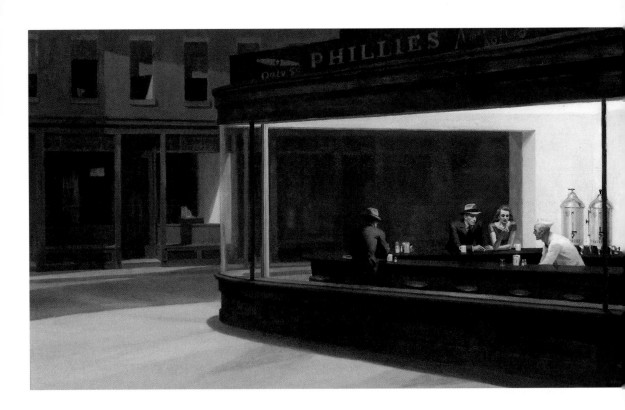

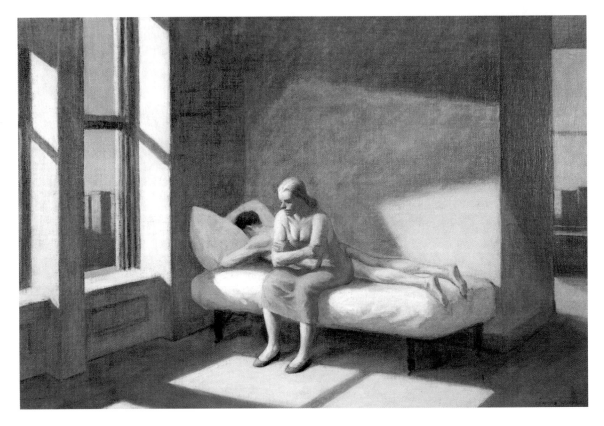

Figure 28.
Edward Hopper,
Nighthawks. Oil on can-
vas, 1942. The Art Insti-
tute of Chicago, Friends
of American Art Collection.
Accession no. 1942.51.
© 2000, The Art Institute
of Chicago. All Rights
Reserved.

Figure 29.
Edward Hopper, *Summer
in the City*. Oil on canvas,
1949. Private collection.

convey the inability of these two people to connect emotionally or phys-
ically, even though their shoulders touch and they form a cohesive trape-
zoid in their complementary poses and gestures.[83] The woman stares at
the matches that she holds in her right hand while the man looks toward
the waiter. Two metal coffee dispensers in the corner reiterate the parallel
but separate existences of these two people in a restaurant that seems im-
maculately clean and bright, but where no food is visible. This pristine
public space is a prisonlike vacuum that discourages human contact.
Hopper thus emphasized the couple's difficulty of maintaining a compan-
ionship relation; he stated that he "was painting the loneliness of a large
city." He clarified this statement, claiming that if loneliness and nostalgia
are themes of his works, it "isn't at all conscious. I probably am a lonely
one."[84]

These paintings visualize the modern marriage in crisis within the
urban and rural worlds and may reflect Hopper's sense of loneliness
within his own life and marriage. The aloof couple in *Summer in the City,*
reminiscent of Hugh McVey and his wife in Sherwood Anderson's *Poor
White,* are immobilized and unable to connect physically and emotion-
ally. Anderson's narrative clearly implicates industrialization as one cause
of this emotional withdrawal between married people; Hopper's painting
identifies urbanization. The surrounding apartment buildings visible
through the windows suggest that this room is in an apartment. *Summer in
the City* demonstrates the alienation that can occur between couples who
live in multiunit dwellings, and it also points to the disintegrating effect of
urbanization upon families.

Cape Cod Evening locates the estrangement between married peo-
ple within the context of the single-family home in the countryside, sug-
gesting that other factors besides urbanization and industrialization con-
tributed to familial discord. Perhaps the isolation of this house within a
vast landscape contributes to the couple's inability to connect. They lack
the larger community that was the setting for Hopper's earlier *Summer
Twilight* (fig. 30). In this etching, a man and woman, in interlocking poses
to underscore their compatibility, relax outside their Victorian home,
which is located along a street of similar large, welcoming houses. A
woman on the street in front of the house next door suggests that this
couple belongs to a larger community that nurtures close family relation-
ships, something noticeably absent in Hopper's later paintings.

Hopper may not have comprehended fully how the dynamics of his
own marriage corresponded to other couples' difficulties, but his works
certainly convey the concept of marriage in crisis. Before he married Jo,
Hopper represented in *Les Deux Pigeons* (fig. 31) a romantic couple who
kiss in a café. They are so absorbed in their passionate embrace that the
waiter stands unnoticed beside them.[85] *Summer Evening* conveys Hopper's

mature, postmarriage attitude toward courtship: the man and woman through posture (seated/standing) and clothing (light pink/dark blue and brown) form binary oppositions despite the protective space of the porch.

Figure 30.
Edward Hopper, *Summer Twilight*. Etching, 1920. Philadelphia Museum of Art, The Harrison Fund. Accession no. 1962-19-25(3).

Figure 31.
Edward Hopper, *Les Deux Pigeons*. Etching, 1920. Philadelphia Museum of Art, The Harrison Fund. Accession no. 1962-19-7.

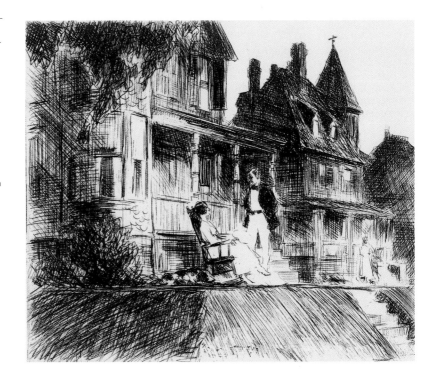

Jo commented in her journal that the woman "stand[s] out for matrimony," suggesting that the distance between these two is the ironic result of a discussion about marriage.[86] But their estrangement merely presages the tensions and conflicts to come, as Hopper's other works suggest.

His paintings, in other words, must be viewed within the context of his own conflictual relationship with Jo and the larger societal discourse of marriage in crisis. Hopper's single-dwelling homes, a subject that his wife similarly focused on throughout her career, suggest a desire for *Gemütlichkeit* within their own lives. The Hoppers lived in an apartment building in New York City all their lives together, but they also built a Cape Cod cottage that was completed in July 1934, in time for their tenth wedding anniversary. This summer home, like the Hoppers' paintings of homes, had both *heimlich* and *unheimlich* associations: the coziness, warmth, and intimacy expressed in Jo's paintings of their living room in New York City, as seen in *Campground for the Battle of Washington Square* (fig. 32), and the dresser in their bedroom in Cape Cod, as in *Cape Cod Bedroom* (fig. 33), are negated by the concealed marital abuse that both partners inflicted and suffered. The very title she gave her seemingly welcoming, comfortable living room with fireplace, chairs, books, and various decorations, "Campground for the Battle of Washington Square," makes it clear that the sense of domestic tranquility conveyed by the hearth obscures its function as the battleground of the couple's daily existence, as well as of their struggle against New York University to avoid eviction from their apartment. In the latter conflict, the Hoppers were, for once, in agreement and worked together.[87]

In fact, the Hoppers' Cape Cod house joined their automobile as a primary site of discord in their marriage.[88] Jo complained that it was not her "idea of a house," but her husband's. It contained a large space for his work but no studio for her. She bitterly resented this arrangement, feeling that he was deliberately curtailing her creativity.[89] She also expressed unhappiness when he invited his family to their new home: "Our lovely little nest turned boarding house for me to cook for."[90] The very kitchen that Jo called "cute as the dickens" and rendered in images that evoke coziness became a place of discontent; she felt that she could not keep the floor clean, and the oil stove took too long to heat hot water for tea.[91] She resented the household work that home economics professionals and others still saw as the responsibility of modern women, whether they worked outside the home or not.

The tranquility of Edward Hopper's images, whether they include Victorian homes, automobiles, or roads, belies the turmoil of their creation and of the artist's life. They project a calm façade that hides the reality of his own marital discord. John Webster, the protagonist of Sherwood Anderson's *Many Marriages,* understands this about small-town homes in

Figure 32. Josephine Nivison Hopper, *Campground for the Battle of Washington Square*. Oil on canvas, 1947. Private collection. Photograph by Geoffrey Clements.

Figure 33.
Josephine Nivison Hopper,
Cape Cod Bedroom.
Oil on canvas, undated.
Private collection.
Photograph by Geoffrey
Clements.

general: "These houses . . . look like just ordinary houses . . . but they aren't like that at all. The outer walls are, you see, just things stuck up, like scenery on a stage. A breath can blow the walls down or an outburst of flames can consume them all in an hour. . . . I'll bet that what you think is that the people back of the walls of these houses are just ordinary people. They aren't at all."[92] Webster recognizes for the first time that his own ordinary family life was fraught with problems that resulted in part from sexual dysfunction. His own ordinary-looking, tranquil home contained unhappiness and loneliness, and was devoid of emotional and physical communication. He envisioned a great fire that would "run through the towns and cities" and "tear walls away," destroying "ugly houses" and thus releasing beauty and allowing intimacy within people's lives.[93]

Hopper's home life corresponded to Webster's vision of a domestic dwelling that projects outward peace but hides inner turmoil. Rather than sharing in Webster's desire to burn them down, however, Hopper instead painted images of tranquility and calm to replace the reality of his own angst-ridden marriage. Webster thinks that his problems reside in his house and hence flees his family with a lover; Hopper, too, may have thought that his problems stemmed from home, but he escaped through his idealistic depictions of elevated, beautiful, and tranquil homes suggestive of the hope for domestic harmony that sociologists and other experts claimed would be found in such settings.[94] Whether boarding-houses or single-family homes, Hopper's buildings suggest the values of a time gone by, the patriarchal family of the Victorian period, when the man

was indisputably in control.[95] He wanted to maintain control within his own family, while his wife often resisted it. Within this context, Hopper's representations of the road could signify his desire for flight from the home that was a discordant space.

Hopper's single-dwelling homes also could reveal this discord, for the sense of emptiness, the isolation of the buildings, and the lifelessness evoked in his painted images suggest the void that Webster, Hopper, and Jo felt in their own marriages. Rather than being a site of domestic harmony promised by sociologists of the day, Hopper's home may have become a location of conflict that makes the nostalgia in his paintings more poignant and the silences more frightening. This nostalgia is not necessarily for a bygone era, but is more likely a recognition of current transformations within the rural and country locales, the community of which was bleeding out as people moved to the city. Moreover, these images of houses are embodiments of empty shells that become hollow metaphors for the Hoppers' inability to realize their own companionship marriage. Rather than being celebrations of a previous lifestyle and type of community, these stark, empty homes with darkened windows could be Hopper's comment that the older and the current states of marriage and family life were not so wonderful.

Thus the sense of isolation within Hopper's paintings of homes extends beyond the threat of industrialization and urbanization to encompass the ideology of marriage in crisis within not only society at large but also his own union with Jo. The presence of sunlight in Hopper's paintings merely underscores the seeming lack of human warmth in these houses that may be a comment upon his own marital situation. Jo and Edward never divorced, but lived out the dysfunctional relationship that at times appeared in his artwork, especially in his images of sexualized women for which, as we shall see, Jo modeled.

Shifting Power Dynamics and Sexuality:

Edward Hopper's *Girlie Show* and

Office at Night

In Edward Hopper's *Girlie Show* of 1941 (plate 5), a burlesque queen performs a striptease before an audience. Although this work appears to present the woman as an object of desire for the masculine gaze, the stripper's muscular body looks somewhat androgynous and the power relations between the men and the dancer are ambiguous and problematic. When examined within the context of Hopper's marriage, the newly emerging companionship marriage of the 1920s, the sexual revolution between the two world wars, and twentieth-century burlesque theatre, the shifting power relations in this painting take on special significance.

Girlie Show is a central work in the lives of both Edward and Jo Hopper. It not only visualizes the changing sexual mores of the 1920s, 1930s, and 1940s, but also addresses the changing roles of women in family and public life. The painting reveals the power struggle between the Hoppers, and became one more battleground within their troubled marriage. Rather than merely reflecting these conflicts, the work became an active agent in a dialectic between husband and wife, artist and model, beholder and subject, male and female, and painter and manager.

Hopper's Models

The dancer in *Girlie Show* stands in the limelight before a male audience. Her red hair, ruby lips, and scarlet nipples, along with her blue high-heeled shoes and the blue drapery billowing behind her back, form the only areas of color in contrast with her pale skin, the gray curtain, and the beige

stage. The woman proudly displays her naked body to the audience, whose heads appear below the stage, at the bottom of the canvas. While the men focus on her performance and sexual allure, a drummer sits with his back to the dancer, his face visible, at the lower left. Other men in the audience are depicted with their backs to the viewer, underscoring their anonymity.

Hopper rendered this painting of American urban entertainment when the popularity of striptease had waned because of legal problems. Burlesque originated during the middle of the nineteenth century; by the 1920s, it included the striptease. During this decade, burlesque also moved from working-class to middle-class neighborhoods and audiences. Shortly thereafter and continuing into the 1930s, police raided theaters to control what some identified as salacious behavior that contributed to the corruption of youths and adults alike. For example, Fiorello H. La Guardia, mayor of New York City at the time, condemned burlesque as "the incorporation of filth." Representing the city in a lawsuit against the theater owners, an attorney contended that burlesque caused "many of our sex crimes" and appealed to "sex-crazed perverts," creating a public menace. Legislation closed burlesque theaters in New York City in April 1937. (One year earlier, the Burlesque Artists Association led a successful strike, petitioning for increased wages and attempting to professionalize

Figure 34.
Edward Hopper, *Study for Girlie Show*. Conté crayon on paper, 1941. Collection of Whitney Museum of American Art, New York, Josephine N. Hopper Bequest. Accession no. 70.134. Geoffrey Clements Photography. Photograph copyright © 1998, Whitney Museum of American Art.

Figure 35.
Edward Hopper, *Study for Girlie Show*. Conté crayon on paper, 1941. Collection of Whitney Museum of American Art, New York, Josephine N. Hopper Bequest. Accession no. 70.135. Geoffrey Clements Photography. Photograph copyright © 1998, Whitney Museum of American Art.

Figure 36.
Edward Hopper, *Study for Girlie Show*. Conté crayon on paper, 1941. Collection of Whitney Museum of American Art, New York, Josephine N. Hopper Bequest. Accession no. 70.136. Geoffrey Clements Photography. Photograph copyright © 1998, Whitney Museum of American Art.

Figure 37.
Edward Hopper, *Legs for Girlie Show*. Conté crayon and charcoal on paper, 1941. Collection of Whitney Museum of American Art, New York, Josephine N. Hopper Bequest. Accession no. 70.997. Geoffrey Clements Photography. Photograph copyright © 1998, Whitney Museum of American Art.

the industry.)[1] Thereafter, burlesque was performed in strip joints on Forty-second Street and still elicited protest from some; commentator Joseph Wood Krutch, for example, accused such lustful "public spectacles" of causing New York City to go "to the dogs."[2]

Hopper probably based his painting on a performance in a strip joint on Forty-second Street. Jo recorded in her diary on 30 March 1939 that he "has made such sketches at a burlesque & is juggling with advisability of attempting a canvas."[3] The preliminary drawings for *Girlie Show* focus on audience, stage, and nude dancer. In these renderings, Hopper agonized over the details. He concentrated on the men in the audience (fig. 34), the position and location of the drums and the drummer (fig. 35), the arrangement of the curtain and the column (fig. 36), and the pose of the dancer (fig. 37). He considered including a piano (fig. 38) and more details for the men in the audience, such as a hat, glasses, facial features, or bust-length bodies (figs. 34 and 39).

In the final painting, Hopper deemphasized the drums and audience so that the stage, curtain, column, and woman dominate the composition. He could have cropped the picture to concentrate exclusively on the nude woman, but instead included the stage and curtain to establish her theatrical occupation. He also could have included other acts; usually a

Figure 38.
Edward Hopper, *Study for Girlie Show*. Conté crayon on paper, 1941. Collection of Whitney Museum of American Art, New York, Josephine N. Hopper Bequest. Accession no. 70.145. Geoffrey Clements Photography. Photograph copyright © 2000, Whitney Museum of American Art.

Figure 39.
Edward Hopper, *Study for Girlie Show*. Conté crayon on paper, 1941. Collection of Whitney Museum of American Art, New York, Josephine N. Hopper Bequest. Accession no. 70.130. Geoffrey Clements Photography. Photograph copyright © 2000, Whitney Museum of American Art.

chorus number (Reginald Marsh in 1935 painted *Minsky's Chorus*) and two or three bawdy comics preceded the striptease that had become the chief attraction. Philip Sterling in *New Theatre* in 1936 explained that burlesque had a specific structure that involved various performances:

> The stripper sings a popular tune which is usually neither new nor tuneful. . . . She sings her first chorus fully clothed, although she is toying with the pins that secure her specially designed costume. On the second chorus the lights change and as she sings she begins to divest herself of either the bottom or top part of her gown. Half undressed she struts, dances or skips . . . timing the removal of the rest of her costume with her exit and the last bars of the music. On her third appearance she may have part of her gown thrown loosely about her but before she makes her final exit she is again totally disrobed save for a small beaded "G-string."[4]

Hopper included the G-string, perhaps to emphasize in Sterling's words that "burlesque . . . has been degraded from a once virile and lusty instrument of folk expression to a hollow, tinsel-draped shell, retaining only those features which are best suited to commercial exploitation."[5]

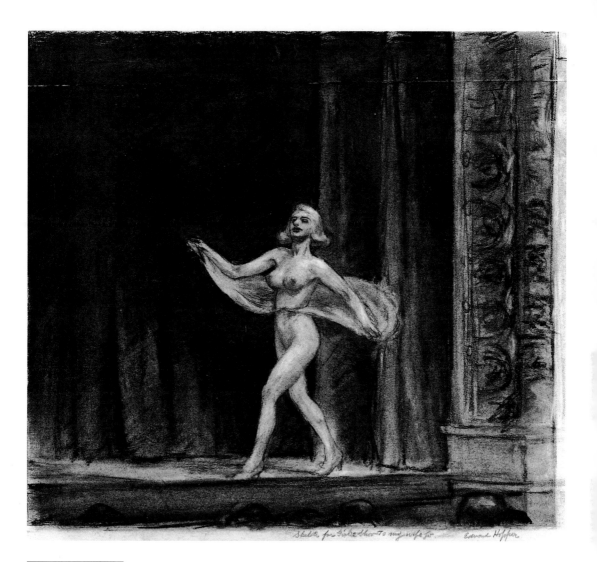

Skeleh for Girlie Show To my wife Jo Edward Hopper

Figure 40.
Edward Hopper, *Study for
Girlie Show*. Conté crayon
on paper, 1941. Collection
of Whitney Museum of
American Art, New York,
Josephine N. Hopper
Bequest. Accession no.
70.295. Geoffrey
Clements Photography.
Photograph copyright ©
2000, Whitney Museum
of American Art.

Another preliminary drawing for *Girlie Show* (fig. 40) shows the dancer's position onstage as she prances naked after removing her skirt. The pose remains roughly the same in the final painting, but the woman's body in this earlier drawing differs, with more curvaceous hips and larger, firmer, and rounder breasts. The woman's face in the drawing, although heavily made up, appears warmer than in the painting because of her softer features and rounder cheeks. The dark shadow beneath her chin that serves to harden her face in the painting looks lighter and smaller in the drawing.

Although Hopper copied details of the setting and the dancer from a performance in a burlesque theater, he used his wife as the model in his studio for the dancer's pose in the preliminary drawing (fig. 41). As Jo wrote her sister-in-law, "I [am] posing without a stitch on in front of the stove—nothing on but high heels in a tottery dance pose."[6] In the sketch

derived from her modeling, Jo, wearing open-toed, strapless shoes, steps forward, her left foot leading. The facial features and thick, shoulder-length, curly dark hair with bangs assure us that the woman indeed is Jo, the subject of numerous informal portraits, as evidenced by *Jo in Wyoming* (see fig. 23). In *Jo Hopper* (fig. 42), for example, Hopper rendered a genre scene of his wife clothed in sweater and pants, seated in a chair against a vague background of untouched paper. She seems to be knitting or sewing. A basket of yarn rests on the ground, casting a shadow. Hopper depicted the yarn in a generalized fashion, but rendered Jo's hair, clothing, and facial features in detail. She appears completely absorbed and content with her domestic activity as she knits. Rather than show Jo

Figure 41.
Edward Hopper, *Study for Girlie Show*. Conté crayon on paper, 1941. Collection of Whitney Museum of American Art, New York, Josephine N. Hopper Bequest. Accession no. 70.301. Geoffrey Clements Photography. Photograph copyright © 2000, Whitney Museum of American Art.

Figure 42.
Edward Hopper, *Jo Hopper*. Conté crayon on paper, 1934–40. Collection of Whitney Museum of American Art, New York, Josephine N. Hopper Bequest. Accession no. 70.289. Geoffrey Clements Photography. Photograph copyright Whitney Museum of American Art.

Figure 43.
Edward Hopper, *Reclining Nude*. Watercolor on paper, circa 1924–27. Collection of Whitney Museum of American Art, New York, Josephine N. Hopper Bequest. Accession no. 70.1089. Photograph copyright © 1989 by Geoffrey Clements Inc., New York.

naked and in the guise of another sexualized persona, Hopper depicted a seemingly warm and tranquil domestic scene. This image itself could be a construction, given their verbally and physically rancorous lives as well as Jo's repeated renunciations of the household chores that she felt took her away from her own painting. Jo's dress, hairstyle, lack of makeup, and body proportions, however, probably are more accurate renderings than her painted role as a voluptuous strip-tease artist. Even when Hopper did representations of Jo unclothed for works that do not function as preliminary drawings for final paintings, these informal images defy his tendency to sexualize the female body. In *Reclining Nude* (fig. 43), Jo appears unaware of her husband's presence. Her relaxed, informal position, combined with the lack of emphasis upon her breasts, indicates that when Jo is not "on show," Hopper could render her in less voluptuous and sexually charged modes.

Hopper often represented the female nude. Early in his career, he had painted the nude in formal poses in a studio, as evident in *Standing Nude* (fig. 44), or in less conventional and rhetorical poses in domestic interiors, as in *Summer Interior* (fig. 45).[7] In these nudes, Hopper always obscured the woman's face, thereby erasing her identity and individuality.

Between 1902 and 1904, Hopper created two paintings that show the male artist painting in his studio, a trope that signifies male creativity.[8] In these works, Hopper showed the model both from the front and from behind; he also placed the artist in different positions: in the foreground with his back to the viewer and in the distance, facing the viewer. In *Painter and Model* (fig. 46), the female nude is represented as "real" in one instance and "painted" in the other: she stands in profile in a self-conscious,

Figure 44.
Edward Hopper, *Standing Nude*. Oil on canvas, 1902–4. Collection of Whitney Museum of American Art, New York, Josephine N. Hopper Bequest. Accession no. 70.1269. Photograph copyright Whitney Museum of American Art.

Figure 45.
Edward Hopper, *Summer Interior*. Oil on canvas, 1909. Collection of Whitney Museum of American Art, New York, Josephine N. Hopper Bequest. Accession no. 70.1197. Geoffrey Clements Photography. Photograph copyright Whitney Museum of American Art.

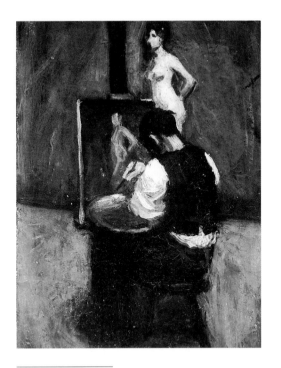

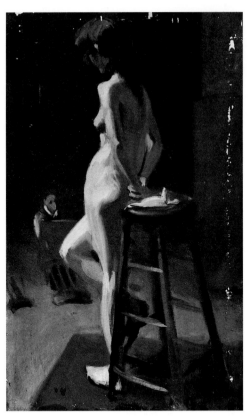

Figure 46.
Edward Hopper, *Painter and Model*. Oil on board, circa 1902–4. Collection of Whitney Museum of American Art, New York, Josephine N. Hopper Bequest. Accession no. 70.1420. Photograph copyright Whitney Museum of American Art.

Figure 47.
Edward Hopper, *Standing Female Nude with Painter in Background*. Oil on canvas, circa 1902–4. Collection of Whitney Museum of American Art, New York, Josephine N. Hopper Bequest. Accession no. 70.1258. Geoffrey Clements Photography. Photograph copyright Whitney Museum of American Art.

academic pose with her hands behind her buttocks while the artist concentrates on painting her.[9] In *Standing Female Nude with Painter in Background* (fig. 47), the model appears relaxed and possibly gazing directly at the artist, thereby placing her in a position of power;[10] but since we cannot see her face, we cannot determine where she is looking. She appears larger than the distant and seemingly more vulnerable male artist. In both works, nevertheless, the women remain the object of the painters' (and the viewer's) gaze, thereby establishing their passive role.

In these paintings, Hopper underscored the dynamism and tension between male and female: artist/model, creativity/muse, dark/light, clothed/nude, passive/active, seated/standing, foreground/background, and viewed from behind/viewed partially from the front.[11] In *Painter and Model*, Hopper truncated the woman's body so that her legs and hands are hidden, suggesting immobility and fragmentation. Hunched over, intensely engaged in painting, the artist in the picture is a barrier to the model and to his painting of her. Hopper contained and imprisoned the nude by confining the full view of her to the artist's painting; the top of the easel, like a bar, further imprisons her.

Hopper implied a similar confinement of his female subject in his more candid bedroom scenes. A greater intimacy than in the artist/model

paintings is evident in *Nude Crawling into Bed* (fig. 48). This painting, like his *Moonlight Interior* (1921–23) and *Evening Wind* (fig. 49), recalls the Ashcan artists' sense of spontaneity and intimacy, dark palette and fluid brushwork, closely cropped compositions, and sexualized imagery of working-class girls. In these earlier works, Hopper painted in a manner similar to John Sloan's *The Cot* (1907) and *Turning Out the Light* (fig. 50) by using the window to contain the subject, constructing boundaries between himself and the woman, and demarcating the private from the public realms.[12] Whereas Sloan frequently included pairs or groups of women to underscore their social lives,[13] Hopper rendered each woman alone in a seemingly hermetically sealed room within the domestic sphere. In

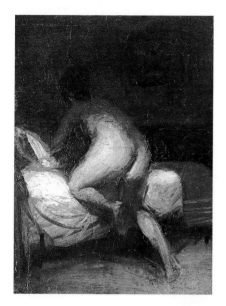

Figure 48. *(below left)* Edward Hopper, *Nude Crawling into Bed.* Oil on board, circa 1903–5. Collection of Whitney Museum of American Art, New York, Josephine N. Hopper Bequest. Accession no. 70.1294. Photograph copyright Whitney Museum of American Art.

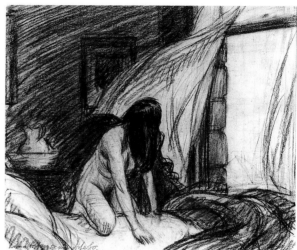

Figure 49. *(above right)* Edward Hopper, *Evening Wind.* Drawing for etching—conté and charcoal on paper, 1921. Collection of Whitney Museum of American Art, New York, Josephine N. Hopper Bequest. Accession no. 70.343. Geoffrey Clements Photography. Photograph copyright © 2001, Whitney Museum of American Art.

Figure 50. *(right)* John Sloan, *Turning Out the Light.* Etching on paper, 1905. Delaware Art Museum, Wilmington. Gift of Helen Farr Sloan. Accession no. 1998-171.

Evening Wind, for example, he showed the woman's containment and imprisonment within the home; the empty space outside the window is a metaphor for her inability to escape the domesticity that both imprisons and protects her. It is also the location from which the artist observes her.

The same sense of containment and regulation of female sexuality appears in *Eleven A.M.* of 1926 (plate 6) and *Morning in a City* of 1944 (fig. 51).[14] Hopper rendered the woman in the former as both visible and invisible. Her hair eclipses her face, identity, and personality. Although she is wearing only shoes, thereby emphasizing her nudity, her hunched seated position does not allow us to see her breasts and pubic hair (the latter is visibly present in his earlier *Summer Interior*). The woman's clasped hands and the chair in which she sits are further enclosures in *Eleven A.M.* The broadly brushed surfaces of her skin are a barrier to the woman's sexuality, which is nevertheless evident, given her state of undress. The room, however, creates compositional control through what Matthew Baigell identified as Hopper's "lock-in" technique: the line of the shadow cast by the window sash continues along the woman's back; her knees, similar in form to the chair arm, continue the horizontal

Figure 51.
Edward Hopper, *Morning in a City.* Oil on canvas, 1944. Williams College Museum of Art, Williamstown, Massachusetts, bequest of Lawrence H. Bloedel, Class of 1923. Accession no. 77.9.7.

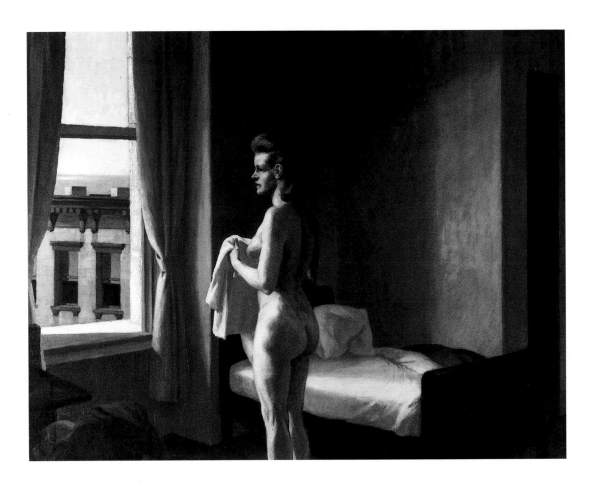

movement of the floor's edge on the left and the line of the shadow at the right; her arms reiterate the shapes of the window curtains and the window sill, while her shoes repeat the angular shapes across the bottom of the canvas.[15] This earlier female nude, like the ones in *Summer Interior* and *Morning in a City*, exposes the female body for the voyeuristic pleasure of the artist and the viewer, who peer at her from a vantage point within the room. The artist's (and our own) proximity to this naked woman who stares onto a city street during the daytime, when we expect her to be engaged in other activities, increases our unease over her sexuality and our voyeurism, and establishes reasons for her containment and regulation. She is a threat to herself, the artist, and to us, the viewer.

Hopper used various unknown models for his academic exercises and his more spontaneous-looking Ashcanlike nudes. After his marriage in 1924, however, his wife, at her insistence, became his most frequent model, as is evident in *Office at Night* (plate 7), *Girlie Show, Eleven A.M.,* and *Morning in a City*.[16] Jo and her husband, in fact, together created personas for the women in his paintings. As Jo explained, many of the women in Hopper's paintings have names that they invented. They called the woman in the theater in *Intermission* (fig. 52) "Norah," because she is Irish and a potential "egghead" who might become either "an efficient

Figure 52.
Edward Hopper, *Intermission*. Oil on canvas, 1963.
Private collection.

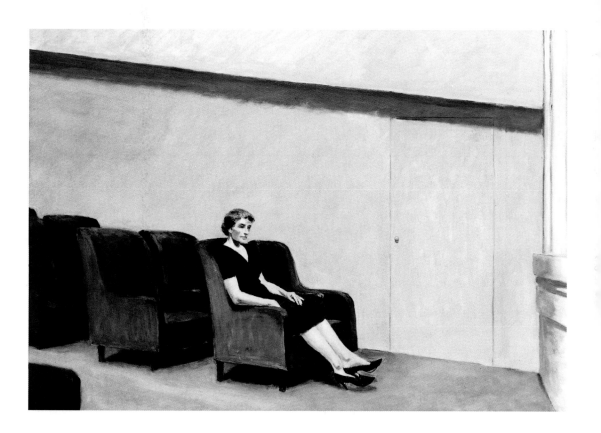

secretary or prize chatelaine of big house," according to Edward, or because she is "a maid or something on her night out," according to Jo.[17] They named the secretary in *Office at Night* "Shirley," while they called the couple in *Sea Watchers* (1952) "Sheila and Adam, Irish girl [and] Yankee clam digger."[18] Jo delighted in helping her husband construct the likenesses and fictional identities of the various women in his paintings.[19] Her interest in naming these women may derive not only from her earlier participation in local theatrical productions with the Washington Square Players in New York,[20] but also from her desire to collaborate in and even control the creation of Hopper's works.

In *Girlie Show*, Hopper transformed his wife into a highly sexualized and erotic spectacle. The stripper's facial features in the final work depart from those in the original drawing. Hopper changed his wife from a modest, middle-aged matron into a sexual siren. He also altered her body by nipping the waist; changing the shape of her breasts to enormous, conelike, pointed forms; muscularizing her legs; and elongating her torso. The stripper in the painting, who combines aspects of the preliminary drawings of his wife in the studio and the stripper in the theater, has sharper angles, as well as more muscular legs and a tighter abdomen. Her body and the highly made-up face are alluring.

A similar transformation occurs in *Office at Night*. In preliminary drawings for this work for which Jo modeled (fig. 53), the secretary becomes increasingly voluptuous and her body more curvaceous, buxom,

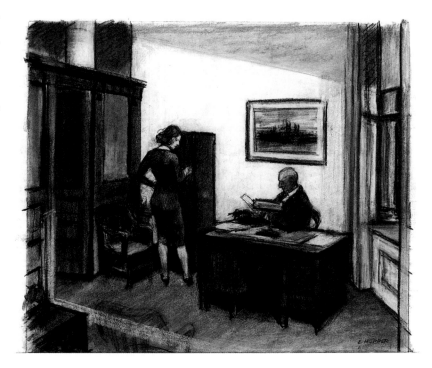

Figure 53.
Edward Hopper, *Study for Office at Night.* Conté crayon, charcoal, and chalk on paper, 1940. Collection of Whitney Museum of American Art, New York, Josephine N. Hopper Bequest. Accession no. 70.340. Geoffrey Clements Photography. Photograph copyright © 2001, Whitney Museum of American Art.

and visible through her tight-fitting dress.[21] In these drawings and in the final composition, she is locked in by the rectangle of the filing cabinet and the table located in the left corner; these two pieces of furniture establish through their edges a vertical and a horizontal axis, linking the woman to the typewriter and filing cabinet to define her secretarial duties. However, her softened facial features, business attire, and deferential yet relaxed pose in the preliminary drawings go through a process of transformation; the result features an exaggerated facial expression, clothing, and body parts that signify a sexually appealing and even threatening siren. It is impossible to determine where she is looking, because her eyes are in shadow, but she does not look at the viewer, or at her boss.

In the painting, Hopper created an off-center perspective with abruptly interrupted diagonals that angle obliquely away from the picture surface to create a more dynamic space.[22] The ground is tilted; the lines between the wall and floor are obscured; the side walls are not parallel; the scales of the secretary's table, the man's desk, and the filing cabinet fail to coincide; and the window and door lead to emptiness, creating the sense that this is a sterile room in which the workers experience physical, emotional, and spiritual alienation.[23] The distance between the woman's black right toe and the white paper on the floor beside the desk emphasizes the emotional void between the two figures, who are demarcated by the green filing cabinet and the dark brown table. Furthermore, the ample light area of the drawing, which creates an angle far above the people's heads in the drawing, is lowered and decreased in the painting, thereby contributing to a sense of enclosure as it marks the places that these two figures inhabit.

Hopper subverted the triangular relationship among typewriter, secretary, and boss that suggests collaboration in writing and typing.[24] He instead conveyed a subtext of tension, uncertainty, and alienation through various means: the tilted space, the psychological and physical separation between the figures (each seems spatially sealed off by confining rectangular spaces), and the failure to resolve the narrative action. The right edge of the foreground table, which connects with the background filing cabinet, is joined by the left edge of the central desk. The line created by this furniture forms an imaginary diagonal that moves from the left corner to the center of the painting, forming a physical barrier between the two figures.

This work thus suggests the separation of modern men and women within an impersonal, industrial, and commercialized environment, a different message from Hopper's earlier illustrations for journals (fig. 54) and his preliminary drawings for this painting, which evoke comradeship. The gender dynamics in *Office at Night* have additional implications in view of the work environment during this period. Consider a sketch for *System,*

Figure 54.
Edward Hopper, illustration from Carroll D. Murphy, "Living Up to Your Employment System," *System, The Magazine of Business* 24 (July 1913): 23. Courtesy of the Library of Congress.

Figure 55.
Edward Hopper, illustration from Carroll D. Murphy, "Buying More with Each Wage-Dollar," *System, The Magazine of Business* 23 (March 1913): 233. Courtesy of the Library of Congress.

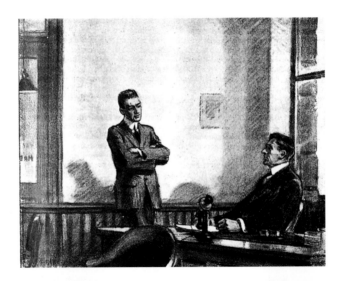

The Magazine of Business (fig. 55), in which a male boss and a female clerk are engaged in a seemingly collegial conversation.[25] "More than half this store manager's time is spent on the floor with his working force, and he thus maintains a personal bond with practically all of the rank and file of his organization,"[26] the text notes. The woman's pose, with arms outstretched on the counter, forward leaning position, and engaged facial expression, suggests her comfort with her employer, who appears gentlemanly and friendly, yet in control.

Ellen Wiley Todd has argued that Hopper's image of a successful private secretary in *Office at Night* places his subject within a privileged category, given the mechanization of office work in the 1930s and the resulting stenographic pools.[27] Successful women clerical workers depended on their efficiency and skill, as well as their good looks. As Elizabeth

MacGibbon argued in *Manners in Business* (1936), "The kind of girl who takes pains to make the most of herself in every detail of her appearance will also be orderly and painstaking in her work."[28] The dress code called for tailored outfits, tasteful makeup, and moderate jewelry; appropriate workplace behavior, according to Hazel Rawson Cades's *Jobs for Girls* (1928), meant "a combination of friendliness and reticence, of assurance and modesty, of ambition and willingness to do anything."[29] Women in the office as well as at home were expected to create a pleasant and efficient environment. Success as a clerical worker would naturally result in marrying a better sort of man, enabling a woman to continue her move up the social ladder.[30]

Hopper's secretary wears a tight dress that fits snugly over her curvaceous buttocks. Her makeup also appears extreme for a woman in her position. The man, on the other hand, wears an appropriately sober jacket, tie, and shirt, evoking dignity, self-control, and a commanding presence.[31] He dominates the space behind his large desk, while she seems to take up less room behind him.

The woman with her sexually alluring dress and body type thus seems responsible for the tensions inherent within the painting, even though the man ignores her. Hopper established her sexuality through his voyeuristic gaze as the artist. A similar claim can be made about Hopper's *Girlie Show,* in which a working-class woman gainfully employed as a stripper performs on a stage. Issues of class, sexuality, gender, and, as we shall see, marriage in crisis also play a role in this painting.

The Companionship Marriage and Sexuality

The first sexual revolution in the United States began in the last three decades of the nineteenth century and gained momentum in the Progressive Era, especially after 1910.[32] "A wave of sex hysteria and sex discussion seems to have invaded this country," one author proclaimed in 1913. He continued, "Our former reticence on matters of sex is giving way to a frankness that would even startle Paris."[33] In 1914, Margaret Sanger, the founder of the birth control movement, began to publish *Woman Rebel* and devote her energies to the promotion of family planning. That same year the Bureau of Social Hygiene, a grant-making agency funded by John D. Rockefeller Jr. that emphasized the study, amelioration, and prevention of social evils, particularly prostitution, began to publish *Social Hygiene,* a journal of the sex education movement. The publication attacked the Victorian "conspiracy of silence," although it continued to support some of the older values, especially the class and gender hierarchy. Founded in 1914 in cooperation with the federal government and other agencies, the American Social Hygiene Association

openly encouraged male sexual fulfillment and from the underground to the center stage of public discussion brought attention to what Kevin White has called the Underworld Masculine Primitive (through its focus on venereal diseases and prostitution).[34] Also during this period, both the British New Moralist Henry Havelock Ellis in his *Studies in Relation to Society* (1910) and *Studies in the Psychology of Sex* (1920) and the Swedish reformer Ellen Key in *Love and Marriage* (1911), *The Woman Movement* (1912), and *Renaissance in Motherhood* (1914) promoted the notion that women were sexually active and deserved fulfillment, linking erotic life to bodily health and spiritual harmony.[35]

After the First World War, the popularization of Freud and true-confession magazines, along with the erotic imagery of Hollywood films, girlie calendars and magazines, and contemporary novels, was responsible for these freer attitudes toward sexuality. The *New York Evening Graphic,* founded in 1924, specialized in sexually explicit materials and appealed mostly to the working class, but it also had a significant middle-class readership.[36] Art magazines such as *Art Studies, Art Poses, Art Models,* and *Art Albums* contained images of nude women in the guise of "art." In the opinion of one critic of the day, these picture books had as their "primary object . . . pseudo-pornography."[37] Social therapist Katharine Bement Davis in *Factors in the Sex Lives of Twenty-Two Hundred Women* (1929) and medical doctor Gilbert V. T. Hamilton in *A Research in Marriage* (1929) pioneered the use of scientific methods to study women's attitudes toward sex. They discovered that the recent lifting of "old repressions, taboos, and inhibitions" enabled most women to be "wholly responsive, warm in their affections, and capable of finding as much in the close intimacies of love as do their partners."[38] As we have seen, Judge Ben B. Lindsey's *Revolt of Modern Youth* (1925) and *The Companionate Marriage* (1927) further popularized the notion of and debate over the sexual revolution. Victor F. Calverton, the outspoken American leftist who wrote about marriage and sex, concluded that "sex ha[d] become an obsession."[39]

Studies on sexuality in courtship and marriage continued to be published during the 1920s and 1930s: Robert L. Dickinson, *A Thousand Marriages: A Study of Sex Adjustment* (1931); Hannah and Abraham Stone, *A Marriage Manual* (1939); Dorothy Bromley and F. L. Britten, *Youth and Sex: A Study of Thirteen Hundred College Students* (1938); Lewis Terman, *Psychological Factors in Marital Happiness* (1938); and Alfred Kinsey, Wardell Pomeroy, and Clyde E. Martin, *Sexual Behavior in the Human Male* (1948), to name a few. Sex manuals proliferated, focusing especially on female sexuality, the role of sex in marriage, and birth control.[40] These publications also discussed premarital sex, masturbation, sexual positions, and orgasms. So did personal advice columnists, such as Doris Blake in the *New York Daily News* and Martha Carr of the *St. Louis Dispatch,* who addressed

sexual matters of concern among middle-class men and women.[41] Gynecologist Theodore H. Van De Velde wrote a best-selling manual about sex, addressing these issues and others within the context of the "Ideal Marriage," while the American Social Hygiene Association, originally formed to address the spread of venereal diseases and to educate men about avoiding them, encouraged sexual pleasure in marriage.[42]

As a result, the Victorian "conspiracy of silence" finally ceased. The working-class public dance hall subculture of the early twentieth century had encouraged lewd language, quick and easy relationships, and unrestrained male sexuality. This more "primitive" culture spread into the mainstream, especially influencing younger people, as did the elite attitudes of the bohemians. The new ideology of sexual expression replaced the Victorian ideology of repression, and sex became the central symbol of youth's rebellion against the older generation's authority and prudery. Middle-class heterosexuality emerged as the dominant and "normal" mode of behavior during a period when manhood was being subverted within the business workforce. As George Chauncey explained, "Middle-class men increasingly conceived of their sexuality—their heterosexuality, or exclusive desire for women—as one of the hallmarks of a real man."[43]

Physicians, social workers, social scientists, and psychologists promoted the romantic companionship marriage to contain the new sexuality that they perceived was threatening the moral codes of the past. In reforming the Victorian system, they incorporated new patterns of sexual behavior from radical and bohemian urban communities, the working classes, middle-class youths, and African-American culture to establish this new concept of marriage. By the 1930s, companionship marriage had become the predominant cultural ideal for sex and gender relations.[44]

As Katherine Davis's study indicates, however, these changes did not occur without tension. Women were anxious about their erotic enjoyment, and men felt torn between acting on their "natural" impulses and taking on the restrained role of husband and father that society expected of them.[45] As writer Sherwood Anderson observed, a "healthy new frankness" existed "in the talk between men and women, at least an admission that we were all at times torn and harried by the same lusts." This new openness led to anxiety between the sexes.[46] The conflict between the more open sexual expression of the modern era and lingering Victorian attitudes underlies the myriad reasons for divorce cited in the records of the 1920s. Some husbands felt uncomfortable with their wives' history of premarital sex; others expressed frustration over their wives' inability to enjoy sex. Some women wanted to escape what they considered their husbands' rough lovemaking, a description that could imply violence or perhaps the woman's distaste for sex itself.[47] Men found the sexual demands of the New Woman bewildering and responded by focusing

on their careers, having affairs, or leaving their feminist wives for more traditional partners.[48]

The ideology of companionship marriage mediated between the reaffirmation of Victorianism by social hygienists and the radicals' and youngsters' vision of sexual liberation. It imposed institutional order upon what the experts perceived as sexual disorder by encouraging erotic pleasure within the confines of the husband-wife relationship.[49] As Kinsey and his associates reported in 1948, "Marital intercourse is the one type of sexual activity which is approved by our Anglo-American mores and legal codes. . . . Society is interested in the nature of marital intercourse because it is interested in the maintenance of the family. . . . Society is also interested in maintaining families as a means of providing a regular sexual outlet for adults, and as a means of controlling promiscuous sexual activity."[50] Sex, in other words, was sanctioned within the confines of matrimony.

Companionship marriage depended on an active and mutually enjoyable sex life characterized by equality and comradeship. "Harmony and mutual satisfaction in the sexual sphere is likely to be the sustaining vital health of the marriage as a whole," proclaimed one sociologist in 1932.[51] As Van de Velde maintained in his *Ideal Marriage*, "In its ideal form, husband and wife take a fully equal and reciprocal share in this most intimate merging; their souls meet and touch as do their bodies; they become *one*. . . . If, anywhere and in any circumstances, the demand for equal rights for both sexes is *incontestable*, it is so in regard to equal consent and equal pleasure in sexual union."[52]

This democratic emphasis, however, masked the reality of women's continued subordination in marriage and in society as a whole, and the passivity men expected from female sexuality. Still subordinate to men, women felt caught between the past and present. Feminist and radical Emma Goldman best articulated this predicament. Women today, she wrote, are "longing for fulfillment very few modern women find because most modern men too are rooted in the older traditions. They too want the woman more as wife and mother than as lover and friend. The modern women cannot be the wife and mother in the old sense, and the new medium has not yet been devised."[53] Men still dominated in sexual relations and were confused by the expectation that they should be both aggressive and gentle. Although birth control became the norm, married women were still expected to have children after a few years of marriage. "In man the sex instinct is primary and the paternal instinct secondary and latent," argued another critic, William Robinson, in 1919. "In woman the maternal instinct is primary and the sex instinct secondary and latent." Marriage reformers may have attempted to make marital sexuality more enjoyable for women in order to keep their discontent from destabilizing the family.[54] Indeed, these advice texts saw sexuality in marriage

as not only a way to maintain the family, but also a means of weakening the Victorian acceptance of same-sex love, which by the 1920s had become pathologized as a sexual deviance.[55]

The Hoppers expressed similar anxieties in their marriage. Jo shared with other women a discomfort with her Victorian upbringing and an inability to reconcile it with the newer, more open sexuality that encouraged experimentation and pleasure; she expressed unease about sex with her husband. Yet his *Sacrament of Sex* (fig. 3) suggests that she controlled their sexual interactions, and that he was uncomfortable with the changing female sexuality that Jo did not realize she exhibited. She confided in her diary on 12 October 1944 that she seldom felt comfortable in her sexual relationship with him, concluding that "the whole thing was entirely for him, his benefit." He refused, she wrote, to allow her to discuss this topic with other women, to "consult . . . over the mysteries," especially her discomfort with her failure to enjoy "attacks from the rear."[56] Her anxieties echo those expressed by women in divorce cases, confided in the chamber of Judge Lindsey, addressed in some of the sex manuals, and discussed in popular journals (albeit with less frankness). Although Jo chose not to divorce her husband, the state of her marriage reflected that of women seeking divorces in the 1920s and 1930s. Like many other women of the period, she could not reconcile her Victorian upbringing with what she perceived as her husband's more aggressive, brutal, and dirty behavior.

Shifting Power Relations

We can discern the troubled dynamics in Jo and Edward's marriage in *Girlie Show* and also in *Office at Night*. In both works, Jo seems to lose her personality and individuality in different sexually charged masquerades in which she is mute and paralyzed, controlled and manipulated. However, as Todd has shown, the more we examine *Office at Night,* the more the power relations between man and woman become obscure. The secretary's "'power' in the workplace came from her ability to behave in a deferential 'womanly' manner," performing "domestic skills" in "the public sphere," where her boss reigned. In *Office at Night,* she towers above the seated male, who sits imprisoned behind the desk. She, however, "never generates an activity but must wait for instructions" from her employer, thereby underscoring her subordination.[57] These shifting power dynamics between secretary and boss, considered within the context of the Hoppers' marriage, suggest that the question of who is in control applies not only to the workforce, but also to their relationship, especially since Jo had more room to maneuver and assert herself (especially verbally) in her marriage than a secretary in the office.

In *Girlie Show,* Hopper, on the surface, seems to render his wife as the object of desire. The painting thus appears to present the polarization between artist/model, masculine/feminine, voyeur/exhibitionist, active/passive. The men in the audience are the surrogates for the artist's masculine gaze. The woman, on the other hand, exists as a spectacular, sexual, and silent female body—a fascinating representation, given Jo's refusal to be silent. Within the context of the art magazines of the 1930s, Hopper's *Girlie Show,* as well as his other female nudes, masks the pseudopornographic arousal for sexual pleasure in the guise of high art. During this period, images of women's bodies were removed from the margins of obscenity to the center of mainstream popular culture in the form of "pinup" girls, girlie calendars, girlie magazines, and *Esquire* magazine illustrations, marking the shifting and contested boundaries of respectable female sexual display and visual pleasure in which *Girlie Show* participates.[58]

The stripteaser, however, asserts her control over the audience by flaunting her naked body, thus threatening patriarchal authority. She appears powerful as she self-assuredly struts across the stage and manipulates the blue cloth behind her body to reveal her nakedness. Her muscular calves, arms, thighs, and buttocks convey strength, as do her confident posture and facial expression.

Figure 56.
Reginald Marsh, *Gaiety Burlesque.* Egg tempera on canvas mounted on masonite, circa 1930–33. Hunter Museum of American Art, Chattanooga, Tennessee, gift of the Benwood Foundation. Accession no. HMAA. 1976.3.21. © 2002 Estate of Reginald Marsh / Art Students League, New York / Artist Rights Society (ARS), New York.

Hopper's muscular stripper contrasts with Reginald Marsh's fleshy, voluptuous women, who appear at times coy and provocative, but are never challenging to their different audiences. Marsh's strippers exhibit the same type of overt sexuality as his Fourteenth Street shoppers, taxi dancers, live models, and Coney Island bathers—women with fleshy, protruding breasts and buttocks.[59] In *Irving Place Burlesque* (1930) and *Gaiety Burlesque* (fig. 56), his ubiquitous buxom performer faces an audience of leering men fixated on her body in an almost caricaturelike manner to emphasize, in the artist's words, that "the burlesque show is a very sad commentary on the state of the poor man. It is the only entertainment, the only representation of sex that he can afford."[60] Marsh's male audience, like that in Thomas Hart Benton's *Burlesque* (1922), represents the "primitive underworld" where men's passions could be exhibited outside the more genteel domestic sphere.[61]

Hopper's audience, on the other hand, appear more sober and restrained in their dress and behavior. Although we cannot see the men's expressions, it is difficult to imagine that they have the lewd faces of Marsh's men. Instead, they appear to represent the older model of gentleman thrust into the commercialized modern arena of sexual expression, who attempt to reconcile their own sexual repression with the sexuality openly displayed on the stage. Hopper's early drawings of the audience had, in fact, provided some clues to personality through glasses, hats, or visible facial features. In the final painting, he removed the audience's individuality, thereby suggesting generic men trapped not only between the stage and the edge of the canvas but also by the temptress's overt and brazen sexuality, and between their own "primitive" desires and older Victorian beliefs.

The strippers in Hopper's, Marsh's, and Benton's burlesque scenes dominate the stage as well as the men who are positioned below it. In Hopper's painting, the spotlight zeroes in upon the prancing entertainer, whose dazzling, highlighted flesh stands out against the gray curtain and blue cloth. She moves energetically across the stage to mesmerize and arouse the inert spectators. Their disembodied status of staring men—mere heads without bodies and faces—underscores their inability to act beyond looking.

In this sense, the men become subordinate to the burlesque queen. The tensions expressed in Hopper's earlier images of the artist and anonymous model are at work in *Girlie Show*. The dichotomy between male and female, clothed and naked, and audience and performer appears stable. However, judgments about control and power, submission and subordination are slippery. Men and women appear either empowered or disabled, depending on the viewer's interpretation of the dynamics between the two polarities. William Dean Howells best summarized the

contradictions inherent in the striptease act and in Hopper's work when making this observation about theatrical actresses: "Though they are not like men, [they] were in most things unlike women . . . a kind of alien sex, parodying both."[62] Hopper portrayed his dancer ambiguously—she is both feminine and masculine. While the breasts clearly show her womanliness, her muscular legs and her position of power are traditionally associated with masculinity.

As a result of the woman's androgynous depiction, questions arise. To what degree does the woman's muscularity masculinize her? Do her facial features suggest control and danger? Does the men's act of staring assert a sense of domination? Do their inert bodies suggest paralysis as a result of her sexual allure, or are their elongated, dark shapes suggestive of phalluses that evoke patriarchal power? And what about the drummer who refuses to turn around and gaze at the performer? Does his indifference lessen whatever control she might exert through her sex appeal and augment her objectification?[63]

Similar questions arise about Jo's modeling. On the one hand, Hopper transformed her into a silent, highly erotic object of desire. At the same time, Jo herself actively participated in her husband's creative process, delighting, for example, in the increased sexualization of her figure in *Office at Night*. In the preliminary drawings for this work for which Jo modeled, Hopper presented her in an increasingly voluptuous manner in a tight-fitting dress, and he added more makeup. About this painting, she noted in her diary, "I'm to pose for the same [female fishing in a filing cabinet] tonight in a tight skirt short to show legs—Nice I have good legs and up and coming stockings." In the record book she kept on his paintings, she emphasized the secretary's modern, overt sexuality in terms of dress and makeup, writing that she wears "a blue dress, white collar, flesh stockings, black pumps & black hair & plenty of lipstick."[64] From the 1920s and into the 1940s, shorter skirts, silk stockings, and cosmetics became the insignia of the first sexual revolution. In *Girlie Show* and *Office at Night,* the lavish makeup, streamlined eyebrows, carefully coifed hair, and nudity or tight-fitting dress (all, except for nudity, absent in the sketches taken from life) reflect both Jo's and Edward's desire to exaggerate the women's sexuality and to convey ambiguity about their status as "good" or "bad."

The woman in *Girlie Show*, in fact, merges into one figure the virgin/whore typos, a contradiction that has prevailed for centuries.[65] The dancer stands on a stage as if on a pedestal, to be viewed and admired, but not touched. Yet she is also a seductive and debased woman. Her angular, hardened features and darkened eyes—not seen in the preliminary sketch of Jo and in Hopper's more detailed drawing, but found in *Office at Night*—suggest a femme fatale who seduces and destroys her lovers. Her

pointed nipples look missilelike and dangerous, almost as if they could tear flesh. Hopper has turned the rounded, soft, and nurturing forms in the headless nude torso taken from life into bizarrely hardened and seemingly fake, threatening breasts. The breasts and face combine with the ominous black silhouetted shadow to affirm a sense of danger. Hence Hopper evoked the old male fear of being devoured by a sexually voracious female, which the painting reinforces through the diminutive quality of the men in the audience, who are overshadowed by the dancer's sexual energy.[66]

The fusion of Madonna and whore in *Girlie Show* embodies the confusion that many young men expressed as women in the middle classes gained greater control over their sexual interactions with them. Middle-class men admitted that they could no longer easily tell a "loose" woman or a prostitute from a virtuous middle-class woman, who rouged her face, bobbed her hair, and dressed provocatively. Fashionable dress and contemporary manners broke down the formerly clear distinctions between the two types.[67] This same confusion applies to *Office at Night,* in which the deferential yet dominant female figure, with her angular facial features, dark, ruby lips, blackened eyes, and buxom body, evokes the siren. Her boss understandably might be confused about her status, given her dress and demeanor—is she a hardworking employee or a femme fatale? As a contemporary commented in 1937, "The world seemed to be populated only by women of easy virtue and men who thought and planned nothing else but their seduction."[68] Viewed from this perspective, the boss may very well be consumed by licentious thoughts, even if uncertain about his secretary's virtue. However, neither his facial expression, his position behind the desk, nor his concentration on work suggests that her allure affects him.

With her modest dress and unfashionable ponytail, Jo rejected the New Woman look that she deliberately adopted for *Office at Night.* She willingly posed as a more enticing type for her husband's fantasies. The women in *Office at Night* and *Girlie Show* are engaged in their respective occupations, middle-class secretary and lower-class stripper, not unlike the models in Hopper's earlier artist/model paintings. Voluntarily or involuntarily, Jo abandoned her career as an artist to work as her husband's privileged model. She received no payment for her services, although Hopper supported her financially. While she railed against him and the strictures of their marriage, she also enjoyed a certain level of power in her multiple roles of wife, model, secretary, and business partner. That power becomes more evident when we consider that Jo modeled for other paintings in which her husband transformed her into sexualized and somewhat commodified women. Even *Hotel Room* (plate 4), *Summertime* (fig. 57), *Summer Evening* (1947), and *High Noon* (fig. 58), for which

Jo modeled, contain sexual tension and allure, since she wore close-fitting and revealing garments. This is especially evident in *Summertime*, in which the flesh color of the breasts clearly shows through the woman's seemingly transparent white dress. In fact, one minute touch of the brush with a slightly darker red pigment suggests the nipple of her left breast. The preliminary drawing for this painting indicates that Hopper's initial conception—probably derived from life—contained a more modest, businesslike woman in sedate dress and hat.

Figure 57.
Edward Hopper, *Summertime.* Oil on canvas, 1943. Delaware Art Museum, Wilmington, gift of Dora Sexton Brown.

Figure 58.
Edward Hopper, *High Noon.* Oil on canvas, 1949. The Dayton Art Institute, Ohio, gift of Mr. and Mrs. Anthony Haswell. Accession no. 1971.7. Photograph © 1971, The Dayton Art Institute.

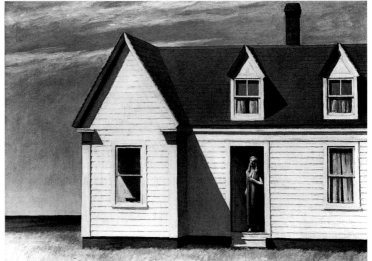

Nonnarrative Genre Scenes

As many critics and art historians have observed, Hopper created works in which "a moment of time is stopped, frozen,"[69] as if, as Gail Levin pointed out, his works were "seen through a shifting camera lens," creating "frozen frames from a movie."[70] As Hopper told Lloyd Goodrich in an interview, "I didn't want just to paint people grimacing and posturing."[71] In other words, he wanted to retreat from his earlier training and profession as an illustrator, where "the editors wanted people waving their arms," to create a denarrativized scene in which nothing happens either before or after the moment rendered.[72] By eliminating exaggerated gestures and facial expressions, Hopper stopped the narrative action.

In *Hotel Room* (plate 4), *Eleven A.M.* (plate 6), and *Office at Night* (plate 7), Hopper provided some clues about the profession and/or class of the figures, but the stasis created by the rectilinear compositions and lack of clear interaction among figures or within settings leaves a series of unanswered and unanswerable questions, thereby creating nonnarrative genre scenes. *Eleven A.M.*, for example, lacks the anecdotal quality, slick surfaces, and minute details evident in Lily Martin Spencer's *Shake Hands?* (fig. 59). Unlike a typical genre scene in which a woman is clearly located within the domestic sphere—a comfortable home with children and servant, *Eleven A.M.* shows a nude woman looking out a window. Why is she nude, wearing only high heels? What is she looking at or thinking about?

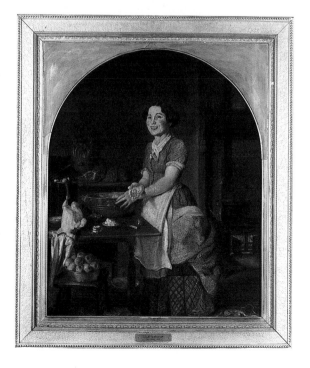

Figure 59.
Lilly Martin Spencer, *Shake Hands?* Oil on canvas, 1854. Ohio Historical Society, Columbus.

Is she married or single? Hopper created a similar sense of stilled action in *Office at Night,* where the only movement appears in the billowing window shade and string. This slight movement suggests a breeze, which has caused a paper to fall on the floor. Will the secretary stoop to pick it up, or are the figures frozen in the positions defined by the furniture?[73]

This stilled-action technique evokes cinema, an art form that Hopper appreciated and that formed the subject for a number of other works, most notably *New York Movie* of 1939 (fig. 60). Indeed, each of his paintings can function like a movie still, a scene that is frozen in time or a fragment removed from a spatiotemporal narrative. Nevertheless, an act of interpretation takes place between the spectator and the image, for, unlike cinema, the viewer is invited to create his or her own story. In other words, in Hopper's works, the narrative implied through the figures, objects, and settings is never completed. Consequently, the narrative consists of both absence and presence: incomplete information is provided by the artist, while the viewer, filling in the details, creates his or her own narrative. As Wolfgang Iser explained about the reader's response to literature, the serialized novel uses a cutting technique in which the action is deliberately interrupted, thereby creating a tension that demands to be resolved

Figure 60.
Edward Hopper, *New York Movie.* Oil on canvas, 1939. The Museum of Modern Art, New York, anonymous gift. Photograph © 2000 The Museum of Modern Art, New York.

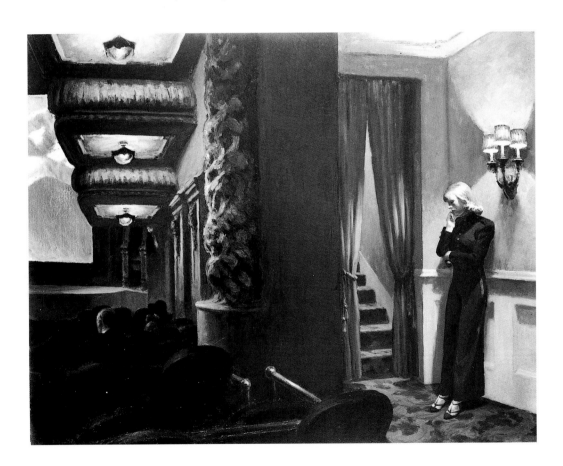

by the reader, who tries to imagine the continuation of the action.[74] Like a film, however, the serialized novel continues; the gaps eventually will be filled. Hopper's viewers, on the other hand, must create this resolution on their own.

Early striptease performances contained a narrative context for the woman's undressed state, showing her preparing for bed or performing her toilette. By the late 1920s, however, this narrative context had disappeared. American Studies scholar Robert C. Allen argued that the striptease no longer needed a "story to support it as spectacle," for it functioned as "a narrative drama of sorts—a tale of revelation that always begins and ends in the same way—but makes no reference to any larger narrative that 'explains' why the stripper should be removing her clothing. In place of that larger narrative is the self-evident rationale provided by spectacle: the stripper is what she does, and does what she does because of who she is." The nude body creates a "textual disturbance" that disrupts or suspends the narrative, creating a "continual eruption of feminine sexual display" in which the "specter of women's sexuality and all the mystery and power it represents continues to hover over the spectacle of the woman onstage no matter how much the male viewer is made to feel in control."[75] By taking away the narrative, the female loses her voice and narrative purpose, but she gains power and control.

As Allen suggested, then, eliminating the narrative content for the striptease silenced the women but also created a more problematic relationship between the object of desire and the onlooker, something that occurs in Hopper's other nonnarrativized paintings. In *Girlie Show,* Hopper similarly eliminated the narrative that had provided the background for the woman's nakedness showing his stripper disrobing for the sake of creating a sexual spectacle out of her body.

Craig Owens's comments about the postmodern photograph or film still are of special interest in this context. The gaze in a photograph or film still "punctuates (arrests, suspends) and punctures (pricks, wounds)," Owens explained. "If, posing for a photograph, I freeze, it is not in order to assist the photographer, but in some sense to resist him, to protect myself from his immobilizing gaze."[76] Further, "to strike a pose is to present oneself to the gaze of the other as if one were already frozen, immobilized—that is, already a picture." The pose mimics "the immobility induced by the gaze, reflecting its power back on itself, forcing it to surrender." It threatens the gaze by immobilizing it.[77] The subject, in other words, resists by adopting the pose that the artist then captures. Hopper's nonnarratives focusing on sexualized women thus function like the spectacle of the actual stripper in burlesque theater who disrupts or suspends the narrative with her self-imposed stance and threatens the viewer's power.

By modeling for Hopper's paintings, was Jo immobilizing the gaze of the viewer and of her husband, subverting the power of their stare? Although Owens suggested that some models (those who freeze in an artificial way) are thwarting the photographer or cameraman, in the Hoppers' case, the model both assisted and resisted the artist. In *Girlie Show* and *Office at Night,* Jo and Edward together created a spectacle of modern urban work or leisure in which the woman parodies, inverts, and challenges her traditional role in society. At the same time, Hopper transformed his wife—a member of the respectable middle class—into a sirenlike secretary or debased stripteaser to challenge and control her sexuality, as well as to assert his virility. In modeling for her husband, Jo used her husband's desire to paint her to challenge the sexual dynamics of their relationship. Adding complexity, Hopper dedicated his two preliminary drawings of the female nude for *Girlie Show* to his wife. By inscribing this dedication, did he hope to acknowledge her role in the creation of this work? Or did he intend to appease her by dedicating these voluptuous, sexually charged images to her, thereby asserting that she remained the inspiration for his painting?

Hopper's nudes embody and reflect the sexual revolution of the 1920s through the 1940s. The containment and regulation that are evident in *Summer Interior* (fig. 45), *Evening Wind* (fig. 49), *Eleven A.M.* (plate 6), and *Morning in a City* (fig. 51) may correspond to the controls that social scientists were trying to place on the new overt sexuality of American culture through the ideology of companionship marriage. *Girlie Show* does not embody this sense of containment. Instead, it addresses and exploits the complexities of the culture's more open sexuality. It functions as the extreme sexualization of the female, and it is the culmination of Hopper's transformation of his wife into a siren. At the same time, *Office at Night* and *Girlie Show* exemplify the confusion that men felt in response to women's changing sexual behavior. These paintings also reflect Hopper's anxieties about his relationship with his wife. Just as the social scientists attempted to impose order upon sexual disorder through a new form of marriage that encouraged mutual erotic pleasure, Hopper through his paintings, especially *Girlie Show,* imposed restrictions upon his marriage to Jo that she both resisted and submitted to.

Georgia O'Keeffe

The Sexualization of Georgia O'Keeffe
As Woman and Artist

Like Hopper, Stieglitz used his wife as a model. O'Keeffe, however, did not insist upon being her husband's favored model, unlike Jo Hopper; in fact, she felt uncomfortable with aspects of this role. And instead of reaching the impasse in her career that Jo experienced—arguably because of Edward's and the critic's marginalization and dismissal of her work—O'Keeffe benefited from her husband's position as a well-known photographer, proponent of modernism, and gallery owner. Moreover, Stieglitz actively promoted O'Keeffe's art, being responsible for her introduction to and promotion in the New York art world.[1] He encouraged and supported her creativity and, as art historian Barbara Buhler Lynes persuasively argued, used a loosely Freudian vocabulary to position her as a woman artist whose work embodies female anatomy and eroticism.[2] This positioning helped make her famous during the first few decades of the twentieth century, but she adamantly rejected it throughout her life. Stieglitz's photographs of O'Keeffe, his critical interpretations, and his influence on other critics resulted in a sexualization of this female artist that takes on added significance in the context of their artistic careers, their relationship, and the discourse on sexuality outside of and within marriage between 1916 and 1946.

Passion had come of age in the United States, and more lifestyle options existed for unmarried and married people alike, resulting in the possibility of a more sexualized and eroticized path to marriage or single adulthood. Stieglitz contributed to this atmosphere through his sexualization of O'Keeffe's art and of her body. O'Keeffe also played a role in this

greater awareness of female eroticism through her participation in the creation of Stieglitz's nude photographs of her and through her nonobjective charcoals and paintings of flowers that embody her feelings about specific relationships with men.

O'Keeffe's Embodiment of Passion

O'Keeffe's early nonobjective charcoal drawings, which she called *Specials,* derived from her intense feelings for Arthur Macmahon, a political science professor whom she met at the University of Virginia while teaching there during the summer of 1915.[3] They shared interests in art, hiking, camping, and feminist issues (he had given her Floyd Dell's *Women as World Builders* to read). That fall, Macmahon returned to New York City; O'Keeffe settled in Columbia, South Carolina, where she was teaching at Columbia College for the academic year. Their romance seems to have involved much correspondence and infrequent meetings. When they were together for four days over Thanksgiving vacation, their relationship accelerated, resulting in their first kiss. The artist was "nearer being in love with him" than she felt comfortable with, fearing an attraction that would swallow her whole.[4] "I want to put my hand on your face and kiss you today—not your lips—it's your forehead—or your hair," she wrote him on Christmas Day.[5] She told her friend Anita Pollitzer that her time with Macmahon left her feeling "stunned" and unable to collect her wits.[6] To express her newfound feelings, O'Keeffe created her *Specials* between 1915 and 1916, producing them almost in a frenzy while crawling on the floor. "I'm trying to say—I don't seem to be able to find words for it," O'Keeffe explained.[7] As she wrote Macmahon in January 1916, "I said something to you in charcoal."[8] Upon hearing a rumor about him that made her "bubble bust," O'Keeffe expressed relief that "those drawings are gone." "I'll not want to see them again unless by some accident—or happenstance find that my bubble didn't break."[9]

O'Keeffe's relief that she no longer could see these intense works indicates that for her, they embodied her passion for Macmahon. She had sent them to Pollitzer, who showed them to Stieglitz. They were his introduction to the artist and her art, and he decided to exhibit them. Whether the pulsating rhythms of these undulating works convey specific emotions related to love or even the sex act remains unknown. Brought up with Victorian notions of courtship and sexuality and living through a time when these conventions were being challenged and restructured, O'Keeffe seems to have channeled her anxieties and feelings into these drawings.

The *Specials* depart from O'Keeffe's earlier academic exercises of realistic still lifes and landscapes executed in earth tones with rich impasto. Here she employed charcoal to create monochromatic, asymmetrical, and

Figure 61. *(right)* Georgia O'Keeffe, *Special No. 4.* Charcoal on paper, 1915. National Gallery of Art, Washington, D.C., The Alfred Stieglitz Collection, gift of The Georgia O'Keeffe Foundation. Accession no. 1992.89.6. © 2002 The Georgia O'Keeffe Foundation / Artist Rights Society (ARS), New York. Photograph © 2000, Board of Trustees, National Gallery of Art, Washington.

swirling forms. *Special No. 4* (fig. 61), for example, contains three elongated, looping shapes of varying shades of black and gray with blurred edges that merge with the background of similarly gentle, rhythmical forms. *No. 8 Special* (fig. 62) contains more rounded, furling shapes that curl and fold into a central motif that, given interpretations of these works as "womblike," can be seen within this context (the center evokes a fetus that is now recognizable via sonograms, something O'Keeffe could not have known).

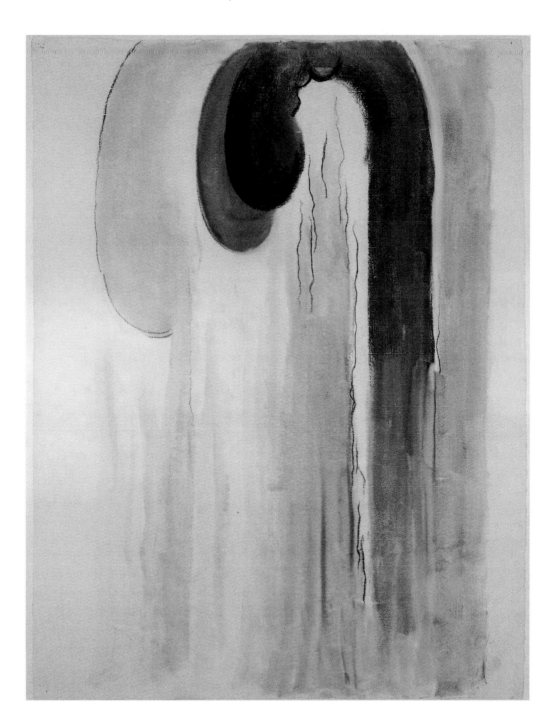

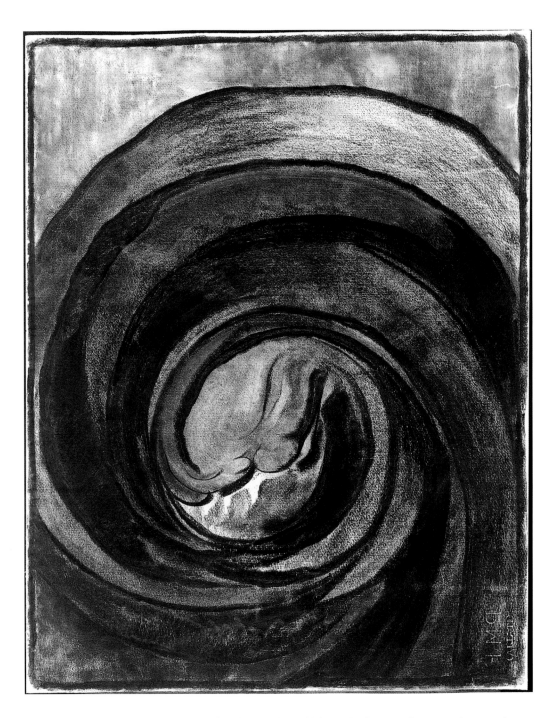

After freeing herself from the human figure, realism, and narrative content, O'Keeffe continued experimenting with nonobjective, monochromatic works, creating watercolors out of blue hues that again evoke furling forms, as in *Blue No. II* (fig. 63). O'Keeffe next abandoned her monochromatic palette, creating in watercolor and in oil richly colored abstractions derived from nature, as in

Figure 62. *(left)*
Georgia O'Keeffe, *No. 8
Special*. Charcoal on
paper mounted on card-
board, 1915. Collection
of Whitney Museum of
American Art, New York,
purchased with funds
from the Mr. And Mrs.
Arthur G. Altschul Pur-
chase Fund. Accession
no. 85.52. © 2002 The
Georgia O'Keeffe Foun-
dation / Artist Rights
Society (ARS), New York.
Photograph copyright ©
by Geoffrey Clements.

Figure 63.
Georgia O'Keeffe, *Blue
No. II*. Watercolor on
tissue paper, 1916. The
Brooklyn Museum,
bequest of Mary T.
Cockcroft. Accession
no. 58.74. © 2002 The
Georgia O'Keeffe Foun-
dation / Artist Rights
Society (ARS), New York.

Light Coming on the Plains II (fig. 64); from the female nude body, as in *Seated Nude No. 10* (fig. 65); and from music, as in *Music—Pink and Blue II* (fig. 66). O'Keeffe's concerns with the essence of nature and synesthesia, manifest in these works, reflect an interest in mysticism that she shared with Arthur Dove, Marsden Hartley, and other early American modernists.[10] By 1924, however, she began to zero in on flowers, placing them laterally across the surface of the canvas, eliminating the background, saturating the hues and shadows, and creating crisp, clear outlines (plate 8).

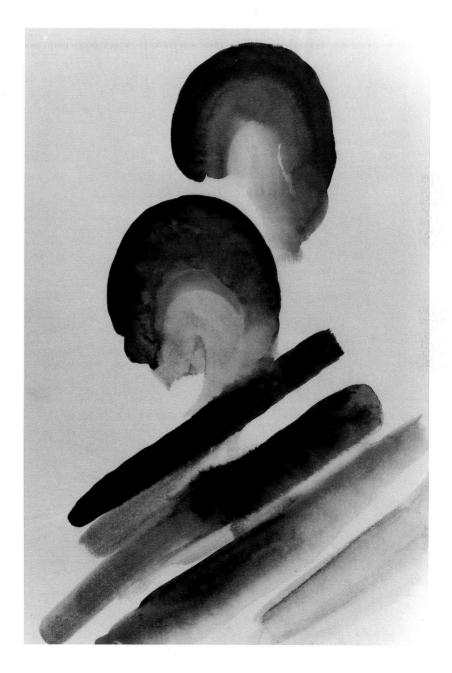

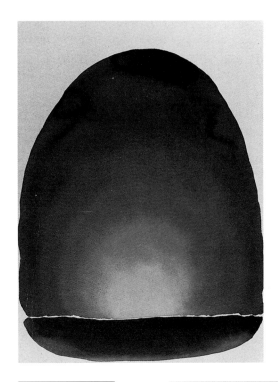

Figure 64.
Georgia O'Keeffe, *Light Coming on the Plains II*. Watercolor on newsprint, 1917. Amon Carter Museum, Fort Worth, Texas. Accession no. 1966.32. © 2002 The Georgia O'Keeffe Foundation / Artist Rights Society (ARS), New York.

Figure 65.
Georgia O'Keeffe, *Seated Nude No. 10*. Watercolor on paper, 1917–18. The Metropolitan Museum of Art, New York, Van Day Truex Fund, 1981. Accession no. 1981.324. © 2002 The Georgia O'Keeffe Foundation / Artist Rights Society (ARS), New York.

Figure 66. Georgia O'Keeffe, *Music—Pink and Blue II*. Oil on canvas, 1919. Collection of Whitney Museum of American Art, New York, gift of Emily Fisher Landau in honor of Tom Armstrong. Accession no. 91.90. © 2002 The Georgia O'Keeffe Foundation / Artist Rights Society (ARS), New York. Photograph copyright © 2000, Whitney Museum of American Art.

Figure 67.
Paul Strand, *Double Akele, New York*. Gelatin silver print, 1922. San Francisco Museum of Modern Art, The Helen Crocker Russell and William and Ethel W. Crocker Family Funds Purchase. Accession no. 80.83. Photograph by Roger Gass.

Paul Strand rendered simplified, close-cropped, magnified images in his photographs of abstract still lifes, such as *Double Akele, New York* (fig. 67). These established a precedent for O'Keeffe's close-up representations of flowers.[11] Both Strand and O'Keeffe enlarged motifs that the picture frame cut off and eliminated details, settings, and contexts. The formal elements of line, shape, and color consequently dominate over mimesis, resulting in bold abstractions of pure form with complex, decorative shapes and surface patterns. O'Keeffe's linear brushstrokes and clear contours reiterate Strand's sharp-focus photographic technique, while her vivid tonal contrasts emulate his similar use of deep shadows and highlighted areas.[12]

O'Keeffe and Strand apparently fell in love during the spring of 1917 while in New York City, shortly after the photographer began these innovative still lifes, which he mailed to her when she returned to Texas. During this period, O'Keeffe in fact created three abstract watercolor portraits of Strand, indicating her interest in working through her feelings for her new friend—not unlike her earlier *Specials,* which relate to her emotions concerning Arthur Macmahon, and her later *Radiator Building,* which, as we shall see, reflects her complex responses to Stieglitz.[13] Turning to the flower motif and rendering it in a simplified, abstract manner *à la* Strand may have been another way for her to acknowledge her emotions.

O'Keeffe had explained to Pollitzer that when she had met Strand, he showed her "photographs that are as queer in shapes as Picasso's drawings."[14] She wrote Strand in June 1917 that she liked his work, and kept transforming in her mind what she saw in nature, "making Strand photographs for myself in my head."[15] O'Keeffe believed that by looking at his prints, she could get closer to the photographer whom she found in the images, and wished, she wrote, to "put my hand in yours as I looked at them."[16] His photographs clearly stimulated O'Keeffe's desire for him. "I loved it—and I love you," she wrote. "I wanted to put my arms around you and kiss you hard. . . . You've gotten in me—way down to my fingertips the consciousness of you."[17] It took O'Keeffe seven years, however, to realize in paint the images she saw in nature via Strand's photographs. Whether she turned to the flower motif in order to remember the love for Strand that she had forfeited in favor of Stieglitz can never be known. But the fact that her husband had begun an affair with Strand's wife one year before O'Keeffe created these works suggests that they may relate in some fashion to him and their earlier friendship, her conflict over Stieglitz's affair with another woman, and her attempts to visualize on canvas all these complex emotions.

Critics saw a connection between O'Keeffe's images and intimate feelings. Lewis Mumford claimed in 1927 that O'Keeffe "has revealed the intimacies of love's juncture with the purity and the absence of shame . . . she has, in sum, found a language for experiences that are otherwise too intimate to be shared." He then linked O'Keeffe's visualization of her "love" for a man to the increased awareness of sex within American culture: "O'Keeffe's paintings . . . would tell much about the departure of Victorian prudery and the ingrowing consciousness of sex . . . were Sherwood Anderson's novels destroyed, were every vulgar manifestation in the newspapers forgotten, were the papers of the Freudian psychologists burned, her pictures would still be a witness" to the transition from the older prudishness to openness both within and outside matrimony.[18] That same year, a reviewer in the *New York Times* claimed that O'Keeffe's "arresting pictures" reveal "passionate ecstasy and enjoying love."[19] The following year, *Time* quoted portions of Mumford's review and placed her flower images further within the context of intimate relations by concluding that they "are full of passion," while Edward Alden Jewell proclaimed that her works capture the "unashamed symbolism of love."[20]

Gendered Readings and Constructions

Stieglitz initiated the critical reception of O'Keeffe's art as gendered and as embodying erotic emotions, a subject Barbara Buhler Lynes has fully explored.[21] Upon first viewing the *Specials,* he purportedly commented

that they resulted from "the seat of her deepest feeling," which he identified as "her Womb." He decided to include them in his May 1916 exhibition at "291" and asked her in a letter why they brought him so much joy. She responded that they express "things I feel and want to say—haven't words for."[22] Stieglitz apparently did not fully understand that these unspoken feelings related to her love for another man, but he recognized that they represented a woman's point of view. He is said to have proclaimed, "Finally a woman on paper. A woman gives herself. The miracle has happened."[23] He elaborated in 1916 that O'Keeffe captured "the fire and flow of a fresh sensualism" in her "feminine forms."[24]

As Lynes has shown, other critics followed his example in associating her early works with female anatomy and experiences.[25] Paul Rosenfeld wrote in 1921, "Her art is gloriously female. Her great painful and ecstatic climaxes make us at last to know something the man has always wanted to know. . . . The organs that differentiate the sex speak. Women, one would judge, always feel, when they feel strongly, through the womb. . . . All is ecstasy here, ecstasy of pain as well as ecstasy of fulfillment."[26] One year later, Rosenfeld repeated his praise: O'Keeffe captured the "mysterious cycles of birth and reproduction and death, expressed through the terms of a woman's body. . . . Essence of very womanhood permeates her pictures."[27] However, a few years later, in 1926, Stieglitz claimed that it was he who had enabled O'Keeffe the painter to be born by "initiating her into the significance of what she was painting,"[28] thereby taking credit for her success and abilities as an artist. Others echoed this idea; Henry McBride, for example, claimed that Stieglitz was "responsible for Miss O'Keeffe the artist."[29] As Marcia Brennan recently argued, gendered formalist critical discourse defined the Stieglitz group, especially after the closing of "291." Stieglitz and his advocates created gendered discourse for the male artists (especially Dove and Marin) and for O'Keeffe, establishing the binary oppositions of "male/female, exterior/interior, assertive/receptive, and detachment/absorption."[30]

O'Keeffe rejected such interpretations, although she acknowledged that these works evolved from her feelings for a man. "The things they write sound so strange and far removed from what I feel of myself," she commented, and she wondered in a letter to Sherwood Anderson whether "man has ever been written down the way he has written woman down."[31] She later reminisced, "I remember how upset I was once by a certain reference Marsden Hartley made to my work in a book. I almost wept. I thought I could never face the world again." Similarly, she admitted that Rosenfeld's comments both embarrassed and angered her.[32] She deleted all psychosexual passages by critics from her exhibition catalogue of 1924,[33] and decided to turn to more "objective" images of flowers and skyscrapers, believing—incorrectly—that these more realistic

images could not be interpreted as embodying a feminine sensibility. As O'Keeffe explained to Anderson, "I suppose the reason I got down to an effort to be objective is that I didn't like the interpretations of my other things."[34]

To O'Keeffe's dismay, by 1927 critics also were viewing her large-scale, close-up views of floral motifs as highly eroticized. McBride identified her as the "priestess of Eternal Woman," an "imaginative biologist of all creation-form on earth" whose flower paintings captured the essence of Womanhood.[35] O'Keeffe later countered in a matter-of-fact manner:

> A flower is relatively small. Everyone has many associations with a flower—the idea of flowers. . . . Still—in a way—nobody sees a flower—really—it is so small—we haven't time. . . . So I said to myself—I'll paint what I see—what the flower is to me but I'll paint it big and they will be surprised into taking time to look at it. . . . Well—I made you take time to look at what I saw and when you took time to really notice my flower and you hung all your associations with flowers on my flower and you write about my flower as if I think and see what you think and see of the flower—and I don't.[36]

In the 1970s, feminist critics and artists declared her art uniquely female because of her centralized forms, "constructed," in the words of Judy Chicago and Miriam Schapiro, "like labia of the vagina."[37] O'Keeffe rebutted this criticism too: "The critics who write about sexual symbolism in my work are just talking about themselves, not what I am thinking. When people read erotic symbols in my paintings they're really talking about their own affairs."[38] She rejected the inclusion of her art in the 1970s feminist canon of centralized core imagery, and sided with those who considered biological essentialism a misguided approach to women's art.[39] O'Keeffe, in short, spent decades rejecting explanations of her flower imagery as sexualized embodiments of the female body, suggesting that these interpreters, male and female alike, were merely imposing their own psychosexual obsessions on her benign, decorative images.

O'Keeffe's continuous denials have resulted in differing opinions among art historians, critics, and even the artist herself, whose private letters suggest more ambiguity than her public statements. Art historian Anna C. Chave, for example, argued that the artist deliberately developed "a (woman's) language of desire," to capture what O'Keeffe identified as "the unknown."[40] Rather than rendering the human body, Chave believed that O'Keeffe "portrayed abstractly . . . her experience of her own body" and her own desires through voids, canyons, crevices, slits, holes, voids, and soft, swelling forms.[41] Chave further asserted that O'Keeffe's art

embodied her childlessness, her empty womb, as well as a sense of "plenitude and gratification."[42] As Wanda Corn explained, "her pronounced use of unfolding petals, eroticized stamens, and mysterious centers encouraged viewers to read in these works . . . sensuous body parts, especially those of female anatomy and male penetration."[43]

O'Keeffe indeed may have consciously intended to evoke such associations. She wrote in 1916, "The thing seems to express in a way what I want it to . . . it is essentially a woman's feeling"; later, in 1925, she wrote that "a woman . . . might say something that a man cant [sic]—I feel that there is something unexplored about woman that only a woman can explore."[44] In 1930, she stated, "I am trying with all my skill to do painting that is all of a woman, as well as all of me."[45] O'Keeffe's intentions (albeit vaguely expressed) thus intersect with interwar discourse concerning women's feelings, attitudes, and sexuality.

If O'Keeffe actually intended to convey something uniquely feminine, then her denial of such meanings seems disingenuous. She may in fact have intended a rather abstract expression of female sexuality, but disavowed interpretations that embodied a masculine position embraced by her lover and male friends. O'Keeffe never claimed to represent the female body or female sexuality, but instead something "only a woman can explore," which may include female experiences, feelings, relationships, attitudes, and perceptions.[46] Whether or not O'Keeffe intended to represent vaginal or womblike images with attendant associations, critics understood her works in this fashion, resulting in her continual and adamant rejections.

To O'Keeffe's dismay, her New York City paintings similarly became the focus of early debates about gender issues. "The men decided they didn't want me to paint New York," she explained. "They told me to 'leave New York to the men.' I was furious!"[47] Her awareness of working in isolation as a woman in a man's world became especially acute when Stieglitz, the organizer of the 1925 group show *Seven Americans,* and her fellow (male) exhibitors excluded her first painted view of the urban landscape, *New York with Moon* of 1925 (fig. 68).[48] After this painting sold in her one-woman show the following year, O'Keeffe noted with sarcasm that "they [the men] *let* me paint New York."[49]

O'Keeffe recognized that men tried to control her subject matter in art, her image as an artist, and her ability to paint. As she stated in 1965, "Men in that day didn't want women painting. The painters and art patrons figured it was strictly a man's world."[50] She consciously invaded the male world when she moved into the Shelton Hotel in 1925: "I realize it's unusual for an artist to work way up near the roof of a big hotel in the heart of the roaring city but I think that's just what the artist of today needs for stimulus. He has to have a place where he can behold the city as

Figure 68. *(right)* Georgia O'Keeffe, *New York with Moon.* Oil on canvas, 1925. Thyssen-Bornemizta Collection, Lugano, Switzerland. © 2002 The Georgia O'Keeffe Foundation / Artist Rights Society (ARS), New York.

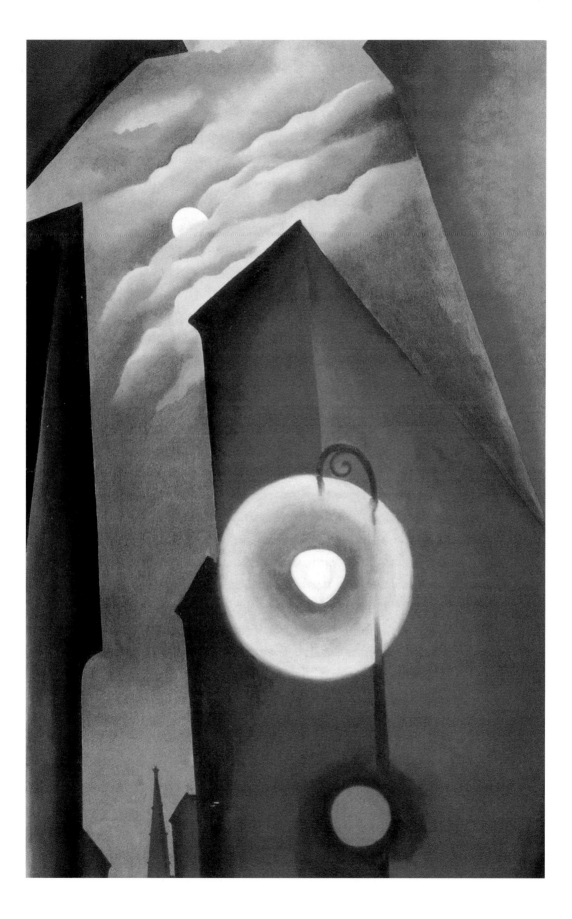

a unit before his eyes."[51] By using the masculine pronoun, O'Keeffe transformed herself from a passive female to an active spectator and artist; having moved into the Shelton, she lived in what was supposed to be a "club-hotel for men" with a commanding view of the urban, commercial, masculine sphere.[52]

O'Keeffe's active association with the National Woman's Party, a radical feminist group, began in the 1920s, when she was struggling to define her art as being separate from her gender. Speaking before this organization at a dinner held on 28 February 1926, she made it clear that her experiences with "the men" over the exhibition of *New York with Moon* contributed to her staunch feminist feelings and support for the Equal Rights Amendment. "I have always resented being told that there are things I cannot do because I am a woman," O'Keeffe declared. "They [men] have objected to me all along; they have objected strenuously. It is hard enough to do the job without having to face the discriminations, too. Men do not have to face these discriminations."[53] During the 1920s, when equal rights was a more contentious issue (even among feminists) than equal suffrage had been, O'Keeffe clearly and unequivocally supported economic and social equality for women.[54] (In 1944, she would write to Eleanor Roosevelt, arguing on behalf of "legal equality for all.")[55] As Frances O'Brien observed in 1927, O'Keeffe "ardently" believed "in woman as an individual . . . not merely with the rights and privileges of man but . . . with the same responsibilities," especially that of "self-realization."[56]

O'Keeffe closed the introduction of her 1976 book with a brief account of a painting she had created in 1907 while still a student at the Art Students League. She had represented a "very alive scene"—two tall poplar trees silhouetted against the dark sky and moonlight on Riverside Drive—which she proudly showed to a fellow student. "He immediately told me," O'Keeffe recalled, "that there was no color in my trees," and proceeded to paint over her canvas "to show me." She continued, "He painted on the trees—the very part that I thought was so good," spoiling a painting that she nevertheless kept for years. "It represented an effort toward something that had meaning to me—much more than the work at school."[57] Always independent, she viewed this altered and consequently ruined work as a lesson that she should follow her own ideas rather than adhere to someone else's opinion, especially that of a domineering man attempting to claim formal authority over nature and her art.[58] "I know that many men here in New York think women can't be artists," she told a friend during the 1920s, "but we can see and feel and work as they can. . . . Perhaps some day a new name will be coined for us [women artists] and so allow men to enjoy a property right to the word 'art.'"[59] As O'Keeffe recalled later in life, "All the male artists I knew, of

course, made it very plain that as a woman I couldn't make it—I might as well stop painting."[60]

O'Keeffe's experiences parallel Jo Hopper's frustrations over the refusal of her husband and others to pay attention to her paintings. O'Keeffe became famous in her own right, and Jo became known as Hopper's wife, but each struggled throughout her life with her identity as a woman artist. In O'Keeffe's case, the struggle derived from the men who pigeonholed her art as uniquely feminine and her sense that the patriarchal art world placed women artists in a subordinate position. She clearly wanted to be known simply as an artist, omitting any reference to her sex, but the critics, her husband, and possibly the works themselves never allowed this to happen. She may have deliberately created flower paintings as a means to force the issue to the surface. Strand had photographed similar abstractions from organic and man-made objects; by employing a style in the paintings that so clearly derived from those photographs (produced, after all, by a man), O'Keeffe may have thought that critics would not label them as feminine—even though they had been created partly in response to her romantic feelings toward Strand.

Even so, she must have recognized that nature had always been identified as a woman's sphere; turn-of-the-century painters and photographers in Stieglitz's Photo-Secession group often used the connection between woman and nature to evoke notions of femininity. Annie Brigman, a photographer included in *Camera Work* (1909), rendered the female nude amid the landscape in *Soul of Blasted Pine* (fig. 69), creating compo-

Figure 69.
Annie Brigman, *Soul of Blasted Pine.* Photograph, 1907. Courtesy George Eastman House, Rochester, New York.

sitional analogies between the two to evoke dependence, passivity, orna-mentality, sexual innocence, and purity.[61] Further, Stieglitz and his friends made analogies between creativity and natural growth, often applying this theory to O'Keeffe.[62] Henry Tyrrell, for example, claimed in 1916 that O'Keeffe's creativity evolved like "the germinating of a flower," while Waldo Frank in 1926 associated the artist with a tree: "Her arms and her head stir like branches in a gentle breeze."[63] Producing flower paintings thus may have been a deliberate maneuver to place her art in an overtly feminine space, as if to say to the critics, as the art historian Anne Middle-ton Wagner astutely suggested, "You want feminine, I'll give you femi-nine."[64] She never intended, however, for these paintings to be interpreted as sexual in form or meaning. To her frustration, Stieglitz and others per-sisted in promoting her art in these terms. In doing so, they were taking advantage of the popularity of Freudian discourse during this period.

Freudian Discourse

The critics who interpreted O'Keeffe's art as sexualized were familiar with the Freudian psychoanalytic theories that had penetrated American popular society during the first two decades of the twentieth century.[65] "Freud . . . has become the vogue in cultural circles" as well as a myth, ac-cording to the author of *Sex Expression in Literature* (1926), Victor F. Calverton.[66] Articles about Freud and his theories had descended from elite cultural circles to popular magazines, including *Time, The Nation, The American Mercury, Scribner's Magazine, Everybody's Magazine,* and *Literary Digest.*[67] A writer in *Current Opinion* concluded in 1920, "One can hardly pick up a newspaper or a magazine without finding psychoanalytic terms." By 1930, a columnist for *Outlook* concluded that "the tenets of psychoanalysis have crept into the common mind and its phrases onto the collective tongue."[68] Also at this time, sociologists, social workers, and psychologists addressed Freud's studies of sexuality and its effects on mar-ital dynamics.[69]

Among O'Keeffe's critics, Helen Appleton Read used Freudian jar-gon to explain O'Keeffe's distinct feminine sensibilities, as evidenced in the "purest abstractions" that suggest "'Suppressed Desires' . . . as the Freudians would call them." "In these days of psychoanalysis," she ex-plained elsewhere, "it is easy to interpret them in terms of Freud."[70] Henry McBride identified O'Keeffe as an artist "B.F."—before Freud: "Her inhi-bitions seem to have been removed before the Freudian recommendations were preached upon this side of the Atlantic." He suggested that "she be-came free without the aid of Freud" through Stieglitz's influence.[71]

In reality, her challenge to nineteenth-century Victorian attitudes predated her introduction to Stieglitz.[72] While teaching at West Texas

State Normal College, she had invited a suitor into her apartment without a chaperone, had gone on an evening drive with this same gentleman ("auto rides at night . . . [are] considered grossly improper—an unpardonable social impropriety," according to the college *Bulletin*), and had walked outdoors with bare feet.[73] Such behavior caused a scandal in the communities in which she had lived and worked.

Although neither waited for Freudian discourse to authorize their challenge to older manners and morals, both Stieglitz and O'Keeffe were aware of the pervasive influence of Freud's theories within bohemian circles. Abraham A. Brill, a student of Freud's, translator of his works, and the American leader of the psychoanalytic movement, promoted Freudian thought among the avant-garde in New York. Stieglitz and Mabel Dodge Luhan, who wrote about her psychoanalytic therapy in *Intimate Memories* (1933), invited Brill to participate in their soirees. Moreover, Stieglitz's library contained books by Havelock Ellis, whose works he recommended to friends. Ellis had used Freud in volume six of *Studies in Relation to Society* to expose the harmful effects of "civilized" sexual morality, especially sexual abstinence, and he had argued in other publications that women, like men, had sexual feelings.[74] Stieglitz's favorite niece, Elizabeth Davidson, corresponded with her uncle about her enjoyment of Freud's *Beyond the Pleasure Principle,* while Katherine Rhoades in 1914 had informed Stieglitz of her interest in Freud's writings, which Stieglitz shared given that he, according to his grandniece Sue Davidson Lowe, "read each volume of Freud as it appeared . . . and embraced wholeheartedly his theories of sexuality."[75] In 1928, both Stieglitz and O'Keeffe read, admired, and recommended D. H. Lawrence's overtly erotic novel *Lady Chatterly's Lover* prior to its availability in the United States.[76] The vernacularized and professional versions of Freudian thought thus were ubiquitous and inescapable in O'Keeffe's milieu and in popular culture.

Challenging Victorian Codes of Conduct

Some sociologists during the interwar years saw the flappers, with their bobbed hair and short skirts, as challengers of Victorian codes of sexuality.[77] Neither O'Keeffe nor Jo appropriated this fashion. Nor did O'Keeffe adopt Jo's matronly style. She preferred instead to wear simple, loose clothing, flat shoes, no makeup, simple hairdos with her hair pulled back or hanging down, and male felt hats. She also favored straight lines and black and white outfits rather than fashionable dresses, flowery hats, and high heels.[78] "She wore black," one fellow student reminisced. "Black, black, black! And her clothing was all like men's clothing. Straight lines, she didn't believe in lace, or jabots in blouses, laces or ruffles or things like that. Everything on straight lines." Another student commented that O'Keeffe

"dressed like a man ... in men tailored suits" and square-toed oxfords, with her hair cut short like a man's and topped by "a man's type felt hat."[79] Charlotte Perkins Gilman's essay "The Dress of Women," which O'Keeffe read in 1915, certainly encouraged her proclivity to reject corsets and lacy dresses, which Gilman condemned as "frou-frou," and high heels—"instruments of torture"—in favor of less restraining clothes that enabled "full freedom of action."[80] Consequently, Stieglitz's fascination with O'Keeffe derived not only from her works, but also from her defiance of current fashions, which his first wife willingly and enthusiastically followed.

Even before her open affair with Stieglitz, we will remember, O'Keeffe had scandalized West Texas State Normal College[81] and initiated her earlier relationship with Macmahon, writing that she wanted to love him and that she hoped he did not object "to a woman daring to—feel—and say so without being urged in the least."[82] She considered marrying another man who lived in Texas during this time, and later developed strong feelings for Paul Strand. She wrote to Strand in June 1917 that she loved him and wanted to kiss him, but recognized the impropriety of kissing more than one man. "So many people had kissed me in such a short time," O'Keeffe explained to Strand, "and I had liked them all and had let them all—had wanted them all to—it simply staggered me that I stood there wanting to kiss someone else—another one I thought. . . . What am I getting into."[83] Her unease parallels that of Floyd Dell's heroine Janet March in the novel by the same name. Swept into the newer mode of sexual behavior, Janet feels doubts about its propriety. Such girls, the narrator explains, "were well-bred, and as they transgressed the old conventions, which limited the degree of permissable [sic] erotic contact, they established new conventions of their own," but not without hesitation at times.[84]

O'Keeffe and Janet March adopted the new style of courtship, dating more than one man at a time and considering long-term relationships with various suitors. Yet they felt uneasy about getting close to more than one person over a short period, questioning their own motives as well as the likely outcome. O'Keeffe eventually settled upon Stieglitz.

Results of a survey in a 1928 issue of *Harper's Magazine* demonstrated that extramarital affairs were becoming more acceptable among "liberal-to-radical" groups in New York City, but that "love affairs and unhappy marriages often coincided."[85] This certainly was the case for Stieglitz and his first wife; for him, the affair with O'Keeffe represented, among other things, a means to express dissatisfaction with his wife as well as society's expectations for married men. For O'Keeffe, the affair, like her radical manner of dressing, may have represented her means of positioning herself as a feminist and liberal who also pursued an unusual and radical career as an artist.

Despite his upbringing during the Victorian era, Stieglitz was in many ways even more rebellious than his second wife. He discussed sex with visitors to his gallery, often embarrassing the women, as when he touched Dorothy Norman's nursing breast. In his magazine, *Camera Work*, he published an article by Sadkichi Hartmann that rejected puritan values that "advocated a joyous superiority to sensual life ... vows of chastity and corporeal penance ... [and] a rigid sense of propriety that is prohibitive, dismal, and destructive to art and all higher intellectual pursuits." "Half of our difficulties in public and private life," Hartmann argued, "are due to the puritanic spirit" still pervading American culture.[86] In addition to *Lady Chatterly's Lover* (1928), Stieglitz read and recommended to his friends books such as Van Wyck Brooks's *The Wine of the Puritans* (1909), which argued against materialistic puritanism. He even considered an exhibition of Lawrence's paintings as a way "to challenge the entire country on the book"[87] and specifically to protest against the government's censorship of it. He encouraged his friends to skinny-dip in Lake George, resulting in the arrest of Paul and Beck Strand, and once got into trouble for photographing nude women out-of-doors.[88]

Nude Photographs As a Public Act of Love

Of all the freewheeling aspects of Stieglitz's conduct, his photographs of nude women especially challenged society's morals, even during the more relaxed 1920s. They also reveal his love interests. His first wife refused to pose in the nude, but he took at least fifteen nude photographs of Rebecca Salsbury Strand in the course of their affair. In some of these images (e.g., fig. 70) Stieglitz cropped at the model's breasts and the knees, thereby objectifying her and removing her identity while revealing her pubic hair. In other similarly cropped photographs, she holds her breasts in both hands, thereby enlarging them (fig. 71); is seen from behind with an emphasis upon her buttocks and the curves of her body (fig. 72); and reclines with no visible head or feet. In some photographs, as in figure 70, this woman's body is visible through translucent waves of water, a fascinating pattern that nonetheless fails to detract from the recognizability of the woman's naked body. Stieglitz also photographed women with whom he probably did not have a relationship—Georgia Engelhard in 1922 and 1923, Eva Herrman in 1925, and Frances O'Brien in 1925—but his comment that when he took a photograph, he made love, suggests that the very act of using his camera aroused and satisfied sexual feelings.[89] Indeed, he once informed Beck Strand that while touching up a photograph of her, he had "been tickling up [her] rear into most perfect condition of delight."[90] O'Keeffe later substantiated this connection between the sex act and the act of taking a photograph in

Figure 70.
Alfred Stieglitz, *Rebecca
Salsbury Strand.* Silver
gelatin developed-out
print, 1923. National
Gallery of Art, Washington,
D.C., The Alfred Stieglitz
Collection. Accession no.
1949.3.548. Photograph
© 2001, Board of
Trustees, National Gallery
of Art, Washington.

Figure 71.
Alfred Stieglitz, *Rebecca
Salsbury Strand.* Silver
gelatin developed-out
print, 1923. National
Gallery of Art, Washington,
D.C., The Alfred Stieglitz
Collection. Accession no.
1949.3.551. Photograph
© 2001, Board of
Trustees, National Gallery
of Art, Washington.

making this comment of men who wanted Stieglitz to photograph their wives or girlfriends: "If they had known what a close relationship would have needed to have to photograph [them] the way he photographed me—I think they wouldn't have been interested."[91] Not surprisingly, Stieglitz also took photographs of Dorothy Norman, beginning in 1930 and continuing for the next seven years, focusing more on her head than her body in closer and softer images and smaller (four- by five-inch) prints (fig. 73). He first publicly exhibited these photographs at An American Place in 1932, thereby indicating, in the words of Norman's friend, "that although Stieglitz's marriage to O'Keeffe was still vital, Norman had acquired a special place in his life."[92]

Stieglitz's best-known female nude series is his *Georgia O'Keeffe—A Portrait,* which consists of 329 photographs that he began creating in 1917. His wife, Emmy, ordered him out of their home upon discovering a naked O'Keeffe modeling for these photographs. Stieglitz protested that his relationship with his model remained platonic despite the eroticism embodied in the images through O'Keeffe's nudity and poses, and the emphasis upon her breasts, thighs, buttocks, and hair (including the hair under her arms and covering her pubis).[93] If their relationship was platonic at that point, the photographer nonetheless was recording an intimate relationship that certainly began once he moved in with her in 1918.

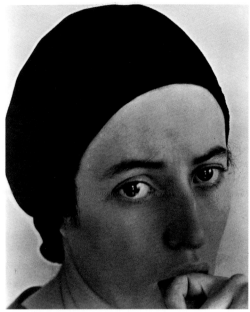

Figure 72.
Alfred Stieglitz, *Rebecca
Salsbury Strand*. Silver
gelatin developed-out
print, 1923. National
Gallery of Art, Washington,
D.C., The Alfred Stieglitz
Collection. Accession no.
1949.3.555. Photograph
© 2001, Board of
Trustees, National Gallery
of Art, Washington.

Figure 73.
Alfred Stieglitz, *Dorothy
Norman*. Silver gelatin
developed-out print,
1932. National Gallery
of Art, Washington, D.C.,
The Alfred Stieglitz
Collection. Accession no.
1949.3.723. Photograph
© 2001, Board of
Trustees, National Gallery
of Art, Washington.

Forty-five photographs depict O'Keeffe in the nude. Seventy-five percent of these were produced during the first two years of her relationship with Stieglitz, when she was photographed, according to the model, "with a kind of heat and excitement" after lovemaking.[94] In seventeen images, her long hair flows freely and loosely (figs. 74 and 75); only in a few does she wear a conventional dress (figs. 76, 79). A group of sixteen photographs represent the model frontally, bust length, and wearing an open white robe, often revealing her breasts (figs. 74, 77, and 78). In some of these, O'Keeffe stands before her early charcoal drawings, establishing a relationship and juxtaposition between her head or hands and the two-dimensional, rounded, undulating forms in the background paintings (figs. 75, 77, and 79). In five of these (figs. 77 and 78), the model disturbingly grasps one or both of her breasts, squeezing them with one or two hands into different shapes. In this way, she created an abstract contrast between her firm hands and elongated fingers and her soft, squashed breasts, as well as between concave and convex shapes.

Other photographs show O'Keeffe in a similar manner—at half- and three-quarter length with white robe open and framing one breast with her fingers—but she stands against a blank, whitish wall (fig. 78), thereby eliminating the relationship between the woman and her art. Besides evoking an interest in formal arrangements, these works also imply eroticism, sexuality, and auto-eroticism, although O'Keeffe's manipulations of her breasts do not appear pleasurable; her firm grasp and the twisting of the misshapen breasts suggest instead discomfort. O'Keeffe's grabbing of her breasts may also signify Stieglitz's "fantasy of possession."[95]

Figure 74.
Alfred Stieglitz, *Georgia O'Keeffe: A Portrait.* Palladium print, 1918. Courtesy The J. Paul Getty Museum. © Estate of Georgia O'Keeffe.

Figure 75.
Alfred Stieglitz, *Georgia O'Keeffe: A Portrait—Head.* Silver gelatin developed-out print, 1918. National Gallery of Art, Washington, D.C., The Alfred Stieglitz Collection. Accession no. 1980.70.19. Photograph © 2001, Board of Trustees, National Gallery of Art, Washington.

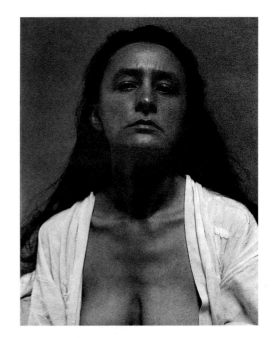

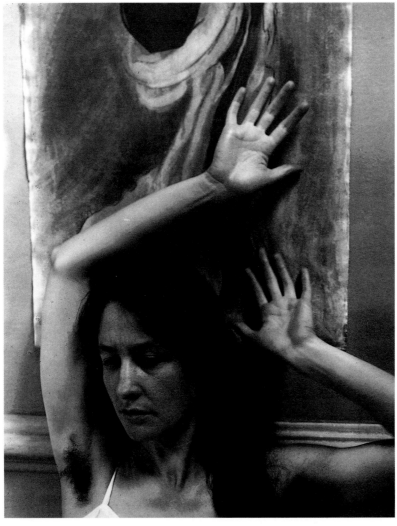

Figure 76.
Alfred Stieglitz, *Georgia O'Keeffe: A Portrait*. Silver gelatin developed-out print, 1927. National Gallery of Art, Washington, D.C., The Alfred Stieglitz Collection. Accession no. 1980.70.222. Photograph © 2001, Board of Trustees, National Gallery of Art, Washington.

Figure 77.
Alfred Stieglitz, *Georgia O'Keeffe: A Portrait*. Black palladium print, 1918. National Gallery of Art, Washington, D.C., The Alfred Stieglitz Collection. Accession no. 1980.70.70. Photograph © 2001, Board of Trustees, National Gallery of Art, Washington.

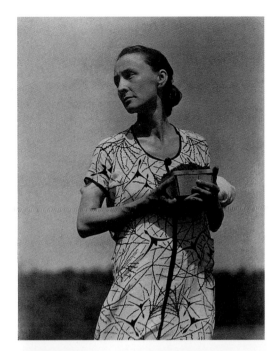

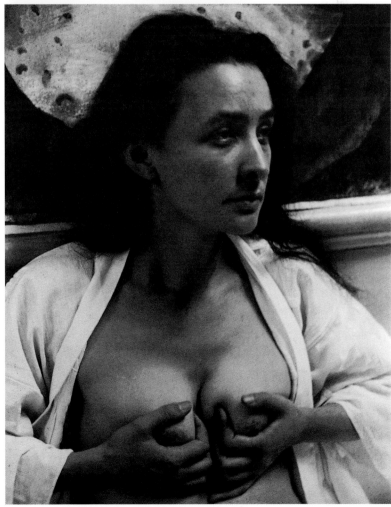

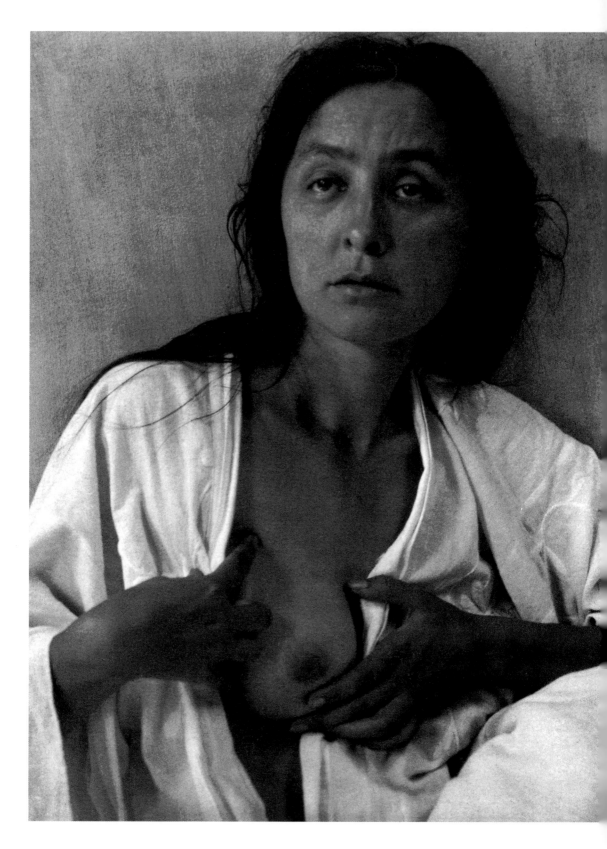

Figure 78. Alfred Stieglitz, *Georgia O'Keeffe: A Portrait*. Palladium photograph, 1918.
Courtesy The J. Paul Getty Museum. © Estate of Georgia O'Keeffe.

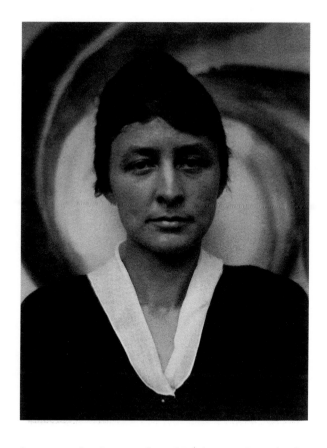

Figure 79.
Alfred Stieglitz, *Georgia O'Keeffe: A Portrait—at "291," June 4, 1917.*
Platinum print, 1917.
Courtesy The J. Paul Getty Museum. © Estate of Georgia O'Keeffe.

In twenty-five images, the subject's torso faces the front or sideways (fig. 80) or can be seen from behind in standing or reclining positions (fig. 81) in which the shapes of the body, its various parts and postures, and the angle of viewing across the picture surface establish abstract designs. Nonetheless, these designs never detract from the vivid representation of intimate body parts such as pubic hair, glimpsed between the cheeks of O'Keeffe's buttocks. In only three images is O'Keeffe standing with her entire body and head visible (fig. 80). One (fig. 82), found in her book *A Portrait by Alfred Stieglitz,* which she compiled in 1978, shows her fragmented torso with breasts and navel visible and with legs open (her vulva cannot be seen, however, because of the blackness of this area).[96] Three more photographs show the model pressing her arms in such a manner as to enlarge and emphasize the roundness of her deliberately distorted breasts. In these works (one of which I was unable to receive permission to publish), Stieglitz contrasted the rounded convex nipples with the darker, smaller, and concave navel, emphasizing the woman's erogenous zones that become abstracted albeit always recognizable. In others (see fig. 75), Stieglitz highlighted O'Keeffe's visible underarm hair, which women at this time never publicly revealed, showing its relationship to her flowing head of hair.

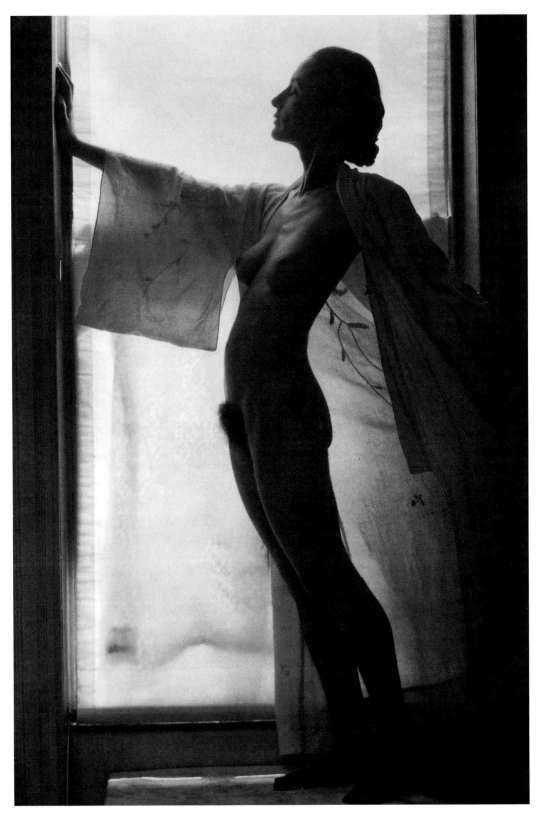

Figure 80. Alfred Stieglitz, *Georgia O'Keeffe: A Portrait*. Platinum print, probably 1918. National Gallery of Art, Washington, D.C., The Alfred Stieglitz Collection. Accession no. 1980.70.97. Photograph © 2001, Board of Trustees, National Gallery of Art, Washington.

Figure 81.
Alfred Stieglitz, *Georgia O'Keeffe: A Portrait— Thighs and Buttocks.* Gelatin silver photograph, 1922. National Gallery of Art, Washington, D.C., The Alfred Stieglitz Collection. Accession no. 1980.70.184. Photograph © 2001, Board of Trustees, National Gallery of Art, Washington.

Figure 82.
Alfred Stieglitz, *Georgia O'Keeffe: A Portrait— Torso.* Palladium photograph, 1918. National Gallery of Art, Washington, D.C., The Alfred Stieglitz Collection. Accession no. 1980.70.34. Photograph © 2001, Board of Trustees, National Gallery of Art, Washington.

Stieglitz also fragmented, objectified, and eroticized O'Keeffe's hands and feet, fetishizing them in that he substituted them for the sexual object.[97] In thirty-eight images, he placed closely cropped hands in the foreground against dark and light amorphous areas such as a wall or a clothed bosom (fig. 83); against biomorphic shapes found in the subject's paintings (figs. 75, 77, 79, 90);[98] beside or holding fruit, such as apples or grapes (fig. 84),[99] or animal skulls (fig. 111); and leaning against or placed before automobile tires enclosed in shiny metal encasements (fig. 85). By focusing exclusively on O'Keeffe's hands, Stieglitz followed the tradition of "equating hands with the artistic creative act."[100] Stieglitz also took four photographs of O'Keeffe's bare feet and one of her bare legs, creating a series whose fetishistic quality is especially apparent in an image in which the sole of the model's foot caresses a statue (fig. 86).[101] O'Keeffe created this sculpture, whose phallic features are emphasized not only in this image (which exists in duplicate), but also in photographs of O'Keeffe's 1917 exhibition (fig. 87), as well as in a photograph of *Music: Pink and Blue I* in which the phallic motif intrudes suggestively into the open, vaginalike or womblike area of O'Keeffe's painting (fig. 88).[102] Two photographs show O'Keeffe holding this statue at its base; the angle of this three-dimensional sculpture, its shape, and the position of her hand all suggest manual manipulation of an erect penis, possibly a replacement for Stieglitz's genitals, which could be "a sign of her debasement or of her power."[103]

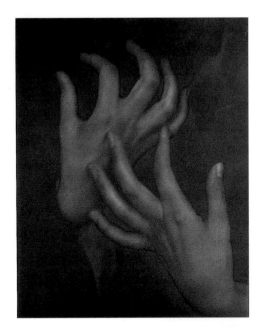

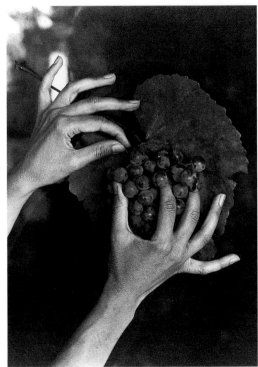

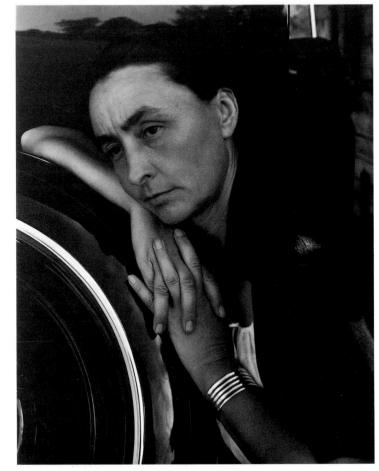

Figure 83. *(above)* Alfred Stieglitz, *Georgia O'Keeffe: A Portrait— Hands.* Palladium print, 1918–20. Courtesy The J. Paul Getty Museum. © Estate of Georgia O'Keeffe.

Figure 84. *(above right)* Alfred Stieglitz, *Georgia O'Keeffe: A Portrait— Hands and Grapes.* Palladium photograph, 1921. National Gallery of Art, Washington, D.C., The Alfred Stieglitz Collection. Accession no. 1980.70.164. Photograph © 2001, Board of Trustees, National Gallery of Art, Washington.

Figure 85. *(right)* Alfred Stieglitz, *Georgia O'Keeffe: A Portrait— With Automobile.* Silver gelatin developed-out print, 1935. National Gallery of Art, Washington, D.C., The Alfred Stieglitz Collection. Accession no. 1980.70.317. Photograph © 2001, Board of Trustees, National Gallery of Art, Washington.

Figure 86.
Alfred Stieglitz, *Georgia O'Keeffe: A Portrait—Feet and Sculpture.* Palladium print, 1918. National Gallery of Art, Washington, D.C., The Alfred Stieglitz Collection. Accession no. 1980.70.55. Photograph © 2001, Board of Trustees, National Gallery of Art, Washington.

Figure 87.
Alfred Stieglitz, *Main Room—Wall, Next to Door, Right.* Gelatin silver photograph, 1917. Courtesy The J. Paul Getty Museum. © Estate of Georgia O'Keeffe.

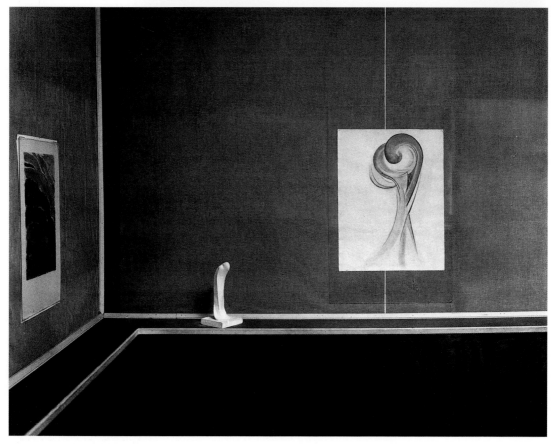

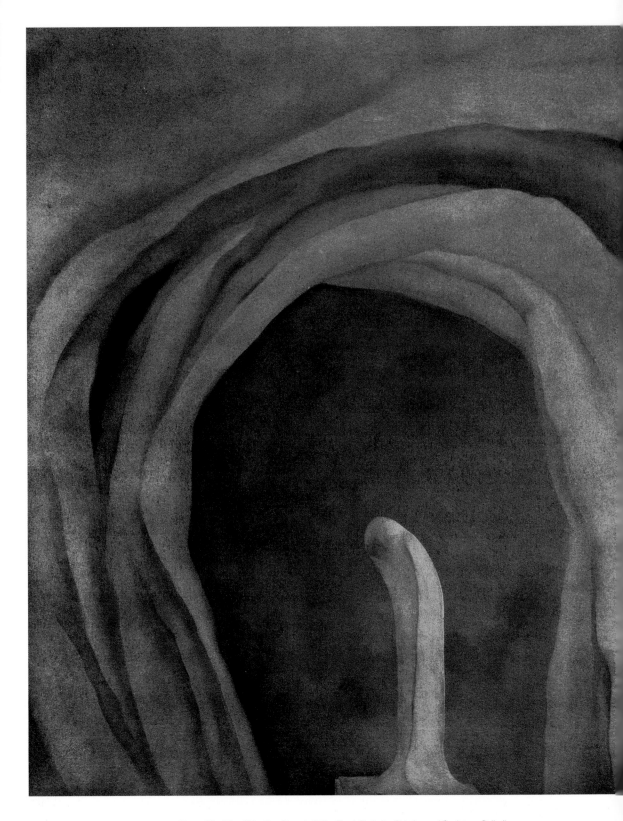

Figure 88. Alfred Stieglitz, *Georgia O'Keeffe: A Portrait—Painting and Sculpture*. Palladium photograph, 1919. National Gallery of Art, Washington, D.C., The Alfred Stieglitz Collection. Accession no. 1980.70.127. Photograph © 2001, Board of Trustees, National Gallery of Art, Washington.

Stieglitz often zeroed in on the human torso and cut off other features, most notably the head and feet. The identity and individuality of the subject—Georgia O'Keeffe—are thus transformed into a generalized representation of Woman, whose breasts, pubic hair, navel, and buttocks become the focus of attention. The photographer called these images a composite portrait of "clean-cut, heartfelt bits of universality in the shape of woman."[104] These photographs objectify, frame, and control the image of woman in a sharp-focus manner, with, as Stieglitz explained, "no tricks . . . no humbug, no sentimentalism."[105] O'Keeffe becomes "woman as spectacle,"[106] for Stieglitz declined to render the nude in a romantic, pictorial haze that disguised sex as artiness.[107] His sharp focus images also depart from the series of female nudes that O'Keeffe had rendered in 1917 (fig. 89), which were probably self-portraits produced with the aid of a mirror.[108] Her loosely brushed watercolors do not indicate facial features, and breasts are quickly sketched, sometimes denying their eroticism. These generalized representations adhere to the type of figure encountered in the soft-focus photographs of the period that Stieglitz rejected. Although he verbally denied the very intimate eroticism of these private photographs by enveloping them within an aesthetic patina of "universality," the public, who came in large numbers to see the forty-five works from *Georgia O'Keeffe—A Portrait* exhibited at The Anderson Galleries in February 1921, understood that they combined formal considerations with sexuality in an overt manner that some found shocking.

Figure 89.
Georgia O'Keeffe, *Seated Nude No. 11*. Watercolor on paper, 1917. The Metropolitan Museum of Art, New York, purchase, Mr. and Mrs. Milton Petrie Gift, 1981. Accession no. 1981.194. © 2002 The Georgia O'Keeffe Foundation / Artist Rights Society (ARS), New York.

From a standpoint of psychoanalytic theory, one could argue—as Deborah Cherry and Griselda Pollock did about Dante Gabriel Rossetti's repetitious preoccupation with women—that in these works "the spectator's gaze is fixated upon a fetish, a fragment of the body, a schematized face, a blank look . . . which signifies an absence, the phallus, allaying the castration anxieties, which the exposure of woman as non-man, as difference, incites."[109] Laura Mulvey elaborated on how men represent women from the two modes of vision identified as voyeuristic investigation and fetishistic scopophilia:

> The woman as icon, displayed for the gaze and enjoyment of men, the active controllers of the look, always threatens to evoke the anxiety it originally signified. The male unconscious has two avenues to escape original trauma (investigating the woman, demystifying her mystery) . . . or else complete disavowal of castration by the substitution of a fetish object or turning the represented figure itself into a fetish so that it becomes reassuring rather than dangerous. . . . This second avenue, fetishistic scopophilia, builds up the physical beauty of the object, transforming it into something satisfying in itself.[110]

Within this context, it can be argued that Stieglitz obsessively photographed O'Keeffe in a multitude of fragmented images to assuage his own fear of castration.

Stieglitz could not have made these images, however, without the collaboration and cooperation of the subject, who willingly posed for long periods in various erotically charged poses.[111] These were not snapshots: the creation of the slower glass negatives required the subject to remain motionless for three to four minutes. O'Keeffe recalled the difficulty of posing: "You blink when you shouldn't—your mouth twitches—your ear itches or some other spot itches. Your arms and hands get tired, and you can't stay still. I was often spoiling a photograph because I couldn't help moving—and a great deal of fuss was made about it."[112] The actual process of taking the photograph, then, tends to negate the eroticism of the finished product, although the model's discomfort is invisible.

Despite her unease, O'Keeffe stayed immobile for the relatively long periods required. In other words, she, like Jo Hopper, was an active agent in her own objectification, enabling Stieglitz as the photographer to exert his control and to frame her as the subject in images that underscore her femininity. O'Keeffe and Stieglitz thus collaborated in these unusual photographs, which document their intimate emotions. Rather than merely acting and functioning as the passive object of the masculine

gaze, O'Keeffe also participated in her husband's artistic endeavor, willingly posing in erotic and revealing ways.

Stieglitz, with O'Keeffe's collaboration, made public through his photographs the private sexual intimacies of their relationship in a manner that corresponded to the newer, more overt discussion of sexuality in American culture. Davis and Hamilton's studies of sexuality, Ellis's and Key's promotion of female eroticism, Judge Lindsey's popular works on sex and marriage, and the increased eroticism in movies and novels indicate that many Americans had a new awareness of a previously taboo topic. O'Keeffe and Stieglitz contributed to this awareness by visualizing female eroticism through photographs that some critics—among them Hartley, Rosenfeld, and Mumford—recognized as resulting from their intimacy.[113] Mumford noted that in these photographs, Stieglitz had created "the exact visual equivalent of the report of the hand or the face as it travels over the body of the beloved."[114] As Mumford later astutely observed, Stieglitz endeavored "to translate the unseen world of tactile values as they develop between lovers not merely in the sexual act but in the entire relationship of two personalities. . . . It was his manly sense of the realities of sex, developing out of his own renewed ecstasy in love that resulted in some of Stieglitz's best photographs."[115] Stieglitz refused to distance the erotic through photographic manipulations that obscure the body in atmospheric haze, this critic (and friend of the photographer) commented; these images instead inscribe the sexual act between photographer and model, making public what had formerly existed as a private act between lovers. Just as he connected O'Keeffe's flowers with the visualization of the erotic, Mumford associated Stieglitz's photographs of O'Keeffe with the increased sexuality of American culture.

Critic Henry McBride gave this recollection of The Anderson Galleries exhibition: "Mona Lisa got but one portrait of herself worth talking about. O'Keeffe got a hundred. It put her at once on the map. Everybody knew the name. She became what is known as a newspaper personality."[116] He recognized that O'Keeffe became well known for two reasons: as a model for her husband's highly erotic photographs and as an artist. Stieglitz made public their passionate feelings, highlighting her gender through his fetishistic close-ups of her body.[117] Given the circumstances of their creation, the photographs themselves became a fetishistic substitute for sex. At the same time, the audience and critics recognized this model's identity as an artist, and applied to her paintings the photographer's emphasis upon his wife's femininity and sexuality. These photographs therefore advanced O'Keeffe's position in the eyes of the public as a woman artist engaged in capturing the female experience.[118]

The Masquerade of Femininity and Androgyny

Psychiatrist Joan Riviere, Freud's colleague and occasional translator, identified in 1929 a new historical character: a person who was both feminine and professional, "a particular type of intellectual woman" who was an excellent wife and mother and appeared extremely "feminine" on the outside, but who acted "masculine" in pursuing a career in academia, business, science, or, we might add, art. In "Womanliness as a Masquerade," she cited the case of a woman engaged in public speaking who needed reassurances from men: "analysis of her behavior after her performance showed that she was attempting to obtain sexual advances from the particular type of men [father figures] by means of flirting and coquetting with them in a more or less veiled manner." As Riviere observed, "Womanliness therefore could be assumed and worn as a mask, both to hide the possession of masculinity and to avert the reprisals expected if [the woman] was found to possess it." Within this context, we might see O'Keeffe in Stieglitz's photographs assuming "the mask of femininity" to demonstrate her womanliness, thereby countering what were perceived as her (and her paintings') "masculine" ambitions.[119]

What about Jo Hopper, who also appropriated a masquerade of femininity for her husband's paintings? Given that Edward and others never perceived her as a successful artist, it does not seem likely that Jo's reasons were similar to O'Keeffe's. Jo assumed a mask not to reassure her husband of her nonthreatening position as an artist, but to assert her own sexual desirability despite her ambivalence toward sex. Her modeling as a sexual siren, according to Riviere's analysis, was Jo's way of being coquettish and flirtatious within the safe environment of the studio, where the act of painting and modeling may have been a fetishistic replacement for lovemaking between artist and model.

Although both Jo Hopper and O'Keeffe appear as erotic and objectified images in their husbands' works, O'Keeffe sometimes had the more severe persona of the two as evident in other pictures, where she has slick, tightly coiffed hair and wears severe black clothing and no-frills hats that hide her body and obscure her gender (fig. 90). These photographs suggest a more androgynous, even masculinized person, aloof, independent, and strong. She is the modern dandy, who deliberately created an expression of artifice through her cross-dressing and who established her independence as a woman.[120] Stieglitz's *Georgia O'Keeffe—A Portrait,* in fact, embodies the subject's various personas—what Stieglitz referred to as her many "Selves"[121]—as artist (figs. 75, 77, 79, and 90), as carnal woman (figs. 74, 75, 77, 78, 80, 81, and 82), and as androgyne (fig. 90). Just as O'Keeffe participated in her own representations as both passive object of desire and active carnal agent, she also must have actively adopted the masquer-

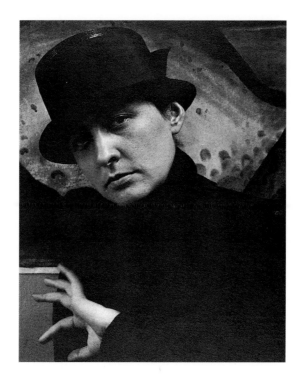

Figure 90.
Alfred Stieglitz, *Georgia O'Keeffe: A Portrait*.
Palladium photograph, 1918. National Gallery of Art, Washington, D.C., The Alfred Stieglitz Collection. Accession no. 1980.70.67. Photograph © 2001, Board of Trustees, National Gallery of Art, Washington.

ade of androgyny, where her sexuality remained contained and hidden behind her stark, dark clothes, pulled-back hair, and bowler hats. Significantly, Stieglitz recommended her placement in front of the early black and white drawings that critics first identified as embodying the female principle. These photographs (e.g., fig. 77), in other words, contrast the curvilinear, womblike forms with O'Keeffe's own face, upper torso, and hands, while the more androgynous representations overtly contest the very images in the charcoals that critics viewed as uniquely feminine.[122] Some of the photographs that Stieglitz exhibited at The Anderson Galleries had in fact influenced the interpretations of the male critics, who applied anthropomorphic analogies to O'Keeffe's nonfigurative abstractions, resulting in her decision to paint flowers and skyscrapers.[123] Stieglitz also promoted the more serious, unadorned woman-as-androgyne during the 1920s through photographs that critics included with their reviews, creating a conflict between these forbidding images and those revealing a sexualized perception of her.[124]

While Stieglitz showed many sides of O'Keeffe in his work, O'Keeffe herself both contributed to and resisted interpretations of the erotic images in her art and in the photographs on which the two artists collaborated between 1917 and 1920. O'Keeffe the androgyne reappeared sporadically in Stieglitz's work during the 1920s. Toward the end of that decade, O'Keeffe inverted the sexual politics of looking by objectifying her husband in an emblematic portrait, *The Radiator Building* (plate 9).

Plate 1. Edward Hopper, *Early Sunday Morning*. Oil on canvas, 1930. Collection of Whitney Museum of American Art, New York. Purchase, with funds from Gertrude Vanderbilt Whitney. Accession no. 31.426. Photograph copyright © 2000, Whitney Museum of American Art.

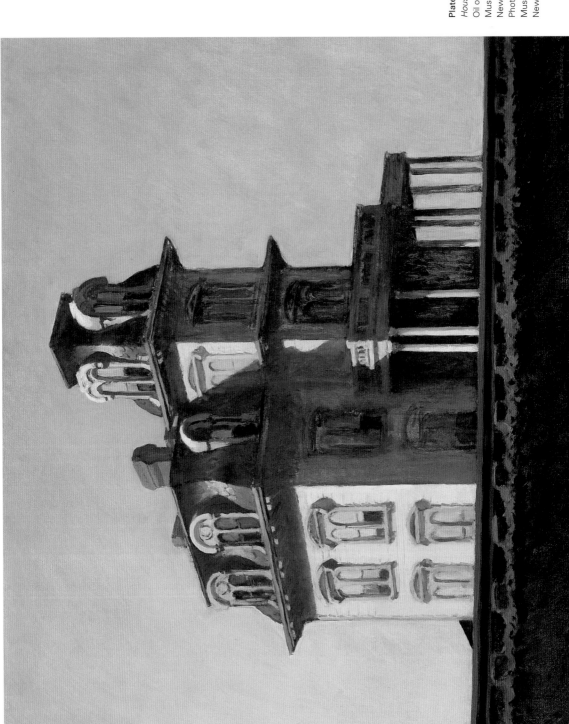

Plate 2. Edward Hopper, *House by the Railroad.* Oil on canvas, 1925. The Museum of Modern Art, New York, anonymous gift. Photograph © 2000, The Museum of Modern Art, New York.

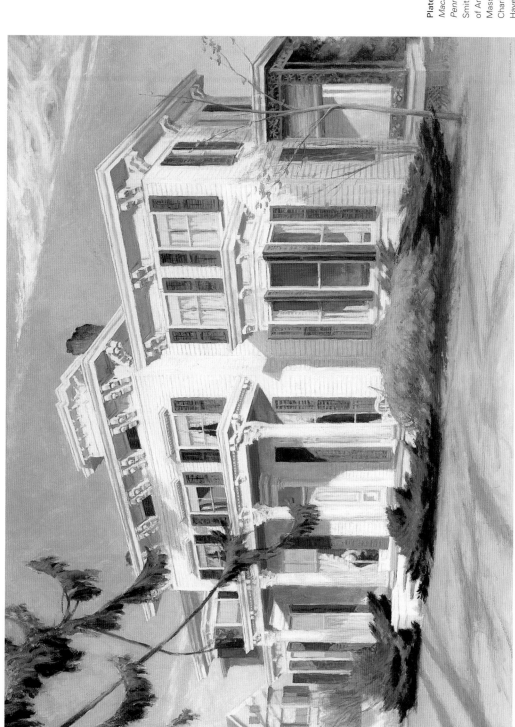

Plate 3. Edward Hopper, *MacArthur's Home "Pretty Penny."* Oil on canvas, 1939. Smith College Museum of Art, Northampton, Massachusetts, gift of Mrs. Charles MacArthur, Helen Hayes, LHD Class of 1940.

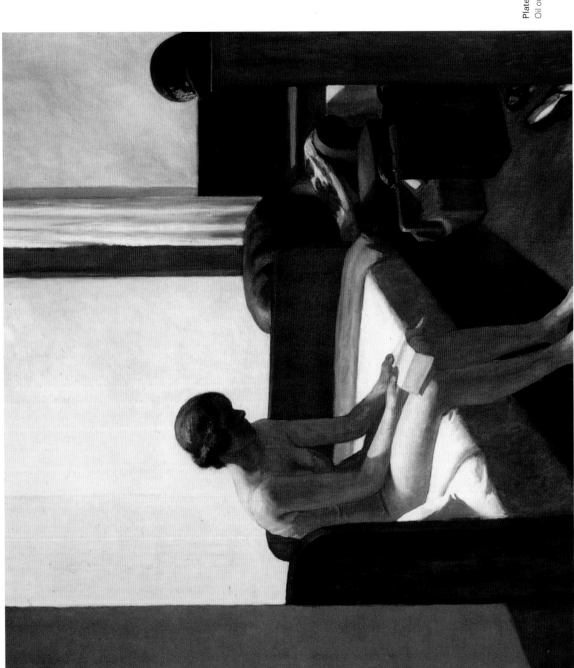

Plate 4. Edward Hopper, *Hotel Room*. Oil on canvas, 1931. Private collection.

Plate 5. Edward Hopper, *Girlie Show*. Oil on canvas, 1941. Private collection.

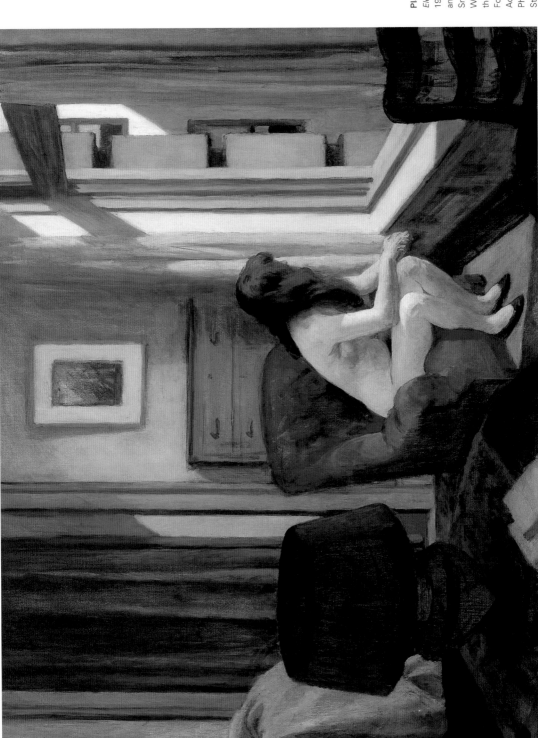

Plate 6. Edward Hopper, *Eleven A.M.* Oil on canvas, 1926. Hirshorn Museum and Sculpture Garden, Smithsonian Institution, Washington, D.C., gift of the Joseph H. Hirshorn Foundation, 1966. Accession no. 66.2504. Photographed by Lee Stalsworth.

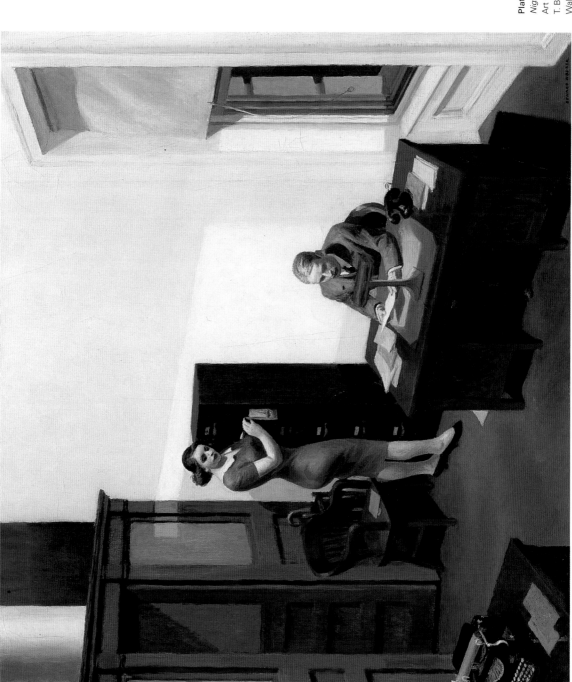

Plate 7. Edward Hopper, *Office at Night.* Oil on canvas, 1940. Walker Art Center, Minneapolis, gift of the T. B. Walker Foundation, Gilbert M. Walker Fund, 1948.

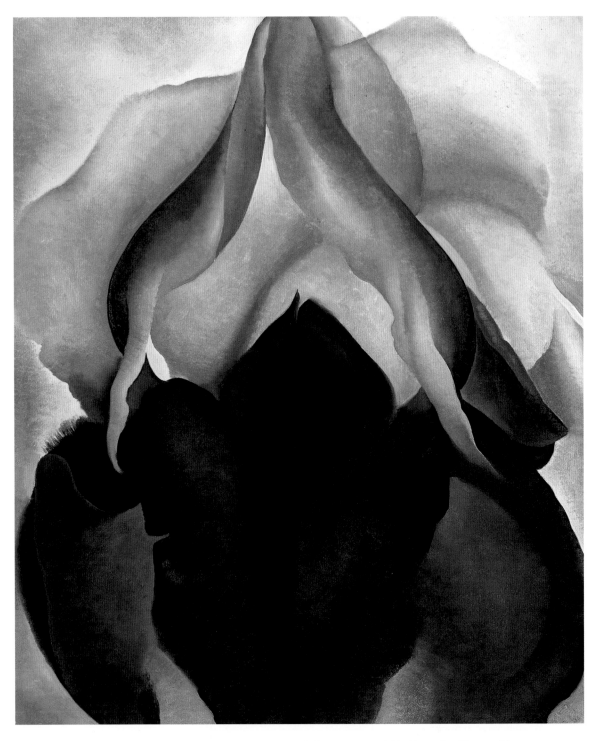

Plate 8. Georgia O'Keeffe, *Black Iris III*. Oil on canvas, 1926. The Metropolitan Museum of Art, New York, Alfred Stieglitz Collection, 1969. Accession no. 69.278.1. © 2002 The Georgia O'Keeffe Foundation / Artist Rights Society (ARS), New York. Photograph © 1987 The Metropolitan Museum of Art.

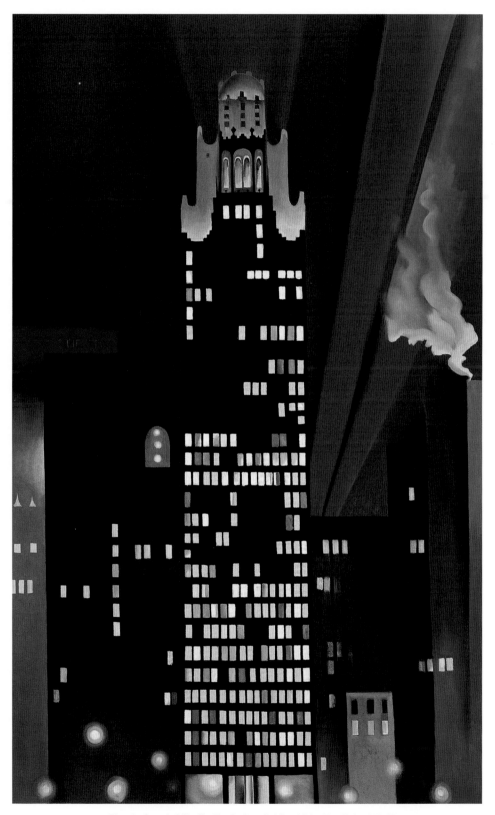

Plate 9. Georgia O'Keeffe, *The Radiator Building: Night, New York*. 1927. Oil on canvas, 1927.
The Alfred Stieglitz Collection of Modern Art, Fisk University Galleries, Nashville, gift of
Georgia O'Keeffe. © 2002 The Georgia O'Keeffe Foundation / Artist Rights Society (ARS), New York.

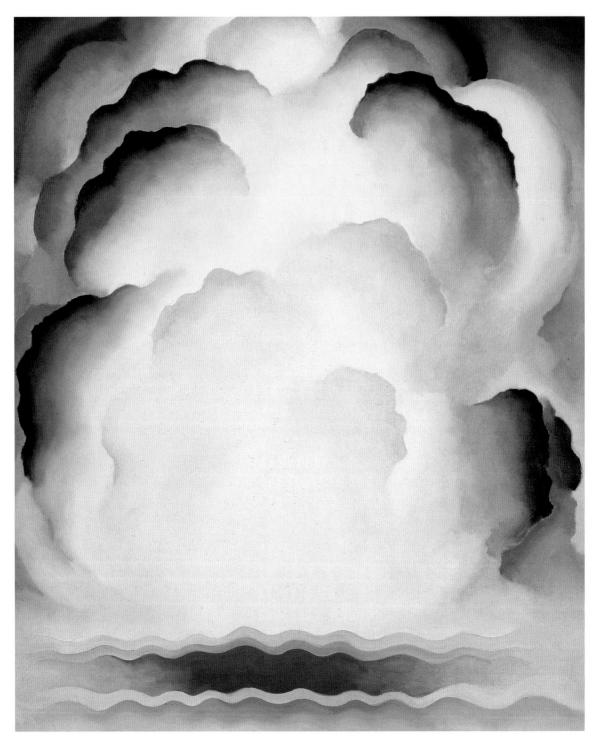

Plate 10. Georgia O'Keeffe, *Abstraction—Alexius*. Oil on canvas, 1928. Daros Collection, Switzerland.
© 2002 The Georgia O'Keeffe Foundation / Artist Rights Society (ARS), New York.

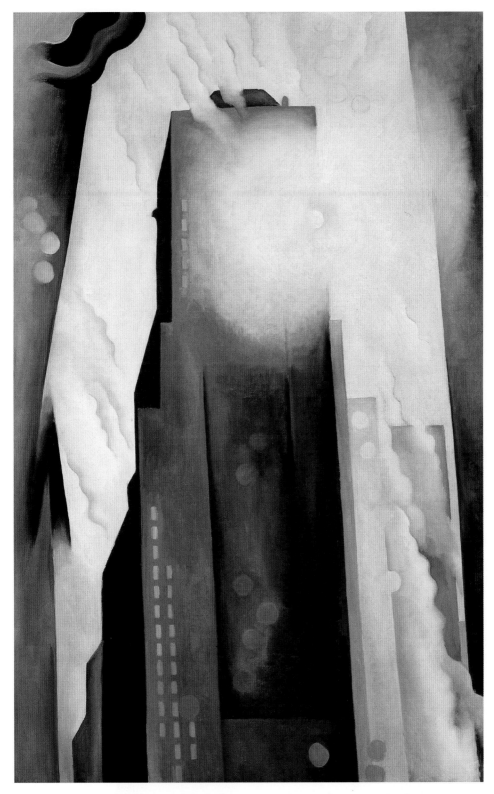

Plate 11. Georgia O'Keeffe, *The Shelton with Sunspots*. Oil on canvas, 1926. The Art Institute of Chicago, gift of Leigh B. Block. Accession no. 1985.206. © The Art Institute of Chicago. All Rights Reserved.

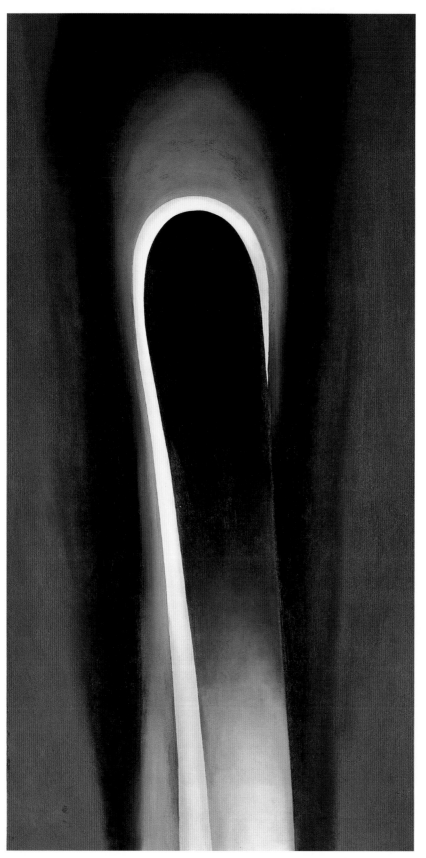

Plate 12. Georgia O'Keeffe,
Jack-in-the-Pulpit No. VI.
Oil on canvas, 1930. National
Gallery of Art, Washington,
D.C., The Alfred Stieglitz
Collection, bequest of Georgia
O'Keeffe. Accession no.
1987.58.5. © 2002 The
Georgia O'Keeffe Foundation /
Artist Rights Society (ARS),
New York. Photograph © 2002,
Board of Trustees, National
Gallery of Art, Washington.

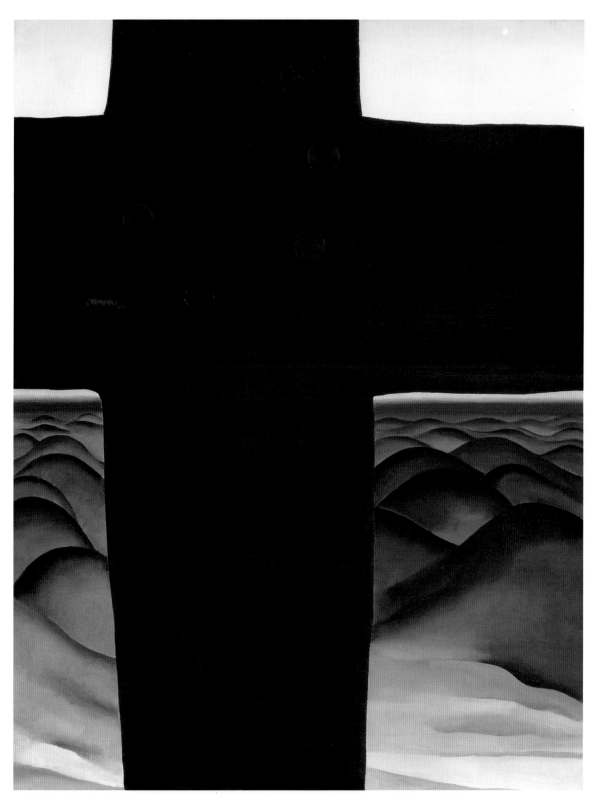

Plate 13. Georgia O'Keeffe, *Black Cross, New Mexico*. Oil on canvas, 1929. The Art Institute of Chicago, Art Institute Purchase Fund. Accession no. 1943.95. © The Art Institute of Chicago. All Rights Reserved.

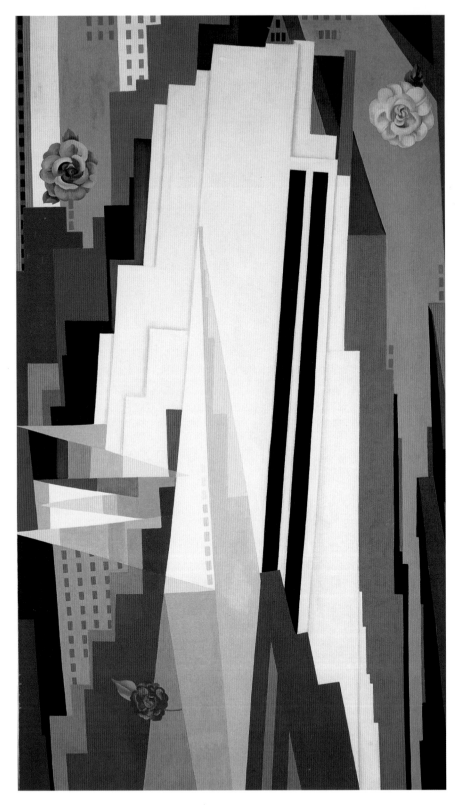

Plate 14. Georgia O'Keeffe, *Cityscape with Roses*. Oil on canvas, 1932. National Museum of American Art, Smithsonian Institution, Washington, D.C., gift of The Georgia O'Keeffe Foundation. Accession no. 1995.3.1. © 2002 The Georgia O'Keeffe Foundation / Artist Rights Society (ARS), New York.

Georgia O'Keeffe's *Radiator Building:* Gender, Sexuality, and Urban Imagery

In *The Radiator Building: Night, New York* (plate 9), O'Keeffe incorporated aspects of the Freudian psychoanalysis that had pervaded American culture and her circle of friends during a year when critics especially were active in connecting her imagery with sexual symbolism. In this work, she ironically alluded to their theories in order to turn the tables on them and criticize their analysis in their own terms in a manner that is both serious and humorously subversive. She constructed her own identity apart from her husband's sexualized biography of her (created, recent art historians have argued, in part to facilitate the sale of her work). And she also drew upon obvious and well-known symbols to convey her own message. In doing so, she adopted the strategy of other second-generation New Women, who seized men's symbolic constructs and invested them with female intent, thereby inverting and repudiating them.[1] She did so at a time when her own marriage was threatened by Stieglitz's affair with Dorothy Norman, which had begun in 1927, the same year O'Keeffe painted this work.[2]

In her only publication about her own work, O'Keeffe discussed *The Radiator Building* among her other cityscapes, explaining that she had "walked across 42nd Street many times at night when the black Radiator Building was new—so that had to be painted, too."[3] This matter-of-fact explanation of her selection of the "new" Radiator Building as a subject is typical of O'Keeffe's tendency to obscure and mystify the meanings of her paintings. She suggested that the building's mere existence in New York City demanded that she paint it along with some twenty other

structures between 1925 and 1930. "There were many other things [in the Big City] that I meant to paint," O'Keeffe reminisced, explaining that she nevertheless felt compelled to move on to other subjects.[4]

Designed by Raymond M. Hood and completed in 1924, the Radiator Building was applauded at the time for its successful use of black materials, its clear silhouette, its "waffle-like" window openings, and the unique floodlighting at its gilded top.[5] This Art Deco skyscraper captured O'Keeffe's imagination, and she represented it with its highlighted crown at nighttime in the center of the New York cityscape to capture, as other artists did, the city's modernity.[6] She located this centralized and flattened tower between flowing, lightly colored smoke on the right and the intense red sign on the left emblazoned with the name ALFRED STIEGLITZ. This sign originally contained the words *Scientific American*. Replacing those words with the name of her husband provides a visible clue that the painting refers to him in ways that heretofore have not been recognized. Among other things, the sign functions as an index of both the presence and the absence of the person named, while the skyscraper, as will be seen, is a topos signifying Stieglitz through Freudian analogies.[7] O'Keeffe chose a currently popular symbolic mode for her painting—the emblematic portrait—to create a work filled with layers of meanings concerning sexuality, gender, urbanization, and heterosexual relationships.

The Emblematic Portrait

During the first two decades of the twentieth century, American modernist painters created emblematic portraits, compositions in which an image—sometimes abstract and sometimes realistic—conveys information about specific people without presenting their likeness. Karl Josef Höltgen defined an emblem as "an epigram [that includes word and image] which describes something so that it signifies something else."[8] The audience, however, must understand what the epigram signifies, requiring, in the words of the literary scholar Michael Bath, the reader's or viewer's ability to recognize "the significant relationship between text and image . . . in many cases where there is based on a received topos, that relationship also involves recognising something which is *hors texte* in the sense that it is not announced by the emblem itself." "A third element" involves "the reader's recognition of the topos itself."[9] An emblem thus often includes word and image to signify specific ideas that the reader or viewer must be able to decode—sometimes a difficult process.

These modern emblematic portraits evolved from two precedents: the eighteenth-century emblematic portrait and Gertrude Stein's abstract word portraits. Charles Willson Peale's *William Pitt* (fig. 91) and Gilbert

Figure 91.
Charles Willson Peale, *William Pitt.* Mezzotint and engraving on cream laid paper, circa 1768. Courtesy of the Pennsylvania Academy of the Fine Arts, Philadelphia, John S. Phillips Collection. Accession no. 1876.9.415.

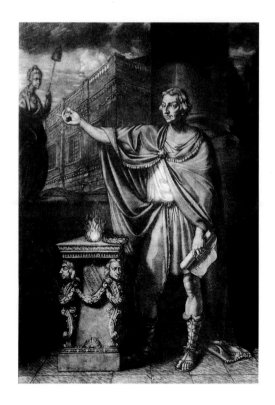

Stuart's *Lanesdowne Washington* (1811) contain a likeness of a specific individual along with storytelling objects to provide information about the subject's historical contributions. In his painting of the British parliamentary leader, Peale included among other symbols a figure of Libertas, the Magna Carta (in Pitt's left hand), the sacred altar of peace before which he stands, and, in the background, the Banqueting Hall of Whitehall Palace as a symbol of monarchical tyranny.[10] Stein's word portraits, on the other hand, capture the essence of a person "not through mimesis but through analogy and symbols."[11]

Stieglitz published Stein's literary portraits "Henri Matisse" and "Pablo Picasso" in the August 1912 special issue of *Camera Work,* thereby introducing these innovative works to the United States.[12] Ten months later, he published Stein's "Portrait of Mabel Dodge at the Villa Curonia," with Dodge's observation that "Gertrude Stein is doing with words what Picasso is doing with paint. She is impelling language to induce new states of consciousness and in doing so language becomes with her a creative art rather than a mirror of history." As Dodge accurately explained, "In Gertrude Stein's writing every word lives" in a "rhythmical and cadenced" manner that creates a "hypnotic effect when read aloud."[13] In her experimental word portraits, Stein thus eliminated or transformed such literary conventions as punctuation, syntax, and grammar to create

poems that contain no plot, no representation, no causal sequences of events, nor any clear sense of connections or progress. She replaced traditional syntax with rhythm, internal rhyme, and ritualistic repetition to evoke the essence of a person and his or her personality.[14] By naming the poems after famous European abstract artists (Matisse and Picasso) or an American who formed her own avant-garde salon in the United States (Dodge), Stein made it clear that these people provided the inspiration for her innovative, flowing, diverse, and multifaceted response to their complexities as artists, human beings, friends, and practitioners and supporters of the avant-garde.

Stein's written portraits influenced, in turn, a number of artists connected to the Stieglitz circle, who applied her experimentation to images, creating abstract portraits through symbols, man-made and natural objects, and sometimes words. Marius De Zayas, whose *Alfred Stieglitz* (fig. 92) appeared in *Camera Work* in 1914, was the first artist to evolve a theory about abstract portraits, using images rather than words to express "my understanding of Stieglitz's mission: to catch souls and to be the midwife who brings out new ideas to the world."[15] De Zayas combined symmetrical, flattened, geometric forms with mathematical equations to refer to the photographer's mechanical soul-catching on film and his

Figure 92.
Marius De Zayas, *Alfred Stieglitz*. Photogravure, 1914, from *Camera Work*, April 1914. Courtesy George Eastman House, Rochester, New York.

Figure 93.
Marius De Zayas, *Throws Back Its Forelock*. Photogravure, 1915, from *Camera Work*, March 1915. Courtesy George Eastman House, Rochester, New York.

dedication to modern art and literature. De Zayas's second abstract caricature of Stieglitz, *Throws Back Its Forelock* (fig. 93), which appeared on the front page of the March 1915 issue of *291,* includes a camera and a schematized rendition of a face.[16] In both works, De Zayas bridged the gap between the celebrity caricatures in the commercial media and the avant-garde art world's concern with discovering innovative ways to represent human beings without a literal likeness. He consequently provided humor and satire to the cult of celebrity that proliferated during this period in stylish magazines such as *Vanity Fair* as personality replaced the nineteenth-century emphasis upon character.[17]

De Zayas's caricatures provided a precedent for the French artist Francis Picabia, whom Stieglitz had paired with De Zayas in back-to-back one-man shows in 1913. Picabia created five emblematic portraits for the 1915 inaugural issue of *291,* published by Marius De Zayas along with Paul Haviland and Agnes Ernest Meyer. This issue's cover contains *Ici, c'est ici Stieglitz* (fig. 94), which represents through mechanized imagery the founder of the gallery after which this journal was named. Picabia appropriately portrayed the man who had introduced photography as a fine art

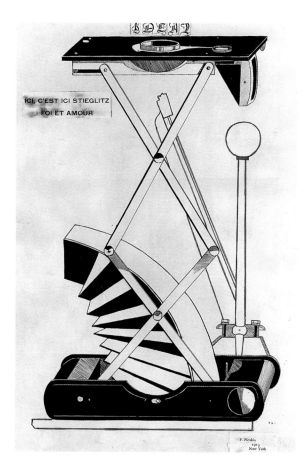

Figure 94.
Francis Picabia. *Ici, c'est ici Stieglitz.* Pen and red and black ink drawing, 1915. From *291,* no. 5-6, July-August 1915. The Metropolitan Museum of Art, New York, Alfred Stieglitz Collection, 1949. Accession no. 49.70.14. All rights reserved, The Metropolitan Museum of Art.

form to the United States satirically as a centralized vest-pocket Kodak camera derived from advertisements. This camera seems to be reaching upward to the word *ideal* in Gothic script, suggesting Stieglitz's dedication to modernist principles in his gallery and publications as well as through his financial and emotional support of his friends. But the camera strains upward without reaching the "ideal," the automotive gear shift is locked in neutral, the hand brake is engaged, and the camera lens evokes impotence, suggesting his frustrations during this period: patrons had stopped buying art, he had to borrow money to keep his gallery open, his stable of artists was breaking up, and *Camera Work* had not been published for many months.[18]

Other artists associated with the Stieglitz circle also worked within this modern idiom. Marsden Hartley painted a memorial to his friend and lover Karl von Freyburg, who had been killed in action during the First World War. In *Portrait of a German Officer* (fig. 95), Hartley included the Iron Cross, flags, and numbers—*4* for the Fourth Regiment, in which his friend served, and *24* for his age at his death—with the colors black, red, and yellow. These objects, symbols, and colors evoke the military pageantry of Germany, where Hartley lived at the time, and his sorrow over the loss of his companion.[19] Charles Demuth, who had visited Stein in 1912, evoked his friends in a series of six works begun in 1923 which

Figure 95.
Marsden Hartley, *Portrait of a German Officer*. Oil on canvas, 1914. The Metropolitan Museum of Art, New York, Alfred Stieglitz Collection, 1949. Accession no. 49.70.42. All rights reserved, The Metropolitan Museum of Art.

Figure 96.
Charles Demuth, *I Saw the Figure 5 in Gold*. Oil on composition board, 1928. The Metropolitan Museum of Art, New York, Alfred Stieglitz Collection, 1949. Accession no. 49.59.1. All rights reserved, The Metropolitan Museum of Art.

he called poster portraits, referring to the commercial signs and billboards that he included in his works. *I Saw the Figure 5 in Gold* (fig. 96), a poster portrait of the poet and physician William Carlos Williams, and *Poster Portrait: O'Keeffe* (fig. 97), a potted plant with the word *O'Keeffe* stenciled in red, both translate Stein's poetic language into visual form in order to capture the essence of the subject rendered. In the latter portrait, Demuth employed a vertical format to emphasize O'Keeffe's preferred format, and included a sansevieria plant with flamelike leaves to evoke his sense of her flower imagery as "a movement in flames." The vertical signage of O'Keeffe's name evokes the billboard advertisements of the day, while the cruciform created by the horizontal *FEE* suggests religious rhetoric and reiterates Calvin Coolidge's claim that commerce was the religion of the age.[20] Demuth's poster portraits were exhibited in the "seven Americans" show at The Anderson Galleries, to which O'Keeffe had submitted her first painting of a skyscraper, *New York with Moon* (fig. 68), possibly inspiring her later emblematic portrait based on another image of a New York City structure, the Radiator Building.[21] Arthur Dove's *Portrait of Alfred Stieglitz* (fig. 98), also exhibited in this show, may have provided another inspiration for O'Keeffe. Other associates of the Stieglitz circle created abstract portraits, but they did so in books. *Port of New York: Essays on Fourteen American Moderns* (1924) by Paul Rosenfeld; *America and Alfred*

Figure 97.

Charles Demuth, *Poster Portrait: O'Keeffe*. Poster paint on panel, 1923–24. Courtesy of the Demuth Foundation, Lancaster, Pennsylvania.

Figure 98.

Arthur Dove, *Portrait of Alfred Stieglitz*. Assemblage: camera lens, photographic plate, clock and watch springs, and steel wool on cardboard, 1925. The Museum of Modern Art, New York, purchase. Photograph © 2000 by The Museum of Modern Art, New York.

Stieglitz: A Collective Portrait (1934), edited by Rosenfeld, Waldo Frank, Norman, Lewis Mumford, and Harold Rugg; and *Stieglitz Memorial Portfolio, 1864–1946,* compiled by Norman (1947), employ the literary portrait format, combining essays, biography, photographic portraits, and criticism to evoke the many aspects of Stieglitz as artist, gallery owner, and so forth.[22]

It is not surprising that Stieglitz, too, experimented with abstract portraits, most notably in his *Equivalent* series. He had written on the back of *Songs of the Sky No. 2* (fig. 99), "Portrait of Georgia," suggesting that he intended this photograph and perhaps others such as *Songs of the Sky No. 3* (1923) to function as a portrait of his second wife.[23] Recall that Stieglitz had explained that he sometimes communicated with O'Keeffe by way of photographing the clouds and sky; he thus may have created these abstract portraits of her via his *Equivalents* to communicate his feelings about her in a rather abstract manner. He also, according to a critic in 1924, created an abstract portrait of "a friend . . . a scientist and philosopher" in his *Songs of the Sky and Trees*.[24]

O'Keeffe herself experimented with using emblematic portraits to render, through imagery and sometimes words, people important to her and to express her feelings about them: "I have painted portraits that to me are almost photographic. I remember hesitating to show the paintings, they looked so real to me. But they have passed into the world as abstractions—no one seeing what they are."[25] Charles C. Eldredge argued that O'Keeffe indeed created at least two abstract portraits: *Lake George,*

Figure 99. *(right)*
Alfred Stieglitz, *Songs of the Sky No 2*. Silver print, 1923. Museum of Fine Arts, Boston, gift of Alfred Stieglitz, April 1924. Courtesy, Museum of Fine Arts, Boston. Reproduced with permission. © Museum of Fine Arts, Boston. All Rights Reserved.

Figure 100. *(opposite right)*
Georgia O'Keeffe, *Lake George, Coat and Red*. Oil on canvas, 1919. The Museum of Modern Art, New York, gift of The Museum of Modern Art, New York, and The Georgia O'Keeffe Foundation. © 2001 The Georgia O'Keeffe Foundation / Artist Rights Society (ARS), New York. Photograph © 2000 by The Museum of Modern Art, New York.

Coat and Red (fig. 100) and *Abstraction—Alexius* (plate 10). Eldredge suggested that O'Keeffe rendered in the latter painting a massive cloud looming above a landscape to evoke the means by which her favorite brother, Alexius, had become a wartime victim of poisonous gas during World War I.[26] This emblematic portrait relates with its dominant clouds to Stieglitz's *Equivalents* as seen in *Songs of the Sky No. 2,* which Paul Strand had interpreted as evoking a "feelings of grandeur, of conflict, of

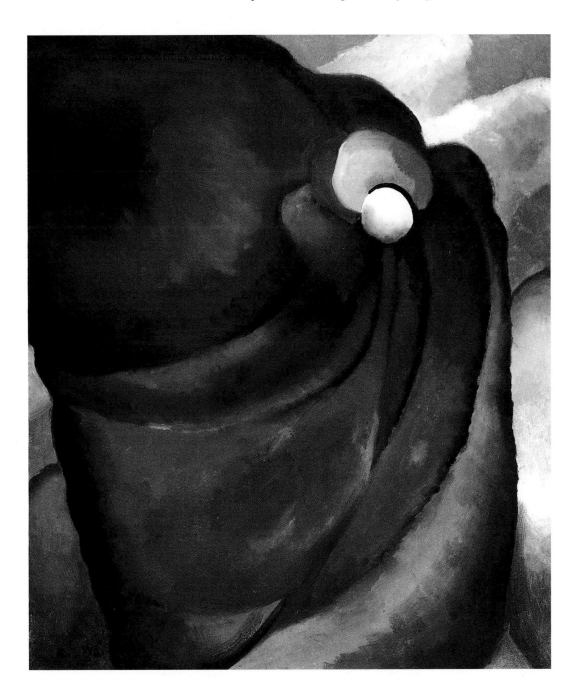

struggle and release, of ecstasy and despair, life and the blotting out of life."[27] O'Keeffe seems have to intended the same sense of "struggle and release" in her painting, suggesting both oppression and a sense of transcendence, perhaps to evoke the essence of her brother in illness and nature's continuation despite man's destruction, a meaning O'Keeffe later attributed to the color blue, a dominant hue in this painting: "Blue will always be there as it is now after all man's destruction is finished."[28]

Lake George also employs undulating rhythmic shapes of rich color to represent a person. Its centralized spiral in gray-black hues with red spot evokes Stieglitz in his dark cape with red lining and red vest. According to Eldredge, "the bright burst at the point where the 'cape' is gathered at the figure's 'shoulder' most likely refers to Stieglitz's color preferences" for red and black. He suggested that this painting shows Stieglitz as he looms over the "sparkling autumnal landscape of Lake George Country."[29] O'Keeffe earlier in 1917 had painted three abstract portraits of Paul Strand, a fact unknown until recently, when Barbara Buhler Lynes identified the subject based on correspondence between Stieglitz and O'Keeffe.[30]

Done eight years after her abstract portrait of Stieglitz in *Lake George, The Radiator Building* evokes again and in a different manner the essence of her husband, friend, artistic influence, dealer, and the critic partially responsible for the sexualized readings of her works. By writing Stieglitz's name in this prominently highlighted red field of neon lights, O'Keeffe not only indicated who this work represents, but also exerted control by appropriating power through naming. Yet the way in which she rendered her husband's name, blazing in the skies of New York City, also suggests her submission to its power. O'Keeffe associated Stieglitz with New York; the placement of his name beside the building gives it as much visual impact as the structure itself.

Stieglitz's name emblazoned in red—the most prominent hue in an otherwise dark painting—must be seen within the context of O'Keeffe's tendency to ascribe meanings to colors. Influenced by Kandinsky's *Concerning the Spiritual in Art* (1912), which she had read at the suggestion of her teacher, Arthur Bement, and reread in the pages of *Camera Work* (July 1912), O'Keeffe used this radiant hue to capture what the Russian artist had identified as a color "of almost tenacious immense power . . . [that] arouses the feeling of strength, energy, ambition, determination."[31] Moreover, according to Dorothy Norman, "other than black and white, Stieglitz loves red, a touch of red," a preference that was evident in his black cape lined with red, covering a red vest.[32] As in O'Keeffe's other emblematic portrait of Stieglitz *(Lake George, Coat and Red),* "a touch of red" signifies his physical and emotional presence.

Without words and names, *Abstraction—Alexius* and *Lake George,* like Demuth's *Calla Lilies (Bert Savoy)* (fig. 101)—an eponymous poster

Figure 101.
Charles Demuth, *Calla
Lilies (Bert Savoy)*. Oil on
composition board, 1926.
Fisk University Galleries,
Nashville, gift of Georgia
O'Keeffe.

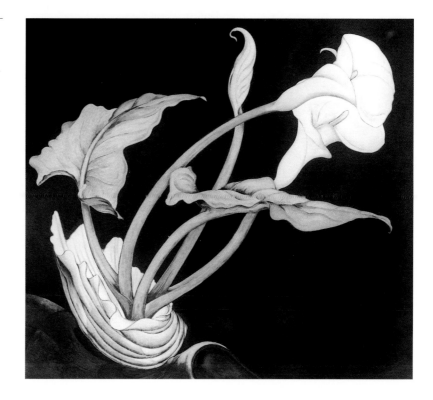

portrait of a female impersonator on the vaudeville stage—and Hartley's
Portrait of a German Officer, were vague in their meaning. Although Demuth
and Hartley deliberately obscured their portraits of homosexual men and
women, Demuth's heterosexual subjects such as Williams and O'Keeffe
remain more recognizable.[33] O'Keeffe may have decided to clarify the
identity of *The Radiator Building*'s subject by including Stieglitz's name,
but her contemporaries and friends failed to decipher this.

 The determined and powerful Stieglitz, who promoted the art of
his circle (which included his wife) in New York City, is rendered
through his name in a form resembling a billboard. O'Keeffe alluded to
modern commercial advertising through this signage, in a manner similar
to Demuth. O'Keeffe also may have intended to suggest that Stieglitz,
who had studied mechanical engineering at the Berlin Polytechnic be-
fore turning to photography, represented a new type of "scientific Amer-
ican" who created fine-art photography and employed modern techno-
logical advancements to produce his magazines.[34] The wry humor behind
the substitution of Stieglitz's name for *Scientific American* matches De
Zayas's tendency to infuse wit into the abstract portraits that he derived
from modern commercial caricatures. The latter became popular be-
tween the two world wars among an urban audience who appreciated his
ability to capture the tempo, energy, newness, and polish of metropolitan
life.[35] O'Keeffe similarly employed ironic humor within a painting that

evokes modernity through subject and style, creating a new type of portraiture that conveys aspects of an individual's personality and her relationship to that person.

Part of the irony within this context comes from Stieglitz's claiming to detest advertising and the commercialization of the arts, modern phenomena inherent to urban America in which, he worried, business and art were becoming fused so that "the whole thing" was becoming "another Wall Street."[36] He condemned, for example, Gertrude Whitney and the Rockefellers, viewing the Whitney Museum and the Museum of Modern Art as a means for powerful and wealthy families to control the art world. Herbert Seligmann recalled Stieglitz's "sustained flow of narration" on such "main themes" as commercialism as "the foe," along with "its accompanying indifference to quality . . . and its disregard for the spirit."[37] Stieglitz stated, "The Room [Intimate Gallery] is established primarily to sell the work of the men here in order to enable them to go on, not as a business; but people have wandered in and out, with no attention paid to selling."[38] He equated "the art business" with prostitution, condemning both for creating situations in which "money ruled" and consistently proclaimed that his gallery was "not a business" and that he was "not a dealer."[39]

Despite his protests against the marketing of art and his continual assertion that he was not a salesman,[40] Stieglitz indeed sold works in his gallery for financial profit, even if his only motive was to enable his friends and his wife to continue producing art and to establish their reputations as excellent modern American artists. Stieglitz always asked high prices for O'Keeffe's art, selling in 1928 (or so he claimed to the press) six calla lily panels for $25,000. This much publicized transaction, resulting in O'Keeffe's nickname as "the Lindbergh of art," assured the increased market value of her paintings, even if the transaction did not occur in the way in which Stieglitz reported it to the press. He claimed to have sold these paintings to a Frenchman for an amount that he could "hardly grasp," and stated that O'Keeffe would give one-fifth of the amount to other artists, given that "the Room is [not] in any way a business" and hence he does not accept money "in any form."[41] He also had sold in 1926 a John Marin watercolor for $6,000, a widely publicized and controversial sale intended to assure the artist's fame despite Stieglitz's stated altruistic reasons of assisting Marin and his family when the watercolorist was ill.[42] Besides claiming to request high prices for these works for selfless reasons, Stieglitz nonetheless reported these transactions to the press, indicating his interest in making it known that he indeed acted as a dealer and negotiated for large sums of money. Like his friends who wrote literary portraits, he promoted and campaigned for the unique "brand-name product: highbrow modern art" that O'Keeffe and Marin represented.[43]

Because of its unique nighttime illumination, the Radiator Building functioned, according to its architect, "as a billboard to advertise itself."[44] Thus the name *Radiator* refers to not only the product manufactured by the company housed within the building, but also the unique emanation of the structure in a process of self-commodification. As another architect commented in 1924, since "commercialism is the guiding spirit of the age, the building which advertises itself is in harmony with that spirit."[45] This art deco skyscraper, with its gilded top illuminated at night, advertised itself just as Stieglitz participated in the very commercialization of American culture that he so adamantly denounced. O'Keeffe implied this much in a baiting manner through the signage in her composition, thereby exposing his hypocritical stance. As Wanda Corn astutely summarized, Stieglitz, Rosenfeld, and others in his circle "were public relations men who promoted Stieglitz as their spiritual head, touted the aesthetic life as one of healthy wholeness, proclaimed their new art a new and modern product, and boasted of their own greatness," appropriating techniques from marketing and commerce.[46]

O'Keeffe's *Radiator Building* thus belongs to the modernist tradition of abstract portraiture initiated by Gertrude Stein (whose word portraits fascinated her)[47] along with Marius De Zayas, Francis Picabia, Marsden Hartley, Charles Demuth, and Arthur Dove, artists she knew through her husband, who also experimented in this mode through his photography. Like these artists, O'Keeffe combined word and image to capture complex concepts and associations about her husband. She also followed the example of Picabia's and De Zayas's abstract portraits of Stieglitz through her selection of a man-made object to represent her subject symbolically. She created the work in a carefully delineated, flattened manner, with few details to evoke the mechanical product of machine and building. Whereas Picabia and De Zayas had selected a camera to signify Stieglitz, O'Keeffe chose a skyscraper—a unique contribution to world architecture and "a symbol of the American spirit," according to her friend and neighbor, architectural theorist, author, and designer Claude Bragdon.[48] This image ironically proclaims her husband as the modern man of commerce, "the scientific American," who embodied contradictions between his insistent protests against the commercialization of art and his actions in selling artworks for profit. She thus exposed his hypocritical stance in a manner that Stieglitz never recognized—perhaps intentionally.

Urban Imagery

The Radiator Building also, of course, represents Manhattan during a period when many artists, American and European alike, rendered this subject in an effort to understand its Americanness, uniqueness, and spirit of

modernity.[49] O'Keeffe executed this painting, like most of her cityscapes of the 1920s, in a Precisionist manner, with clear contours, little modulation in color, smooth, slick surfaces, solid shadows, and an absence of detail or human figures, thereby emulating the technique of straight photography that Stieglitz, Strand, and others developed during this period.[50] She celebrated "the City Electric,"[51] capturing the uniqueness of modern lighting; and she created works that differed, for example, from Hugh Ferriss's Deco-futurist skyscraper images or George Ault's more claustrophobic urban vision.

Stieglitz especially had documented the changing cityscape in nearly one hundred views between 1893 and 1932. At the same time, as editor of the *American Amateur Photographer* (1893–98), *Camera Notes* (1897–1902), and *Camera Work* (1903–7), he struggled to establish the city as a viable subject in art. He celebrated "the new America which was still in the making" in *Flat-Iron Building, New York* (fig. 102), "a triangular piece of real estate" that, Sidney Allen wrote in the October 1903 issue of *Camera*

Figure 102.
Alfred Stieglitz, *Flat-Iron Building, New York*. Photogravure, 1903. Philadelphia Museum of Art, gift of Carl Zigrosser. Accession no. 74.106.2.

Figure 103.
Alfred Stieglitz, *City of Ambition*. Photogravure, 1910. The Art Institute of Chicago, Alfred Stieglitz Collection. Accession no. 1949.836. © 2000, The Art Institute of Chicago. All Rights Reserved.

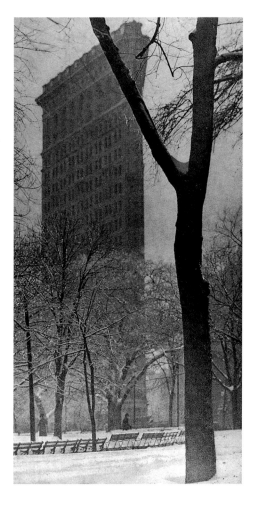

Work, "is typically American in conception as well as . . . [its] iron-construction."[52] For Stieglitz, this new structure combined lightness with solidity and represented in the United States "what the Parthenon was to Greece."[53] This soft-focus photograph merges the building into the atmospheric sky that surrounds it, resembling "some modern Cathay caught up in the air, or becom[ing] in one's imagination the strongholds of strange genii whose fevered breath pants out in gusts of steam."[54] Stieglitz's *City of Ambition* (fig. 103), and *Old and New New York,* which was published in *Camera Work* in 1911, similarly applaud the transformation taking place in the city. The latter photograph especially emphasizes the contrast between the old and the new, showing the brownstones in shadow while the frame of a skyscraper dominates the landscape, emerging out of the shadowed foreground into the highlighted sky.

By the early 1920s, however, Stieglitz had become less interested in this topic. His frequent trips to Lake George and his increasingly negative responses to the First World War and urbanization meant fewer works focusing on the skyscraper and technology.[55] He called New York "the City of Terribleness" in a letter to Paul Rosenfeld during the summer of 1920, but he told Hamilton Easter Field that he loved this "City of the Blessed." He felt overwhelmed by its mad pace, he wrote to Sherwood Anderson.[56] "I am a little bit more human than when I got away from that miserable hole the centre of the universe—Dame New York," he said a letter to Rebecca Salsbury Strand from Lake George.[57]

Although her feelings were ambivalent, O'Keeffe often embraced her metropolitan surroundings, an affection that is especially evident in her New York City paintings. *City Night* (fig. 104) suggests her admiration for these mammoth towers, which overwhelm the viewer and landscape with their uninterrupted vertical thrust (the lack of windows and central stripes emphasize this upward sweep). She enjoyed the view from the Shelton Hotel, where she and Stieglitz had settled in November 1925. "It is very grand looking out over the city," she informed her sister.[58] The year after she painted *The Radiator Building,* O'Keeffe proclaimed her love for the "roaring city," which she believed "an artist of today needs for stimulus."[59] "Today the city is something bigger, grander, more complex than ever before in history," she stated. "There is a meaning in its strong warm grip we are all trying to grasp. And nothing can be gained from running away. I wouldn't if I could." In this same interview, she claimed that the city provided more solitude than the country.[60] Yet in 1924, Stieglitz commented that his wife was "more at home in the soil, while I am a city person."[61] That same year, he told Jean Toomer that "New York [is] very bad for her."[62] Earlier, O'Keeffe herself had admitted to Sherwood Anderson that "New York . . . makes me feel more and more dumb as the days go by."[63] In November 1924, she expressed anxieties

Figure 104. Georgia O'Keeffe, *City Night*. Oil on canvas, 1926. The Minneapolis Institute of Arts, gift of the Regis Corporation, Mrs. And Mrs. W. John Driscoll, the Beim Foundation, the Larsen Fund, and public subscription. © 2002 The Georgia O'Keeffe Foundation / Artist Rights Society (ARS), New York.

about living in the city, where she could not write because "it wasnt [sic] nice—it was cracked and torn and bent and a little moldy."[64] She wrote to her sister Ida in 1925: "It isn't nice here—New York seems as a queer place—and I wonder what business we have here."[65]

O'Keeffe's urbanscapes thus express both her excitement over her shifting surroundings and her sense of melancholy in a city that oppressed and stifled, inspired and stimulated her.[66] While she felt threatened in 1924 and 1925, by 1928 she proclaimed her love for it, indicating that her ambivalence and change of feeling over time did not follow a clear path. She painted these towering buildings in a tightly controlled manner that, along with the lack of space, suggests a sense of claustrophobia; the walls of these structures become prisonlike barriers. *The Radiator Building* from this viewpoint becomes a demonic icon of modernity, suggesting that underneath the gilded surface of the crown reside threatening forces over which people have little control. A New York architectural journal agreed in 1924, viewing the black surface of the Radiator Building as "the color of darkness, not of light, the color of iron, not of life. . . . It is beautiful with the beauty of sin. . . . Behind the brutality is power, but not the power of Fate or God; it is the power of [a] monster, of a relentless machine."[67] To this critic (not unlike O'Keeffe), the building's very uniqueness with its gold crown and black walls embodied the horror that underlies technology, promising not life but only more machine-made objects.

It is significant that O'Keeffe selected a skyscraper, a symbol of the urban, commercial world, to visualize both her excitement and her discontent with city life. Social scientists of the time were arguing that urbanization and industrialization caused competition rather than cooperation within the workplace and at home, giving rise to morose, discordant, and difficult environments, and fostering disorganization and discontent within families. Companionship marriage reigned among utopian visions of cities, but the luxuries and consumerist culture of modern urban life threatened patriarchal systems and the authority of the family.[68] In his work, Hopper clearly highlighted the automobile and apartment houses as the specific aspects of modern urban life that created tension and ruptures within families; O'Keeffe turned her attention to the more commercial, public aspect of people's lives. Skyscrapers contained a multitude of working people who, modernists suggested in their writings and works, were becoming automata devoid of passion and consumed by the same commercial interests that Stieglitz and De Zayas believed threatened the arts as well.

As Elizabeth Wilson argued, the city embodies contrasts—natural and unnatural, monolithic and fragmented, private and public, rich and poor, vertical buildings and decentralized city plans, to list a few. These divisions, inscribed on urban life and determining the planning and

development of cities, also were mapped onto the larger oppositions between city and country, culture and nature, male and female. Wilson attributed the desire to master the city to masculine attitudes and saw the tendency to surrender to the city as feminine. Yet she noted that urban life created a space in which some women could experiment with new roles, such as becoming an artist and mastering the city in art.[69] O'Keeffe expressed excitement about her urban setting, but also struggled to reconcile through her art the disjunction between city and country and between nature and culture. Through her paintings, she both surrendered to the city and attempted to master and control it.

Society at this time saw the city as a masculine domain, created, managed, built, photographed, and painted by men. In *Winds of Doctrine* (1913), George Santayana explained that the American skyscraper represents "the sphere of the American man," as well as "aggressive enterprise."[70] The construction of skyscrapers required the ingenuity and physical strength deemed inherently masculine. In daily activity, men generally assumed the authoritative roles in the business sector, and claimed civic duty as a male responsibility. Female photographers and painters rarely focused on the urban setting, because they could not appear in public unaccompanied and work freely without attracting unwanted attention.[71] Painting the massive skyscrapers required the artist to assume a commanding view of the subject. In doing so, O'Keeffe challenged men—including her husband, who had told her not to paint the city. As she stated, "I want to paint in terms of my own thinking, and feeling the facts and things which men know."[72]

In fact, O'Keeffe appropriated techniques perfected by her husband in his medium of photography. She did so in order to control the environment in which she lived for his benefit, to reconcile her conflicting attitudes toward the city, and to diffuse the domination of the mechanical. In her paintings, she mimicked photographic effects to underscore the dominance of nature and to reject the public perception of images of the skyscraper as a masculine art form. She demonstrated a mastery of photo-optics in her own work, which included photographic distortions created by the camera and perfected by Stieglitz—halation, lens flare, and the panoramic lens—but she did so through the brush to assert her own mastery and originality of the medium of painting.[73]

Halation, a blurred effect around the edges of highlighted areas in a photographic image, is caused by the reflection and scattering of the light through the emulsion from the back surface of the film support or plate. This effect appears in *New York with Moon* (fig. 68) in the nearly circular orb of the streetlight with its pale yellow halo and in the red glow of the stoplight below. The spherical shapes of each mimic the unobtrusive full moon above.[74] Halation appears again in *City Night* (fig. 104), in the

glowing orb of a street lamp at the base of the canvas. In *Ritz Tower, Night* (1928), the lucent globe of the streetlight is seemingly unattached to any pole or ground support. The light radiates outward, forming the nimbus that both distorts the viewer's perceptions of the façade and recalls the shadowed form of the full moon at the top of the canvas. O'Keeffe repeatedly used such rounded forms to establish a parallel between features of the man-made city and elements of nature, allowing the artificial forms to replicate celestial orbs.

She utilized other photographic distortions to integrate skyscrapers with nature. In *The Shelton with Sunspots* (plate 11), O'Keeffe mimicked the malfunction known as lens flare. As a result of reflections within the camera, light may inadvertently hit the lens and rebound, thereby lightening dark areas, erasing outlines, and uniting building and clouds in a haze of light.[75] *East River from the Shelton* (fig. 105) shows a flattened horizontal effect from an aerial perspective to depict the broad regions of

Figure 105.
Georgia O'Keeffe, *East River from the Shelton*. Oil on canvas, 1927–28. New Jersey State Museum Collection, purchased by the Friends of the New Jersey State Museum, Trenton, with a gift from Mary Lea Johnston. © 2002 The Georgia O'Keeffe Foundation / Artist Rights Society (ARS), New York.

sky and water.[76] Here O'Keeffe mimicked the effect of the telephoto lens to reduce the city to silhouetted forms, casting a shadow that blends smoke issuing from the factories with the clouds, thereby distorting the sun and creating sunspots around the central orb.

In a 1928 review, critic Louis Kalonyme recognized O'Keeffe's attempt to merge the realms of nature and city in some of her urbanscapes. Identifying woman with nature and skyscrapers with man, he observed that the buildings thrust into the sky, "cleaving the sun and moon."[77] *New York with Moon* (fig. 68) captures the city at the onset of dusk, when the fading light reduces the buildings to continuous dark geometric shapes. The transitional sky dominates the canvas, with billowing clouds and moon at the top. *East River from the Shelton* also treats nature as a force that imposes itself upon the city, utilizing a distanced and high point of view as well as strong colors to both heighten and diminish the contrast between the organic and the mechanical. Working from her residence at the Shelton, O'Keeffe rendered the city as two horizontal gray silhouetted strips in the foreground and background. Sandwiched between the flattened, monochromatic zones of the city is the water that reflects the sky and ripples outward in ebbs of white, pinkish red, and blue. The sky occupies nearly two-thirds of the canvas, shrouding the background shoreline in haze from the clouds and rays of light that emanate outward from the centralized, radiating sun. *The Radiator Building* similarly shows this dichotomy between two realms, with its dominating centralized structure rendered in starkly contrasting black and white cubes with clear outlines, and the curvilinear cascade of smoke (with fluctuating hues of white, pink, purple, and aqua) that flows out of the smaller building to the right. Here, too, halation creates small, concentric, radiating white orbs out of streetlights at the bottom of the canvas that contrast with the harsh rectilinear lines in the Radiator Building itself.

O'Keeffe often represented skyscrapers at night, emulating a technique that Stieglitz had discovered early in the 1880s to soften the harshness of the city.[78] In *New York, Night* (fig. 106), she assumed an aerial viewpoint over Lexington and Fifth Avenues, placing herself opposite the imposing form of a skyscraper for direct, albeit distanced, confrontation. This nocturnal transformation of the city—nearly the last representation of this theme—sets dark against light, losing altogether the intricate form of the steel construction, which merges into the surrounding city in a blanket of darkness. The warm hues of red, orange, and yellow created by interior lights and the hazy, indistinct glow of traffic and light on the city streets contribute to the sense that the buildings lack solidity and are instead efflorescent shells that merge with the sky. The looming buildings seen from below in *City Night* do not lose their solidity, but similarly appear shell-like as they ascend upward into the softer hues of the blue sky.

The darkness imposed by night masks the surface features of the buildings, eliminating the facades and windows that grant them function and identity. *The Radiator Building* also renders New York City at night, shrouding the hectic pace of the city in darkness and emphasizing illusionistic displays of artificial light from the diagonal beams of blue searchlights and the windows.

Figure 106.
Georgia O'Keeffe, *New York, Night.* Oil on canvas, 1928–29. Sheldon Memorial Art Gallery, University of Nebraska-Lincoln, Nebraska Art Association, Thomas C. Woods Memorial Collection. © 2002 The Georgia O'Keeffe Foundation / Artist Rights Society (ARS), New York.

O'Keeffe and Freud

Besides creating, controlling, and manipulating New York City in *The Radiator Building*, O'Keeffe did the same with the male body. The centralized skyscraper evokes Stieglitz through the abstracted phallus with its highlighted crown, framed on the left by the red sign with his name. These two references indicate O'Keeffe's desire to fragment his body and personality into component parts that both reveal and obscure him. By selecting a building that some critics viewed as monstrous and demonic, O'Keeffe symbolically subverted Stieglitz.

A tradition of figuring the skyscraper as implicitly masculine, and therefore phallic, extended back to Louis Sullivan and before, when visual conventions of representation in portraiture and other genres routinely assigned phallic objects to males. It was not until the influence of Freud was felt, however, that these associations became codified and clearly understood within American culture. Edward Westermarck, for example, in 1934 summarized the Freudian ideas with which New York intellectuals were already well acquainted. According to Freudians, he wrote, "All hard, elongated, tubular objects are symbols of the phallus—sticks, umbrellas, chimneys, church spires, revolvers and what not [such as skyscrapers], while soft or hollow objects are likely to be the vagina."[79] O'Keeffe replaced what critics identified as female forms in her floral paintings—the pastel hues and saturated primary colors, undulating curves, and central-core compositions—with the elongated, tubular, chimneylike, phallic building, the harsher colors, the rectilinear contours, and the hard edges that symbolize masculine genius and power. This can be said about all of O'Keeffe's New York City paintings, but only *The Radiator Building*, with its highlighted crown between the name *Stieglitz* on the left and the ephemeral stream on the right, coalesces these ideas. O'Keeffe continued to play around with these ideas in her later jack-in-the-pulpit series (1930). These six canvases move from the more realistic representations of the first three, as in *Jack-in-the-Pulpit No. II* (fig. 107), to greater simplification and abstraction as O'Keeffe zeroed in on the flower. *Jack-in-the-Pulpit No. VI* (plate 12) lacks the background, leaves, and petals found in the earlier renditions. O'Keeffe instead focused exclusively upon the stamen, which, as Arthur Dove noted, resembles a "phallic symbol."[80] Here O'Keeffe combined the phallic and vaginal forms ("tubular" stamen with floral motif) in one image, as if to challenge her own unitary approach in *The Radiator Building*—which, as we shall see, is more complicated.

The Radiator Building itself becomes less established as a masculine signifier when the composition is further analyzed. The red sign—small, marginalized, horizontal, and blurred—contrasts with the phallic verticality of the building, whose solidity is undermined by the multitude of

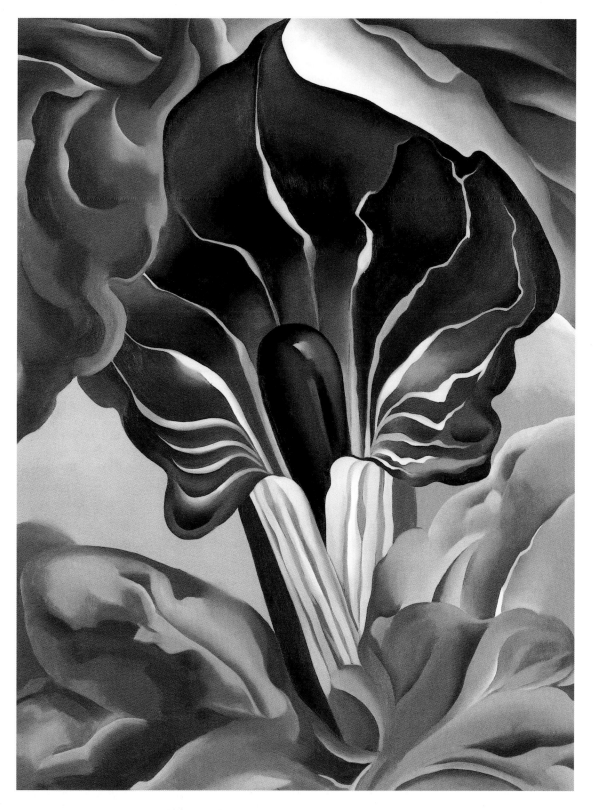

Figure 107. Georgia O'Keeffe, *Jack-in-the-Pulpit No. II.* Oil on canvas, 1930. National Gallery of Art, Washington, D.C., The Alfred Stieglitz Collection, bequest of Georgia O'Keeffe. Accession no. 1987.58.1. © 2002 The Georgia O'Keeffe Foundation / Artist Rights Society (ARS), New York. Photograph © 2001, Board of Trustees, National Gallery of Art, Washington.

electrically lit windows, especially those situated at the base. O'Keeffe hollowed out the mass of the building, making it less stable. By emphasizing void rather than solidity and stressing the interior spaces of the structure, she seems to feminize the phallic tower. The highly ornate decoration of the building itself could also bear connotations of femininity, indicating another reason that she selected this building for her emblematic portrait; it contained in its own architectural features both masculine and feminine characteristics, which O'Keeffe reiterated through the buildings and the curling smoke on the right. This furling, lighter motif, rising from a phallic building, evokes, within the context of popular Freudian discourse, both ejaculation and vaginal imagery. Its soft and flowing hues suggest a feminine sphere as well as sexual intercourse between phallus (skyscraper) and vagina (smoke). Could O'Keeffe have deliberately included these lighter, undulating streams on the right to allude to, dismiss, and also incorporate the very Freudian interpretations that she disliked? If so, she would have been taking an ironic stance, both including and (by implication, given her outspoken criticism of Freudianism) rejecting such references.[81]

In a reductive act that echoes the male interpretations of her art as uniquely feminine, *The Radiator Building* presents Stieglitz as a phallus, the symbol of power that women can never attain except through motherhood or, in O'Keeffe's own case, through the act of painting and controlling her own identity and her husband's likeness. As she wrote to Paul Strand in 1917, men "never understand me—unless maybe Stieglitz does—dont [sic] know that I understand myself. . . . As I see it—[being] a woman . . . means willingness to give life— . . . to give up life—or give other life."[82] A woman should give life by having a child, something Stieglitz would not allow, or "give other life" by painting pictures.

Psychoanalyst Joan Riviere argued that the intellectual modern woman exhibits a compulsive need for attention from various father figures. She maintained that this compulsion derives from an Oedipal rivalry with the mother and father, resulting in dreams and fantasies of castrating her husband, "as well as claims to superiority over . . . the father-figures." As Riviere explained, this modern woman "bitterly resented any assumption that she was not equal to them and (in private) would reject the idea of being subject to their judgment or criticism." The result was a "wish for 'recognition' of her masculinity from men"; such women "claim to be the equals of men, or in other words to be men themselves," yet each "publicly" acknowledges her "condition of womanhood" through "her compulsive ogling and coquetting." Riviere, a contemporary of O'Keeffe's who similarly struggled as a professional woman in a man's world in the 1920s and 1930s, concluded that this type of woman both desired to castrate her father and feared "the retribution the father would then exact,"

so she "put on a mask of womanliness to avert anxiety and the retribution feared from men."[83]

Riviere might have identified O'Keeffe as a bisexual with both masculine and feminine attributes. Her extremely sexualized nude poses in Stieglitz's photographs could then be seen as reflecting a desire to attain her position of womanhood, inspired by a fear of retribution from her husband and father figure, Alfred Stieglitz. As O'Keeffe admitted shortly after his death, Stieglitz "was the leader or he didn't play. . . . It was his game and we all played along or left the game."[84] *The Radiator Building* could be seen within this context as a symbol of O'Keeffe's desire to remove the male power and privilege of critics (especially her husband) who expressed a sexualized and sexist interpretation of her work, thereby making them (and him), in Riviere's analysis, "powerless and helpless (her gentle husband)."[85] She did not want to castrate her husband per se, but wished to cut off his power to shape her public identity, and to empower herself.

O'Keeffe thus assumed the masculine position of artist. She reversed the power between her gallery-owner husband and herself by promoting him; in doing so, she exposed the reality that her art indeed advanced him and his gallery. This painting expresses visually what she maintained verbally throughout her life; it rejects "the idea of being subject to the [male critic's and her husband's] judgement or criticism,"[86] and it does so ironically and humorously, presenting Stieglitz in obvious phallic terms to provoke her viewers into thinking again about the Freudian interpretations of her works.

At the same time, *The Radiator Building* may be O'Keeffe's tribute to Stieglitz's strength, an acknowledgment of his important position as both father figure and mentor. This viewpoint suggests that her masculine position enables her to be more like Stieglitz, to identify with him and thus assume his power. She could only accomplish this by becoming separate and self-sufficient, with the self-assurance to name her own "babies" and control their meaning. Such an interpretation intersects with O'Keeffe's shifts between masculine and feminine modes, showing the conflict that existed on many levels and that Stieglitz apparently recognized and recorded in his photographs of her. O'Keeffe thus struggled to maintain control of the shaping of her identity, and both needed and rejected Stieglitz as a defining force in this process. This struggle manifested itself in her very choice of Stieglitz as a husband; she alternated between pleasing her much older spouse and railing against him (much like a child). He functioned, in a sense, like her father: a powerful figure in the art world who served as her mentor and who encouraged her to produce her art (her "children"), which he "named" by creating the discourse of femininity through which they were understood. Moreover, during the

period when O'Keeffe worked on *The Radiator Building,* Stieglitz referred to her paintings as their "children."

In this painting, O'Keeffe may have been provoking her viewers to wonder whether she intended these various levels of psychoanalytic readings. In producing this work, she was faced with two tasks: to authorize herself by appropriating Stieglitz's authority and then to detach his authority through the actual rendering of the Radiator Building, which follows a process of abstraction in its format as an emblematic portrait. O'Keeffe thus appropriated the male vocabulary of the emblematic portrait, the skyscraper, and photographic distortions to establish her own identity, which Stieglitz's photographs too coded as both masculine and feminine. British and American physicians and scientists of this period contended that unmarried professional women and female political activists fused the male and female, becoming "Mannish Lesbians" and the embodiment of social disorder.[87] Like the feminist writers of the 1920s and 1930s—Virginia Woolf in *Orlando* (1928), Radclyffe Hall in *The Well of Loneliness* (1934),[88] and Djuna Barnes in *Nightwood* (1937)—O'Keeffe adopted a masculine language that both empowered and restrained her. Just as she empowered herself through her cross-dressing, O'Keeffe appropriated masculine strategies in art making as a way to challenge the dominant male discourse.[89]

Separation from Stieglitz meant ignoring his voice and his dictates regarding her work, as well as refusing to be shaped by him. O'Keeffe began in 1929 to spend her summers in New Mexico rather than at Lake George, where she felt especially oppressed by Stieglitz, his family, his guests, and (between 1927 and 1933) his affair with Dorothy Norman. She established a pattern of spending subsequent summers away from him and his paternalistic control. It is not surprising, then, that O'Keeffe abandoned the subject of the skyscraper in 1929 because of the stock market crash, her dislike of sharing subjects with Stieglitz (who had returned to this one),[90] and her ambivalence about the urbanscape. At this point, she turned almost exclusively to brightly colored landscapes that seem to extend into infinity. *Ranchos Church* (fig. 108) and *Manhattan* (fig. 112) indicate that when O'Keeffe again painted buildings, she focused either on low, adobe structures that merged with the landscape and reiterated the mountains, or the inclusion of flowers as separate from the buildings to indicate that they exist in two different realms.[91]

The Radiator Building thus embodies O'Keeffe's conflicting feelings about not only living in the city, but also her husband. In fact, she painted this emblematic portrait during a period of tension. She and Stieglitz had grown apart and abandoned their artistic collaborations after only three years of marriage because of his ill health, the differences

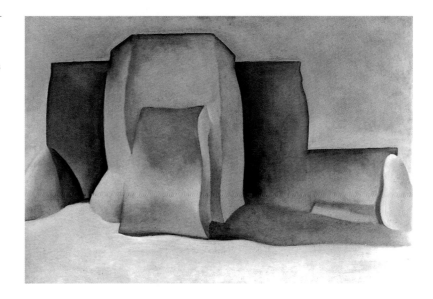

Figure 108.
Georgia O'Keeffe,
Ranchos Church. Oil on
canvas, 1929. The Phillips
Collection, Washington,
D.C. © 2002 The Georgia
O'Keeffe Foundation /
Artist Rights Society
(ARS), New York.

in age, her increasing boredom with Lake George, and his affair with Dorothy Norman.[92] It does not seem accidental that she created her New York paintings during the very period when her husband had abandoned the subject, suggesting that she deliberately took over the cityscape and some of his photographic techniques in order to mold them in her own terms and to move into the masculine arena of painting and mastering New York City.

That her contemporaries and others have not understood the complex meanings of this work is not surprising, given that some emblematic portraits by others, most notably Demuth and Hartley, also had not been fully decoded. "If you could 'read' the portraits," observed Wanda Corn, "you were one of those who 'got' modern art," but not every such work was fully deciphered.[93] In *The Radiator Building,* O'Keeffe acknowledged and subverted the power and celebrity of her subject, Alfred Stieglitz— something that her contemporaries may have been unwilling to do. For doing so may have meant demystifying the "great" Stieglitz and exposing his hypocrisy, which was no small undertaking. And so, in the end, we are left with merely the obvious: *The Radiator Building* as a skyscraper image.

Conclusion

Resolutions

Georgia O'Keeffe's Declaration of Independence

During her southwestern retreats, O'Keeffe discovered new subjects in the New Mexican landscape, focusing on the desert and mountains, adobe churches, and bleached bones. These paintings not only rejected the subject of the urbanscape and challenged "the Stieglitz circle whose worldview had always included the American [northeastern] countryside," but also suggested her interest in returning to the southwestern landscape for emotional and artistic renewal, as well as to "carve out a space" that "she could call her own."[1]

The inner conflicts that O'Keeffe had experienced while living in the city were resolved over the years as she continued her annual summer excursions to New Mexico. Spending her first summer in Taos at Mabel Dodge Luhan's home in 1929, she realized that she had never felt at home in the East; on the train ride back to New York, she admitted that she was returning only because of Stieglitz.[2] After a brief visit to the city, O'Keeffe wrote to friends in New Mexico that it seemed "too mad . . . what nonsense to come to N.Y."[3] Thirteen years later, in Abiquiu, she wrote that New York City "seems all so far away that it is difficult for me to imagine that I'll be having city life again so soon—I get so much into the way of living here that a change seems very odd." In the same letter, O'Keeffe described "the beautiful world" that she saw out her window— the pink earth, yellow cliffs, pink and purple hills, and scrubby cedars— that established a great "feeling of much space."[4] Clearly, she felt confined in the city and was more comfortable with the open vistas of the South-

west, but she felt divided "between my man and a life with him—and some thing of the outdoors."[5] She always returned to their urban apartment during Stieglitz's lifetime, but after his death in 1946, she settled permanently in New Mexico. The arid desert enabled O'Keeffe to return to her earlier concern with mysticism, seeking the spiritual content of the land and metaphors for the eternal and infinite, and to separate herself physically and symbolically from Stieglitz (her paintings of New Mexico subjects departed from the work of Stieglitz, who had returned to the skyscraper in his photographs).[6] At the same time, the Southwest inspired new themes that enabled her to finally establish herself as "the artist-priestess, Saint Georgia of the Desert" with a regional rather than a gendered identity that successfully reshaped her public persona.[7] As she claimed in the 1977 documentary *Georgia O'Keeffe,* which has been televised on PBS: "That was my country. It fitted to me exactly." This film shows the elderly O'Keeffe as she determinedly walks through the desert despite—as she admits—the heat, bees, and wind.[8] During this period, O'Keeffe lived a divided life, split between the green and the arid; city and desert; East and West; marriage and work. As she admitted in a 1932 letter to a friend, "I have to get along with my divided self the best way I can."[9]

O'Keeffe's southwestern paintings of crosses and skulls placed parallel to the picture surface reflect a new obsession with death and regeneration. *Black Cross, New Mexico* (plate 13) displays the Penitente crosses that she saw as "a thin dark veil of the Catholic Church spread over the New Mexico landscape."[10] These artifacts evoke Catholicism through their associations with the Old Penitente sects (secret male societies whose members flagellate themselves and reenact the Crucifixion at Easter time)[11] and nature ("painting the crosses was a way of painting the country");[12] moreover, in Christian iconography, they refer to death and rebirth. The crosses against the arid desert and skies loom over the land in ways that evoke O'Keeffe's earlier images of skyscrapers, indicating a continuing compulsion to come to terms with aspects of her environment.[13] O'Keeffe often placed roads that "converge and separate" behind these crosses,[14] perhaps to suggest the new path she took in New Mexico apart from Stieglitz.

Although O'Keeffe, not surprisingly, denied any symbolism in her skeletal paintings (fig. 109)—"they are strangely more living than the animals walking around" and are "symbols of the desert, but nothing more"[15]—these symmetrical images nevertheless inevitably evoke the warning of memento mori (be mindful, death is coming). Contemporaries certainly understood the series in these terms. Henry McBride associated her skulls with Hamlet, while another critic wrote about her "grim research into the mysteries of death in the desert."[16] One news-

paper retitled *Cow's Skull: Red, White and Blue* "Death and Transformation," another called it "Life and Transformation," and her *Horse's Skull with Pink Rose* was renamed "Life and Death."[17]

O'Keeffe often placed these bones in a cruciform shape to emphasize the vertical and horizontal axes through the black lines in the background and the protruding horns, as in *Cow's Skull: Red, White and Blue* (fig. 109) and *Cow's Skull with Calico Roses* (fig. 110), thereby suggesting not only death but also salvation (deliverance from danger or difficulty). The theme of rebirth is reiterated in her paintings of skulls that include flowers (fig 110).[18] In these she juxtaposed flowers, a symbol of fertility and life, with the deathlike images of skulls. These iconic images also evoke the masks worn by native dancers, Navajo blankets, the theme of the Vanishing American, the landscape, and the Southwest region itself.[19] The prominent vertical lines in these paintings of crosses and skulls may visibly signify the division that O'Keeffe felt between her husband and independence, the East and the West. These lines disrupt the compositions, especially in the skull paintings that may also refer to Stieglitz's declining health and her thoughts about his mortality.[20]

Figure 109.
Georgia O'Keeffe, *Cow's Skull: Red, White and Blue*. Oil on canvas, 1931. The Metropolitan Museum of Art, New York, Alfred Stieglitz Collection, 1949. Accession no. 52.203. © 2002 The Georgia O'Keeffe Foundation / Artist Rights Society (ARS), New York.

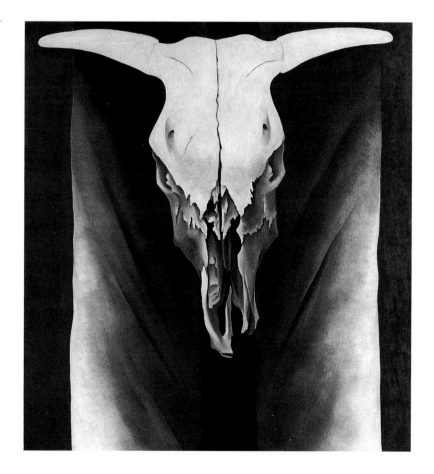

Figure 110.
Georgia O'Keeffe, *Cow's Skull with Calico Roses.* Oil on canvas, 1932. The Art Institute of Chicago, gift of Georgia O'Keeffe. Accession no. 1947.712. © 2000, The Art Institute of Chicago. All Rights Reserved.

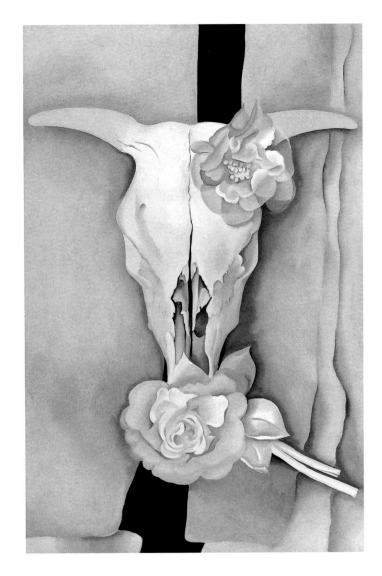

Charles C. Eldredge suggested that O'Keeffe's initial retreat to New Mexico in the summer of 1929 resulted from her increasing discomfort with city living, her desire to escape the art press, and her distaste for the family gatherings at Lake George.[21] But equally distressing, if not more so, was Stieglitz's involvement with Dorothy Norman, an affair that had begun two years previously. O'Keeffe turned to the desert for emotional rejuvenation, worn out from the marital strains created by Norman's presence in their lives and later, in 1932, from their disagreements about her commission to decorate the Radio City Music Hall. In the context of the Norman-Stieglitz affair, O'Keeffe's obsession with crucifixes and skulls relates to her sense of failure within her marriage and her hopes for its rejuvenation.[22] Operations in June and December 1927 for a benign breast tumor[23] also must have encouraged her contemplation of death

Figure 111.
Alfred Stieglitz, *Georgia
O'Keeffe: A Portrait—
With Cow Skull.* Silver
gelatin developed-out
print, 1931. National
Gallery of Art, Washington,
D.C., The Alfred Stieglitz
Collection. Accession no.
1980.70.263. Photograph
© 2001, Board of
Trustees, National Gallery
of Art, Washington.

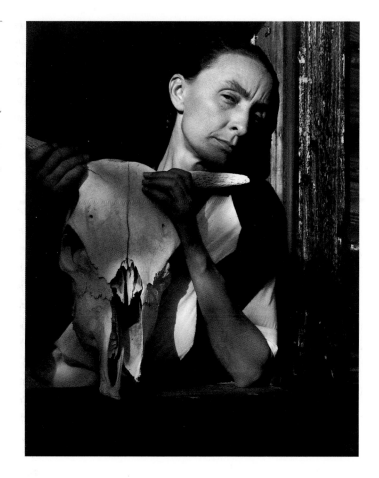

and rebirth, leading either consciously or unconsciously to her skull and cross series.

Stieglitz understood on some level that O'Keeffe's move to New Mexico and discovery of new subjects marked a change in her art and emotions. He created portraits of his wife between 1930 and 1931 that incorporate these subjects, showing O'Keeffe leaning against a window frame and a bleached cow's skull (fig. 111). The window contains and frames them, making her and the skull appear trapped and unapproachable.[24]

In 1929, Stieglitz had begun another series of fifteen portraits that he would continue over the next six years. In these photographs (see fig. 85), he showed his wife either leaning against or driving her new Ford sedan (she had purchased one in New Mexico in 1929, and she had another at Lake George). Rebecca Salsbury Strand and Tony Luhan had taught O'Keeffe how to drive, supporting Beck's assurances that she had become "a new woman."[25] O'Keeffe took great pleasure in the freedom enabled by driving, spending days traveling throughout New Mexico, camping and hiking in the desert, and even exploring Upstate New York, where she felt challenged by the traffic. Taking over the steering wheel was

her declaration of independence; it corresponded to the decision of many other women of that period to move into the driver's seat and thus challenge the patriarchal authority of their husbands. O'Keeffe told Calvin Tomkins in an interview that although Mabel Dodge Luhan wanted Stieglitz to join them out west, he did not come because O'Keeffe would not allow him. "He had the sort of mind that wouldn't have let me drive five miles to the market by myself," she recalled.[26] Consequently, she would not allow him to invade her private world in New Mexico, which included her newfound freedom of traveling by car through the desert.[27]

Although O'Keeffe and Stieglitz did not drive together (he had learned how to drive but decided it was not for him), they nevertheless cooperated in creating photographs that involved her new sedan. They commemorated O'Keeffe's newly discovered independence in these photographs, which show her standing erect with pride and strength beside her new symbol of mobility and freedom—a fascinating image, given Stieglitz's earlier aversion to the Model T that had revolted him. As he had ranted earlier, "I hate the sight of one [the Ford car] because of its absolute lack of any kind of quality feeling. . . . They are just *ugly* things in line & texture—in every sense of sensibility in spite of the virtue of so called usefulness."[28] In these later photographs, the Ford becomes a fascinating black abstract motif that compositionally frames O'Keeffe. Her black clothing matches the motorcar, suggesting an affinity between the two that Stieglitz underscored.[29] The Ford enabled the couple to work together in an activity—creating photographs—that had defined their first years of intense love and collaboration. Indeed, despite experts' concern that the automobile would contribute to family disintegration, it actually held some Middletown families together, as sociologists Robert S. and Helen M. Lynd learned. In the case of Steiglitz and O'Keeffe, it allowed them once again to share in the activity of creating art amidst emotional turmoil.

The truce achieved through artistic collaboration was short lived. In 1932, O'Keeffe undertook a commission to produce a mural for the Radio City Music Hall. As the title of this triptych suggests, *Manhattan* (fig. 112) revisits the subject of skyscrapers.[30] O'Keeffe again rendered this subject in a Precisionist idiom. Unlike her other skyscraper paintings, however, the central panel—*Cityscape with Roses* (plate 14)—contains pastel hues, most notably pink and shades of light blue. Rather than using photographic techniques or organic forms to destabilize the man-made buildings and fuse them into nature, O'Keeffe created clear distinctions between the organic and the man-made. Three flowers—a red one at the bottom, a light blue one on the left, and a pink one above on the right—hover on the surface of the canvas and appear disconnected from the background buildings. The red flower with green stem especially emphasizes

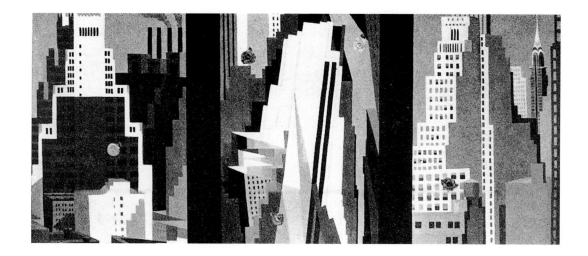

Figure 112.
Georgia O'Keeffe,
Manhattan. Oil on canvas,
1932. Reproduced in
*The American Magazine
of Art* (August 1932) as
"Murals at the Museum
of Modern Art." © 2002
The Georgia O'Keeffe
Foundation / Artist Rights
Society (ARS), New York.

the separation between the two realms. Its stem emerges from the side of the building, but it would be impossible for the flower to grow naturally from this hard-edged structure.

The disjunction between the rectilinear buildings and undulating flowers is heightened by the ambiguity of the space. The two-dimensional buildings, rendered in flat areas of unmodulated hues, contrast with the three-dimensional zigzag rooftops on the left and the buildings on the right. O'Keeffe produced a dizzying array of shifting rectangles and triangles through the central buildings, which tilt over, establishing a sense of instability.

This painting thus merges the two subjects for which O'Keeffe had become known. As she explained later in life, she had decided to render flowers on a large scale in response to the buildings that "seemed to be going up overnight in New York." "I thought I'll make them big like the huge buildings going up," O'Keeffe remarked in her characteristic matter-of-fact manner. "People will be startled," she admitted, but "they'll *have* to look at" these enormous flowers. As for the subject that initially inspired the flowers—the skyscraper—she recalled some objections: "'You can't paint New York; you're well launched on the flowers.'"[31] *Cityscape with Roses* was perhaps a way to use scale to underscore the relationship among city, architecture, and nature. These roses, however, fail to fill up the surface of the canvas; they appear small in relation to the background buildings that dominate but are diffused because of their light hues. They also function as a type of signature because so many associated O'Keeffe with her flower paintings.[32]

Within the context of Freudian discourse, gender differences, and *The Radiator Building* (plate 9), O'Keeffe's failure to merge the organic and the man-made objects in this painting is significant. The buildings and flowers again evoke the masculine and feminine realms—more

specifically, the phallus and the vagina. The two forms and the two genders appear distinct, yet O'Keeffe blurred the boundaries between nature and culture and between the masculine and feminine by using soft, pastel hues for the structures. The tilted and consequently unstable edifices underscore these gender ambiguities and contradictions.

O'Keeffe thus continued to authorize herself and appropriate power through the process of painting and the representation of the phallic buildings, but she also diminished the masculine power through the pastel hues and destabilized structures. This painting in many ways parallels her appropriation of power within her life by learning to drive.

Cityscape with Roses won first place in the competition sponsored by the Museum of Modern Art for the Radio City Music Hall commission. It formed the basis for O'Keeffe's design for the mural project, resulting in further tensions within her marriage. Donald Deskey, the designer of the Music Hall's interiors, offered O'Keeffe fifteen hundred dollars to paint a mural for the walls and ceiling of the ladies' powder room. Stieglitz opposed O'Keeffe's foray into what he called "that Mexican disease called murals." For him, the Mexican and New Deal muralists represented the democratization of art, which he opposed. He also feared that the commission would lessen the market value of her paintings (whose prices had been steadily increasing for the past sixteen years). Despite his objections, O'Keeffe signed the contract, upon which Stieglitz informed Deskey that, as her business agent, he had considered the fee unacceptable. According to Deskey, Stieglitz argued that O'Keeffe was "a child and not responsible for her actions." Stieglitz informed him the next day that she had had a nervous breakdown, was confined in a sanatorium, and consequently could not fulfill her contract.[33]

Stieglitz had lied. O'Keeffe was at Lake George, where she continued to work on the Radio City Music Hall mural, even though she feared she couldn't "make a go of" the project. As she wrote a friend, "No-one in my world wants me to do it but I want to do it. . . . I want to try it—I must admit that experimenting so publicly is a bit precarious in every way."[34] Stieglitz must have been aware of O'Keeffe's doubts and probably contributed to them. But his construction of her as an irresponsible "child" and as mentally ill indicates the steps he would take to control what she painted, for whom, and the amount paid by a patron. In short, he refused to allow her to act as an adult and a professional, making her own decisions within the realm of art. His insistence that O'Keeffe deserved more money for the commission clearly indicates the hypocrisy of his objections to the commodification of the art world. Stieglitz sanctioned O'Keeffe's driving, but he controlled her in the one aspect of their life together in which he always had participated: her career as an artist. O'Keeffe visited the mural site in December, saw that a portion of the

wall was damaged, and backed out of the project. She ultimately acquiesced to his wishes.

The marital strife over the Radio City Music Hall commission; O'Keeffe's anxieties concerning its outcome; the potential location of the mural—a women's public bathroom, signifying both her fame and her marginalization as a woman artist;[35] and the Stieglitz-Norman affair resulted in O'Keeffe's seven-week hospitalization in 1933 for "psychoneurosis" and her inability to paint for more than a year. Upon her release, O'Keeffe joined some friends in Bermuda and then returned without Stieglitz to Lake George, where she fell in love with Jean Toomer but chose not to consummate their relationship.

O'Keeffe, a woman who rejected some of society's codes by modeling nude, wearing masculine-looking clothes, ignoring the rules of courtship, and having an affair with a married man, could not engage in a romance with another man during her marriage to Stieglitz. She remained married to him, caring for him as he became more frail (except during the summers, when she continued her visits to New Mexico). However, she ignored Stieglitz's wish to stay in the Shelton Hotel. In 1936, she moved them into a new apartment on East Fifty-fourth Street so that she would have more space to paint and be closer to An American Place. O'Keeffe apparently learned from her illness, her husband's six-year affair, and the ill-fated Radio City Music Hall commission that she needed to assert her own voice and establish her independence from Stieglitz's power, something she had visualized earlier in *The Radiator Building.*

Upon Stieglitz's death, O'Keeffe demanded control of An American Place, ending Norman's administrative and financial roles. With Stieglitz gone, O'Keeffe could finally admit that she found Norman's relationship with her husband "absolutely disgusting."[36] She kept painting, continuing her fascination with bones and the southwestern desert as well as her search for the "transcendence of time into the eternal,"[37] represented by the holes in the skeletons that she placed against blue skies and extensive landscapes. Rather than rendering skulls in cruciform shapes, she shifted her focus to pelvises, emphasizing their asymmetrical, undulating forms with open spaces through which the sky could be seen, as in *Pelvis with Moon* (fig. 113). As O'Keeffe explained, "When I started painting the pelvis I was most interested in the holes in the bones—what I saw through them, particularly the blue from holding them up in the sun against the sky as one is apt to do when one seems to have more sky than earth in one's world. . . . I have tried to paint the Bones and the Blue."[38] Within the context of this series, O'Keeffe asserted that these skulls were "wonderful against the Blue" because the color "Blue . . . will always be there as it is now after all man's destruction is finished."[39] This statement takes on new meanings when the Norman-Stieglitz affair is considered. The blues

Figure 113.
Georgia O'Keeffe, *Pelvis with Moon*. Oil on canvas, 1943. Norton Museum of Art, West Palm Beach, Florida, R. H. Norton Fund purchase. © 2002 The Georgia O'Keeffe Foundation / Artist Rights Society (ARS), New York.

seen through these holes may symbolize her survival despite the destructive experiences of her marriage.

In her final years, O'Keeffe also turned to other subjects such as clouds, ladders, and her patio, rendered almost in a minimalist style. But she seldom returned to the subject of New York City, with the exception of the Brooklyn Bridge in 1949. It was her renderings of the city, for which she had conflicted feelings, that enabled her to temporarily work through her conflicts with Stieglitz as her husband, gallery promoter, and critic; and while these difficulties ultimately caused her nervous breakdown, they also led to her search for her own rejuvenation in New Mexico.

Edward Hopper after the Second World War

Edward and Jo Hopper, like O'Keeffe and Stieglitz, remained married. The post–World War II decades of the Hoppers' lives (and O'Keeffe's) saw more changes within the institutions of family and marriage in addition to society's attitudes toward sexuality and gender roles. The depression and the war had laid the foundations for the advancement of stable middle-class families dwelling in modern suburban homes. A powerful ideology of domesticity re-emerged, including a return to older gender

roles with men as breadwinners and women as homemakers. The postwar housewife, *Life* proclaimed in 1956, embodied the "feminine qualities [of] receptivity, passivity, and the desire to nurture."[40] Four years earlier and in the same magazine, William H. Whyte Jr. had encouraged the corporate wife to contribute to her husband's success in business through "judicious talking" and good listening. She should function as his "publicity agent," "keeper of the retreat," nurturer of "the male ego," and practitioner of "good homemaking."[41]

Also during this period, people were marrying younger, the birthrate was increasing, and the divorce rate was decreasing. Elaine May has traced this return to marriage and parenthood to the fear of the atomic bomb; domestic containment provided security and shelter during the nuclear age. Eventually, the baby boomers would return to the ideals of the bohemians and radicals of their grandparents' generation, rejecting their parent's domestic and sexual codes and creating a counterculture, as well as launching the women's liberation movement.[42]

The Hoppers lived through these changes. But just as Edward's art remained stylistically and compositionally the same, his life followed the cultural patterns of the first few decades of the twentieth century. He continued to paint theaters, railroads, hotels, offices, estranged couples, female nudes, and Victorian houses, maintaining his theme of the isolation of people in modern society. If anything had changed within his work, it was the importance of light; sometimes light was the sole protagonist, as in *Sun in an Empty Room* (fig. 114). Even when accompanied by a figure, as in *A Woman in the Sun* (fig. 115), the sunlight remains prominent and

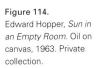

Figure 114.
Edward Hopper, *Sun in an Empty Room.* Oil on canvas, 1963. Private collection.

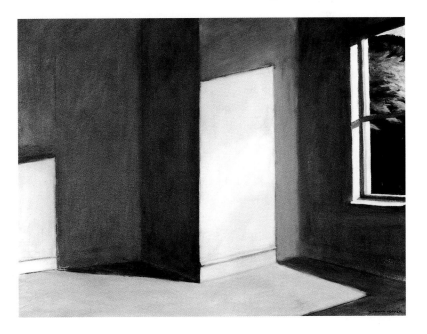

Figure 115.
Edward Hopper, *A Woman in the Sun*. Oil on canvas, 1961. Collection of Whitney Museum of American Art, New York, fiftieth anniversary gift of Mr. And Mrs. Albert Hackett in honor of Edith and Lloyd Goodrich. Accession no. 84.31. Photograph copyright © 1989 by Geoffrey Clements Inc., New York.

seems to intensify the woman's sense of desolation and containment within this empty domestic setting. This nude, for whom Jo was again the model,[43] has an aging, elongated, and muscular body with sagging breasts and tight buttocks and legs. Rather than displaying her frontal torso like the burlesque stripper of *Girlie Show* (plate 5), she stands in profile, looking out a window and smoking a cigarette. Jo identified this woman as both "tragic" and "sad," while Edward called her "a wise tramp,"[44] suggesting that her nakedness, unmade bed, and tossed-off pumps signify prostitution.

Hopper claimed that the theme for *Second Story Sunlight* (fig. 116) was sunlight itself, which he attempted to paint "as white with almost no yellow pigment in the white." "Light is an important expressive force for me," he explained, "a natural expression for me."[45] He further explained that he wanted to show how the light on the upper part of a house could be different from that on the lower part. Consequently, Hopper rendered this building with intense sunlight upon its upper half, and placed its side in bluish shadow. He framed the twin highlighted towers between the mass of trees on the right side of the canvas and the dark side of the house on the left. Although the black roof merges in terms of color with the background landscape, the sharp linear contours and tight brushstrokes of the building contrast with the curvilinear, loosely sketched leaves. Thus, as

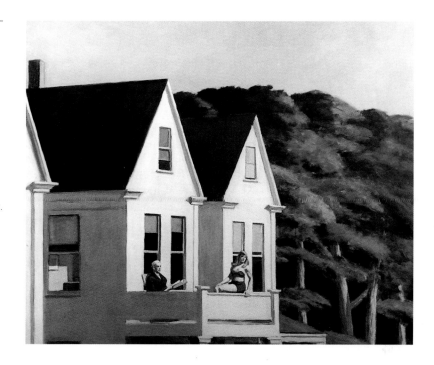

Figure 116.

Edward Hopper, *Second Story Sunlight*. Oil on canvas, 1960. Collection of Whitney Museum of American Art, New York, purchased with funds from the Friends of the Whitney Museum of American Art. Accession no. 60.54. Oliver Baker Associates, Inc. Photography. Photograph copyright © 2000, Whitney Museum of American Art.

he had done in *Gas* (fig. 8), Hopper separated nature from the man-made structure.

Hopper recalled that in painting this picture, he was more concerned with the sunlight than with the figures. "I don't think there was really any idea of symbolism in the two figures . . . there may have been vaguely," he allowed, but not "obsessively so."[46] But Jo contradicted Hopper's insistence that he was primarily more interested in compositional matters. She noted in her record book that the two figures represent a "white haired, Gothic & elderly" woman and "Toots . . . alert but not obstreperous. Lamb in wolf's clothing."[47] This observation derives from Hopper's comments to his patrons about this work. He identified the two women as "Toots" and "the Gothic mother-in-law (or grandmother)," and said that he deliberately chose not to mention them in the title of the painting. Hopper thus intended to create specific types in the figures, but he downplayed their significance in the composition through his emphasis of formal considerations. This decision may have been influenced by the prominence of abstract painting during this period. As he asserted, "I have no conscious themes."[48]

This claim is further complicated by the fact that Jo had modeled for the women. "Jo posed for both figures," Hopper affirmed. "[S]he's always posed for everything."[49] In one image, Hopper transformed his wife into a buxom young woman with long, straight blond hair, clad in a tank top and shorts. Her arched back emphasizes her full bosom, while her clothing, hair, and makeup evoke sensuality. Hopper's insistence that she is

a "lamb in wolf's clothing" and not "obstreperous" suggests that he sensed this figure could be construed as overly erotic and possibly threatening. He insisted that she is instead a lamb—sweet, perhaps passive, perhaps loving. The mother-in-law or grandmother in the painting also appears full-bosomed, but her more sedate dark-blue dress and gray hair pulled back into a bun indicate a less sexual and less threatening person. As Hopper implied by way of this figure type and his comments, an older woman is a safer matronly or grandmotherly form. *Second Story Sunlight* may thus be a commentary upon the passage of time and its effects on the female body and personality. Within this scenario, the younger and the older woman represent the two ages of woman, showing the effects of time upon the same person.[50]

This painting is exceptional in the Hopper oeuvre for its representation of two women together. *Chop Suey* of 1929 is the only other painting in which he depicted such a pairing; in other works, two women may exist in the same space, but without interacting or otherwise indicating that they know each other. More common representations are men and women who occupy the same room, yet fail to interact. *Hotel by a Railroad*

Figure 117.
Edward Hopper, *Hotel by a Railroad*. Oil on canvas, 1952. Hirshorn Museum and Sculpture Garden, Smithsonian Institution, Washington, D.C., gift of the Joseph H. Hirshorn Foundation, 1966. Accession no. 66.2507. Photographed by Lee Stalsworth.

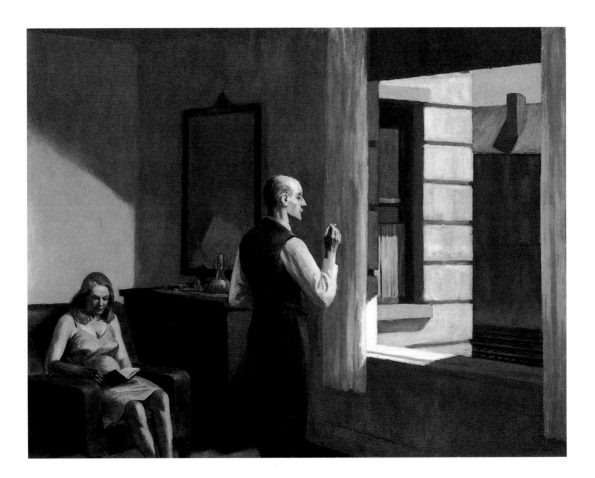

(fig. 117) and *Excursion into Philosophy* (fig. 118) show an older man and woman in a hotel room or bedroom, psychologically and physically separated from each other. The brown dressers and mirror in the former painting form a wedge between the cigarette-smoking man, who looks out the window, and the woman, who reads a book and appears to be contained within the confines of her gray chair. *Excursion into Philosophy* clarifies the sexual tensions that Hopper implied in other paintings. Here a clothed man sits on the edge of a bed, seemingly dejected and lost in thought, while a woman lies upon the bed with her pink dress pulled up to expose her bare buttocks. Jo's comment in her diary that she felt uncomfortable with her husband's "attacks from the rear" may indicate one of the reasons for this couple's lack of contact.

Toward the end of his life, Hopper referred more overtly to himself and his wife in his painted fantasies. In *Two Comedians* (fig. 119), his final painting, he included himself as the model for the male figure and once again used Jo for depicting the actress. According to Gail Levin, the work "was intended as a personal statement, a farewell of sorts, for when he showed them gracefully bowing out." As she suggested, Hopper cast himself and his wife in the role of the young lovers Pierrot and Pierrette from the *commedia dell'arte*, a frequent theme in the French symbolist poetry

Figure 118.
Edward Hopper,
Excursion into Philosophy.
Oil on canvas, 1959.
Private collection.

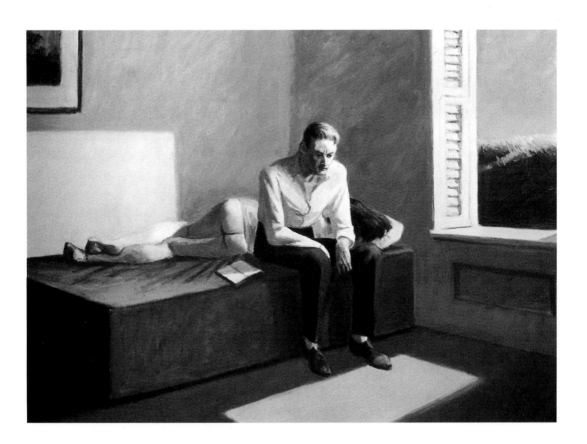

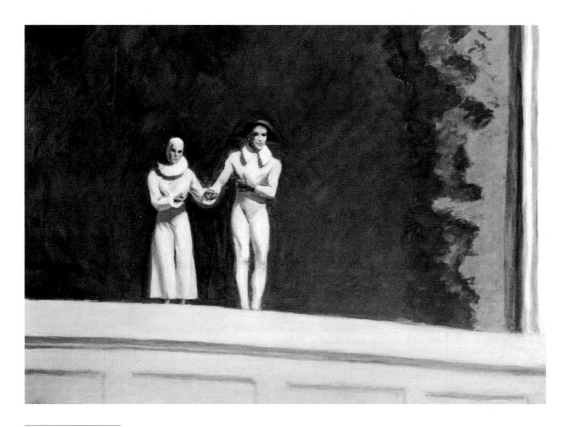

Figure 119.
Edward Hopper,
Two Comedians. Oil on
canvas, 1965. Private
collection.

that Edward and Jo had quoted to each other during their courtship. "They appear," Levin continued, "as two comedians who, by their last act, have discovered the most ironic comedy of all—human existence."[51]

Two Comedians tellingly shows husband and wife, Edward and Jo, holding hands and working in unison. Hopper's composition underscores the sense of the couple as a team. The two figures hold hands while their free arms are almost identically posed and gesture toward each other. Their flesh-colored, clasped hands, undulating contours, and similar white clothing with blue shadows further establish cohesion. Both have blackened eyes, although the woman's red lips and cheeks contrast with the man's pale face. He wears a bright red hat, while she wears a white cap. His triangular collar contrasts with her rounded one, as do his tight-fitting trousers with her loose pants. Although his legs seem to merge into the stage, her visible ankles mark a clear distinction between person and wood. Perhaps more significant, given the Hoppers' relationship, is that the man stands forward, while the woman, seemingly more shy, stands behind him—not unlike Jo's role as her husband's supporter and promoter. The acerbic, outspoken character that people saw in Jo and that Hopper visualized in his earlier caricatures seems absent here. Instead, a more reticent, humble performer appears, to whom the man proudly points in a gesture of appreciation.

Two Comedians suggests some type of resolution within the Hoppers' marriage. Here, in the mid-sixties, Edward has hinted that he and Jo, despite their differences and conflicts, formed a team in their enfeebled later lives (he had difficulty walking because of his stooped posture; she had poor eyesight). This painting implies that by the end of their lives, Hopper conceived of himself and his wife as finally living the companionship marriage of the interwar years, with its mutual affection, shared interests, and support, and also enjoying the security that marriage provided, according to the ideology of the cold war period. This final document of their relationship is a departure from not only his earlier images of estranged couples, but also the testimony of Jo's private diary, which she continued to keep after her husband's death.

The greater sense of companionship suggested by this painting may have derived in part from the fact that Jo was happier by this time, seeming to have come to terms with being an unsuccessful artist and Hopper's wife. A letter she wrote on 13 November 1965 expressed concern over her husband's increased infirmity ("it breaks my heart"), and claimed that she found "comfort" in her New York studio, surrounded by her "progeny"—a "record of my life, here or there—relived—little bastards & not unrepentant." Whether these "bastards" represent Jo's paintings or Edward's is not clear, but either or both served to record their life together, given her role as his favored model and business partner. If the "bastards" are solely her paintings, as Levin believed they are,[52] then they documented her home life with Edward that, although filled with tension, she nevertheless envisioned as tranquil and harmonious. "I've learned, lots of women can't help being more interested in people & life than in art," she wrote. "They must have both." This comment suggests some sort of reconciliation with her failure to become a renowned artist, although some bitterness remained: "Art can't be bothered much about the female—as we have occasion to observe."[53]

In *Two Comedians,* Hopper showed himself and his wife in white clothes that distinguish them from the dark background. Yet the blue shadows in their costumes echo the dominant hue behind them, suggesting that they both emerge from and fade into the theatrical setting. Although Jo identified the proscenium as "strong as the deck of the ship,"[54] it forms a wedgelike, unstable base that could start sinking toward the right corner, threatening to drown the figures in a sea of viewers who are absent from the painting. Whether Hopper realized that this painting would be his last is unclear. It does indeed seem to be his farewell, however. He and his wife appear to bow out of the scene, graciously fading into the murky blue setting. They seem to say their goodbyes together, underscoring their collaboration on his art.

Hopper died two years after completing this painting. Jo recorded her sadness that he "left" so "suddenly," failing to wait for her.[55] Less than ten months later, she herself was dead.

Who Is the Silent Partner?

Nine years before Hopper painted *Two Comedians*, *Time* magazine featured him on its cover. The accompanying article opens with a description of "a green and white 1954 three-hole Buick sedan" which "came to a gentle halt." The "elderly couple" who emerged "were just tourists," the author continued, "just passing by." This older man and his wife who "chattered warmly" observed "an untinted America" through the new clear glass windshield that had been installed; they toured the highways in what seems, at least on the surface, to have been a close relationship, with common interests in traveling, sketching, and conversation.

William Johnson, the author of this article, like most people was unaware that the Buick had been a source of antagonism between husband and wife, although one quotation suggests some tension. "Sometimes talking with Eddie is just like dropping a stone in a well," Jo confessed, "except that it doesn't thump when it hits bottom." Johnson, however, dismissed this comment, explaining that "Hopper lives in his eyes," while his words remain "alien to him." It is understandable, Johnson implied, that such silences existed while they were together, given his visual rather than oral proclivity.[56]

Hopper, we will recall, rendered only one image of Jo in a car, while Stieglitz did an entire series of his own wife in such a setting. Unlike O'Keeffe, Jo never could assert her control in the driver's seat, because Edward never allowed her to do so. O'Keeffe, on the other hand, made sure that Stieglitz was not around when she drove, although she enabled and assisted him in his photographs of her and her car. The automobile existed as the central unifying force in the later years of O'Keeffe and Stieglitz during a period of marital discord. Their collaboration probably brought them closer in a fashion similar to Strand, who had photographed his wife. "I have two things which seem pretty complete," he wrote Stieglitz. "[I]t has given us a fine companionship in the open air and a chance to work together."[57] Stieglitz and O'Keeffe probably experienced something similar, a sense of fine companionship in working together.

Jo and Edward, too, experienced a sense of companionship by collaborating, for Hopper always used his wife as his model for his paintings, transforming her into various sexualized personas that depart from Jo's more conservative self-presentation. The medium of painting enabled him to obscure the relationship between model and painted figure. Thus Hopper transformed his wife into different personas, providing different

facial features, hairstyles and hair colors, and intensified sexuality, whereas Stieglitz always enabled the viewer to recognize the presence of the subject even when her face was not visible; the titles of the photographs, if nothing else, enable the viewer to identify the subject. Stieglitz did not attempt to erase O'Keeffe's identity in his portraits of her. The title of the series, the model's placement before her earlier artworks, and the details of her hair, face, and other body parts explicitly designate O'Keeffe as the model and subject. The photographic medium did not allow the same separation between model and subject except for the close-up views of the naked body in which the face is eliminated. But here again the title enables us to always identify the sitter as O'Keeffe. Moreover, photographs suggest a sense of "truth"; the illusion of seeing the real is asserted through Stieglitz's medium and style of straight photography in which the pictorial effects are eliminated. Hopper's painted fantasies, by contrast, enabled a greater distance between model and painting, especially since many viewers probably did not know that his wife modeled for the pictures and hence would not assume that the paintings offered some insight into the "truth" of Jo Hopper. This underscores a prime difference between painted realism, with its fictive aspect, and Stieglitz's photography.

Jo was not alone in employing her posing as a means to both assist and resist the artist. O'Keeffe similarly was able to present herself to the gaze of her husband and at the same time immobilize that gaze by reflecting it back upon itself. It is not surprising that Hopper's paintings resemble film stills and that Stieglitz employed the medium of photography as a means to capture their wives in paint and on film. Both models, however, ultimately took advantage of these techniques as a means to threaten the husband's and the viewer's gaze by immobilizing it.

One could argue that both Stieglitz's and Hopper's repeated representations of such silent images of sexualized meanings function as fetishes. In the case of Hopper, Jo's entire body, and in the case of Stieglitz, O'Keeffe's entire body or parts of her body, became means by which these men reassured themselves, their wives, and their viewers of their virile heterosexuality. Although Freud and most psychoanalysts believed fetishism was an exclusively masculine perversion, some feminists argue that women can disavow their own castration through a narcissistic love of one's own self-image.[58] This can certainly apply to O'Keeffe, whose modeling was narcissistic. Jo, on the other hand, allowed her self-image to become sexualized but also assisted in her transformation, so that the model is not as easily recognized.

Both Jo and O'Keeffe represented psychoanalyst Joan Riviere's conception of the modern woman by resenting their "inferior" status to their husband's perceived superiority. According to Riviere's interpretation, Jo's participation in her husband's eroticized painted fantasies

enabled her to assume the masquerade of femininity through ogling and coquetting to counter his fear of retribution. She similarly wanted to shape her public identity and empower herself, which she accomplished as Edward's model. Whereas O'Keeffe sometimes appropriated masculine characteristics to challenge the dominant male patriarchy, Jo never considered this option. She instead assumed her identity as a homely helpmate who existed in her husband's shadow, only to emerge occasionally as his spokesperson, secretary, and manager.

As the manager of her husband's estate after his death, Jo donated to the Whitney Museum more than two thousand items, including Hopper's student work, early drawings, preliminary drawings for etchings and paintings, etchings and plates, watercolors, and many oil paintings. Brian O'Doherty assessed her bequest as solidifying Hopper's position as "the major twentieth-century American 'realist' and one of the giants of American painting."[59] First Lloyd Goodrich and then Gail Levin, followed by other curators, organized major exhibitions of Hopper's art—all enabled by this bequest, which assured Hopper's reputation.

Although Stieglitz died in 1946, O'Keeffe never remarried. She remained single and continued living in New Mexico, enjoying her independence and her status as the keeper and promoter of the Stieglitz legacy. In dividing his collection among major public institutions in New York, Boston, Chicago, Cleveland, Philadelphia, and Washington, D.C., as well as establishing the private museum at Fisk University in Nashville, she assured her husband's status as the founder and supporter of early American modernism. As Wanda Corn astutely observed, this distribution formed his "final 'collective portrait'" of Stieglitz and his circle that, we might add given my argument about *The Radiator Building*, further enabled O'Keeffe to control her husband and in this case his legacy.[60] By donating his correspondence, papers, and catalogues to the Beinecke Library at Yale University, O'Keeffe enshrined him within a hallowed space for researchers. She once again reversed the roles between herself and her husband, making Stieglitz now the subject of the scholarly and public debate. Whereas Stieglitz had earlier placed her portraits within the walls of The Anderson Galleries, promoted her art through his galleries, and promulgated the critical perception of her art as uniquely feminine, she now placed his photographs, collection of artworks, and correspondence within the walls of public and private spaces for the scrutinizing gaze to mark, guarantee, and guide his reputation. His body may not be exposed in the way hers was in his earlier photographs, but his career, life, friendships, work, and ideas are available and on display.

Thus, O'Keeffe ultimately controlled her husband and his reputation after his death, ensuring his legacy as the father of American modernism. She also retained her position as Mrs. Alfred Stieglitz, attempting

to control scholars' perceptions of their marriage. The O'Keeffe Foundation or the executor of her estate, in following her "will," refused permission for me to publish a photograph of a painting by O'Keeffe in an article entitled "Georgia O'Keeffe and Alfred Stieglitz: A Marriage in Crisis, 1928–1933."[61] Although no explanation was provided, I learned that my request was denied because the title of the article suggested a subject that O'Keeffe's "will" specifically targeted as unacceptable. (Whether her "will" refers to the legal document or her wishes remains unclear.)

Besides controlling Stieglitz's reputation, O'Keeffe also spearheaded her own. Although she initially supported Anita Pollitzer's decision in 1950 to publish her biography, she withdrew her approval in 1965 upon reading the manuscript, complaining that it was poorly written, the facts "were entirely muddled and wrong," and Pollitzer's "idea of [her] as a person and a painter [was] a dream."[62] "I don't like being written about," O'Keeffe chided in another letter. "[I]t just seems ridiculous."[63] This critique seems especially harsh, given Pollitzer's significance during O'Keeffe's early years, when she relied upon her friend to keep her informed about exhibitions, lectures, and concerts in New York City and the happenings at "291." At the same time, Pollitzer provided an avenue for the budding artist to express her ideas about art; feelings about being an artist, teaching, and relationships with men; and thoughts inspired by certain readings such as Kandinsky and Ibsen. Equally as important, Pollitzer provided continuous support of O'Keeffe's early experimental works and introduced Stieglitz to them, initiating her entry into his gallery.

Pollitzer was not the only biographer whose work O'Keeffe rejected. She informed Laurie Lisle in 1977 that she would not approve of her unauthorized biography.[64] She instead wanted to represent herself, which she did in her 1976 autobiography, *Georgia O'Keeffe,* declaring that she alone could interpret her art with authority.[65] She selected Juan Hamilton, a potter and her handyman, and Sarah Greenough, a research curator at the National Gallery of Art, to compile her letters in *Georgia O'Keeffe: Art and Letters.* In addition, she contributed to the documentary of her life by Perry Miller Adato (1977), published in 1978 a collection of Stieglitz's photographs of her, and in 1983 assisted Greenough in mounting a major retrospective of Stieglitz's photographs from 1890 to 1935, which omitted portraits of Dorothy Norman.[66] O'Keeffe's emergence as the chronicler of her art and that of Stieglitz coincided with the resurgence of interest in her art in the 1970s as feminists rewroted history to include formerly forgotten women artists.

Juan Hamilton, who became O'Keeffe's assistant and eventually her agent, confidant, nurse, secretary, and inheritor of her enormous estate, had begun helping her in 1962, a role that Adato's documentary emphasizes. Although it was rumored that the two were married, no evidence

suggests this was the case, which would have been especially problematic in that Hamilton married Anna Marie Erskin in 1980. O'Keeffe and Hamilton nevertheless had an intense, mutually dependent relationship. He relied upon her financially; without his association with her, he possibly never would have had exhibitions of his pottery. In turn, Hamilton became O'Keeffe's eyes and hands as a degenerative eye disease that began in 1964 worsened over the years. And just as Stieglitz had been O'Keeffe's senior in age and artistic reputation, O'Keeffe became Hamilton's. Debate continues about whether he took advantage of O'Keeffe's increasing frailty and dependence by manipulating the various codicils in her will that left everything to him. Just as we can never know the intimate details of the O'Keeffe-Stieglitz marriage, we can never know what occurred between O'Keeffe and Hamilton (despite the fact that he is still alive). In some ways with the younger male artist, O'Keeffe seemed to have taken over the role that her husband had played in her life and career, once again turning the tables within patriarchal society.[67] In the end, she was the promoter of the works of two men (at least until her frailty and dementia set in): Stieglitz and Hamilton.

O'Keeffe's *Radiator Building* and her eventual regulation of Stieglitz's reputation embody her hard-won control over her husband, who becomes the silenced and silent partner. Most people, however, fail to recognize *The Radiator Building* as an emblematic portrait of Stieglitz in which O'Keeffe constructed her husband's representation. Instead, they probably will reflect upon his portraits of her in which she is the silenced model who nevertheless actively participated in her own subjectivity.

The viewer unaware of the marital conflict between Hopper and his wife could never discern the layers of complexity inherent in *Girlie Show, Office at Night,* and other paintings. Jo may have written her diary as one means to control her husband's art and reputation. In essence, the diary contains the last word about his paintings and their relationship, which Edward cannot dispute. Thus, he becomes the silenced and silent partner. However, most people familiar with the paintings will not have read Jo's diary, rendering her the silenced and silent partner. The battle for control continues within public and private spheres—the "public" paintings and the private word—where cultural contradictions and contestations over the definition of womanhood are acted out.

O'Keeffe secured her own position as a great American artist— something that Jo could not achieve, to her regret and dismay. While O'Keeffe endured as a woman artist who defied societal barriers, Jo succumbed to those same pressures. Both women, however, had the last word through the dissemination of their husbands' estates, and both ultimately controlled and guaranteed their husbands' places within the history of American art.

Introduction

1. This distinction between Hopper and those who created abstract works continued into the 1950s, the height of the abstract expressionist movement. *Time,* for example, applauded the awarding to Hopper of the Gold Medal for Painting, commenting, "In an age when the younger generation of artists is plunging headlong into the fashionable mists of abstractionism, Hopper is a spearhead of the opposite tradition, that art should reflect the contemporary scene." See "Gold for Gold," *Time* 65 (30 May 1955): 72.

2. John Wilmerding, *American Art* (New York: Penguin Books, 1976), 187, 194. Matthew Baigell similarly identified Hopper as "perhaps the premier 20th-century realist" and O'Keeffe as "a painter of the first generation of American modernists" in his *Dictionary of American Art* (New York: Harper & Row, 1979), 171, 257.

3. Lloyd Goodrich, *Edward Hopper: Retrospective Exhibition* (New York: Whitney Museum of American Art, 1950), 3. For a discussion of these themes in Hopper's art, see Gail Levin, *Edward Hopper: The Art and the Artist* (New York: W. W. Norton & Company and Whitney Museum of American Art, 1980), 41–64; and Levin, *Edward Hopper: A Catalogue Raisonné* (New York: W. W. Norton & Company and Whitney Museum of American Art, 1980), 1:75–88. Andrew Hemingway showed that Goodrich presented Hopper in these terms in "To 'Personalize the Rainpipe': The Critical Mythology of Edward Hopper," *Prospects* 17 (1992): 382.

4. Helen Appleton Read, "The American Scene," *The Brooklyn Daily Eagle,* 20 February 1927, p. 6E. See also her "Racial Quality of Hopper Pictures at Modern Museum Agrees With Nationalistic Mood," *The Brooklyn Daily Eagle,* 5 November 1933, p. 12B–C; "Art Annual Statistics Prove U.S.A. Greatest Art Market in World," *The Brooklyn Daily Eagle,* 7 March 1926, p. 7E; and "Edward Hopper," *Parnassus* 5 (November 1933): 8–9; 30. For more recent discussions of Hopper as an American Scene painter, see Lawrence Campbell, "Hopper: Painter of 'Thou Shalt Not,'" *Art News* 63 (October 1964): 42–45; and Levin, *The Art and the Artist,* 6–8.

The same year that Read first linked Hopper with the American Scene, Hopper wrote an essay on John Sloan that, without directly employing this phrase, nevertheless provides an excellent definition that could apply to his own work as well. The urban realists, he wrote, "are no longer content to be citizens of the world of art, but believe that now or in the near future American art should be weaned from its French mother The 'tang of the soil' is becoming evident more and more in their painting. . . . We should not be quite certain of the crystallization of the art of America into something native and distinct." See Hopper, "John Sloan and the Philadelphians," *The Arts* 11 (April 1927): 177–78.

Hopper, however, rejected the rubric of American Scene painting, saying, "The thing that makes me so mad is the American Scene business." He explained that American Scene artists, such as Thomas Hart Benton and John Steuart Curry, "caricatured America": "I always wanted to do myself." Similarly, in his interview with Katherine Kuh in 1960, Hopper stated, "I don't think I ever tried to paint the American scene; I'm trying to paint myself. I don't see why I must have the American scene pinned on me. Eakins didn't have it pinned on him." He also clearly objected to the tendency to identify a movement with a country: "The French painters didn't talk about the 'French Scene,' or the English painters about the 'English Scene.'" See Brian O'Doherty, "Portrait: Edward Hopper," *Art in America* 52 (October 1964): 72; Katherine Kuh, *The Artist's Voice: Talks with Seventeen Artists* (New York: Harper & Row, 1960; reprint, New York: Harper & Row, 1962), 135; and Brian O'Doherty, *American Masters: The Voice and the Myth* (New York: Random House, 1973), 15.

5. Matthew Baigell, *A Concise History of American Painting and Sculpture* (New York: Icon Editions, 1984), 251–53.

6. Hopper often failed to mention that he had studied with Chase prior to working with Henri. See Levin, *A Catalogue Raisonné,* 1:41.

7. Both detested their experiences in the commercial art sector. Hopper expressed his distaste at having to show people grimacing and gesturing for his illustrations for *Everybody's, System Magazine,* and *Farmer's Wife,* among other magazines. O'Keeffe, who worked on advertisements in Chicago, recalled, "That's where I learned to hurry. The idea was to do it faster or you didn't get the job. I pretty soon found out I wasn't cut out for that. It was appalling." Quoted in Charles C. Eldredge, "Georgia O'Keeffe: The Development of an American Modern" (Ph.D. diss., University of Minnesota, 1971), 11. For information about O'Keeffe's illustrations for *Vanity Fair,* see Bram Dijkstra, *Georgia O'Keeffe and the Eros of Place* (Princeton, N.J.: Princeton University Press, 1998), 115–22. For information about Hopper as a commercial illustrator, see Gail Levin, *Edward Hopper as Illustrator* (New York: W. W. Norton & Company and Whitney Museum of American Art, 1979); Levin, "Edward Hopper as Printmaker and Illustrator: Some Correspondences," *Print Collector's Newsletter* 10 (1979): 121–23; and Levin, *Edward Hopper: The Complete Prints* (New York: W. W. Norton & Company and Whitney Museum of American Art, 1979).

8. Lloyd Goodrich, "Portrait of The Artist," *Woman's Day* (February 1965): 41.

9. Ibid.

10. Robert Hughes called O'Keeffe "an icon of Southwestern modernism." See Hughes, *American Visions: The Epic History of Art in America* (New York: Alfred A. Knopf, 1997), 391.

11. Baigell, *Dictionary of American Art,* 171. Lloyd Goodrich concurred, writing that Hopper remained "unusually impervious to outside influences" throughout his life. See Goodrich, *Edward Hopper* (New York: Whitney Museum of American Art, 1964), p. 7. For the influence of impressionism on Hopper, see Gail Levin, "Edward Hopper: Francophile," *Arts Magazine* 53 (June 1979): 114–21.

12. Read, "Edward Hopper," 30; and Read, "Racial Quality of Hopper Pictures," 12B–C.

13. Hemingway, "'To Personalize the Rainpipe,'" 380–81. Hemingway showed that Lloyd Goodrich was the prime critic who saw Hopper as an alternative to modernism. See p. 382.

14. Hopper first exhibited in 1908 at the National Academy's Exhibition of Paintings and Drawings by Contemporary American Artists. The show included various students of Henri. Hopper participated in the MacDowell Club for the first time in 1912, exhibiting with Henri and members of his circle (John Sloan, William Glackens, and George Luks). See Levin, *A Catalogue Raisonné,* 1:50; and her *Edward Hopper: An Intimate Biography* (New York: Alfred A. Knopf, 1995), 86.

15. Hopper sold his first painting through the Armory Show, earning $250 for its purchase by a Manhattan textile manufacturer. See Levin, *An Intimate Biography,* 90.

16. For a list of the Whitney Studio, Whitney Studio Club, and Whitney Studio Galleries exhibitions, including dates and artists, see the Exhibition List, Whitney Museum of American Art Library. For information concerning Gertrude Vanderbilt Whitney's role in supporting American figurative realism through these privately sponsored exhibition spaces, see Patricia Hills and Roberta K. Tarbell, *The Figurative Tradition and the Whitney Museum of American Art* (New York: Whitney Museum of American Art in association with University of Delaware Press, 1980), 11–22.

17. Hopper exhibited with O'Keeffe in the 1923 Brooklyn Museum of watercolors and drawings by American and European artists. (See Levin, *An Intimate Biography,* 171). Alfred Barr included both O'Keeffe and Hopper in two eclectic exhibitions held at the Museum of Modern Art—*Paintings by Nineteen Living Americans* (December 1929–January 1930) and *Art of Our Time* (1939)—to showcase the variety of movements in contemporary American painting. See Alfred Barr, *Paintings by Nineteen Living Americans* (New York: The Museum of Modern Art, 1929), 9, 33, 65; and Barr, *Art of Our Time* (New York: The Museum of Modern Art, 1930).

18. Hopper included works in the Tenth and Eleventh Annual Exhibitions of the Whitney Studio Club in 1925 and 1926, held in The Anderson Galleries; O'Keeffe had a solo exhibition in 1923, a group show with Stieglitz in 1924, and another group show, *Seven Americans,* in 1925 in this space. For Stieglitz's promotion of O'Keeffe through The Anderson Galleries, see Barbara Buhler Lynes, *O'Keeffe, Stieglitz and the Critics, 1916–1929* (Ann Arbor, Mich.: UMI Research Press, 1989), 9.

19. A statement by the show's curator, Lloyd Goodrich, strikingly coincides with O'Keeffe's philosophy: "One reason why the modern artist finds flowers so particularly sympathetic as subjects is that they are completely free from any suggestion of morality or philosophy or story-telling, existing entirely for themselves and the delight which they give us—perhaps the nearest approach to the pure sensuousness of music that can be achieved in a representational theme." Lloyd Goodrich, *Spring Exhibition 1930: Whitney Studio Galleries* (New York: Whitney Studio Galleries, 1930), n.p. For Stieglitz's comments about the Whitney Studio Club, see Herbert Seligmann, *Alfred Stieglitz Talking: Notes on Some of His Conversations, 1925–1931* (New Haven, Conn.: Yale University Press, 1966), 122.

20. From notes by Bill Johnson based on an interview of 30 October 1956, unpublished notes in the Whitney Museum of American Art, New York City.

21. Levin, *An Intimate Biography,* 409.

22. Hopper praised Sloan and the "Eight" in his article "John Sloan and the Philadelphians." See especially p. 174.

23. Gail Levin, "Josephine Verstille Nivison Hopper," *Woman's Art Journal* 1 (spring-summer 1980): 28–32; and Levin, *An Intimate Biography,* 163–66.

24. Gail Levin to Vivien Green Fryd, e-mail, 18 June 2000.

25. Preparing for a retrospective exhibition at the Arts Club of Chicago in 1934, Jo wrote to Alice F. Roullier: "Mr. Hopper makes me his secretary and on occasions I elect myself . . . to the office of manager." See Jo Hopper to Alice F. Roullier,

25 November 1933, Jo Hopper's correspondence, Whitney Museum of American Art (originally located in the Arts Club of Chicago). For additional information about Roullier and Jo's role in the exhibition, see Levin, *An Intimate Biography,* 255.

26. Griselda Pollock, "Agency and the Avant-Garde: Studies in Authorship and History by Way of Van Gogh," in *Avant-Gardes and Partisans Reviewed,* ed. Fred Orton and Griselda Pollock (Manchester: Manchester University Press, 1996), 327.

27. Arlene Skolnick, *Embattled Paradise: The American Family in an Age of Uncertainty* (New York: Basic Books, 1991). Other helpful secondary sources on the family during this period are Nancy F. Cott, *The Grounding of Modern Feminism* (New Haven, Conn.: Yale University Press, 1987); John D'Emilio and Estelle B. Freedman, *Intimate Matters: A History of Sexuality in America* (New York: Harper & Row, 1988); Paula S. Fass, *The Damned and the Beautiful: American Youth in the 1920s* (New York: Oxford University Press, 1977), 74; Peter Gabriel Filene, *Him/Her/Self: Sex Roles in Modern America* (New York: Harcourt Brace Jovanovich, 1975); Christopher Lasch, *Haven in a Heartless World: The Family Besieged* (New York: Basic Books, 1977); Elizabeth Lunbeck, *The Psychiatric Persuasion: Knowledge, Gender, and Power in Modern America* (Princeton, N.J.: Princeton University Press, 1994); and William L. O'Neill, *Divorce in the Progressive Era* (New Haven, Conn.: Yale University Press, 1967).

28. For information about the New Woman, see especially Carroll Smith-Rosenberg, ed., *Disorderly Conduct: Visions of Gender in Victorian America* (New York: Alfred A. Knopf, 1985), 245–296; and Ellen Wiley Todd, *The "New Woman" Revised: Painting and Gender Politics on Fourteenth Street* (Berkeley and Los Angeles: University of California Press, 1993).

29. See Michel Foucault, "What Is an Author?" in *Language, Counter-Memory, Practice: Selected Essays and Interviews,* ed. D. F. Bouchard (Ithaca, N.Y.: Cornell University Press, 1977); and Roland Barthes, "The Death of the Author," in *Image-Music-Text,* ed. and trans. S. Heath (New York: Hill and Wang, 1977).

30. Pollock, "Agency and the Avant-Garde," 321.

31. Mieke Bal and Norman Bryson, "Semiotics and Art History," *The Art Bulletin* 73 (June 1991): 183.

32. Ibid., 179.

33. See especially Linda Nochlin, *The Politics of Vision: Essays on Nineteenth-Century Art and Society* (New York: Harper & Row, 1989); and her *Women, Art and Power and Other Essays* (New York: Harper & Row, 1988), as well as Griselda Pollock and Rozsika Parker, *Old Mistresses: Women, Art and Ideology* (New York: Pantheon Books, 1981); and Griselda Pollock, ed., *Generations and Geographies in the Visual Arts: Feminist Readings* (London: Routledge, 1996); and Pollock, *Vision and Difference: Femininity, Feminism, and the Histories of Art* (London: Routledge, 1988).

34. Pollock, "Feminist Interventions in the Histories of Art," in *Vision and Difference,* 9.

35. Patricia Mathews, "The Politics of Feminist Art History," in *The Subjects of Art History: Historical Objects in Contemporary Perspectives,* ed. Mark A. Cheetham, Michael Ann Holly, and Keith Moxey (London: Cambridge University Press, 1998), 96. See also Norma Broude and Mary D. Garrard, eds., *The Expanding Discourse: Feminism and Art History* (New York: Icon Editions, 1992), 2.

36. Todd, *The "New Woman" Revised,* xxviii; and Lisa Tickner, "Feminism, Art History, and Sexual Difference," *Genders* 3 (Fall 1988): 96–97.

37. Elizabeth Wright, ed., *Feminism and Psychoanalysis: A Critical Dictionary* (Cambridge, Mass.: Basil Blackwell, 1992), 9–10.

38. Laura Mulvey, "Visual Pleasure and Narrative Cinema," in *Visual and Other Pleasures* (Bloomington: Indiana University Press, 1989), 19.

39. Pollock, "Woman as Sign: Psychoanalytic Readings," in *Vision and Difference,* 127.

40. The restriction will be lifted on 6 March 2006.

Chapter One

1. S. Josephine Baker, M.D., "Marriage from the Side Lines," *Ladies' Home Journal* 43 (April 1926): 37.

2. Beatrice M. Hinkle, "The Chaos of Modern Marriage," *Harper's Magazine* 152 (December 1925): 1–13; "Dire Dangers Threatening Family Life," *Literary Digest* 94 (13 August 1927): 26–27; Edward Sapir, "What Is the Family Still Good For?" in *American Mercury* 19 (1930): 145–51; and "Fighting Breakdowns in Marriage," *Literary Digest* 121 (April 25, 1936): 17–18. For the quotation, see Sapir, "What Is the Family Still Good For?" 146.

3. "Address of Professor Ellsworth Huntington on The Happy Family," *Living* 1 (January 1939): 15.

4. Harry Emerson Fosdick, "What is Happening to the American Family?" in *American Magazine* 106 (October 1928): 98; and Hinkle, "The Chaos of Modern Marriage," 5.

5. Victor Calverton, *The Bankruptcy of Marriage* (New York: Macaulay Company, 1928), 2.

6. Dorothy Ross, "The Development of the Social Sciences," in *The Organization of Knowledge in Modern America, 1860–1920,* ed. Alexandra Oleson and John Voss (Baltimore: Johns Hopkins University Press, 1979), 125.

7. See Ellen Kay, *Love and Marriage* (New York: G. P. Putnam's Sons, 1911); Anna Garlin Spencer, *The Family and Its Members* (Philadelphia: J. B. Lippincott, 1923); Robert C. Binkley and Frances Williams Binkley, *What Is Right with Marriage: An Outline of Domestic Theory* (New York: D. Appleton and Company, 1929); Ray E. Baber, *Marriage and the Family* (New York: McGraw-Hill, 1939); and Henry A. Bowman, *Marriage for Moderns* (New York: Whittlesey House, 1942).

8. Lemo Dennis Rockwood, "The Development of Education in Family Life in the United States," in *Readings in Mental Hygiene,* ed. Ernest R. Groves and Phyllis Blanchard (New York: Henry Holt & Co., 1936), 255.

9. "Marriage and Love Affairs: The Report of a Scientific Research by G. V. Hamilton, M.D. and Kenneth MacGowan," *Harper's Magazine* 157 (August 1928): 277–87. This resulted in Hamilton's more extensive report, *A Research in Marriage* (New York: A. and C. Boni, 1929).

10. "The Protestant Church View of Sex, Love and Marriage," *Current History* 29 (February 1929): 807–21.

11. William F. Ogburn, the University of Chicago sociologist who led the president's council, examined "the changes within the family as an economic institution, its protective, religious, recreational and educational functions, trends in the way in which families are organized, the extent of broken homes and problems arising in connection with them, relations of parents and children and of husbands and wives, and finally, the efforts to deal with family problems." Obgurn, "The Family and Its Functions," in *Recent Social Trends in the United States,* report of the President's Research Committee on Social Trends (New York: McGraw-Hill, 1933), 661.

12. "Pope Pius XI on Marriage and Morals: Full Text of the Encyclical," *Current History* 33 (February 1931): 797. The pope's encyclical received extensive press coverage. See, for example, "The Encyclical on Marriage: An Editorial," *Outlook* 157 (21 January 1931): 90.

13. "The Luncheon Meeting during the First Annual Meeting in the National Conference on Family Relations, Held in New York City, September 17, 1938," *Living* 1 (January 1939): 13.

14. "Editorial Comment," *Living* 1 (January 1939): 25–27.

15. Rockwood, "The Development of Education," 254–55.

16. J. Steward Burgess, "The College and the Preparation for Marriage and Family Relationships," *Living* 1 (spring-summer 1939): 39. See also Jerome Beatty, "Taking the Blinders off Love," *American Magazine* 124 (December 1937): 181. For information about one such course taught at the State University of Iowa, see Moses Jung, "The Course in Modern Marriage at the State University of Iowa," *Living* 1 (spring-summer 1939): 43.

17. Beth L. Bailey, *From Front Porch to Back Seat: Courtship in Twentieth-Century America* (Baltimore: Johns Hopkins University Press, 1988), 119.

18. Ibid., 126. See also Beatty, "Taking the Blinders off Love," 22–23, 181–85; and Dr. James L. McConaughy, "Now That You Are Engaged," *Good Housekeeping* 105 (October 1937): 28–29, 209–16.

19. Rockwood, "The Development of Education," 260, 264. For the Bride's School, see "Fighting Breakdowns in Marriage," *Literary Digest* 121 (25 April 1936): 17–18.

20. Emily Hartshorne Mudd and Elizabeth Kirk Rose, "Development of Marriage Counsel of Philadelphia as a Community Service, 1932–1940," *Living* 2 (May 1940): 40.

21. "Fighting Breakdowns in Marriage," 17. See also "Marriage Riddle Studied Intensely," *Literary Digest* 123 (13 March 1937): 30.

22. See Allan E. Risedorph and Jeannie R. Risedorph, "Education for Marriage and the Family as a Means of Strengthening National Security in the Community," *Marriage and Family Living* 4 (summer 1942): 56–58, 62; and Louise Ramsey, "Education for Marriage and Family Life in the High School as a Means of Strengthening National Defense," *Marriage and Family Living* 4 (summer 1942): 52–55.

23. "A School of Marriage," *Literary Digest* 102 (7 September 1929): 26; and "Making Marriage Fit the Times," *Literary Digest* 105 (17 May 1930): 24.

24. "The Protestant Church View of Sex, Love and Marriage," *Current History* 29 (February 1929): 807.

25. The disciplines of social work and psychology were differentiated in 1918 at the Smith College of Social Work, which offered for the first time "a systematic course of instruction for the training of psychiatric social workers." See Ernest R. Groves and Phyllis Blanchard, *Introduction to Mental Hygiene* (New York: Henry Holt & Co., 1920), 376.

26. *Encyclopedia of Psychology,* 2d ed., s.v. "marriage counseling."

27. For Ernest Groves's program at the University of North Carolina, see Ernest W. Burgess and Harvey J. Locke, *The Family: From Institution to Companionship* (New York: American Book Company, 1945), 737–43. The quotation is derived from the book Groves edited with Phyllis Blanchard of the Philadelphia Child Guidance Clinic, *Readings in Mental Hygiene* (New York: Henry Holt & Co., 1936), 221. See also Groves and Blanchard, *Introduction to Mental Hygiene; Groves, The Family and Its Relationships* (Chicago: J. B. Lippincott, 1934); Groves, *Case Book of Marriage Problems* (New York: Henry Holt & Co., 1941); and Groves and Gladys Hoagland Groves, *Sex in Marriage* (New York: Emerson Books, 1943).

28. Christopher Lasch, *Haven in a Heartless World: The Family Besieged* (New York: Basic Books, 1977), 12–20. As Anna Garlin Spencer assessed the situation in 1923, "The next job is to adjust the family order itself to a contract system of industry

that gives each member of the family a free and often a separating access to daily work and to its return in wages or salary, in such a manner as to retain family unity and mutual aid while giving freedom and opportunity for each of its members." See Spencer, *The Family and Its Members,* 10.

29. Ogburn, "The Family and Its Functions," 675. For information about these changes as a result of modern urban amusements, see John Kasson, *Amusing the Million: Coney Island at the Turn-of-the-Century* (New York: Hill and Wang, 1978); Lary May, *Screening Out the Past: The Birth of Mass Culture and the Motion Picture Industry* (New York: Oxford University Press, 1980); Lewis A. Ehrenberg, *Steppin' Out: New York Nightlife and the Transformation of American Culture, 1890–1930* (Westport, Conn.: Greenwood Press, 1981); and Kathy Peiss, *Cheap Amusements: Working Women and Leisure in Turn of the Century New York* (Philadelphia: Temple University Press, 1986).

30. James Quale Dealey, *The Family in Its Sociological Aspects* (Boston: Houghton Mifflin, 1912), 90–91.

31. See Ogburn, "The Family and Its Functions," 681. See also Ogburn, "Eleven Questions concerning American Marriages," *Social Forces* 6 (1927): 11.

32. Ernest R. Mowrer, *The Family: Its Organization and Disorganization* (Chicago: University of Chicago Press, 1932), 182.

33. Lasch, *Haven in a Heartless World,* 33–43.

34. Ernest R. Groves, *The American Family* (Chicago: J. B. Lippincott, 1934), 123–24.

35. Calverton, *The Bankruptcy of Marriage,* 34.

36. Charles W. Wood, "What Is Happening to Marriage" in *The Nation* 128 (20 March 1929): 341–44; quotation on p. 343.

37. Sherwood Anderson, *Poor White* (New York: B. W. Huebsch; 1920; reprint, New York: New Directions, 1993), 326.

38. Ernest R. Mowrer, "The Family in the Machine Age," *Living* 1 (November 1939): 67–68, 86. At least one person in 1930 defended industrialization's affect upon the family. Floyd Dell argued that modern machinery laid the basis for a more normal family life based on romantic love. See his *Love in the Machine Age: A Psychological Study of the Transition from Patriarchal Society* (New York: Farrar and Rinehart, 1930).

39. These statistics can be found in Burgess and Locke, *The Family,* 504, table 21, derived from the U.S. Bureau of the Census.

40. Christina Clare Simmons, "'Marriage in the Modern Manner': Sexual Radicalism and Reform in America, 1914–1941" (Ph.D. diss., Brown University, 1982), 152.

41. Burgess and Locke, *The Family,* 504.

42. Mowrer, *The Family: Its Organization and Disorganization,* 270, 276.

43. Ernest Groves, "Marriage," *American Youth* 19 (January 1920): 24.

44. This process was accelerated by the mingling of the sexes in the new, commercialized public amusements. See Simmons, "'Marriage in the Modern Manner,'" 6–7.

45. Elaine Tyler May, *Great Expectations: Marriage and Divorce in Post-Victorian America* (Chicago: University of Chicago Press, 1980), 2–26.

46. Ogburn, "Eleven Questions concerning American Marriages," 7. See also "The Peril in the Declining Marriage Rate," *Literary Digest* 97 (16 June 1928): 30; and I. M. Rubinow, "Marriage Rate Increasing Despite Divorces," *Current History* 29 (November 1928): 289–94.

47. Mowrer, "The Family in the Machine Age," p. 67.

48. William O'Neill, *Divorce in the Progressive Era* (New Haven: Yale University Press, 1967), p. 21.

49. Ogburn, "The Family and Its Functions," 708; and "Dire Dangers Threatening Family Life," 26.

50. As reported in "The Peril in the Declining Marriage Rate," 30.

51. "I Would Not Divorce Him Now," *Reader's Digest* 39 (September 1941): 18–20..

52. Robert S. Lynd and Helen M. Lynd, *Middletown in Transition* (New York: Harcourt, Brace & Co., 1937), 152.

53. See Groves and Blanchard, *Introduction to Mental Hygiene,* 172–73, for this summary. See also Barbara Epstein, "Family, Sexual Morality, and Popular Movements in Turn-of-the-Century America," in *Powers of Desire: The Politics of Sexuality,* ed. Ann Snitow, Christine Stansell, and Sharon Thompson (New York: Monthly Review Press, 1983), 118.

54. For these statistics about the birth control clinics, see Simmons, "'Marriage in the Modern Manner,'" 151–52.

55. Henry F. Pringle, "What Do the Women of America Think About Birth Control?" *Ladies' Home Journal* 60 (March 1938): 14.

56. Ben B. Lindsey and Wainwright Evans, *The Revolt of Modern Youth* (New York: Boni and Liveright, 1925) and *The Companionate Marriage* (New York: Boni and Liveright, 1927), especially pp. v, 104, 131, 138, and 156. For information about Evans, a magazine writer who assisted Lindsey in writing, see Charles Larsen, *The Good Fight: The Life and Times of Ben B. Lindsey* (Chicago: Quadrangle Books, 1972), 160–65. See also Charles Larsen, "Ben Lindsey: Symbol of Radicalism in the 1920's," in *Freedom and Reform: Essays in Honor of Henry Steele Commager,* ed. Harold M. Hyman and Leonard W. Levy (New York: Harper & Row, 1967), 255–75. In June 1929, Lindsey joined Victor F. Calverton and Margaret Mead, among others, to address an audience at the John Hayes Holmes Community Church in New York City. An outgrowth of this debate was Calverton's publication in collaboration with Samuel Schmalhausen, *Sex in Civilization* (London: George Allen and Unwin, 1929), which includes essays by Lindsey, Havelock Ellis, and Margaret Sanger, among others. For more information about this publication and Lindsey's participation in the debate, see Leonard Wilcox, *V. F. Calverton: Radical in the American Grain* (Philadelphia: Temple University Press, 1992), 78–80.

57. Simmons, "'Marriage in the Modern Manner,'" 116.

58. Cott, *The Grounding of Modern Feminism,* 156.

59. Joseph Collins, "The Doctor Looks at Companionate Marriage," *Outlook* 147 (21 December 1927): 492; and Fosdick, "What Is Happening to the American Family?" 21.

60. Helen Conway, "We Try Trial Marriage," *Forum* 84 (November 1930): 272–76; and William E. Kerrish, "Companionate Marriage," *The Commonweal* 13 (25 March 1931): 580.

61. Larsen, *The Good Fight,* 175; and "Clash in a Cathedral," *Outlook* 156 (17 December 1930): 604.

62. "Pope Pius XI on Marriage and Morals," 801. For an attack on the pope's stance, see "The Week," *New Republic: A Journal of Opinion* 65 (21 January 1931): 255–56. For another religious condemnation of Lindsey's concept of marriage, see Kathleen Norris, "A Laywoman Looks at 'Companionate Marriage,'" *The Catholic World* 127 (June 1928): 257–63. The Federal Council of the Churches of Christ in America in 1929 formed a committee to examine marriage in response to Lindsey's proposal, which they believed put "sex desire first" to the detriment of marriage as "a spiritual experience of love and devotion." See "The Protestant Church View of Sex,

Love and Marriage," 816, as well as "The Protestant Church's Survey of Marriage Evils," *The Literary Digest* 100 (23 February 1929): 26–27.

63. Groves, *The American Family*, 235.

64. John Levy and Ruth Monroe, *The Happy Family* (New York: Alfred A. Knopf, 1938), 4–5. For a defense of Lindsey's proposal, see M. G. L. Black, "A Business Woman on Companionate Marriage," *Outlook* 148 (22 February 1928): 286–87; and Calverton, *The Bankruptcy of Marriage*, 150.

65. Simmons, "'Marriage in the Modern Manner,'" 118.

66. Lindsey and Evans, *The Companionate Marriage*, 153.

67. Lindsey proclaimed that having children would ideally result in what he called "the procreative marriage" or "The Family." See ibid., 138–39.

68. Calverton, *The Bankruptcy of Marriage*. For a discussion of Calverton's leftist politics and role in publishing *Modern Quarterly*, as well as an analysis of the marxist basis of *The Bankruptcy of Marriage*, see Wilcox, *V. F. Calverton*, 69–85. See also Philip Abbott, *Leftward Ho! V. F. Calverton and American Radicalism* (Westport, Conn.: Greenwood Press, 1993).

69. Kevin White, *The First Sexual Revolution: The Emergence of Male Heterosexuality in Modern America* (New York: New York University Press, 1993), 172.

70. Malcom Cowley, *Exile's Return: A Literary Odyssey of the 1920's* (New York: W. W. Norton & Company, 1934; reprint, London: The Bodley Head, 1951), 59–60.

71. "The Modern Wife's Difficult Job," *Literary Digest* 106 (30 August 1930): 18.

72. Robert S. Lynd and Helen M. Lynd, *Middletown: A Study in Contemporary American Culture* (New York: Harcourt, Brace & Co., 1929), 114–15.

73. André Maurois, "The Art of Marriage," *Ladies' Home Journal* 57 (April 1940): 11.

74. Sapir, "What Is the Family Still Good For?" 148; and Hinkle, "The Chaos of Modern Marriage," 12.

75. Floyd Dell, *Janet March* (New York: Alfred A. Knopf, 1923), 53. See also Floyd Dell, *Moon-Calf* (New York: Sagamore Press, 1920).

76. Stephen Vincent Benét, *The Beginning of Wisdom* (New York: Henry Holt & Co., 1921), 343–44. For a discussion of these novels, see White, *The First Sexual Revolution*, 41–42.

77. Burgess and Locke, *The Family*, vii.

78. Ibid. For a similar summary, see Smiley Blanton and Woodbridge Riley, "Shell Shocks of Family Life," *The Forum* 82 (November 1929): 282: "The patriarchal family, with its idea of male superiority, is now coming into conflict with a different type of family organization, based largely on the ideal of perfect equality between men and women."

79. Burgess and Locke, *The Family*, 511.

80. Groves, *The American Family*, 167.

81. Bowman, *Marriage for Moderns*, 21; Bronislaw Malinowski, "Parenthood—The Basis of Social Structure," in *The New Generation: The Intimate Problems of Modern Parents and Children*, ed. V. F. Calverton and Samuel D. Schmalhausen (New York: McCaulay, 1930), 162; Ruth Nanda Anshen, "The Family in Transition," in *The Family: Its Function and Destiny*, ed. Anshen (New York: Harper and Brothers, 1949), 3; Anshen, "The Conservation of Family Values," in ibid., 429; and Willystine Goodsell, *A History of Marriage and the Family* (New York: Macmillan, 1935), 482.

82. For a good summary of these historical factors, see Filene, *Him/Her/Self*, 169–85.

83. See Lynd and Lynd, *Middletown in Transition,* 179; and Elaine Tyler May, *Homeward Bound: American Families in the Cold War Era* (New York: Basic Books, 1988), 38.

84. Lynd and Lynd, *Middletown in Transition,* 155.

85. President's Research Committee on Social Trends, *Recent Social Trends in the United States* (New York: McGraw-Hill, 1933), xlvi–vii.

86. Sapir, "What Is the Family Still Good For?" 147.

87. "Pope Pius XI on Marriage and Morals," 802. For an argument in support of working wives and mothers, see Virginia MacMakin Collier, "Baby Plus Job—By Choice," *Woman's Journal* 13 (March 1928): 14–16, 40: "women are happier working than not," because they want "to be self-sustaining both economically and personally whether the need arises or not" (40).

88. "Working Wives and Others' Bread: Married Women in Jobs Stir Sociological Controversy," *Literary Digest* 123 (15 May 1937): 25. See also Paul Popenoe, *Conservation of the Family* (Baltimore: Williams and Wilkins, 1926); his *Modern Marriage: A Handbook* (New York: Macmillan, 1940); and his *Marriage Before and After* (New York: W. Funk, 1943). For his Institute of Family Relations, see "How to Be Marriageable," *Ladies' Home Journal* (March 1954): 46–47.

89. Rockwood, "The Development of Education," in *Readings in Mental Hygiene,* 253–67.

90. Lorine Pruette, *Women and Leisure: A Study of Social Waste* (New York: Dutton, 1924), 99. See also White, *The First Sexual Revolution,* 176. White discussed Virginia McMakin Collier's study of one hundred couples involved in "career marriages," finding that the majority of these husbands favored their wives' careers. He located this more positive attitude among upper-class, educated men. See Virginia McMakin Collier, *Marriage and Careers: A Study of One Hundred Women Who Are Wives, Mothers, Homemakers, and Professional Workers for the Bureau of Vocational Information* (New York: Channel Bookshop, 1926).

91. "Working Wives and Others' Bread," 26.

92. Lynd and Lynd, *Middletown in Transition,* 410.

93. May, *Homeward Bound,* 40–59.

94. Ibid.

95. Simmons, "'Marriage in the Modern Manner,'" 125.

96. Blanton and Riley, "Shell Shocks of Family Life," p. 287.

97. Max Eastman, *Enjoyment of Living* (New York: Harper & Row, 1948), 321. For a discussion of Eastman's difficulties in realizing companionship love, see Steven Seidman, *Romantic Longings: Love in America, 1830–1980* (New York: Routledge, 1991), 97–101.

98. Sherwood Anderson, *Many Marriages* (New York: Grosset and Dunlap, 1923). See especially pp. 78, 197, and 188.

99. Susan Hegeman addressed the act of shame as embodied in Anderson's *Many Marriages* in her paper, "The Politics of Embarrassment: Sherwood Anderson's *Many Marriages,*" delivered at the 1999 American Studies Association annual meeting, 29 October, Montreal.

100. Eleanor Anderson, ed., *Sherwood Anderson's Memoirs* (New York: Harcourt, Brace & Co., 1942), 379–81. See also Charles E. Modlin, ed., *Sherwood Anderson's Love Letters to Eleanor Copenhaver* (Athens: The University of Georgia Press, 1989); and Ray Lewis White, ed., *Sherwood Anderson's Secret Love Letters* (Baton Rouge: Louisiana State University, 1991).

101. Dell, *Love in the Machine Age,* 33. For a discussion of Dell's move toward the concept of a more conservative type of companionship marriage, see Ellen Kay Trimberger, "Feminism, Men, and Modern Love," in *Powers of Desire: The Politics of*

Sexuality, ed. Ann Snitow, Christine Stansell, and Sharon Thompson (New York: Monthly Review Press, 1983).

Chapter Two

1. Count Hermann Keyserling, ed., *The Book of Marriage* (New York: Harcourt, Brace & Co., 1926), 35–36.

2. Herbert Seligmann, *Alfred Stieglitz Talking: Notes on Some of His Conversations, 1925–1931* (New Haven, Conn.: Yale University Press, 1966), 84.

3. Ibid.

4. Sherwood Anderson to Georgia O'Keeffe, 2 February 1923, YCAL MSS 85, Box 178, folder 2064.

5. Sherwood Anderson to Georgia O'Keeffe, 9 December 1935, YCAL MSS 85, Box 178, folder 2964.

6. For information about Stieglitz and Emmy's courtship, see Sue Davidson Lowe, *Stieglitz: A Memoir/Biography* (New York: Farrar Straus Giroux, 1983), 90–102; and Richard Whelan, *Alfred Stieglitz: A Biography* (New York: Little, Brown, 1995), 123–28.

7. Whelan wrote that Stieglitz claimed they did not have sex for at least a year, but also said it took four years. See Whelan, *Alfred Stieglitz,* 126.

8. Emmeline Stieglitz to Alfred Stieglitz, 20 August 1914, YCAL MSS 85, Box 57, folder 1358.

9. Emmeline Stieglitz to Alfred Stieglitz, 23 August 1914, YCAL MSS 85, Box 57, folder 1358.

10. Whelan, *Alfred Stieglitz,* 154–55.

11. Ibid., 385, 388.

12. Lowe, *Stieglitz,* 95, 105.

13. Quoted in Roxana Robinson, *Georgia O'Keeffe: A Life* (New York: Harper & Row, 1989), 194.

14. Elizabeth Davidson to Alfred Stieglitz, 9 September 1923, YCAL MSS 85, Box 54, folder 1307.

15. Stieglitz wrote to Katherine Rhoades in May: "I recognized them [the drawings] at once as the work of a woman. I had never seen anything in painting or drawing by woman so thoroughly feminine, so thoroughly frank, selfexpressive [sic]." Stieglitz to Rhoades, 31 May 1916, YCAL MSS 85, Box 40, folder 976.

16. Whelan, *Alfred Stieglitz,* 399.

17. O'Keeffe also commented, "He would notice shapes and colors different from those I had seen and so delicate that I began to notice more." See Anita Pollitzer, *A Woman on Paper: Georgia O'Keeffe* (New York: Simon and Schuster, Inc., 1988), 168.

18. Sue Davidson Lowe, "O'Keeffe, Stieglitz, and the Stieglitz Family: An Intimate View," in *From the Faraway Nearby: Georgia O'Keeffe as Icon,* ed. Christopher Merrill and Ellen Bradbury (Reading, Mass.: Addison-Wesley Publishing Company, 1992), 143–44.

19. *Georgia O'Keeffe,* prod. and dir. Perry Miller Adato, Educational Broadcast Company, 1977, videocassette.

20. Ibid.

21. Lowe, *Stieglitz,* 265–67; and Whelan, *Alfred Stieglitz,* 462.

22. Quoted in Robinson, *Georgia O'Keeffe,* 275.

23. Calvin Tompkins, "The Rose in the Eye Looked Pretty Fine," *The New Yorker* 50 (4 March 1974): 47.

24. Stieglitz reported this to *Art News* (see Stieglitz, "O'Keefe [sic] and the Lilies," *Art News* 26 [21 April 1928]: 10).

25. Quoted in Lisle, *Portrait of an Artist,* 143.

26. "There had never been anyone else that I would want—or would have for the father of my child." She also wrote, "[I]t seems that I must have [a child] some time." O'Keeffe to Macmahon, 28 December 1916, as quoted in Robinson, *Georgia O'Keeffe,* 135, 168.

27. Elizabeth Davidson to Alfred Stieglitz, February 1922 and 10 February 1922, YCAL MSS 85, Box 54, folder 1306.

28. Whelan, *Alfred Stieglitz,* 427–28.

29. Robinson, *Georgia O'Keeffe,* 235. Sue Davidson Lowe confirmed this, stating that Stieglitz forbade O'Keeffe to have a child. See "O'Keeffe, Stieglitz, and the Stieglitz Family," 154.

30. See Lisle, *Portrait of an Artist,* especially pp. 138–44, 160, 191, 327.

31. Ibid., 146.

32. Ray E. Baber, *Marriage and the Family* (New York: McGraw-Hill, 1939), 518.

33. Dorothy Norman, *Alfred Stieglitz: An American Seer* (New York: Random House, 1960; reprint, New York: Aperture, 1970), 120–23.

34. Lisle, *Portrait of an Artist,* 107.

35. Stieglitz to Rebecca Salsbury Strand, 17 May 1929, YCAL MSS 85, Box 26, folder 6.

36. Adato, *Georgia O'Keeffe.*

37. Georgia O'Keeffe, *A Portrait by Alfred Stieglitz* (New York: Metropolitan Museum of Art, 1978), n.p.

38. Whelan, *Alfred Stieglitz,* 525.

39. Ibid., 465.

40. Robinson, *Georgia O'Keeffe,* 260. Other biographers interpret these letters as mere flirtations. See Lowe, *Stieglitz,* 255; and Whelan, *Alfred Stieglitz,* 433, 452. Benita Eisler, on the other hand, concurred that they had a short-lived affair. See Eisler, *O'Keeffe and Stieglitz,* 306. Too much evidence exists in private letters to consider this a flirtation. Stieglitz wrote to Rebecca in the fall that he would never forget that summer, which "was very wonderful even if very painful." She similarly referred to an experience during her visit to Lake George that brought "infinite pleasure and real suffering." Almost a year later, Stieglitz again alluded to those events, commenting to Rebecca that he missed her in Lake George, but that he nevertheless understood her absence because of "all the 'unnecessary . . . unpleasantnesses.'" Stieglitz to Rebecca Salsbury Strand, 2 October 1923, YCAL MSS 85, Box 25, folder 609; Rebecca Salsbury Strand to Stieglitz, 6 October 1923, YCAL MSS 85, Box 25, folder 609; Stieglitz to Rebecca Salsbury Strand, 5 September 1924, YCAL MSS 85, Box 25, folder 610.

41. Robinson, *Georgia O'Keeffe,* 260.

42. Stieglitz wrote to Elizabeth Stieglitz Davidson on 24 September 1923, "Beck . . . seemed millions of miles removed from me—She's all right—but there is a messiness somewhere which will ever remain messy—I'm sorry." See ibid., 585 n. 14, for this quotation and Elizabeth's reference to this relationship.

43. Stieglitz to Elizabeth Stieglitz Davidson, 2 October 1923, quoted in ibid., 261; and Whelan, *Alfred Stieglitz,* 453.

44. Bram Dijkstra provided this date for the beginning of their affair in his *Georgia O'Keeffe and the Eros of Place* (Princeton, N.J.: Princeton University Press, 1998), 210.

45. Lisle, *Portrait of an Artist,* 253.

46. As quoted in Robinson, *Georgia O'Keeffe,* 302. Stieglitz mailed their correspondence to his niece, Elizabeth, until he "worked" his "way through this tangle." Norman donated their letters to the Beinecke Library at Yale University, stipulating they could not be seen by the public until the year 2020. See Stieglitz to Elizabeth Davidson, 18 August 1929, and Elizabeth to Stieglitz, after 18 August 1929(?), quoted in Robinson, *Georgia O'Keeffe,* 341.

47. As Norman herself explained, she was dedicated "to advance both art and action." See "Dorothy Norman, 92, Dies; Photographer and Advocate," *New York Times,* 13 April 1997, Obituaries, p. 38.

48. Lowe, *Stieglitz,* 316.

49. Miles Barth, ed., *Intimate Visions: The Photographs of Dorothy Norman* (San Francisco: Chronicle Books, 1993), 13.

50. Stieglitz to Jean Toomer, 22 October 1928, YCAL MSS 85, Box 49, folder 1173.

51. Stieglitz to Rebecca Salsbury Strand, 17 May 1929, YCAL MSS 85, Box 26, folder 6.

52. Stieglitz to Rebecca Salsbury Strand, 21 July 1929, YCAL MSS 85, Box 26, folder 6.

53. Dorothy Norman, *Encounters: A Memoir* (New York: Harcourt Brace Jovanovich, Publishers, 1987), 71–107.

54. "Marriage and Love Affairs: The Report of a Scientific Research by G. V. Hamilton, M.D., and Kenneth MacGowan," *Harper's Magazine* 157 (August 1928): 280.

55. Robinson, *Georgia O'Keeffe,* 308.

56. Lisle, *Portrait of an Artist,* 192–95.

57. Ernest W. Burgess and Harvey J. Locke, *The Family: From Institution to Companionship* (New York: American Book Company, 1945), 590–91.

58. Quoted in Robinson, *Georgia O'Keeffe,* 339.

59. O'Keeffe to Mabel Dodge Luhan, summer 1929, as quoted in ibid., 339.

60. O'Keeffe to Mabel Dodge Luhan, 1 July 1929, quoted in ibid., 338.

61. Stieglitz to Elizabeth Sieglitz Davidson, September 2, 1929, quoted in ibid., 342; and O'Keeffe to Mabel Dodge Luhan, September 1929(?), quoted in *Georgia O'Keeffe: Art and Letters,* ed. Sarah Greenough and Juan Hamilton (Washington, D.C.: National Gallery of Art, 1987), 196.

62. O'Keeffe to Jean Toomer, 10 January 1934, JWJ MSS 1, Series Number I, Box 6, folder 204.

63. O'Keeffe to Jean Toomer, 14 January 1934 JWJ MSS 1, Series Number I, Box 6, folder 204; and O'Keeffe to Jean Toomer, 17 January 1934, JWJ MSS 1, Series Number I, Box 6, folder 204..

64. O'Keeffe to Jean Toomer, 17 January 1934, JWJ MSS 1, Series Number I, Box 6, folder 204.

65. Jean Toomer to O'Keeffe, 21 January 1934, YCAL MSS 85, Box 216, folder 3831.

66. O'Keeffe to Jean Toomer, 14 February 1934, JWJ MSS I, Number I, Box 6, folder 204.

67. O'Keeffe to Jean Toomer, 5 March 1934, JWJ MSS I, Number 1, Box 6, folder 204.

68. See O'Keeffe to Jean Toomer, 11 May 1934, JWJ MSS I, Number I, Box 5, folder 204; and Toomer to O'Keeffe, 15 May 1934, JWJ MSS I, Number I, Box 5,

folder 204. See also Whelan, *Alfred Stieglitz,* 548–49, for information about their relationship.

69. O'Keeffe to Jean Toomer, JWJ MSS 1, Series Number I, Box 6, folder 204.

70. Whelan, *Alfred Stieglitz,* 484.

71. Robinson, *Georgia O'Keeffe,* 221.

72. Ibid., 340.

73. Seligmann, *Alfred Stieglitz Talking,* 58.

74. Stieglitz to Rebecca Salsbury Strand, 16 September 1924, YCAL MSS 85, Box 25, folder 610.

75. Stieglitz to Rebecca Salsbury Strand, 21 July 1929, YCAL MSS 85, Box 26, folder 6.

76. Ibid.

77. O'Keeffe to Anita Pollitzer, October 1915, quoted in *Lovingly, Georgia: The Complete Correspondence of Georgia O'Keeffe and Anita Pollitzer,* ed. Clive Giboire (New York: Touchstone, 1990), 53.

78. Barbara Novak, "The Posthumous Revenge of Josephine Hopper," *Art in America* 84 (June 1996): 31.

79. Gail Levin, *Edward Hopper: An Intimate Biography* (New York: Alfred A. Knopf, 1995), 116.

80. Brian O'Doherty, *American Masters: The Voice and the Myth* (New York: Random House, 1973), 13, 16; and Levin, *An Intimate Biography,* 124. See also Levin, *Edward Hopper: The Complete Prints* (New York: W. W. Norton & Company and Whitney Museum of American Art, 1979), 6.

81. Brian O'Doherty, "Portrait: Edward Hopper," *Art in America* 52 (October 1964): 69.

82. Novak, "The Posthumous Revenge of Josephine Hopper," 27.

83. O'Doherty, *American Master,* 17.

84. O'Doherty, *American Masters,* 17–18.

85. O'Doherty, "Portrait: Edward Hopper," 75, 74.

86. O'Doherty, *American Masters,* 18.

87. Novak, "The Posthumous Revenge of Josephine Hopper," 27.

88. Gail Levin also analyzed these cartoons in her *Edward Hopper: The Art and The Artist* (New York: W. W. Norton & Company and Whitney Museum of American Art, 1980), 11-12; and *An Intimate Biography,* 177–79, 236–37.

89. Novak, "The Posthumous Revenge of Josephine Hopper," 31.

90. Levin, *An Intimate Biography,* 351, 390–91; O'Doherty, *American Masters,* 41.

91. Novak, "The Posthumous Revenge of Josephine Hopper," 31, 29.

92. Quoted in ibid., 29.

93. Burgess and Locke, *The Family,* 468.

94. For more information about this, see Levin, *An Intimate Biography.*

95. Gail Levin, "Josephine Verstille Nivison Hopper," *Woman's Art Journal* (spring/summer 1980): 30.

96. Suzanne Burrey, "Edward Hopper: The Emptying Spaces," *Arts Digest* 29 (1 April 1955): 8.

97. Levin, *An Intimate Biography,* 171.

98. Levin, "Josephine Verstille Nivison Hopper," 30.

99. Ibid., 29. The quotations are from Royal Cortissoz, "Charming Water Colors and Drawings," *New York Tribune,* 25 November 1923, p. 8; and Helen Apple-

ton Read, "Brooklyn Museum Emphasizes New Talent in Initial Exhibition," *The Brooklyn Daily Eagle,* 18 November 1923, sec. 2B.

100. Novak, "The Posthumous Revenge of Josephine Hopper," 29.

101. Heywood Broun, "Wife of Lot," in *The Collected Heywood Broun* (New York: Harcourt, Brace & Co., 1941), 176, quoted in Kevin White, *The First Sexual Revolution: The Emergence of Male Heterosexuality in Modern America* (New York: New York University Press, 1993), 115.

102. For more information about this couple, see White, *The First Sexual Revolution,* 114–15.

103. Jo staged hunger strikes regularly, often succeeding in gaining her husband's attention. For details of these events, see Levin, *An Intimate Biography,* 386–88, 392, 404, 409–10, 430, 448–49, 555.

104. For information about the bohemian lifestyle, see Leslie Fishbein, *Rebels in Bohemia: The Radicals of* The Masses, *1911–1917* (Chapel Hill: University of North Carolina Press, 1982).

Chapter Three

1. For this observation, see especially Lloyd Goodrich, *Edward Hopper* (New York: Whitney Museum of American Art, 1964), 17; Matthew Baigell, "The Silent Witness of Edward Hopper," *Arts Magazine* 49 (September 1974): 29; Linda Nochlin, "Edward Hopper and the Imagery of Alienation," *Art Journal* 41 (summer 1981): 136–49; Gail Levin, *Hopper's Places* (New York: Alfred A. Knopf, 1985), 5; Levin, *Edward Hopper: The Art and the Artist* (New York: W. W. Norton & Company and Whitney Museum of American Art, 1980), 43–46; and Frank Getlein, "The Legacy of Edward Hopper, Painter of Light and Loneliness," *Smithsonian Studies in American Art* 2 (September 1971): 60–67. See also Levin, *Edward Hopper: A Catalogue Raisonné* (New York: Whitney Museum of American Art and W. W. Norton & Company, 1995), 1:12.

2. Wieland Schmied, *Edward Hopper: Portraits of America* (Munich: Prestel, 1995), 11.

3. Ernest Brace, "Edward Hopper," *Magazine of Art* 30 (May 1937): 275–77; Helen Appleton Read, "Edward Hopper," *Parnassus* 5 (November 1933): 10; and Read, "America Today," *The Brooklyn Daily Eagle,* 7 March 1926, p. 7. Andrew Hemingway attributed the theme of alienation to the postwar period, claiming that Tyler Parker first used it in his 1948 article, "Edward Hopper: Alienation by Light" (*Magazine of Art* 41 [December 1948]: 290–95), in which he maintained that *House by the Railroad* is "a symbol of the lone individual." See Parker, "Edward Hopper," 293; and Hemingway, "'To Personalize the Rainpipe': The Critical Mythology of Edward Hopper," *Prospects* 17 (1992): 399. But Read and Brace had already addressed Hopper's art in these terms even if they did not use the word *alienation.*

4. Levin, *The Art and the Artist,* 10.

5. Levin, *A Catalogue Raisonné,* 3:198. See also Gail Levin, "Edward Hopper: The Influence of Theater and Film," *Arts Magazine* 55 (October 1980): 125–26; Katherine Kuh, *The Artist's Voice: Talks with Seventeen Artists* (New York: Harper & Row, 1962), 131; and Karal Ann Marling, "*Early Sunday Morning,*" *Smithsonian Studies in American Art* 2 (fall 1988): 23–53.

6. Lloyd Goodrich, "Portrait of the Artist," *Woman's Day* (February 1965): 41.

7. Ibid. Robert Hobbs, on the other hand, viewed this work as a testament to the "enduring strengths of small service-oriented businesses" during the Great Depression. See Hobbs, *Edward Hopper* (New York: Harry N. Abrams, 1987), 77.

8. Brace, "Edward Hopper," 275. Hopper initially intended to include a figure in the fourth window on the left above the storefronts, but decided to leave him out.

For more information about this painting, see Marling, "*Early Sunday Morning,*" 23–53.

9. Levin, *A Catalogue Raisonné,* 3:180.

10. Hemingway, "'To Personalize the Rainpipe,'" 387. Duncan Philips, for example, retitled Hopper's *Hoboken Façade* as *Sunday on Main Street.*

11. As Gail Levin pointed out, Hopper became interested in the subject of trains in 1899, when he began to commute to New York City to attend classes. The theme appears in his work done for journals and the drawings he produced in France between 1906 and 1908, as well as in his mature oil paintings. See Levin, "Edward Hopper as Printmaker and Illustrator: Some Correspondences," *Print Collector's Newsletter* 10 (1979): 122. See also Levin, "Edward Hopper's Railroad Imagery," in *The Railroad in American Art,* ed. Susan Danly and Leo Marx, 165–82 (Cambridge, Mass.: MIT Press, 1988).

12. Goodrich observed "a gasoline station on a country road with darkness coming on, its lighted red pumps bright against the somber woods and cold evening sky, expressing all the loneliness of a traveler on a strange road at nightfall." See Goodrich, "Portrait of the Artist," 92.

13. See Karen Lucic, *Charles Sheeler and the Cult of the Machine* (Cambridge, Mass.: Harvard University Press, 1991), 103–4, for a further analysis of this painting.

14. Quoted in ibid., 73.

15. Quoted in Martin L. Friedman, *The Precisionist View in American Art* (Minneapolis: Walker Art Center, 1960), 35.

16. Ibid.

17. Malcolm Cowley, *Exile's Return: A Literary Odyssey of the 1920's* (New York: W. W. Norton & Company, 1934), 9, 201.

18. Helen Appleton Read, "The American Scene," *The Brooklyn Daily Eagle,* 20 February 1927, p. 6E.

19. Helen Appleton Read, "Racial Quality of Hopper Pictures at Modern Museum Agrees with Nationalistic Mood," *The Brooklyn Daily Eagle,* 5 November 1933, p. 12 B–C.

20. Goodrich, "Portrait of the Artist," 92; and Goodrich, *Edward Hopper,* 19.

21. Baigell, "The Silent Witness of Edward Hopper," 31–32; and Hobbs, *Edward Hopper,* 79.

22. Margaret Iverson, "In the Blind Field: Hopper and the Uncanny," *Art History* 21 (September 1998): 409–29.

23. Stephen B. Safran and Monty L. Kary, "Edward Hopper: The Artistic Expression of the Unconscious Wish For Reunion with the Mother," *Arts in Psychotherapy* 13 (1986): 307–22.

24. Lewis Mumford, "The Intolerable City: Must It Keep on Growing?" *Harper's Magazine* 152 (February 1926): 283–86.

25. This is Levin's assessment in *A Catalogue Raisonné,* 3:156.

26. For the summary of Hopper's displeasure in completing this commission, see ibid., 3:268. The subject, in other words, was dictated by a patron, but he was able to move beyond his dislike of doing a commission to find in the house the same kinds of domestic ideals that he embodied in others.

27. James Quayle Dealey, *The Family in Its Sociological Aspects* (Boston: Houghton Mifflin, 1912), 91–92.

28. Dorothy Donnell Calhoun, "In a Little Crooked House," *The Farmer's Wife* 21 (March 1919): 228.

29. Ray E. Baber, *Marriage and the Family* (New York: McGraw-Hill, 1939), 10–12.

30. Robert S. Lynd and Helen M. Lynd, *Middletown: A Study in Contemporary Culture* (New York: Harcourt, Brace & Co., 1929), 93–110.

31. Ernest R. Mowrer, *The Family: Its Organization and Disorganization* (Chicago: University of Chicago Press, 1932), 22, 182.

32. Ernest W. Burgess and Harvey J. Locke, *The Family: From Institution to Companionship* (New York: American Book Company, 1945), 128.

33. Ernest R. Groves, *The American Family* (Chicago: J. B. Lippincott, 1934), 128–29.

34. For these statistics, see Burgess and Locke, *The Family,* 487. See also Baber, *Marriage and the Family,* 12; and Ogburn, "The Family and Its Functions," 667.

35. Lloyd Goodrich, "The Paintings of Edward Hopper," *The Arts* 11 (March 1927):136.

36. Read, "Edward Hopper," 10.

37. Edward Sapir, "What Is the Family Still Good For?" *American Mercury* 19 (1930): 146.

38. Charles W. Wood, "What Is Happening to Marriage?" *The Nation* 128 (20 March 1929): 343.

39. Anna Garlin Spencer, "What Makes a Home? The Problem as Youth Faces It," *Ladies' Home Journal* 46 (October 1929): 107, 131.

40. James L. McConaughy, "Now That You Are Engaged," *Good Housekeeping* 105 (October 1937): 213.

41. Lewis Mumford, "The City," in *Civilization in the United States, An Inquiry by Thirty Americans,* ed. Harold E. Stearns (New York: Harcourt, Brace & Co., 1922), 13.

42. Lewis Mumford, "The Metropolitan Milieu," in *America and Alfred Stieglitz: A Collective Portrait,* ed. Waldo Frank et al. (New York: Doubleday, Doran & Company, 1934; reprint, New York: Aperture, 1979), 29.

43. For information about how these new amusements fostered youth-oriented, heterosocial relationships and freer sexual expression, see Kathy Peiss, *Cheap Amusements: Working Women and Leisure in Turn-of-the-Century New York* (Philadelphia: Temple University Press, 1986); and Lewis A. Erenberg, *Steppin' Out: New York Nightlife and the Transformation of American Culture, 1890–1930* (Westport, Conn.: Greenwood Press, 1981).

44. Sapir, "What Is the Family Still Good For?" 146.

45. Burgess and Locke, *The Family,* 523.

46. "Traveling Man," *Time* 51 (19 January 1948): 59.

47. Hobbs, *Edward Hopper,* 11, 93.

48. John C. Long, "Ask Mother—She Knows," *Motor* (September 1923): 92.

49. Baber, *Marriage and the Family,* 16.

50. Lynd and Lynd, *Middletown,* 119, 257.

51. Virginia Scharff, *Taking the Wheel: Women and the Coming of the Motor Age* (New York: Free Press, 1991), 52–142. For additional information about how the car influenced Americans during this period, see Glen Jeansonne, "The Automobile and American Morality," *Journal of American Culture* 8 (summer 1974): 125–31; and Michael L. Berger, "Women Drivers!: The Emergence of Folklore and Stereotypic Opinions Concerning Feminine Automotive Behavior," *Women's Studies International Forum* 9 (1986): 257–63.

52. Christine McGaffey Frederick, "The Commuter's Wife and the Motor Car," *Suburban Life* 14 (July 1912): 13.

53. Lynd and Lynd, *Middletown,* 137, 522.

54. Beth L. Bailey, *From Front Porch to Back Seat: Courtship in Twentieth-Century America* (Baltimore: Johns Hopkins University Press, 1988), 19. For a contemporary account of the transition from courtship to dating, see Willard Waller, "The Rating and Dating Complex," *American Sociological Review* 2 (1937): 727–34.

55. Burgess and Locke, *The Family*, 523–33.

56. Harry A. Bowman, *Marriage for Moderns* (New York: Whittlesey House, 1942), 160.

57. Victor F. Calverton, *The Bankruptcy of Marriage* (New York: Macaulay Company, 1928), 92. Jerome Beatty concurred, observing that the motorcar was responsible for the greater amount of petting among unmarried youngsters. See Beatty, "Taking the Blinders Off Love," *American Magazine* 124 (December 1937): 182. See also Wood, "What Is Happening to Marriage?," 343; and "All the Comforts of Home," *Motor* (December 1919): 58.

58. Lynd and Lynd, *Middletown,* 137.

59. "Keeping Up with the Crowd," *True Story* 8 (1923): 46–48; 110–12.

60. Scharff, *Taking the Wheel,* 140.

61. Burgess and Locke, *The Family,* 533. The Lynds reported the same data: Lynd and Lynd, *Middletown,* 258.

62. Burgess and Locke, *The Family,* 538.

63. Bailey, *From Front Porch to Back Seat,* 20–21, 87.

64. For information about the influence of the garage on domestic architecture, see Folke T. Kihlstedt, "The Automobile and the Transformation of the American House, 1910–1935," in *The Automobile and American Culture,* ed. David L. Lewis and Laurence Goldstein (Ann Arbor: University of Michigan Press, 1983), 160–75.

65. For a color reproduction of this painting, see Levin, *A Catalogue Raisonné,* 3:321.

66. "All the Comforts of Home," 58.

67. Burgess and Locke, *The Family,* 533.

68. Lynd and Lynd, *Middletown,* p. 114.

69. This quotation is from Goodrich, *Edward Hopper,* 42. It is repeated in Goodrich, *Edward Hopper: Selections from the Hopper Bequest* (New York: Whitney Museum of American Art, 1971), 9. Robert Hobbs examined the automobile within the context of Hopper's art, commenting, "He is also the first chronicler of the views of America dictated by the automobile, and most important, he is the first to understand the ramifications of the automobile, an invention that would serve to isolate people from each other and separate them from the country they hoped to escape to on weekends." Hobbs further attributed Hopper's unique view of nature to his viewing the outside world from the automobile. See Hobbs, *Edward Hopper,* 11–16.

70. Geraldine Sartain, "You and Your Car," *Independent Woman* 18 (May 1939): 134–35.

71. Jo Hopper diary entry, 1 August 1937, quoted in Gail Levin, *Edward Hopper: An Intimate Biography* (New York: Alfred A. Knopf, 1995), 297.

72. Jo Hopper diary entry, 26 May 1938, quoted in ibid., 305.

73. Jo Hopper diary entry, 12 October 1944, quoted in ibid., 372.

74. Barbara Novak, "The Posthumous Revenge of Josephine Hopper," *Art in America* 84 (June 1996): 29.

75. Levin makes a similar observation. See *An Intimate Biography,* 206, 172.

76. David L. Lewis, "Sex and the Automobile: From Rumble Seats to Rockin' Vans," in *The Automobile and American Culture,* ed. David L. Lewis and Laurence Goldstein (Ann Arbor: University of Michigan Press, 1983), 129.

77. Josephine N. Hopper, *Edward Hopper: His Work* (manuscript, Whitney Museum of American Art, New York), vol. 3, and quoted in Levin, *A Catalogue Raisonné,* 3:308.

78. Susan Alyson Stein, "Edward Hopper: The Uncrossed Threshold," *Arts Magazine* 54 (March 1980): 160.

79. Gail Levin, "Edward Hopper's Process of Self-Analysis," *Art News* 79 (October 1980): 146. Levin discussed the differences between the drawing and the painting.

80. Levin addressed the theme of estranged couples in Hopper's works in *A Catalogue Raisonné,* 1:77–81.

81. Levin made similar comments concerning the "absence of communication between a man and a woman painfully contrasted with the intimate domesticity of their surroundings." See ibid., 3:220–21.

82. Hobbs made this observation about the lighting. See Hobbs, *Edward Hopper,* 129. Hopper, in an interview with Kuh in 1960, explained that this work "was suggested by a restaurant on Greenwich Avenue where two streets meet." Kuh asked if he thought of the night street as "lonely and empty." Hopper replied, "I didn't see it as particularly lonely. . . . Unconsciously, probably I was painting the loneliness of a large city." See Kuh, *The Artist's Voice,* 134.

83. Hobbs made this observation about their compositional cohesion. See Hobbs, *Edward Hopper,* 131.

84. Kuh, *The Artist's Voice,* 134.

85. Levin addressed the change that occurs in Hopper's images of couples from his earlier works to those produced after his marriage, attributing the change in attitude to his difficult relationship with Jo. See Levin, *A Catalogue Raisonné,* 1:75–78.

86. Josephine N. Hopper, *Edward Hopper: His Work,* vol. 3. See also Levin, *A Catalogue Raisonné,* 3:320.

87. Levin, *An Intimate Biography,* 395.

88. Ibid., 261.

89. Jo Hopper to Elizabeth Cameron Blanchard, 14 June 1934, quoted in ibid., 259.

90. Jo Hopper to Marion Hopper, 23 August 1934, quoted in ibid., 263.

91. Jo Hopper to Elizabeth Cameron Blanchard, 17 October 1934, quoted in ibid., 263.

92. Sherwood Anderson, *Many Marriages* (New York: Grosset and Dunlap, 1923), 68.

93. Ibid., 78.

94. Ibid., 85.

95. Levin made a similar observation, interpreting the foreground rotting tree in *Libby House, Portland* (1927) as "a metaphorical suggestion of Victorian values in decay." See *An Intimate Biography,* 209.

Chapter Four

1. Philip Sterling, "Burlesque," *New Theatre* (June 1936): 19.

2. For the history of burlesque in the United States, see Robert C. Allen, *Horrible Prettiness: Burlesque and American Culture* (Chapel Hill: University of North Carolina Press, 1991), especially 255–58. Already in 1930, at least one commentator believed burlesque was "tottering on its last legs," concluding that "having lost its spice" through "legitimizing what once was naughty . . . burlesque has also lost its reason for being." See Joseph Kaye, "The Last Legs of Burlesque," *Theater Magazine*

51 (February 1930): 36–37. See also Joseph Wood Krutch, "Burlesque," *The Nation* 134 (8 June 1932): 647.

3. Quoted in Gail Levin, *Edward Hopper: An Intimate Biography* (New York: Alfred A. Knopf, 1995), xii.

4. Sterling, "Burlesque," 18.

5. Ibid.

6. Jo Hopper to Marion Hopper, 21 February 1941, Whitney Museum Papers.

7. Brian O'Doherty addressed Hopper's earlier "life class . . . rhetorical academic poses" in "The Hopper Bequest at the Whitney," *Art in America* 59 (September 1971): 69. Ernest Brace recognized that Hopper "never conventionally posed" his later nudes. See Brace, "Edward Hopper," *Magazine of Art* 30 (May 1937): 277.

8. For this reading of the meaning of the male artist who paints the female nude in the studio, see Rozsika Parker and Griselda Pollock, "Painted Ladies," in their book, *Old Mistresses: Woman, Art and Ideology* (New York: Pantheon Books, 1981), 114–33; Deborah Cherry and Griselda Pollock, "Woman as Sign in Pre-Raphaelite Literature: A Study of the Representation of Elizabeth Siddall," in Pollock, *Vision and Difference: Femininity, Feminism, and the Histories of Art* (London: Routledge, 1988), 91–114; and Marcia Pointon, "Reading the Body: Historiography and the Case of the Female Nude," in *Naked Authority: The Body in Western Painting 1830–1908* (New York: Cambridge University Press, 1990), 14.

9. Pointon, "Reading the Body," 23–25.

10. For information about the power of the gaze on the part of a woman, see especially Griselda Pollock, "The Gaze and the Look: *Women with Binoculars*—A Question of Difference," in *Dealing with Degas: Representations of Women and the Politics of Vision,* ed. Richard Kendall and Griselda Pollock (New York: Universe, 1992), 106–132.

11. For the interpretation in which the male artist signifies culture and the female nude signifies nature, see Kenneth Clark, *The Nude: A Study of Ideal Art* (London: John Murray, 1956; reprint, Harmondsworth: Penguin Books, 1970); and Pointon, "Reading the Body," 18–19.

12. Others have noticed the correspondence between the works by Sloan and Hopper. See, for example, Gail Levin, *Edward Hopper: The Complete Prints* (New York: W. W. Norton & Company and Whitney Museum of American Art, 1979), 25–27; Robert Hobbs, *Edward Hopper* (New York: Harry N. Abrams, 1987), 40–48; and Charlene S. Engel, "On the Art of Seeing Feelingly: Intaglio Prints by Edward Hopper," *Print Collector's Newsletter* 20 (January-February 1990): 211. For a discussion of Sloan, see the following by Janice M. Coco: "Exploring the Frontier from the Inside Out: John Sloan's Nude Studies," *Journal of the American Psychoanalytic Association* 47 (1999): 1335–76; "Inscribing Boundaries in John Sloan's *Hairdresser's Window:* Privacy and the Politics of Vision." *Prospects* 24 (1999): 393–416; and "Re-viewing John Sloan's Images of Women," *Oxford Art Journal* 21 (1998): 79–97. See Hopper's discussion of Sloan's art, which includes an illustration of *Turning Out the Light,* in "John Sloan and the Philadelphians," *The Arts* 11 (April 1927): 169–78.

13. Patricia Hills, "John Sloan's Images of Working-Class Women: A Case Study of the Roles and Interrelationships of Politics, Personality, and Patrons in the Development of Sloan's Art, 1905–16," *Prospects* 5 (1980): 160.

14. For a general discussion of the female nude as a representation of the containment and regulation of the female sexual body, see Lynda Neal, *The Female Nude: Art, Obscenity and Sexuality* (London: Routledge, 1992).

15. Matthew Baigell, "The Silent Witness of Edward Hopper," *Arts Magazine* 49 (September 1974): 31.

16. Gail Levin, "Josephine Verstille Nivison Hopper," *Woman's Art Journal* 1 (spring–summer 1980): 30. Hopper said in an interview in 1960 that Jo "always posed for everything." See Katherine Kuh, *The Artist's Voice: Talks with Seventeen Artists* (New York: Harper & Row, 1960; reprint, New York: Harper & Row, 1962), 134.

17. O'Doherty, "Portrait: Edward Hopper," *Art in America* 52 (October 1964): 70. See also Gail Levin, *Edward Hopper: A Catalogue Raisonné* (New York: Whitney Museum of American Art and W. W. Norton & Company, 1995), 3:374; and Josephine N. Hopper, *Edward Hopper: His Work* (manuscript, Whitney Museum of American Art, New York), 3:81.

18. Hopper, *Edward Hopper: His Work,* 2:79. Also cited in Levin, *A Catalogue Raisonné,* 3:270, 374.

19. As Hobbs observed, "Edward used his wife as a model for the women in his paintings, being careful to change her face and hair to reflect a specific type." See Hobbs, *Edward Hopper,* 19.

20. For more information about Jo as an actress in regional theatre, see Levin, *An Intimate Biography,* 155–57, 161–62; and her "Josephine Verstille Nivison Hopper," 28–29.

21. Levin has addressed the changes that occurred between the preliminary drawings and the final painting in "Edward Hopper's 'Office at Night,'" *Arts Magazine* 52 (January 1978): 134–37; and in *A Catalogue Raisonné,* 3:270–73. See also her "The Office Image in the Visual Arts," *Arts Magazine* 59 (summer 1984): 98–103.

22. Jerrold Lanes made these observations about Hopper's compositions in general. See his review, "Current and Forthcoming Exhibitions," *Burlington Magazine* 107 (January 1965): 45.

23. Hobbs made some of these observations about the compositional distortions that establish tensions. See Hobbs, *Edward Hopper,* 115.

24. Susan Alyson Stein discussed this triangular relationship in "Edward Hopper: The Uncrossed Threshold," *Arts Magazine* 54 (March 1980): 157–58.

25. Carroll D. Murphy, "Living Up to Your Employment System," *System: The Magazine of Business* 24 (July 1913): 23. Illustrated in Gail Levin, *Edward Hopper as Illustrator* (New York: W. W. Norton & Company and Whitney Museum of American Art, 1979), ill. 67; and Levin, *A Catalogue Raisonné,* vol. 1, ill. 1-145c.

26. Carroll D. Murphy, "Buying More with Each Wage-Dollar," *System: The Magazine of Business* 23 (March 1913): 233. Also quoted in Levin, *Edward Hopper as Illustrator,* ill. 54; and Levin, *A Catalogue Raisonné,* vol. 1, ill. 1-141d.

For additional information about Hopper as an illustrator, see Gail Levin, "Edward Hopper as Printmaker and Illustrator: Some Correspondences," *Print Collector's Newsletter* 10 (1979): 121–23; her "Hopper's Etchings: Some of the Finest Examples of American Printmaking," *Art News* 78 (September 1979): 90–93; and Robert Silberman, "Edward Hopper: Becoming Himself," *Arts in America* 68 (January 1980): 45–47.

27. Ellen Wiley Todd, "Will (S)he Stoop to Conquer? Preliminaries toward a Reading of Edward Hopper's *Office at Night,*" in *Visual Theory: Painting and Interpretation,* ed. Norman Bryson, Michael Ann Holly, and Keith Moxey (New York: Icon Editions, 1991), 50.

28. Elizabeth MacGibbon, *Manners in Business* (New York: Macmillan, 1936), 16–17.

29. Hazel Rawson Cades, *Jobs for Girls* (New York: Harcourt, Brace & Co., 1928), 16.

30. Todd, "Will (S)he Stoop to Conquer?" 50–51.

31. Kevin White addressed the meaning of this type of clothing for men in his

The First Sexual Revolution: The Emergence of Male Heterosexuality in Modern America (New York: New York University Press, 1993), 16.

32. For more information about this topic, see Nathan G. Hale, *Freud and Americans: The Beginnings of Psychoanalysis in the United States, 1876–1917* (New York: Oxford University Press, 1971); and *The Rise and Crisis of Psychoanalysis in the United States: Freud and the Americans, 1917–1985* (New York: Oxford University Press, 1995). See also Peter Gabriel Filene, *Him/Her/Self: Sex Roles in Modern America* (New York: Harcourt Brace Jovanovich, 1975); Nancy F. Cott, *The Grounding of Modern Feminism* (New Haven: Yale University Press, 1987); and White, *The First Sexual Revolution*. Victor F. Calverton concluded that the Victorian smugness of the nineteenth century was transformed into a new sense of freedom and morality that was evident in recent literature. See his summary in his book *Sex Expression in Literature* (New York: Boni and Liveright, 1926), 275. See also James R. McGovern, "The American Woman's Pre-World War I Freedom in Manners and Morals," *Journal of American History* 55 (September 1968): 315–33.

33. "Sex O'Clock in America," *Current Opinion* 55 (July 1913): 113.

34. Christina Clare Simmons, "'Marriage in the Modern Manner': Sexual Radicalism and Reform in America, 1914–1941" (Ph.D. diss., Brown University, 1982), v–vi, 105, 129; and White, *The First Sexual Revolution,* 15, 60, 72–74.

35. For information about Ellis's and Key's attitudes toward female eroticism, see Cott, *The Grounding of Modern Feminism,* 46–47. See also Leslie Fishbein, *Rebels in Bohemia: The Radicals of* The Masses, *1911–1917* (Chapel Hill: University of North Carolina Press, 1982), 38–39, 77–78.

36. White, *The First Sexual Revolution,* 61.

37. Harold Brainerd Hersey, *Pulpwood Editor: The Fabulous World of the Thriller Magazines Revealed by a Veteran Editor and Publisher* (New York: Frederick A. Stokes, 1937; reprint, Westport, Conn.: Greenwood Press, 1965), 240. See also Oswald Garrison Villard, "Sex, Art, Truth, and Magazines," *Atlantic Monthly* 137 (March 1926): 388–89.

38. Frederick Harris, "The Influence of Sex in Family Life," in *Readings in Mental Hygiene,* ed. Ernest R. Groves and Phyllis Blanchard (New York: Henry Holt & Co., 1936), 230. See also Katherine Bement Davis, *Factors in the Sex Lives of Twenty-Two Hundred Women* (New York: Harper and Brothers, 1929); and Gilbert Van Tassel Hamilton, *A Research in Marriage* (New York: A. and C. Boni, 1929). Hamilton, a psychiatrist and director of the Psychobiological Research Division of the Bureau of Social Hygiene, interviewed two hundred married men and women under the age of forty, concluding that "the institution of marriage has fared better than might have been expected" (553).

39. For a discussion of the media's populariziation of Lindsey, see Charles Larsen, *The Good Fight: The Life and Times of Ben B. Lindsey* (Chicago: Quadrangles Books, 1972), 144–82. For Victor Calverton's comment, see his *Bankruptcy of Marriage* (New York: Macaulay Company, 1928), 3. See also Calverton, *Sex Expression in Literature.*

40. See Robert L. Dickinson, *A Thousand Marriages: A Study of Sex Adjustment* (Baltimore: Williams and Wilkins, 1931); Hannah Stone and Abraham Stone, *A Marriage Manual: A Practical Guide-Book to Sex and Marriage* (New York: Simon and Schuster, 1939); Dorothy Bromley and F. L. Britten, *Youth and Sex: A Study of Thirteen Hundred College Students* (New York: Harper and Brothers, 1938); Lewis Terman, *Psychological Factors in Marital Happiness* (New York: McGraw-Hill, 1938); and Alfred Kinsey, Wardell B. Pomeroy, and Clyde E. Martin, *Sexual Behavior in the Human Male* (Philadelphia: W. B. Saunders, 1948). See also Michael Gordon, "From an Unfortunate Necessity to a Cult of Mutual Orgasm: Sex in American Marital Education Litera-

ture, 1830–1940," in *The Sociology of Sex,* ed. James M. Henslin and Edward Sagarin (New York: Schocken Books, 1978), 82; and Paul Robinson, *The Modernization of Sex: Havelock Ellis, Alfred Kinsey, William Masters and Virginia Johnson* (New York: Harper & Row, 1976).

41. White, *The First Sexual Revolution,* 159.

42. Theodore H. Van de Velde, *Ideal Marriage: Its Physiology and Technique,* trans. Stella Browne (New York: Random House, 1930); and White, *The First Sexual Revolution,* 72–75. For information about the influence of the social hygiene movement upon American attitudes toward sex, see John C. Burnham, "The Progressive Era Revolution in American Attitudes toward Sex," *Journal of American History* 59 (March 1973): 885–908.

43. George Chauncey, *Gay New York: Gender, Urban Culture, and the Making of the Gay Male World, 1890–1940* (New York: Basic Books, 1994), 117.

44. Simmons, "'Marriage in the Modern Manner,'" vi.

45. Davis, *Factors in the Sex Lives of Twenty-Two Hundred Women.*

46. Quoted in Fishbein, *Rebels in Bohemia,* 74.

47. Elaine Tyler May, *Great Expectations: Marriage and Divorce in Post-Victorian America* (Chicago: University of Chicago Press, 1980), 105.

48. White, *The First Sexual Revolution,* 125.

49. Simmons, "'Marriage in the Modern Manner,'" v–vi, 105, 129; and White, *The First Sexual Revolution,* 15, 60, 72–74.

50. Kinsey, Pomeroy, and Martin, *Sexual Behavior in the Human Male,* 563.

51. M. J. Exner, *The Sexual Side of Marriage* (New York: W. W. Norton & Company, 1932), 19–20. For an elaboration of the discourse of mutual sexual contentment within a companionship marriage, see Steve Seidman, *Romantic Longings: Love in America, 1830–1980* (New York: Routledge, 1991), 65–118. See also Jeffrey Weeks, *Sex, Politics and Society: The Regulation of Sexuality Since 1800* (London: Longman, 1989), especially pp. 199–231.

52. Van de Velde, *Ideal Marriage,* 172.

53. As quoted in Seidman, *Romantic Longings,* 107.

54. Simmons, "'Marriage in the Modern Manner,'" 165, 201; and White, *The First Sexual Revolution,* 182. Robinson's quotation is from William Robinson, *Sex Morality* (New York: Critic and Guide, 1919), 26.

55. Seidman, *Romantic Longings,* 89; and Chauncey, *Gay New York,* 8. Rayna Rapp and Ellen Ross proposed that the promotion of companionship marriage and condemnation of lesbianism undermined organized feminism. See Rapp and Ross, "The Twenties' Backlash: Compulsory Heterosexuality, the Consumer Family, and the Waning of Feminism," in *Class, Race, and Sex: The Dynamics of Control,* ed. Amy Swerdlow and Hanna Lessinger (Boston: G. K. Hall, 1983), 100. See also Lisa Duggan, "The Social Enforcement of Heterosexuality and Lesbian Resistance in the 1920s," in *Class, Race, and Sex,* 75–92.

56. Jo Hopper, diary entry for 12 October 1944. Quoted in Levin, *An Intimate Biography,* 179–80.

57. Todd, "Will (S)he Stoop to Conquer?" 51.

58. Joanne Meyerowitz, "Women, Cheesecake, and Borderline Material: Responses to Girlie Pictures in the Mid-Twentieth-Century U.S.," *Journal of Women's History* 8 (fall 1996): 10.

59. Ellen Wiley Todd, *The "New Woman" Revised: Painting and Gender Politics on Fourteenth Street* (Berkeley and Los Angeles: University of California Press, 1993), 186.

60. Lloyd Goodrich, *Reginald Marsh* (New York: Harry N. Abrams, 1972), 37.

61. White, *The First Sexual Revolution,* 70–71.

62. Quoted in Allen, *Horrible Prettiness,* 25.

63. In a sociological study conducted in the 1960s, strippers commented upon their awareness of the audience members' masturbation. See James K. Skipper and Charles H. McCaghy, "Stripteasing: A Sex-Oriented Occupation," in *Studies in the Sociology of Sex,* ed. James M. Henslin (New York: Appleton-Century-Crofts, 1971), 284.

64. From Jo Hopper's diary, 1 February 1940, quoted in Levin, *Catalogue Raisonné,* 3:272. See also Josephine N. Hopper, *Edward Hopper: His Work* (manuscript, Whitney Museum of American Art, New York), 2:79.

65. For a further discussion of the virgin/whore typos at the end of the nineteenth century, see Bram Dijkstra, *Idols of Perversity: Fantasies of Feminine Evil in Fin-de-Siecle Culture* (New York: Oxford University Press, 1986).

66. Gail Levin made a similar observation about the sense of sexual fear in *Approaching the City.* See her "Edward Hopper's Railroad Imagery," in *The Railroad in American Art: Representations of Technological Change,* ed. Susan Danly and Leo Marx (Cambridge, Mass.: MIT Press, 1988), 177–78.

67. White, *The First Sexual Revolution,* 84, 183.

68. Hersey, *Pulpwood Editor,* 230.

69. Sydney Tillim, "Edward Hopper and the Provincial Principle," *Arts Magazine* 39 (November 1964): 27.

70. Gail Levin, "Edward Hopper: The Influence of Theater and Film," *Arts Magazine* 55 (October 1980): 126. Levin addressed Hopper's love for theatre and movies, explaining how they influenced his work in terms of subject and composition (p. 123). Hobbs also addressed Hopper's tendency to "focus on strangely isolated stills" that "elicit feelings of isolation and loss" because his paintings "remain unsolvable question marks that indicate a profound distrust of the entire modern age." See Hobbs, *Edward Hopper,* 16. See also John Updike, "Hopper's Polluted Silence," *The New York Review of Books* (10 August 1995): 19. Updike observed Hopper's failure to tell a story fully, creating dramatic tension within settings that suggest stage sets. See also Lucy Fischer, "The Savage Eye: Edward Hopper and the Cinema," in *A Modern Mosaic: Art and Modernism in the United States,* ed. Townsend Ludington (Chapel Hill: University of North Carolina Press, 2000), 334–56.

71. Lloyd Goodrich, *Edward Hopper* (New York: Whitney Museum of American Art, 1950), 31.

72. Archer Winsten, "Wake of the News. Washington Square North Boasts Strangers Worth Talking To," *New York Post,* 26 November 1935, p. 15.

73. This is the question Todd asks in "Will (S)he Stoop to Conquer?" 49.

74. Wolfgang Iser, "Indeterminacy and the Reader's Response in Prose Fiction," in *Aspects of Narrative: Selected Papers from the English Institute,* ed. J. Hillis Miller (New York: Columbia University Press, 1971), 11–12.

75. Allen, *Horrible Prettiness,* 264–65.

76. Craig Owens, "Posing," in *Beyond Recognition: Representation, Power, and Culture* (Berkeley and Los Angeles: University of California Press, 1992), 207–10.

77. Craig Owens, "The Medusa Effect," in *Beyond Recognition,* 198.

Chapter Five

1. Barbara Buhler Lynes, *O'Keeffe, Stieglitz and the Critics, 1916–1929* (Ann Arbor, Mich.: UMI Research Press, 1989), 1, 9.

2. Ibid., 2, 23–25; and Barbara Buhler Lynes, "Georgia O'Keeffe and Feminism: A Problem of Position," in *The Expanding Discourse: Feminism and Art History,* ed. Norma Broude and Mary D. Garrard (New York: Icon Editions, 1992), 439.

3. For more about Macmahon, O'Keeffe's relationship with him, and her response through the *Specials,* see especially Laurie Lisle, *Portrait of an Artist: A Biography of Georgia O'Keeffe* (New York: Washington Square Press, 1980), 77–90; and Roxana Robinson, *Georgia O'Keeffe: A Life* (New York: Harper & Row, 1989), 113–36.

4. O'Keeffe to Anita Pollitzer, October 1915, quoted in Clive Giboire, ed., *Lovingly, Georgia: The Complete Correspondence of Georgia O'Keeffe and Anita Pollitzer* (New York: Touchstone, 1990), 47; and O'Keeffe to Anita Politzer, 4 October 1915, quoted in ibid., 53.

5. O'Keeffe to Arthur MacMahon, 25 December 1915, quoted in Robinson, *Georgia O'Keeffe,* 127.

6. O'Keeffe to Anita Pollitzer, November 1915, quoted in Giboire, *Lovingly, Georgia,* 92.

7. O'Keeffe to Anita Pollitzer, December 1915, quoted in ibid., 103.

8. Georgia O'Keeffe to Arthur MacMahon, 6? January 1916, quoted in Robinson, *Georgia O'Keeffe,* 130.

9. O'Keeffe to Anita Pollitzer, 16 February 1916, YCAL MSS 85, Box 208, folder 3650.

10. For O'Keeffe's mysticism, see Sharyn R. Udall, "Beholding the Epiphanies: Mysticism and the Art of Georgia O'Keeffe," in *From the Faraway Nearby: Georgia O'Keeffe as Icon,* ed. Christopher Merrill and Ellen Bradbury (Reading, Mass.: Addison-Wesley Publishing Co., 1992), 89–112. For more on the relationship between O'Keeffe's art and music, see Donna M. Cassidy, *Painting the Musical City: Jazz and Cultural Identity in American Art, 1910–1940* (Washington, D.C.: Smithsonian Institution Press, 1997); and Katherine Hoffman, *Georgia O'Keeffe: A Celebration of Music and Dance* (New York: George Braziller, 1997). Bram Dijkstra believed O'Keeffe was not "driven by mystical impulses," but instead was guided from "the invisible bond she felt between her body and the landscape." See Dijkistra, *Georgia O'Keeffe and the Eros of Place* (Princeton, N.J.: Princeton University Press, 1998), 153.

11. O'Keeffe wrote Pollitzer that she "almost lost [her] mind over" Strand's photographs. See O'Keeffe to Anita Pollitzer, 20 June 1917, quoted in Giboire, *Lovingly, Georgia,* 256. Others agree that Strand's abstract still lifes influenced O'Keeffe's flower paintings. See, for example, Milton Brown, "Cubist-Realism: An American Style," *Marsyas* 3 (1946): 155; Charles C. Eldredge, "Georgia O'Keeffe: The Development of an American Modern," (Ph.D. diss., University of Minnesota, 1971), 51; Katherine Hoffman, *An Enduring Spirit: The Art of Georgia O'Keeffe* (Metuchen, N.J.: Scarecrow Press, 1984), 30; and Lise Messinger, "Georgia O'Keeffe," *Metropolitan Museum of Art Bulletin* (fall 1984): 18. Sarah Peters, on the other hand, rejected the possibility of Strand's influence. See Peters, *Becoming O'Keeffe: The Early Years* (New York: Abbeville Press, 1991), 193.

For information about Strand's photographs, see especially Sarah Greenough, *Paul Strand: An American Vision* (New York: Aperture Foundation, 1990); and Maria Morris Hambourg, *Paul Strand Circa 1916* (New York: Metropolitan Museum of Art, 1998).

12. O'Keeffe had written an article in 1922, praising Strand's photographs of "shapes." See O'Keeffe, "To MSS," *MSS,* no. 4 (December 1922): 17–18, quoted in Lynes, *O'Keeffe, Stieglitz and the Critics,* 182–84.

13. Barbara Buhler Lynes, *Georgia O'Keeffe: A Catalogue Raisonné* (New Haven, Conn.: Yale University Press in conjunction with the National Gallery of Art and The Georgia O'Keeffee Foundation, 1999), 1:112.

14. See O'Keeffe to Anita Pollitzer, 20 June 1917, quoted in Giboire, *Lovingly, Georgia,* 256.

15. O'Keeffe to Paul Strand, 3 June 1917, quoted in *Georgia O'Keeffe: Art and Letters,* ed. Sarah Greenough and Juan Hamilton (Washington, D.C.: National Gallery of Art, 1987), 161.

16. O'Keeffe to Paul Strand, 25 June 1917, quoted in ibid., 164.

17. O'Keeffe to Paul Strand, 12 June 1917, quoted in Robinson, *Georgia O'Keeffe,* 184.

18. Lewis Mumford, "O'Keefe [sic] and Matisse," *New Republic* 50 (2 March 1927): 41–42, quoted in Lynes, *O'Keeffe, Stieglitz and the Critics,* 265–66. On pp. 121–23, Lynes analyzed the positive response of Stieglitz and O'Keeffe to this review, suggesting that she would not have felt comfortable with his references to sexual feelings, although she accepted the concept that her art "addressed" the "female experience."

19. "Musicians Afield—Local Art Notes. In New York Galleries: Georgia O'Keeffe's Arresting Pictures," *New York Times* (16 January 1927), sec. 7, p. 10, quoted in ibid., 260.

20. "Art: On View," *Time* 11 (20 February 1928): 21–22; and Edward Alden Jewell, "Georgia O'Keeffe, Mystic: Her Patterns Weave through Boundless Space," *New York Times* (22 January 1928), sec. 10, p. 12, quoted in Lynes, *O'Keeffe, Stieglitz and the Critics,* 283–84 and 278. For similar connections between O'Keeffe's flowers and "passionate ecstasy" and "love," see also Louise Kalonyme, "Georgia O'Keeffe: A Woman in Painting," *Creative Art* 2 (January 1928): xxxiv–xl, quoted in ibid., 278–84. As Lynes pointed out, Marya Mannes rejected these associations in 1928. See ibid., 140–41, 282–83.

21. Lynes (*O'Keeffe, Stieglitz and the Critics,* 156–59) showed that the "idea of sexual symbolism in her imagery" first surfaced in 1916, became especially pronounced in 1927 and 1928, and disappeared in 1929, only to resurface in the early thirties. See also Lynes, "Georgia O'Keeffe and Feminism," 437–49; and Wanda Corn, *The Great American Thing: Modern Art and National Identity, 1915–1935* (Berkeley and Los Angeles: University of California Press, 1999), 240.

22. O'Keeffe to Alfred Stieglitz, 6? January 1916, quoted in Robinson, *Georgia O'Keeffe,* 131; and Anita Pollitzer, *A Woman on Paper: Georgia O'Keeffe* (New York: Simon and Schuster, 1988), 123–24. The quotation regarding the womb derives from Dorothy Norman, *Alfred Stieglitz: An American Seer* (New York: Random House, 1960; reprint, New York: Aperture, 1990), 120–22.

23. The quotation is probably apocryphal. Dorothy Norman and Herbert Seligmann presented it as fact (see Norman, *An American Seer,* 111; and Seligmann, *Alfred Stieglitz Talking: Notes on Some of His Conversations, 1925–1931* [New Haven, Conn.: Yale University Press, 1966], 23), but a good summary of the debate over its authenticity appears in Naomi Rosenblum, "Georgia O'Keeffe," *Art Journal* 51 (spring 1992): 107 and n. 3. As Rosenblum asserted, "The phrase appears penciled into the Pollitzer letter . . . and [does] not seem to be in her hand."

24. Alfred Stieglitz, "Georgia O'Keeffe—C. Duncan—Réné [sic] Lafferty," *Camera Work,* no. 48 (October 1916): 12–13, quoted in Lynes, *O'Keeffe, Stieglitz and the Critics,* 166–67.

25. Lynes, "Georgia O'Keeffe and Feminism," 440. For other quotations that relate O'Keeffe's work to female anatomy or the experiences of womanhood, see also Hoffman, *An Enduring Spirit,* 59–69. Dijkstra also addressed the association between O'Keeffe and the womb as well as Stieglitz's participation in this critical association in his *Georgia O'Keeffe and the Eros of Place,* 192–202.

26. Paul Rosenfeld, "American Painting," *Dial* 71 (December 1921): 666.

27. Paul Rosenfeld, "The Paintings of Georgia O'Keeffe," *Vanity Fair* 19 (October 1922): 112, quoted in Lynes, *O'Keeffe, Stieglitz and the Critics,* 178. Rosenfeld repeated this idea in his *Port of New York: Essays on Fourteen American Moderns* (New York: Harcourt Brace and Company, 1924; reprint, Urbana: University of Illinois Press, 1961), quoted in ibid., 207.

28. Seligmann, *Alfred Stieglitz Talking,* 71.

29. Henry McBride, "News and Reviews," *New York Herald,* 4 February 1923, sec. 7, p. 7, quoted in Lynes, *O'Keeffe, Stieglitz and the Critics,* 187.

30. Marcia Brennan, *Painting Gender, Constructing Theory: The Alfred Stieglitz Circle and American Formalist Aesthetics* (Cambridge, Mass.: MIT Press, 2001), pp. 97–102.

31. Quoted in Greenough and Hamilton, eds., *Art and Letters,* 170–71; and Lynes, "O'Keeffe and Feminism," 443.

32. Grace Glueck, "Art Notes: 'It's Just What's In My Head,'" *New York Times,* 18 October 1970, sec. 2., p. 24. O'Keeffe wrote Mitchell Kennerley in the summer of 1922, "Rosenfelt's [sic] articles have embarrassed me . . . reading [his] article in *The Dial* I was in a fury." Quoted in Robinson, *Georgia O'Keeffe,* 240.

33. Lynes, "Georgia O'Keeffe and Feminism," 444.

34. O'Keeffe to Sherwood Anderson, 11 February 1927, quoted in Greenough and Hamilton, *Art and Letters,* 176.

35. Henry McBride, "Modern Art," *Dial* 82 (March 1927): 262–63, quoted in Lynes, *O'Keeffe, Stieglitz and the Critics,* 266. Oscar Bluemner repeated these very words in "A Painter's Comment," in the exhibition catalogue *Georgia O'Keeffe: Paintings, 1926* (New York: Intimate Gallery, 1927), quoted in Lynes, *O'Keeffe, Stieglitz and the Critics,* 257.

36. O'Keeffe, *Georgia O'Keeffe* (New York: Penguin Books, 1976), n.p., opposite figs. 23 and 24.

37. Judy Chicago and Miriam Schapiro, "Female Imagery," *Womanspace Journal* 1 (summer 1973): 11, 13.

38. Glueck, "'It's Just What's In My Head,'" 24.

39. For an excellent account of the 1970s feminist debate about art, see *The Power of Feminist Art: The American Movement of the 1970s, History and Impact,* ed. Norma Broude and Mary D. Garrard (New York: Harry N. Abrams, 1994), especially pp. 24–25.

40. Anna C. Chave, "O'Keeffe and the Masculine Gaze," *Art in America* 78 (January 1990): 115–16.

41. Ibid., 119, 124.

42. Ibid., 119.

43. Corn, *The Great American Thing,* 242.

44. O'Keeffe to Anita Pollitzer, 4 January 1916, and to Mabel Dodge Luhan, 1925?, quoted in Greenough and Hamilton, *Art and Letters,* 147, 180.

45. Gladys Oaks, "Radical Writer and Woman Artist Clash on Propaganda and Its Uses," *The [New York] World* 16 (March 1930), Women's section, pp. 1, 3. Quoted in Lynes, "Georgia O'Keeffe and Feminism," 442.

46. Lynes (*O'Keeffe, Stieglitz and the Critics,* 11–12) suggested that the Stieglitz group read and believed in the theories of Henri Bergson, who stated that intuition, a feminine characteristic, is crucial to creative production. Accordingly, O'Keeffe would be seen as naturally creative because of her gender.

47. Ralph Looney, "Georgia O'Keeffe," *The Atlantic Monthly* 215 (April 1965): 108.

48. Ibid.; and Lynes, "Georgia O'Keeffe and Feminism," 443.

49. Lynes, "Georgia O'Keeffe and Feminism," 443.

50. Looney, "Georgia O'Keeffe," 108.

51. Lynes, *O'Keeffe, Stieglitz and the Critics,* 287.

52. Claude Bragdon, "The Shelton Hotel, New York," *Architectural Record* 58 (July 1925): 18.

53. Lynes, "Georgia O'Keeffe and Feminism," 442–43.

54. For the National Woman's Party's struggle to define and implement equal rights, see Nancy F. Cott, *The Grounding of Modern Feminism* (New Haven, Conn.: Yale University Press, 1987), 119–29.

55. O'Keeffe to Eleanor Roosevelt, 10 February 1944, quoted in Greenough and Hamilton, *Art and Letters,* 235.

56. Frances O'Brien, "Americans We Like: Georgia O'Keeffe," *Nation* 125 (12 October 1927): 361–62, quoted in Lynes, *O'Keeffe, Stieglitz and the Critics,* 272.

57. O'Keeffe, *Georgia O'Keeffe,* n.p.

58. Ibid., n.p. Bram Dijkstra addressed this episode as an indication of a man's attempt to claim "formal authority over nature, a genuine 'triumph of the will' of evolutionary masculinity over the forces of degeneration." See Dijkstra, *Georgia O'Keeffe and the Eros of Place,* 77.

59. Blanche Matthias, "Georgia O'Keeffe and the Intimate Gallery," *The Chicago Evening Post Magazine of the Art World,* 2 March 1926, 14.

60. Glueck, "'It's Just What's in My Head.'"

61. For turn-of-the-century paintings that draw such analogies between women and flowers, see Annette Stott, "Floral Femininity: Pictorial Definition," *American Art* 6 (spring 1992): 61–77. For Brigman, see Naomi Rosenblum, *A History of Women Photographers* (New York: Abbeville Press, 1994), 296; and Judith Fryer, "Women's *Camera Work:* Seven Propositions in Search of a Theory," *Prospects* 16 (1991): 107–12.

62. Lynes, *O'Keeffe, Stieglitz and the Critics,* 19–23.

63. Henry Tyrrell, "New York Art Exhibitions and Gallery News," *Christian Science Monitor,* 2 June 1916, p. 10; and Waldo Frank, "White Paint and Good Order," in *Time-Exposures* (New York: Boni and Liveright, 1926), 31–35, quoted in Lynes, *O'Keeffe, Stieglitz and the Critics,* 166, 255.

64. Anne Middleton Wagner, *Three Artists (Three Women): Modernism and the Art of Hesse, Krasner, and O'Keeffe* (Berkeley and Los Angeles: University of California Press, 1996), 98. Dijkstra suggested that rather than intending to spite the critics, O'Keeffe "wanted to show that 'even' flowers could express the nongendered elements of emotional experience echoed in *all* the shapes of nature." He also proposed that O'Keeffe was aware of the association between woman and "man-eating flower" in popular culture and hence may have deliberately painted the flower to dissociate it from this discourse: "to make the public recognize the inherent absurdity of any comparisons between women and flowers." See Dijkstra, *Georgia O'Keeffe and the Eros of Place,* 96, 223–27.

65. Lynes, *O'Keeffe, Stieglitz and the Critics,* 23. See also Brennan, *Painting Gender, Constructing Theory,* 102–7.

66. Victor Calverton, *Sex Expression in Literature* (New York: Boni and Liveright, 1926), 276.

67. See, for example, "Intellectual Provocateur," *Time* 33 (26 June 1939): 59–62; "Editorial Comment," *The Nation* 132 (20 May 1931): 545; W. Béran Wolfe, "The Twilight of Psychoanalysis," *American Mercury* 35 (August 1935): 385–94; Harvey Carson Grumbine, "Reaction of a Layman to Psychoanalysis," *Scribner's*

Magazine 68 (November 1920): 602–6; Max Eastman, "Exploring the Soul and Healing the Body," *Everybody's Magazine* 32 (1915): 741–50; and "Psychoanalysis Fails to Account for the Artist," *Literary Digest* 83 (4 October 1924): 32.

68. "Is Freudism Destined to Live?" *Current Opinion* 69 (September 1920): 355; and Karl Menninger, "Pseudonanalysis: Perils of Freudian Verbalisms," *Outlook and Independent* 155 (9 July 1930): 363. Sharyn Udall proposed that O'Keeffe's landscapes were in fact self-portraits; the land, according to this scholar, becomes a metaphor for O'Keeffe's body. See Sharyn Udall, *Carr, O'Keeffe, Kahlo: Places of Their Own* (New Haven, Conn.: Yale University Press, 2000), 118.

69. As Therese Benedek concluded in 1949, Freud's "intellectual revolution" revealed the "boiling cauldron of emotions underneath the static-appearing, smooth ideological surface of the patriarchal Victorian family." See Benedek, "The Emotional Structure of the Family," in *The Family: Its Function and Destiny*, ed. Ruth Nanda Anshen (New York: Harper and Brothers, 1949), 203. For how professionals addressed debates on Freud's theories, see Erich Fromm, "Sex and Character," in *The Family: Its Function and Destiny*, 375–92. For Freud's influence in the United States, see F. H. Matthews, "The Americanization of Sigmund Freud: Adaptations of Psychoanalysis before 1917," *Journal of American Studies* 1 (1967): 39–62.

70. Helen Appleton Read, "Georgia O'Keeffe's Show an Emotional Escape," *Brooklyn Sunday Eagle Magazine* (11 February 1923), 2 B. She reiterated this idea in "Georgia O'Keeffe—Woman Artist Whose Art Is Sincerely Feminine," *Brooklyn Sunday Eagle Magazine* (6 April 1924), 4, cited in Lynes, *O'Keeffe, Stieglitz and the Critics*, 192, 212–13. See also Read, "News and Views on Current Art: Alfred Stieglitz Presents 7 Americans," *The Brooklyn Daily Eagle*, 15 March 1915, p. 2 B, quoted in Lynes, *O'Keeffe, Stieglitz and the Critics*, 234.

71. McBride, "News and Reviews," cited in Lynes, *O'Keeffe, Stieglitz and the Critics*, 187.

72. Robinson, *Georgia O'Keeffe*, 174–94.

73. Ibid., 171–72. O'Keeffe wrote to Pollitzer about her experience. She had invited the lawyer to her room "and then my landlady informed me that she objected to my having anyone come see me at all—and I nearly died laughing. . . . When he came—I had to tell him right away about the old lady and that he couldn't come anymore—it was so funny. . . . Well—he said—let's not stay here, let's ride, so I got my coat and hat—and off we went. We rode a long time. . . . We got out and walked along the way. . . . When we got back in the car we sat there talking a long time—I was leaning forward . . . and bless you—when I sat back straight—his arm was round me." See O'Keeffe to Anita Pollitzer, 17 January 1917, YCAL MSS 85, Box 209, folder 3654.

74. For a discussion of Freud's undermining of "civilized morality" in the United States, see Nathan G. Hale, *Freud and Americans: The Beginnings of Psychoanalysis in the United States, 1876–1917* (New York: Oxford University Press, 1995). Stieglitz had purchased all six volumes of Ellis's series by the end of 1911. See Brennan, *Painting Gender, Constructing Theory*, 105.

75. Elizabeth Davidson to Stieglitz, 8 November 1924, YCAL MSS 85, Box 54, folder 1308; and Katherine Rhoades to Stieglitz, 4 October 1914, YCAL MSS 85, Box 40, folder 972. See also Sue Davidson Lowe, *Stieglitz: A Memoir/Biography* (New York: Farrar Straus Giroux, 1983), xxi.

76. Charles C. Eldredge, *Georgia O'Keeffe: American and Modern* (New Haven, Conn.: Yale University Press, 1993), 177; and Hale, *Freud and Americans*, 44.

77. Ellen Wiley Todd demonstrated that the 1920s were not fully liberating for women. See Todd, *The "New Woman" Revised: Painting and Gender Politics on Fourteenth Street* (Berkeley and Los Angeles: University of California Press, 1993), especially pp. 150–53.

78. Lisle, *Portrait of an Artist,* 97, 118.

79. Quoted in Robinson, *Georgia O'Keeffe,* 159, 89.

80. Charlotte Perkins Gilman, "The Dress of Women," in *The Forerunner* (New York: Charlton, 1915), 20–80. O'Keeffe mentioned this essay to Anita Pollitzer in O'Keeffe to Pollitzer, 1916?, YCAL MSS 85, Box 209, folder 3652. O'Keeffe called the Gilman essay "great" and Gilman a "smart old girl." See O'Keeffe to Anita Pollitzer, 30 October 1916, YCAL MSS 85, Box 209, folder 3653. That Pollitzer did not share her friend's attitude toward dress is suggested by a letter that described and illustrated "a pink satin" dress "with a wonderful rose colored tulle over it," resulting in something "really lovely." See Anita Pollitzer to O'Keeffe, 20 December 1915, YCAL MSS 85, Box 208, folder 3648. In another letter, she verbally described and sketched "the loveliest dress" and included a sample of its blue fabric. See Anita Pollitzer to O'Keeffe, 21 November 1916, YCAL MSS 85, Box 209, folder 3652.

81. Robinson, *Georgia O'Keeffe,* 171–72.

82. O'Keeffe to Arthur Macmahon, 8 February 1916, quoted in Robinson, *Georgia O'Keeffe,* 134.

83. O'Keeffe to Paul Strand, 25 June 1917, quoted in ibid., 184–85.

84. Floyd Dell, *Janet March* (New York: Alfred A. Knopf, 1923), 118.

85. "Marriage and Love Affairs: The Report of a Scientific Research by G. V. Hamilton, M.D. and Kenneth MacGowan," *Harper's Magazine* 157 (August 1928): 280.

86. Sadkichi Hartmann, "Puritanism, Its Grandeur and Shame," *Camera Work,* no. 32 (October 1910): 17–18. See also Richard Whelan, *Alfred Stieglitz: A Biography* (New York: Little, Brown, 1995), 229.

87. Seligmann, *Alfred Stieglitz Talking,* 135. See also Whelan, *Alfred Stieglitz,* 502.

88. Whelan, *Alfred Stieglitz,* 433.

89. This comment can be found in Robinson, *Georgia O'Keeffe,* 251; Whelan, *Alfred Stieglitz,* 403; and Nancy Newhall, *From Adams to Stieglitz: Pioneers of Modern Photography* (Millerton, N.Y.: Aperture Foundation, 1989), 66. As Jonathan Weinberg recently suggested, this statement could mean that he made "love to the subject [O'Keeffe], the camera, the process of printmaking, or all three." See Jonathan Weinberg, *Ambition and Love in Modern American Art* (New Haven, Conn.: Yale University Press, 2001), 87.

90. Stieglitz to Rebecca Salsbury Strand, 6 August 1923, quoted in Whelan, *Alfred Stieglitz,* 452.

91. O'Keeffe, *Georgia O'Keeffe,* introduction, n.p.

92. Miles Barth, ed., *Intimate Visions: The Photographs of Dorothy Norman* (San Francisco: Chronicle Books, 1993), 28.

93. Seligmann reported that Stieglitz claimed, "I was ordered out of my home by my wife while I was working, photographing. It was the unfairest thing that ever happened to any man. . . . There was no more between me and O'Keeffe than there is between us here." See Seligmann, *Alfred Stieglitz Talking,* 125.

94. Georgia O'Keeffe, *A Portrait by Alfred Stieglitz,* n.p. O'Keeffe reminisced that during their first visit to Lake George, "We'd say we were going to have a nap. Then we'd make love. Afterwards he would take photographs of me." Robinson, *Georgia O'Keeffe,* 212.

95. Weinberg, *Ambition and Love in Modern American Art,* 100.

96. Plate 27 in O'Keeffe, *A Portrait by Alfred Stieglitz.* O'Keeffe selected nine nude portraits of herself to be reproduced in this book.

97. For Freud's discussion of the fetish, see Sigmund Freud, *Three Essays on the Theory of Sexuality,* trans. James Strachey (New York: Basic Books, 1975), 19. See also

Abbot A. Bronstein, "The Fetish, Transitional Objects and Illusion," *Psychoanalytic Review* 79 (summer 1992): 240.

Stieglitz enjoyed the continuity of O'Keeffe's manner of dressing (he was a creature of habit himself) and the obvious contrast with his fashion-conscious first wife. But his appreciation of high-heeled shoes appears in three photographs of Dorothy True in which the woman's leg appears at an angle from the left-hand corner. Its curved calf plays against the curves of the shoes and short dress as well as the angles of the tiled floor. This foot evokes fashion and artificiality in a way that contrasts with Stieglitz's photographs of O'Keeffe's bare feet. Both, however, evoke eroticism and fetishism.

98. See also an illustration of Alfred Stieglitz's *Georgia O'Keeffe: A Portrait— Hands and Watercolor, June 4, 1917,* which can be found in Wagner's *Three Artists (Three Women),* p. 87, fig. 23, and Peters, *Becoming O'Keeffe,* p. 152, fig. 63. In this photograph, which I was denied permission to publish, O'Keeffe's hands appear to caress the folds of one of her charcoal *Specials* that resembles the form of an embryo.

99. For an analysis of the meaning of these apples ("the sources of O'Keeffe's art"), see Sarah Greenough, "From the American Earth: Alfred Stieglitz's Photographs of Apples," *Art Journal* 41 (spring 1981): 49.

100. Weinberg, *Ambition and Love in American Art,* 91.

101. Jeffrey Hogrefe identified this statue as *Bending Figure* and claimed O'Keeffe created it in response to her despair over the death of her mother. See Hogrefe, *O'Keeffe: The Life of an American Legend* (New York: Bantam Books, 1992), 68–69. Lynes concurred that O'Keeffe completed this sculpture shortly after the death of her mother, but identified the work as *Abstraction.* See Lynes, *Georgia O'Keeffe: A Catalogue Raisonné,* 1:63. O'Keeffe apparently did not like this sculpture. As she wrote Pollitzer: "I sat up almost all night one night this week and made the most internally ugly little shape you ever saw—I wanted to break it when I got through—but didn't—then next afternoon when I had time to look at it it amused me so that I didn't—really it's laughable—it's so ugly—and still in some ways it is quite beautiful." See O'Keeffe to Anita Pollitzer, 3 October 1916, YCAL MSS 85, Box 209, folder 3653.

102. This photograph suggests, in Lynes's view, "an interaction between" the male and female (i.e., coitus). See Lynes, *O'Keeffe, Stieglitz and the Critics,* 50. See also Corn, *The Great American Thing,* 241.

103. Weinberg, *Ambition and Love in American Art,* 102. For an illustration of Stieglitz's *Georgia O'Keeffe: A Portrait—Sculpture* (1920), see Peters, *Becoming O'Keeffe,* p. 155, fig. 67. I was denied permission to publish this photograph.

104. Norman, *Alfred Stieglitz,* 119. For other discussions of these photographs, see especially Lynes, *O'Keeffe, Stieglitz and the Critics,* 37–53; Wagner, *Three Artists (Three Women),* 79–96; and Peters, *Becoming Georgia O'Keeffe,* 147–81.

105. Norman, *Alfred Stieglitz,* 119.

106. Laura Mulvey, *Visual and Other Pleasures* (Bloomington: Indiana University Press, 1989), 20.

107. Lewis Mumford, "The Metropolitan Milieu," in *America and Alfred Stieglitz: A Collective Portrait,* ed. Waldo Frank, Lewis Mumford, Dorothy Norman, Paul Rosenfeld, and Harold Rugg (New York: Doubleday, Doran and Company, 1934), 37.

108. Lynes, *Georgia O'Keeffe: A Catalogue Raisonné,* 1:106; and Peters, *Becoming Georgia O'Keeffe,* 109–12. Both Lynes and Peters addressed these watercolors within the context of Rodin's influence.

109. Deborah Cherry and Griselda Pollock, "Woman as Sign in Pre-Raphaelite Literature: A Study of the Representation of Elizabeth Siddall," in *Vision and Difference: Femininity, Feminism, and the Histories of Art* (London: Routledge, 1988), 140.

110. Mulvey, *Visual and Other Pleasures,* 21.

111. Wagner, *Three Artists (Three Women),* 93; and Lisle, *Portrait of an Artist,* 134. O'Keeffe nevertheless claimed that she posed because "it was something *he* wanted to do." See Mary Lynn Kotz, "Georgia O'Keeffe at 90," *Art News* 76 (December 1977): 44.

112. O'Keeffe, *A Portrait by Alfred Stieglitz,* n.p.

113. Lynes argued that Hartley and Rosenfeld responded to O'Keeffe's art in terms of Stieglitz's erotic photographs. See Lynes, *O'Keeffe, Stieglitz and the Critics,* 52–53.

114. Mumford, "The Metropolitan Milieu," 37.

115. Ibid., 36–37.

116. Henry McBride, "O'Keeffe at the Museum," *New York Sun,* 18 May 1946, quoted in Whelan, *Alfred Stieglitz,* 418.

117. Edith Evans Asbury, who wrote O'Keeffe's obituary for the *New York Times,* called these photographs "the greatest love poem in the history of photography." See her "Georgia O'Keeffe Dead at 98: Shaper of Modern Art in U.S.," *New York Times,* 7 March 1986, p. 44–45.

118. Dijkstra suggested that Stieglitz's photographs of nude women also represent an act of "masculine self-assertion, of sexual appropriation" devoid of the "mental and physical dangers of sex itself." He furthermore posited that O'Keeffe's participation in their creation indicates her success in "deflecting his attempts to take control over her identity." See Dijkstra, *Georgia O'Keeffe and the Eros of Place,* 171, 183.

119. Joan Riviere, "Womanliness as a Masquerade," in *Psychoanalysis and Female Sexuality,* ed. Henrik M. Ruitenbeek (New Haven, Conn.: College and University Press, 1966), 209–20. Mary Ann Doane based her well-known theory about the female masquerade in Hollywood films upon Riviere's psychoanalytic observations. See Doane, "Film and the Masquerade: Theorizing the Female Spectator," *Screen* 23 (September–October 1982): 74–87. For Wagner's discussion of this text in relation to O'Keeffe, see Wagner, *Three Artists (Three Women),* 96–103.

Benita Eisler saw O'Keeffe's androgyny not as a masquerade, but as an accurate reflection of her lesbianism. She claimed that O'Keeffe was involved sexually with Rebecca Salsbury Strand, Mabel Dodge Luhan, and other women. She also called Stieglitz a pedophile on the basis of his relationship with his daughter, Kitty, and romances with pubescent girls. See Eisler, *O'Keeffe and Stieglitz: An American Romance* (New York: Penguin Books, 1991), and her "Scenes from a Marriage," *Mirabella* (July 1989): 182.

120. This is Susan Fillin-Yeh's argument in "Dandies, Marginality and Modernism: Georgia O'Keeffe, Marcel Duchamp and Other Cross-dressers," *Oxford Art Journal* 18 (1995): 33. See also Susan Gubar, "Blessings in Disguise: Cross-Dressing as Re-Dressing for Female Modernists," *Massachusetts Review* 22 (autumn 1981): 477–508.

121. Wagner, *Three Artists (Three Women),* 81.

122. This is Lynes's argument in *O'Keeffe, Stieglitz and the Critics.*

123. Ibid., 52.

124. Ibid., 132.

Chapter Six

1. Carroll Smith-Rosenberg discussed this strategy among the second generation of New Women. See Smith-Rosenberg, ed., *Disorderly Conduct: Visions of Gender in Victorian America* (New York: Alfred A. Knopf, 1985), 246–65.

2. For an explanation for the dating of this work, see Barbara Buhler Lynes, *Georgia O'Keeffe: A Catalogue Raisonné* (New Haven, Conn.: Yale University Press in conjunction with the National Gallery of Art and The Georgia O'Keeffe Foundation, 1999), 1:333.

3. O'Keeffe, *Georgia O'Keeffe* (New York: Penguin Books, 1976), opposite plate 20. She actually walked a farther distance, given that the Shelton was located on Lexington Avenue between Forty-eighth and Forty-ninth Streets, while the Radiator Building is located on West Fortieth Street.

4. Ibid.

5. "Editorial Comment," *American Architect* 126 (19 November 1924): 487. For information about O'Keeffe's cityscapes, see especially Anna C. Chave, "'Who Will Paint New York?': 'The World's New Art Center' and the Skyscraper Paintings of Georgia O'Keeffe," *American Art* 5 (winter/spring 1991): 87–107; Sarah Whitaker Peters, "O'Keeffe and Stieglitz in New York City," in *Becoming O'Keeffe: The Early Years* (New York: Abbeville Press, 1991): 277–304; and Elizabeth Duvert, "Georgia O'Keeffe's *Radiator Building:* Icon of Glamorous Gotham," *Places* 2 (1985): 3–17.

6. For artists capturing the spirit of modernity in New York City, see Wanda Corn, "The Artist's New York: 1900–1930," in *Budapest and New York: Studies in Metropolitan Transformation: 1870–1930,* ed. Thomas Bender and Carl E. Schorske (New York: Russell Sage Foundation, 1994), 275–308; and Corn, *The Great American Thing: Modern Art and National Identity, 1915–1935* (Berkeley and Los Angeles: University of California Press, 1999), 135–219.

7. For a discussion of the use of a name as a standard example of the index in semiotics, see Wendy Steiner, *Exact Resemblance to Exact Resemblance: The Literary Portraiture of Gertrude Stein* (New Haven, Conn.: Yale University Press, 1978), 6.

8. Karl Josef Höltgen, *Aspects of the Emblem: Studies in the English Emblem Tradition and the European Context* (Kassel, Germany: Edition Reichenberger, 1986), 24.

9. Michael Bath, *Speaking Pictures: English Emblem Books and Renaissance Culture* (London: Longman, 1994), 31. Other books that address the tradition of emblems and emblematic imagery include William E. Engel, *Mapping Mortality: The Persistence of Memory and Melancholy in Early Modern England* (Amherst: University of Massachusetts Press, 1995); Peter M. Daly, ed., *The English Emblem and the Continental Tradition* (New York: AMS Press, 1988); and Daniel Russell, *Emblematic Structures in Renaissance French Culture* (Toronto: University of Toronto Press, 1995).

10. For the emblematic portrait in eighteenth-century American painting, see Roger Stein, "Charles Willson Peale's Expressive Design: The Artist in His Museum," *Prospects* 6 (1981): 139–85.

11. Steiner, *Exact Resemblance,* 5.

12. *Camera Work,* special issue (August 1912).

13. Gertrude Stein, "Portrait of Mabel Dodge at the Villa Curonia," *Camera Work,* special issue (June 1913): 3–5; and Mabel Dodge, "Speculations," *Camera Work,* special issue (June 1913): 8.

14. As Stein explained, "And so I am trying to tell you what doing portraits meant to me. I had to find out what it was inside of any one, and by any one I mean every one I had to find out inside every one what was in them that was intrinsically exciting and I had to find out not by what they said not by what they did not by how much or how little they resembled any other one but I had to find out by the intensity of movement what there was inside in any one of them." Quoted in Steiner, *Exact Resemblance,* 5. For additional discussions of Stein's verbal portraits, see Carolyn Faunce Copeland, *Language and Time and Gertrude Stein* (Iowa City: University of Iowa Press, 1975); Michael Hoffman, *Gertrude Stein* (Boston: Twayne Publishers, 1976); and Bettin Knapp, *Gertrude Stein* (New York: Continuum Publishing Co., 1990).

15. Quoted in Willard Bohn, "The Abstract Vision of Marius De Zayas," *Art Bulletin* 62 (September 1980): 435.

16. Ibid., 434–52.

17. Wendy Wick Reaves, *Celebrity Caricature in America* (New Haven, Conn.: Yale University Press for the National Portrait Gallery, 1998). For the change from the culture of character in the nineteenth century to the culture of personality in the twentieth, see Warren I. Sussman, "Personality and the Making of Twentieth-Century Culture," in *Culture as History: The Transformation of American Society in the Twentieth Century* (New York: Pantheon, 1973), 271–85. See also Corn, *The Great American Thing,* 223.

18. For Picabia's abstract portraits, see especially William Homer, "Picabia's *Jeune fille américaine dans l'état de nudité* and Her Friends," *Art Bulletin* 57 (March 1975): 110–15; William Camfield, *Francis Picabia: His Art, Life and Times* (Princeton, N.J.: Princeton University Press, 1979); William Rozaitis, "The Joke at the Heart of Things: Francis Picabia's Machine Drawings and the Little Magazine 291," *American Art* 8 (summer/fall 1994): 43–59; and Corn, *The Great American Thing,* 23–24.

19. For an analysis of Hartley's painting, see Gail Levin, "Hidden Symbolism in Marsden Hartley's Military Pictures," *Arts Magazine* 54 (October 1979): 155–56; Jonathan Weinberg, *Speaking for Vice: Homosexuality in the Art of Charles Demuth, Marsden Hartley, and the First American Avant-Garde* (New Haven, Conn.: Yale University Press, 1993), 151–59; and Patricia McDonnell, "El Dorado: Marsden Hartley in Imperial Berlin," in *Dictated by Life: Marsden Hartley's German Paintings and Robert Indiana's Hartley Elegies* (New York: Distributed Art Publishers for Frederick R. Weisman Art Museum, University of Minnesota, 1995), 15–42.

20. Corn, *The Great American Thing,* 228–31.

21. Considerably more information is available about Demuth's poster portraits; see especially Abraham A. Davidson, "The Poster Portraits of Charles Demuth," *Auction* 3 (September 1969): 28–31; and his "Demuth's Poster Portraits," *Artforum* 17 (November 1978): 54–57; Edward A. Aiken, "'I Saw the Figure 5 in Gold': Charles Demuth's Emblematic Portrait of William Carlos Williams," *Art Journal* 46 (fall 1987): 178–84; Barbara Haskell, *Charles Demuth* (New York: Whitney Museum of American Art and H. N. Abrams, 1987); Wanda M. Corn, *In the American Grain: The Billboard Poetics of Charles Demuth* (Poughkeepsie, N.Y.: Vassar College, 1991); and Robin Jaffee Frank, *Charles Demuth: Poster Portraits, 1923–1929* (exhibition catalogue) (New Haven, Conn.: Yale University Art Gallery, 1994). See also Patricia Everett, "Andrew Dasburg's Abstract Portraits: Homages to Mabel Dodge and Carl Van Vechten," *Smithsonian Studies in American Art* 3 (winter 1989): 73–87; and Steven Watson, *Group Portrait: The First American Avant-Garde* (Washington, D.C.: National Portrait Gallery, 1991).

22. Corn, *The Great American Thing,* 38–39.

23. Peters, *Becoming O'Keeffe,* 250. Peters asserted that Stieglitz made three abstract photographs of O'Keeffe in 1923, as well as one self-portrait; see pp. 250, 354 n. 69.

24. Elizabeth Luther Cary, "Art: Exhibitions of the Week," *New York Times* (9 March 1924), sec. 8, p. 10, as quoted in Barbara Buhler Lynes, *O'Keeffe, Stieglitz and the Critics, 1916–1929* (Ann Arbor, Mich.: UMI Research Press, 1989), 198.

25. O'Keeffe, *Georgia O'Keeffe,* opposite plate 55.

26. Charles C. Eldredge, *Georgia O'Keeffe: American and Modern* (New Haven, Conn.: Yale University Press, 1993), 172–73.

27. Paul Strand, "Stieglitz, An Appraisal," *Popular Photography* (July 1947): 96. For information on Stieglitz's cloud studies, see Sarah Greenough, "Alfred Stieglitz's Photographs of Clouds" (Ph.D. diss., University of New Mexico, 1984).

28. Quoted in Eldredge, *Georgia O'Keeffe*, 165. Wassily Kandinsky certainly influenced O'Keeffe's symbolic reading of the color blue as heavenly: "Blue is the typical heavenly colour." See Kandinsky, *On Concerning the Spiritual in Art* (1912; reprint, New York: Solomon R. Guggenheim Foundation, 1946), 63.

29. Eldredge, *Georgia O'Keeffe*, 172.

30. Lynes, *Georgia O'Keeffe: A Catalogue Raisonné*, 1:112.

31. Kandinsky, *On Concerning the Spiritual in Art*, 69. That O'Keeffe ascribed meanings to colors is clear. At the outset of her book, she stated the following: "The meaning of a word—to me—is not as exact as the meaning of a color. Colors and shapes make a more definite statement than words." O'Keeffe, *Georgia O'Keeffe*, n.p.

32. Dorothy Norman, *Alfred Stieglitz: An American Seer* (New York: Random House, 1960; reprint, New York: Aperture, 1990), 178.

33. Corn, *The Great American Thing*, 227–28; and Weinberg, *Speaking for Vice*, 50–51.

34. As Herbert J. Seligmann observed, Stieglitz "intuitively" understood "the creative resources of the machine. He impressed the sensibility of the human spirit on processes which dominant industrialism could use only for the crude purposes of mass production. So he achieved through the refinements of photo-engraving and other reproductive processes results which are miracles of revelation and delicacy. These he insisted on embodying not in books but in a series of magazines, constituting the unsurpassable record of the early phase of his demonstration: the fifty members of *Camera Work,* the antecedent *Camera Notes,* and the later posteresque and typographically pioneering *291.*" See Seligmann, *Alfred Stieglitz Talking: Notes on Some of His Conversations, 1925–1931* (New Haven, Conn.: Yale University Press, 1966), iii.

35. Reaves, *Celebrity Caricature in America*, 3–14.

36. Norman, *Encounters: A Memoir* (New York: Harcourt Brace Jovanovich, Publishers, 1987), 64.

37. Seligmann, *Alfred Stieglitz Talking,* iv.

38. Ibid., 3.

39. Ibid., 40, 9.

40. Stieglitz asserted that his gallery "is not a business, and I am not a dealer." See ibid., 9, 27.

41. Alfred Stieglitz, "O'Keefe [sic] and the Lilies," *Art News* 26 (21 April 1928): 10. Although some accept Stieglitz's report that he sold the calla lilies to a Frenchman as fact (see MaLin Wilson, "An American Phenomenon: On Marketing Georgia O'Keeffe," in *From the Faraway Nearby: Georgia O'Keeffe as Icon,* ed. Christopher Merrill and Ellen Bradbury [Reading, Mass.: Addison-Wesley Publishing Company, 1992], 85; and Laurie Lisle, *Portrait of an Artist: A Biography of Georgia O'Keeffe* [New York: Washington Square Press, 1980], 191–95), Charles C. Eldredge and Benita Eisler believe this was a fictional transaction concocted by Stieglitz and his friend Mitchell Kennerley, or Stieglitz and O'Keeffe. (See Eldredge to Vivien Green Fryd, unpublished reviewer's comments on book manuscript, University of Chicago Press; and Eisler, *O'Keeffe and Stieglitz: An American Romance* [New York: Penguin Books, 1991], 370–72.) Whelan argued that Kennerley bought the paintings as a premature wedding present for his fiancée, and that he had mentioned that the paintings would "go to France" perhaps because Kennerley intended to move there or to visit. Whelan believed it was a transaction made in good faith but never realized, although the works were in Kennerley's collection for a time. See Whelan, *Alfred Stieglitz,* 497–98. According to Barbara Buhler Lynes's catalogue raisonné, some of the calla lily panels were indeed in Kennerley's possession in 1928. See *Georgia O'Keeffe: A Catalogue Raisonné,* (New Haven, Conn.: Yale University Press in conjunction with the National Gallery of Art and The Georgia O'Keeffe Foundation, 1999), 1:228–31.

42. Timothy Robert Rodgers, "Alfred Stieglitz, Duncan Phillips, and the $6,000 Marin," *Oxford Art Journal* 15 (1992): 55–56.

43. Corn, *The Great American Thing,* 39. As Jonathan Weinberg recently observed, Stieglitz "recognized the relationship between price and artistic prestige, while maintaining the fiction that he was not interested in commercial success." See Weinberg, *Ambition and Love in Modern American Art* (New Haven, Conn.: Yale University Press, 2001), 86. Celeste Connor argued the opposite, claiming that because Stieglitz "received no remuneration for" the sale of artworks in his galleries, he was "not a dealer in the usual sense," but instead an "active patron … astute collector, and impassioned supporter of the arts." See her *Democratic Visions: Art and Theory of the Stieglitz Circle, 1924–1934* (Berkeley and Los Angeles: University of California Press, 2001), 4.

44. Raymond M. Hood, "The American Radiator Company Building, New York," *American Architect* 126 (19 November 1924): 474.

45. Harvey Wiley Corbett, "The American Radiator Building, New York City, Raymond M. Hood, Architect," *Architectural Record* 55 (May 1924): 477.

46. Corn, *The Great American Thing,* 39.

47. O'Keeffe wrote to Anita Pollitzer that she loved "the Gertrude Stein portrait—the stuff simply fascinates me." See O'Keeffe to Pollitzer, 4 January 1916, quoted in Clive Giboire, ed., *Lovingly, Georgia: The Complete Correspondence of Georgia O'Keeffe and Anita Pollitzer* (New York: Touchstone, 1990), 118.

48. Claude Bragdon, "The Shelton Hotel, New York," *Architectural Record* 58 (July 1925): 1. For information about Bragdon, see Eldredge, *Georgia O'Keeffe,* 190; Peters, *Becoming O'Keeffe,* 73–75; Bram Dijkstra, *Georgia O'Keeffe and the Eros of Place* (Princeton, N.J.: Princeton University Press, 1998), 151–52; and Sharyn R. Udall, "Beholding the Epiphanies: Mysticism and the Art of Georgia O'Keeffe," in *From the Faraway Nearby: Georgia O'Keeffe as Icon,* ed. Christopher Merrill and Ellen Bradbury (Reading, Mass.: Addison-Wesley Publishing Co., 1992), 95. For more information about the identification of the skyscraper as a uniquely American invention that reflects American democracy and commerce, see Corn, "The Artist's New York," 303.

49. For artists' representations of New York City, see especially Corn, "The Artist's New York"; Corn, "The New New York," *Art in America* 61 (July-August 1973): 58–63; Corn, *The Great American Thing,* 135–224; and Merrill Schleier, *The Skyscraper in American Art, 1890–1931* (Ann Arbor, Mich.: UMI Research Press, 1986).

50. For a discussion of the influence of photography upon Precisionist art, see Karen Tsujimoto, *Images of America: Precisionist Painting and Modern Photography* (Seattle: University of Washington Press, 1982); and Ellen Handy, "The Idea and the Fact: Painting, Photography, Film, Precisionists, and the Real World," in *Precisionism in America 1915–1941: Reordering Reality* (New York: Harry N. Abrams and Montclair Art Museum, 1995), 4–51.

51. Corn, *The Great American Thing,* 171.

52. Alfred Stieglitz, "Modern Pictorial Photography in the United States," *Century Magazine* 64 (October 1902): 824–25; and Sidney Allen, "The 'Flat-Iron' Building—An Aesthetical Dissertation," *Camera Work,* no. 4 (October 1903): 36.

53. Norman, *An American Seer,* 45.

54. Sydney Allen, "The 'Flat-Iron' Building," 39. See also Alan Trachtenberg, *Reading American Photographs: Images as History, Mathew Brady to Walker Evans* (New York: Hill and Wang, 1989), 164–230.

55. Peters, *Becoming O'Keeffe,* 278.

56. Stieglitz to Paul Rosenfeld, 28 August 1920; Stieglitz to Hamilton Easter Field, 16 November 1920; and Stieglitz to Sherwood Anderson, 9 December 1925. These letters are quoted in Peters, *Becoming O'Keeffe,* 278. See also Stieglitz to Rebecca Salsbury Strand, 19 July 1927, YCAL MSS 85, Box 26, folder 612.

57. Stieglitz to Rebecca Salsbury Strand, 26 June 1924, YCAL MSS 85, Box 25, folder 610.

58. O'Keeffe to Catherine O'Keeffe Klenert, 24 December 1926, quoted in Robinson, *Georgia O'Keeffe: A Life* (New York: Harper & Row, 1989), 288.

59. B. Vladimir Berman, "She Painted the Lily and Got $25,000 and Fame for Doing It! Not in a Rickety Atelier But a Hotel Suite on the 30th Floor, Georgia O'Keefe [sic], New Find of Art World, Sets Her Easel," *New York Evening Graphic,* 12 May 1928, 3 M. Quoted in Lynes, *O'Keeffe, Stieglitz and the Critics,* 285–88.

60. Ibid.

61. Stieglitz to J. B. Neumann, 18 June 1924, J. B. Neumann Papers, Archives of American Art, Smithsonian Institution, Washington, D.C. Quoted in Peters, *Becoming O'Keeffe,* 277; and Stieglitz to Jean Toomer, 15 June 1924, YCAL MSS 85, Box 49, folder 1173.

62. Stieglitz to Jean Toomer, 15 June 1924, YCAL MSS 85, Box 49, folder 1173.

63. O'Keeffe to Sherwood Anderson, 11 June 1924, quoted in *Georgia O'Keeffe: Art and Letters,* ed. Sarah Greenough and Juan Hamilton (Washington, D.C.: National Gallery of Art, 1987), 175.

64. O'Keeffe to Sherwood Anderson, 11? November 1924, quoted in ibid., 178.

65. Georgia O'Keeffe to Ida O'Keeffe, November 1925, on Shelton Hotel letterhead, YCAL MSS 85, Box 37, folder 891.

66. Schleier similarly suggested that O'Keeffe, like Stieglitz, was ambivalent about New York City, seeing their continual escapes to Lake George or New Mexico as symptomatic of this. See Schleier, *The Skyscraper in American Art,* 108–9. Celeste Connor concurred, arguing that the entire Stieglitz circle expressed ambiguities about urban living. See her chapter on "The City," in *Democratic Visions: Art and Theory of the Stieglitz Circle, 1924–1934* (Berkeley and Los Angeles: University of California Press, 2001), 141–73.

67. Hood, "The American Radiator Company Building," 483–84.

68. Elizabeth Wilson, *The Sphinx in the City: Urban Life, the Control of Disorder, and Women* (Berkeley and Los Angeles: University of California Press, 1991), 14.

69. Ibid., 7–17.

70. George Santayana, *Winds of Doctrine, and Platonism and the Spiritual Life* (1913; reprint, New York: Harper and Brothers, 1957), 188.

71. Naomi Rosenblum, *A History of Women Photographers* (New York: Abbeville Press, 1994), 109.

72. Blanche Matthias, "Georgia O'Keeffe and the Intimate Gallery," *Chicago Evening Post Magazine of the Art World,* 2 March 1926, p. 14.

73. Peters addressed the malfunctions that O'Keeffe adopted in her discussion of O'Keeffe's cityscapes; see Peters, *Becoming O'Keeffe,* 280–85.

74. Schleier suggested, "O'Keeffe's repeated use of glowing, often celestial orbs conveys her confidence in nature as a regenerative force." She noted the juxtaposition between the spire of the church and the skyscraper, suggesting that it records the "overshadowing of the spiritual by commercial interests." See Schleier, *The Skyscraper in American Art,* 110.

75. Peters, *Becoming O'Keeffe,* 284.

76. Ibid., 289.

77. Louis Kalonyme, "Georgia O'Keeffe: A Woman in Painting," *Creative Art* 2 (January 1928): xxxiv–xl, quoted in Lynes, *O'Keeffe, Stieglitz and the Critics,* 281.

78. Laurie Lisle (*Portrait of an Artist: A Biography of Georgia O'Keeffe* [New York: Washington Square Press, 1980], 49) discussed Stieglitz's innovations in

photographing in rain, during snowstorms, and at night. For a discussion of how Stieglitz's nighttime photographs softened the harshness of the city, see Sarah Greenough and Juan Hamilton, *Alfred Stieglitz: Photographs and Writings* (Washington, D.C.: National Gallery of Art, 1983), 14. See also William Sharpe, "New York, Night, and Cultural Mythmaking: The Nocturne in Photography, 1900–1925," *Smithsonian Studies in American Art* 2 (fall 1988): 2–21.

79. Edward Westermarck, *Three Essays on Sex and Marriage* (London: Macmillan, 1934), 22.

80. Arthur Dove wrote to Stieglitz in December 1930: "The bursting of a phallic symbol into white light may be the thing we all need." Quoted in Anne Middleton Wagner, *Three Artists (Three Women): Modernism and the Art of Hesse, Krasner, and O'Keeffe* (Berkeley and Los Angeles: University of California Press, 1996), 70. On pp. 70–76, Wagner further addressed the phallic imagery of the later jack-in-the-pulpit images, suggesting that "if critics never tired of asserting [that] O'Keeffe is her art, then in the *Jack-in-the-Pulpit* series she is the phallus, no less—at least she can perform it."

81. Dijkstra suggested something similar about *Fifty-Ninth Street Studio,* indicating that she combined her love for the organic with the modernist (and masculinist) fascination with the "stylized, flattened, and abstracted, and hence 'intellectualized' picture plane." He continued, "She was well aware that mechanistic configurations of perception had come to be privileged as 'masculine.' She also knew that every other form of the organization of perception, ranging from religious mysticism to organic materialism, had come to be branded as expressive of the 'feminine' consciousness. Thus O'Keeffe, by conjoining prejudicially identified, and supposedly contradictory, elements of style in painting, brilliantly succeeded in subverting and transcending the reigning clichés of gender in art." See Dijkstra, *Georgia O'Keeffe and the Eros of Place,* 189.

82. O'Keeffe to Paul Strand, 23 July 1917, quoted in Peters, *Becoming O'Keeffe,* 186.

83. Joan Riviere, "Womanliness as a Masquerade," in *Psychoanalysis and Female Sexuality,* ed. Henrik M. Ruitenbeek (New Haven, Conn.: College and University Press, 1966), 209–15.

84. Georgia O'Keeffe, "Stieglitz: His Pictures Collected Him," *New York Times Magazine,* 11 November 1949, p. 24.

85. Riviere, "Womanliness as a Masquerade," 218.

86. Ibid.

87. For more about this scientific discourse, see Smith-Rosenberg, ed., *Disorderly Conduct,* 265.

88. Ibid., 266, 288–95.

89. Susan Fillin-Yeh argued that O'Keeffe's cross-dressing "framed a challenge to the dominant mode of male discourse by using its own symbols against it." See Fillin-Yeh, "Dandies, Marginality and Modernism: Georgia O'Keeffe, Marcel Duchamp and Other Cross-dressers," *Oxford Art Journal* 18 (1995), 36.

90. Chave, "'Who Will Paint New York?'" 76.

91. Charles C. Eldredge ("Georgia O'Keeffe: The Development of an American Modern" [Ph.D. diss., University of Minnesota, 1971], 65–66) provided a similar analysis of O'Keeffe's *Ranchos Church.*

92. Peters, *Becoming O'Keeffe,* 240.

93. Corn, *The Great American Thing,* 223.

Chapter Seven

1. Wanda Corn, *The Great American Thing: Modern Art and National Identity, 1915–1935* (Berkeley and Los Angeles: University of California Press, 1999), 244–45, 248.

2. Ibid., 245, 283.

3. O'Keeffe to Henry McBride, summer 1929, and O'Keeffe to Ettie Stettheimer, 24 August 1929, quoted in *Georgia O'Keeffe: Art and Letters,* ed. Sarah Greenough and Juan Hamilton (Washington, D.C.: National Gallery of Art, 1987), 189, 195; and O'Keeffe to Dorothy Brett, 24 October 1929, YCAL MSS 85, Box 181, folder 3022.

4. O'Keeffe to Arthur Dove, September 1942, quoted in Greenough and Hamilton, eds., *Art and Letters,* 233.

5. O'Keeffe to Russell Vernon Hunter, spring 1932, quoted in ibid., 207.

6. Sharyn R. Udall, "Beholding the Epiphanies: Mysticism and the Art of Georgia O'Keeffe," in *From the Faraway Nearby: Georgia O'Keeffe as Icon,* ed. Christopher Merrill and Ellen Bradbury (Reading, Mass.: Addison-Wesley Publishing Co., 1992), 91. See also Corn, *The Great American Thing,* 266; and Celia Weisman, "O'Keeffe's Art: Sacred Symbols and Spiritual Quest," *Woman's Art Journal* 3 (fall 1982/winter 1983): 10–14.

7. Corn, *The Great American Thing,* 248, 290.

8. *Georgia O'Keeffe,* prod. and dir. Perry Miller Adato, Educational Broadcast Company, 1977, videocassette.

9. Greenough and Hamilton, *Georgia O'Keeffe: Art and Letters,* 207.

10. O'Keeffe, *Georgia O'Keeffe* (New York: Penguin Books, 1976), opposite plate 64; and Katherine Kuh, *The Artist's Voice: Talks with Seventeen Artists* (New York: Harper & Row, 1960; reprint, New York: Harper & Row, 1962), 202.

11. Corn, *The Great American Thing,* 252.

12. O'Keeffe, *Georgia O'Keeffe,* opposite plate 64.

13. Corn, *The Great American Thing,* 264.

14. Sharyn Udall, *Carr, O'Keeffe, Kahlo: Places of Their Own* (New Haven, Conn.: Yale University Press, 2000), 62.

15. As quoted in Charles C. Eldredge, *Georgia O'Keeffe: American and Modern* (New Haven, Conn.: Yale University Press, 1993), 201.

16. Quoted in ibid., 201.

17. Corn, *The Great American Thing,* 269.

18. Others have suggested that O'Keeffe's skulls resemble the cross in their composition. See, for example, Charles C. Eldredge, "Georgia O'Keeffe: The Development of an American Modern" (Ph.D. diss., University of Minnesota, 1971), 73; and Corn, *The Great American Thing,* 247. Lise Mintz Messinger similarly suggested that the cross configuration comes from the extended horns and the vertical support created by a tree or easel. See Messinger, "Georgia O'Keeffe," *Metropolitan Museum of Art Bulletin* (fall 1984): 49; and Messinger, "Sources for O'Keeffe's Imagery: A Case Study," in *From the Faraway Nearby: Georgia O'Keeffe as Icon,* ed. Christopher Merrill and Ellen Bradbury (Reading, Mass.: Addison-Wesley Publishing Company, 1992), 63.

19. Corn, *The Great American Thing,* 245–291. Sharyn Udall suggests that O'Keeffe's *Ram's Head—White Hollyhock—Lake Hills, New Mexico* (1935) represents her own resurrection in which "the woman artist gives birth to herself." See Sharyn Udall, *Carr, O'Keeffe, Kahlo: Places of Their Own* (New Haven, Conn.: Yale University Press, 2000), p. 186.

20. Jonathan Weinberg, *Ambition and Love in Modern American Art* (New Haven, Conn.: Yale University Press, 2001), 109.

21. Eldredge, *Georgia O'Keeffe,* 195.

22. Christopher Merrill similarly viewed O'Keeffe's arid New Mexican landscapes and bones as symbolic of her struggle over the Stieglitz-Norman affair. See Christopher Merrill and Ellen Bradbury, eds., *From the Faraway Nearby: Georgia O'Keeffe as Icon,* (Reading, Mass.: Addison-Wesley Publishing Company, 1992), 10–12. Jeffrey Hogrefe, too, identified the bone paintings with "the death of her relationship with Stieglitz." See Hogrefe, *O'Keeffe: The Life of an American Legend* (New York: Bantam Books, 1992), 158.

23. Merrill suggested that an operation in 1927 for a benign tumor in her breast also had an impact upon her art and life. See Merrill and Bradbury, eds., *From the Faraway Nearby,* 10–12. Barbara Buhler Lynes also discussed this operation; see her *O'Keeffe, Stieglitz and the Critics, 1916–1929* (Ann Arbor, Mich.: UMI Research Press, 1989), 149.

24. Messinger viewed these photographs as indicative of their marital discord, suggesting that Stieglitz drew an analogy between "O'Keeffe and the bone she touches—both beautiful but unapproachable." See Messinger, "Georgia O'Keeffe," 46.

25. Rebecca Salsbury Strand to Paul Strand, 2 May 1929, quoted in Roxana Robinson, *Georgia O'Keeffe: A Life* (New York: Harper & Row, 1989), 327.

26. Ibid., 328.

27. Toward the end of her life, O'Keeffe again associated the car with independence. As she told her nurse, "I used to get in that car and go and go all over the place. And now I can't do that anymore. That's a different way to live when you have to depend on others to take you driving." See Christine Taylor Patten and Alvaro Cardona-Hine, *Miss O'Keeffe* (Albuquerque: University of New Mexico Press, 1992), 71.

28. Corn, *An American Thing,* 23.

29. Robinson interpreted these photographs in a similar fashion. See Robinson, *Georgia O'Keeffe,* 344.

30. For a photograph of O'Keeffe's triptych, see Dorothy Grafly, "Murals at the Museum of Modern Art," *American Magazine of Art* 25 (August 1932): 97. Grafly clearly did not like O'Keeffe's design, asking (p. 93) whether "post-War civilization" means only "a brilliant geometrization of skyscrapers across which a few adroit pink-and-blue roses are strewn for color and emotional effect?"

31. Kuh, *The Artist's Voice,* 190–91.

32. Weinberg, *Ambition and Love in Modern American Art,* 112.

33. According to Laurie Lisle and Richard Whelan, O'Keeffe responded with outrage and tears, on visiting the site on 16 November, leaving the room. Stieglitz informed Deskey the following day of O'Keeffe's supposed breakdown. Robinson, on the other hand, claimed that O'Keeffe remained calm but refused to paint on wet plaster and hence left. For this anecdotal information about her commission based on interviews with Deskey, see Laurie Lisle, *Portrait of an Artist: A Biography of Georgia O'Keeffe* (New York: Washington Square Press, 1980), 258–61; Richard Whelan, *Alfred Stieglitz: A Biography* (New York: Little, Brown, 1995), 541–43; and Robinson, *Georgia O'Keeffe,* 370–71, 378–81.

34. O'Keeffe to Rebecca Salsbury Strand, 6 October 1932, and O'Keeffe to Dorothy Brett, September 1932, quoted in Robinson, *Georgia O'Keeffe,* 380.

35. Weinberg, *Ambition and Love in Modern American Art,* 113.

36. Whelan, *Alfred Stieglitz,* 573.

37. Udall, "Beholding the Epiphanies," 110.

38. Quoted in Eldredge, "Georgia O'Keeffe: The Development of an American Modern," 76.

39. Eldredge, *Georgia O'Keeffe,* 165.

40. Robert Coughlan, "Changing Roles in Modern Marriage," *Life* (24 December 1956): 41.

41. William H. Whyte Jr., "The Wife Problem," *Life* (7 January 1952): 33.

42. For information about domestic containment during the cold war, see Elaine Tyler May, *Homeward Bound: American Families in the Cold War Era* (New York: Basic Books, 1988).

43. Gail Levin, *Edward Hopper: A Catalogue Raisonné* (New York: W. W. Norton & Company and Whitney Museum of American Art, 1980), 3:368.

44. Josephine N. Hopper, *Edward Hopper: His Work* (manuscript, Whitney Museum of American Art, New York), 3:75. See also Levin, *A Catalogue Raisonné,* 3:368.

45. Kuh, *The Artist's Voice,* 134

46. Ibid. See also Levin, *Edward Hopper: An Intimate Biography* (New York: Alfred A. Knopf, 1995), 539–40.

47. Hopper, *Edward Hopper: His Work,* 3:73. See also Levin, *A Catalogue Raisonné,* 3:366.

48. Kuh, *The Artist's Voice,* 135.

49. Ibid., 134. See also Levin, *An Intimate Biography,* 540.

50. Levin concurred, arguing that the work "brings to mind the *vanitas* theme." See Levin, *A Catalogue Raisonné,* 1:84. James Thomas Flexner similarly interpreted the work within this context, saying that he "felt it was an allegory of winter and spring, life and death." See ibid., 1:85.

51. Gail Levin, "Edward Hopper: The Influence of Theater and Film," *Arts Magazine* 55 (October 1980): 125. See also Levin, *An Intimate Biography,* 572–74; *Edward Hopper: The Art and the Artist* (New York: W. W. Norton & Company and Whitney Museum of American Art, 1980), 55; and *A Catalogue Raisonné,* 3:380.

52. As Gail Levin explained in an e-mail to me, "[T]he bastards were clearly Jo's paintings; their 'children' were Hopper's pictures." Levin, e-mail message to Vivien Green Fryd, 9 August 2000.

53. Jo Hopper to Annette Chatterton, 13 November 1965. Quoted in Levin, *An Intimate Biography,* 574.

54. Levin, *A Catalogue Raisonné,* 3:380.

55. Levin, *An Intimate Biography,* 577.

56. William Johnson, "The Silent Witness," *Time* 68 (24 December 1956): 34–39.

57. Paul Strand to Alfred Stieglitz, 16 November 1920, quoted in Belinda Rathbone, "Portrait of a Marriage: Paul Strand's Photographs of Rebecca," *The J. Paul Getty Museum Journal* 17 (1989): 87.

58. Elizabeth Wright, ed., *Feminism and Psychoanalysis: A Critical Dictionary* (Cambridge, Mass.: Basil Blackwell, 1992), 115.

59. Brian O'Doherty, "The Hopper Bequest at the Whitney," *Art in America* 59 (September/October 1971): 68–69.

60. Corn, *The Great American Thing,* 40.

61. As Sarah Greenough, curator of photographs at the National Gallery, explained in a letter to me: "I am sorry to say that your permission to reproduce Alfred Stieglitz's *Georgia O'Keeffe: A Portrait—with Cow Skull* and *Georgia O'Keeffe: A Portrait—with Automobile* for the article 'A Marriage in Crisis' has been denied. The Gallery must adhere to strict guidelines spelled out by Georgia O'Keeffe in her deed of gift to the Gallery, and therefore we cannot authorize this use of Stieglitz photographs" (Sarah Greenough to Vivien Green Fryd, 22 December 1999, personal letter).

An assistant of Sarah Greenough's informed me that this decision evolved from a "third party," who I incorrectly attributed to the O'Keeffe Foundation. Judy Lopez, director of the O'Keeffe Foundation, informed me that Sarah Greenough had made the decision. I have since learned that the "third party" is Juan Hamilton, the executor of O'Keeffe's estate. For the article in question, see Vivien Green Fryd, "Georgia O'Keeffe and Alfred Stieglitz: A Marriage in Crisis, 1928–1933," in *Amor y Desamor en las Artes*, edited by Arnulfo Herrera, 67–81 (Mexico City: Universidad Nacional Autónoma de México, 2001).

62. O'Keeffe to Anita Pollitzer, 2 October 1967, YCAL MSS 85, Box 209, folder 3661.

63. O'Keeffe to Anita Pollitzer, 28 November 1977, YCAL MSS 85, Box 209, folder 3661.

64. O'Keeffe to Laurie Lisle, 23 August 1977, YCAL MSS 85, Box 200, folder 3437.

65. This is the astute observation of Edward Abrams in his various reviews of Pollitzer, Cowart, Hamilton and Greenough's *Art and Letters,* and Doris Bry's *Some Memories of Drawings.* See his review, "The Image Maker," *The New Republic* 200 (30 January 1989): 41–45.

66. Ibid., 43.

67. For the best summaries of the intricacies between O'Keeffe and Hamilton and his inheritance, see especially Lisle, *Portrait of an Artist,* 408–35; Robinson, *Georgia O'Keeffe,* 523–60; Hogrefe, *O'Keeffe,* 229–322; and Patten and Cardona-Hine, *Miss O'Keeffe.*

Primary Sources

Beinecke Rare Book and Manuscript Library, Yale University, New Haven, Conn.

 Rebecca Salsbury James Papers, Yale Collection of American Literature (YCAL)

 Mabel Dodge Luhan Papers, C A Luhan, Yale Collection

 The Henry McBride Papers, Yale Collection of American Literature (YCAL)

 Georgia O'Keeffe Papers, YCAL MSS 31

 Alfred Stieglitz Papers, YCAL

 Jean Toomer Papers, James Weldon Johson Collection

Whitney Museum of American Art, New York, New York

 Edward Hopper Papers

 Josephine N. Hopper, *Edward Hopper: His Work,* manuscript, 3 vols.

 Whitney Studio, Whitney Studio Club, and Whitney Studio Galleries
 Exhibition List

Secondary Sources

Abbott, Philip. *Leftward Ho! V. F. Calverton and American Radicalism.* Westport, Conn.:
 Greenwood Press, 1993.

Abrams, Edward. "The Image Maker." *The New Republic* 200 (30 January 1989):
 41–45.

Adato, Perry Miller, producer and director. *Georgia O'Keeffe.* Educational Broadcast
 Company, 1977. Video.

"Address of Professor Ellsworth Huntington on the Happy Family." *Living* 1 (January
 1939): 15.

Aiken, Edward A. "'I Saw the Figure Five in Gold': Charles Demuth's Emblematic
 Portrait of William Carlos Williams." *Art Journal* 46 (fall 1987): 178–84.

Aisen, Maurice. "The Latest Evolution in Art and Picabia." *Camera Work,* special issue (June 1913): 14–21.

"All the Comforts of Home." *Motor* (December 1919): 58.

Allen, Sydney. "The 'Flat-Iron' Building—An Esthetical Dissertation." *Camera Work* 4 (October 1903): 36–40.

_____. "A Visit to Steichen's Studio." *Camera Work* 2 (April 1903): 25–28.

Allen, Robert C. *Horrible Prettiness: Burlesque and American Culture.* Chapel Hill: University of North Carolina Press, 1991.

Anderson, Eleanor, ed. *Sherwood Anderson's Memoirs.* New York: Harcourt, Brace & Co., 1942.

Anderson, Sherwood. *Many Marriages.* New York: Grosset and Dunlap, 1923.

_____. *Poor White.* New York: B. W. Huebsch, 1920. Reprint, New York: New Directions, 1993.

Anshen, Ruth Nanda, ed. *The Family: Its Function and Destiny.* New York: Harper and Brothers, 1949.

Arrowsmith, Alexandra, and Thomas West, eds. *Georgia O'Keeffe and Alfred Stieglitz: Two Lives.* New York: Callaway Editions, 1992.

Asbury, Edith Evans. "Georgia O'Keeffe Dead at 98: Shaper of Modern Art in U.S." *New York Times,* 7 March 1986, sec. A1 and A17, pp. 44–45.

Baber, Ray E. *Marriage and the Family.* New York: McGraw-Hill, 1939.

Baigell, Matthew. "American Art and National Identity: The 1920s." *Arts Magazine* 61 (February 1987): 48–55.

_____. *A Concise History of American Painting and Sculpture.* New York: Icon Editions, 1984.

_____. "The Silent Witness of Edward Hopper." *Arts Magazine* 49 (September 1974): 29–33.

Bailey, Beth L. *From Front Porch to Back Seat: Courtship in Twentieth-Century America.* Baltimore: Johns Hopkins University Press, 1988.

Baker, S. Josephine, M.D. "Marriage from the Side Lines." *Ladies' Home Journal* 43 (April 1926): 37, 176, 179.

Bal, Mieke, and Norman Bryson. "Semiotics and Art History." *The Art Bulletin* 73 (June 1991): 174–208.

Barr, Alfred. *Art of Our Time.* New York: The Museum of Modern Art, 1939.

_____. *Paintings by Nineteen Living Americans.* New York: Museum of Modern Art, 1930.

Barth, Miles, ed. *Intimate Visions: The Photographs of Dorothy Norman.* San Francisco: Chronicle Books, 1993.

Bath, Michael. *Speaking Pictures: English Emblem Books and Renaissance Culture.* London: Longman, 1994.

Beatty, Jerome. "Taking the Blinders off Love." *American Magazine* 124 (December 1937): 22–23, 181–85.

Benedek, Therese. "The Emotional Structure of the Family." In *The Family: Its Function and Destiny,* edited by Ruth Nanda Anshen, 202–25. New York: Harper and Brothers, 1949.

Benét, Stephen Vincent. *The Beginning of Wisdom.* New York: Henry Holt & Co., 1921.

Berger, Michael L. "Women Drivers!: The Emergence of Folklore and Stereotypic Opinions concerning Feminine Automotive Behavior." *Women's Studies International Forum* 9 (1986): 257–63.

Binkley, Robert C., and Frances William Binkley. *What Is Right with Marriage: An Outline of Domestic Theory*. New York: D. Appleton and Company, 1929.

Black, M. G. L. "A Business Woman on Companionate Marriage." *Outlook* 148 (22 February 1928): 286–87.

Blanchard, Phyllis, and Carlyn Manasses. *New Girls for Old*. New York: Macaulay, 1930.

Blanton, Smiley, and Woodbridge Riley. "Shell Shocks of Family Life." *The Forum* 82 (November 1929): 282–87.

Bohn, Willard. "The Abstract Vision of Marius De Zayas." *Art Bulletin* 62 (September 1980): 434–52.

Boursault, A. K. "Is Photography a Science?" *Camera Work* 7 (July 1907): 41–42.

Bowman, Henry A. *Marriage for Moderns*. New York: Whittlesey House, 1942.

Brace, Ernest. "Edward Hopper." *Magazine of Art* 30 (May 1937): 274–80.

Bragdon, Claude. "The Shelton Hotel, New York." *Architectural Record* 58 (July 1925): 1.

Brennan, Marcia. *Painting Gender, Constructing Theory: The Alfred Stieglitz Circle and American Formalist Aesthetics.* Cambridge, Mass.: MIT Press, 2001.

Bromley, Dorothy, and F. L. Britten. *Youth and Sex: A Study of Thirteen Hundred College Students*. New York: Harper and Brothers, 1938.

Broude, Norma, and Mary D. Garrard, eds. *The Power of Feminist Art: The American Movement of the 1970s, History and Impact*. New York: Harry N. Abrams, 1994.

Brown, Milton W. "Cubist-Realism: An American Style." *Marsyas* 3 (1946): 139–60.

_____. "The Early Realism of Hopper and Burchfield." *College Art Journal* 7 (autumn 1947): 3–11.

Buffet, Gabrielle. "Modern Art and the Public." *Camera Work,* special issue (June 1913): 10–14.

Burgess, Ernest W., and Harvey J. Locke. *The Family: From Institution to Companionship*. New York: American Book Company, 1945.

Burgess, J. Stewart. "The College and the Preparation for Marriage and Family Relationships." *Living* 1 (spring/summer 1939): 39.

Burnham, John C. "The Progressive Era Revolution in American Attitudes toward Sex." *Journal of American History* 59 (March 1973): 885–908.

Burrey, Suzanne. "Edward Hopper: The Emptying Spaces." *Art Digest* 29 (1 April 1955): 8–10, 54.

Caffin, Charles H. "Edward J. Steichen's Work—An Appreciation." *Camera Work* 2 (April 1903): 21–24.

_____. "Mrs. Käsebier's Work—An Appreciation." *Camera Work* 1 (January 1903): 17–19.

Calhoun, Dorothy Donnell. "In a Little Crooked House." *The Farmer's Wife* 21 (March 1919): 228–29, 252.

Calverton, Victor F. *The Bankruptcy of Marriage*. New York: Macaulay Company, 1928.

_____. *Sex Expression in Literature*. New York: Boni and Liveright, 1926.

Camera Work. Special issue (August 1912).

Camfield, William. *Francis Picabia: His Art, Life and Times*. Princeton, N.J.: Princeton University Press, 1979.

_____. "The Machinist Style of Francis Picabia." *Art Bulletin* 48 (September-December 1966): 309–22.

Campbell, Lawrence. "Hopper: Painter of 'Thou Shalt Not.'" *Art News* 63 (October 1964): 42–45, 58.

Cassidy, Donna M. *Painting the Musical City: Jazz and Cultural Identity in American Art, 1910–1940.* Washington, D.C.: Smithsonian Institution Press, 1997.

Chadwick, Wendy, and Isabelle de Courtivron, eds. *Significant Others: Creativity and Intimate Partnership.* New York: Thames and Hudson, 1993.

Chauncey, George. *Gay New York: Gender, Urban Culture, and the Making of the Gay Male World, 1890–1940.* New York: Basic Books, 1994.

Chave, Anna C. "O'Keeffe and the Masculine Gaze." *Art in America* 78 (January 1990): 115–24, 177–79.

_____. "'Who Will Paint New York?': 'The World's New Art Center' and the Sky-scraper Paintings of Georgia O'Keeffe. *American Art* 5 (Winter/Spring 1991): 87–107.

Cherry, Deborah D, and Griselda Pollock. "Woman as Sign in Pre-Raphaelite Literature: A Study of the Representation of Elizabeth Siddall." In Pollock, *Vision and Difference: Femininity. Feminism, and the Histories of Art.* London: Routledge, 1988.

Chicago, Judy, and Miriam Schapiro. "Female Imagery." *Womanspace Journal* 1 (summer 1973): 11, 13.

Clark, Kenneth. *The Nude: A Study of Ideal Art.* London: John Murray, 1956. Reprint, Harmondsworth: Penguin Books, 1970.

"Clash in a Cathedral." *Outlook* 156 (17 December 1930): 604.

Coco, Janice M. "Exploring the Frontier from the Inside Out: John Sloan's Nude Studies." *Journal of the American Psychoanalytic Association* 47 (1999): 1335–76.

_____. "Inscribing Boundaries in John Sloan's *Hairdresser's Window:* Privacy and the Politics of Vision." *Prospects* 24 (1999): 393–16.

_____. "Re-Viewing John Sloan's Images of Women." *Oxford Art Journal* 21 (1998): 79–97.

Collier, Virginia MacMakin. "Baby Plus Job—By Choice." *The Woman's Journal* 13 (March 1928): 14–16, 40.

_____. *Marriage and Careers: A Study of One Hundred Women Who Are Wives, Mothers, Homemakers, and Professional Workers for the Bureau of Vocational Information.* New York: Channel Bookshop, 1926.

Collins, Joseph. "The Doctor Looks at Companionate Marriage." *Outlook* 147 (21 December 1927): 492–94, 503.

Connor, Celeste. *Democratic Visions: Art and Theory of the Stieglitz Circle, 1924–1934.* Berkeley and Los Angeles: University of California Press, 2001.

Conway, Helen. "We Try Trial Marriage." *Forum* 84 (November 1930): 272–76.

Coon, Spender H. "The Work of William M. Chase as Artist and Teacher." *Metropolitan Magazine* (May 1897): 307–13.

Copeland, Carolyn Faunce. *Language and Time and Gertrude Stein.* Iowa City: University of Iowa Press, 1975.

Corbett, Harvey Wiley. "The American Radiator Building, New York City, Raymond M. Hood, Architect." *Architectural Record* 55 (May 1924): 473–77.

Corn, Wanda. "The Artist's New York: 1900–1930." In *Budapest and New York: Studies in Metropolitan Transformation: 1870–1930,* edited by Thomas Bender and Carl E. Schorske, 275–308. New York: Russell Sage Foundation, 1994.

_____. *The Great American Thing: Modern Art and National Identity, 1915–1935.* Berkeley and Los Angeles: University of California Press, 1999.

_____. *In the American Grain: The Billboard Poetics of Charles Demuth.* Poughkeepsie, N.Y.: Vassar College, 1991.

_____. "In Detail: Joseph Stella and *New York Interpreted.*" *Portfolio* (January/February 1982): 40–45.

_____. "The New New York." *Art in America* 61 (July–August 1973): 58–63.

Cott, Nancy F. *The Grounding of Modern Feminism*. New Haven, Conn.: Yale University Press, 1987.

Coughlan, Robert. "Changing Roles in Modern Marriage." *Life* (24 December 1956): 41, 108–18.

Cowley, Malcolm. *Exile's Return: A Literary Odyssey of the 1920's*. New York: Norton, 1934. Reprint, London: The Bodley Head, 1951.

Culler, Jonathan. *Framing the Sign: Criticism and Its Institutions*. Norman: University of Oklahoma Press, 1988.

Daly, Peter M., ed. *The English Emblem and the Continental Tradition*. New York: AMS Press, 1988.

Davidson, Abraham A. "Demuth's Poster Portraits." *Artforum* 17 (November 1978): 54–57.

_____. "The Poster Portraits of Charles Demuth." *Auction* 3 (September 1969): 28–31.

Davis, Douglas. "Art: Return of the Native." *Newsweek* 76 (12 October 1970): 105.

Davis, Katherine Bement. *Factors in the Sex Lives of Twenty-Two Hundred Women*. New York: Harper and Brothers, 1929.

Dealey, James Quayle. *The Family in Its Sociological Aspects*. Boston: Houghton Mifflin, 1912.

Degler, Charles N. "What Ought to Be and What Was: Women's Sexuality in the Nineteenth Century." *American Historical Review* 79 (December 1974): 1467–90.

D'Emilio, John, and Estelle B. Freedman. *Intimate Matters: A History of Sexuality in America*. New York: Harper & Row, 1988.

Dell, Floyd. *Janet March*. New York: Alfred A. Knopf, 1923.

_____. *Love in the Machine Age: A Psychological Study of the Transition from Patriarchal Society*. New York: Farrar and Rinehart, 1930.

_____. *Moon-Calf*. New York: Sagamore Press, 1920.

De Zayas, Marius. "From "291"—July–August Number, 1915." *Camera Work* 48 (October 1916): 69–70.

Dickinson, Robert L. *A Thousand Marriages: A Study of Sex Adjustment*. Baltimore: Williams and Wilkins, 1931.

Dijkstra, Bram. *Georgia O'Keeffe and the Eros of Place*. Princeton, N.J.: Princeton University Press, 1998.

_____. *Idols of Perversity: Fantasies of Feminine Evil in Fin-de-Siecle Culture*. New York: Oxford University Press, 1986.

"Dire Dangers Threatening Family Life." *Literary Digest* 94 (13 August 1927): 26–27.

Doane, Mary Ann. "Film and the Masquerade: Theorizing the Female Spectator." *Screen* 23 (September–October 1982): 74–87.

Dodge, Mabel. "Speculations." *Camera Work*, special issue (June 1913): 6–9.

"Dorothy Norman, 92, Dies; Photographer and Advocate." *New York Times*, Obituaries, 13 April 1997, p. 38.

Doss, Erika. "Edward Hopper, Nighthawks and Film Noir." *Post Script* 2 (winter 1983): 14–36.

Duggan, Lisa. "The Social Enforcement of Heterosexuality and Lesbian Resistance in the 1920s." In *Class, Race, and Sex: The Dynamics of Control*, edited by Amy Swerdlow and Hanna Lessinger, 75–92. Boston: G. K. Hall and Co., 1983.

Duvert, Elizabeth. "Georgia O'Keeffe's *Radiator Building*: Icon of Glamorous Gotham." *Places* 2 (1985): 3–17.

Eastman, Max. "Exploring the Soul and Healing the Body." *Everybody's Magazine* 32 (1915): 741–50.

"Editorial Comment." *American Architect* 126 (19 November 1924): 487.

"Editorial Comment." *Living* 1 (January 1939): 25–27.

"Editorial Comment." *The Nation* 132 (20 May 1931): 545.

Eisler, Benita. *O'Keeffe and Stieglitz: An American Romance*. New York: Penguin Books, 1991.

_____. "Scenes from a Marriage." *Mirabella* (July 1989): 178–86.

Eldredge, Charles C. *Georgia O'Keeffe: American and Modern*. New Haven, Conn.: Yale University Press, 1993.

_____. "Georgia O'Keeffe: The Development of an American Modern." Ph.D. diss., University of Minnesota, 1971.

"The Encyclical on Marriage: An Editorial." *Outlook* 157 (21 January 1931): 90.

Engel, Charlene S. "On the Art of Seeing Feelingly: Intaglio Prints by Edward Hopper." *The Print Collector's Newsletter* 20 (January-February 1990): 209–11.

Engel, William E. *Mapping Mortality: The Persistence of Memory and Melancholy in Early Modern England*. Amherst: University of Massachusetts Press, 1995.

Epstein, Barbara. "Family, Sexual Morality, and Popular Movements in Turn-of-the-Century America." In *Powers of Desire: The Politics of Sexuality,* edited by Ann Snitow, Christine Stansell, and Sharon Thompson, 117–30. New York: Monthly Review Press, 1983.

Erenberg, Lewis A. *Steppin' Out: New York Nightlife and the Transformation of American Culture, 1890–1930*. Westport, Conn.: Greenwood Press, 1981.

Everett, Patricia. "Andrew Dasburg's Abstract Portraits: Homages to Mabel Dodge and Carl Van Vechten." *Smithsonian Studies in American Art* 3 (winter 1989): 73–87.

Exhibition of Paintings by Members of the Whitney Studio Club. New York: Whitney Museum Studio Club, 1927.

Exner, M. J. *The Sexual Side of Marriage*. New York: W. W. Norton & Company, 1932.

Fass, Paula S. *The Damned and the Beautiful: American Youth in the 1920s*. New York: Oxford University Press, 1977.

"Fighting Breakdowns in Marriage." *Literary Digest* 121 (25 April 1936): 17–18.

Filene, Peter Gabriel. *Him/Her/Self: Sex Roles in Modern America*. New York: Harcourt Brace Jovanovich, 1975.

Fillin-Yeh, Susan. "Dandies, Marginality and Modernism: Georgia O'Keeffe, Marcel Duchamp and Other Cross-Dressers." *Oxford Art Journal* 18 (1995): 33–44.

Fischer, Lucy. "The Savage Eye: Edward Hopper and the Cinema." In *A Modern Mosaic: Art and Modernism in the United States,* edited by Townsend Ludington, 334–56. Chapel Hill: University of North Carolina Press, 2000.

Fishbein, Leslie. *Rebels in Bohemia: The Radicals of* The Masses *1911–1917*. Chapel Hill: University of North Carolina Press, 1982.

Fosdick, Harry Emerson. "What Is Happening to the American Family?" *American Magazine* 106 (October 1928): 20–21, 96–102.

Frank, Robin Jaffee. *Charles Demuth: Poster Portraits, 1923–1929*. New Haven, Conn.: Yale University Art Gallery, 1994.

Frank, Waldo, Lewis Mumford, Dorothy Norman, Paul Rosenfeld, and Harold Rugg, eds. *America and Alfred Stieglitz: A Collective Portrait*. New York: Doubleday, Doran and Company, 1934. Reprint, New York: Aperture, 1979.

Frederick, Christine McGaffey. "The Commuter's Wife and the Motor Car." *Suburban Life* 14 (July 1912): 13–14, 46.

Freud, Sigmund. "On Dreams." In *Freud Reader,* edited by Peter Gay, 143–71. New York: W. W. Norton & Company, 1989.

Friedman, Martin L. *The Precisionist View in American Art.* Minneapolis: Walker Art Center, 1960.

Fromm, Erich. "Sex and Character." In *The Family: Its Function and Destiny,* edited by Ruth Nanda Anshen, 375–92. New York: Harper and Brothers, 1949.

Fryd, Vivien Green. "Georgia O'Keeffe and Alfred Stieglitz: A Marriage in Crisis 1928–1933." In *Amor y Desamor en las Artes*, edited by Arnulfo Herrera, 67–81. Mexico City: Universidad Nacional Autónoma de México, 2001.

Fryer, Judith. "Women's *Camera Work:* Seven Propositions in Search of a Theory." *Prospects* 16 (1991): 57–113.

Fuget, Dallet. "Notes by the Way: The Man behind the Camera." *Camera Work* 2 (April 1903): 52.

Getlein, Frank. "The Legacy of Edward Hopper, Painter of Light and Loneliness." *Smithsonian Studies in American Art* 2 (September 1971): 60–67.

Giboire, Clive, ed. *Lovingly, Georgia: The Complete Correspondence of Georgia O'Keeffe and Anita Pollitzer.* New York: Touchstone, 1990.

Gilman, Charlotte Perkins. "The Dress of Women." In *The Forerunner* (New York: Charlton, 1915), 20–334.

Glueck, Grace. "Art Notes: 'It's Just What's in My Head.'" *New York Times,* 18 October 1970, sec. 2., p. 24.

"Gold for Gold." *Time* 65 (30 May 1955): 72.

Goodrich, Lloyd. *Edward Hopper.* New York: Whitney Museum of American Art, 1964.

———. *Edward Hopper: Retrospective Exhibition.* New York: Whitney Museum of American Art, 1950.

———. *Edward Hopper: Selections from the Hopper Bequest.* New York: Whitney Museum of American Art, 1971.

———. "The Paintings of Edward Hopper." *The Arts* 11 (March 1927): 135–38.

———. "Portrait of The Artist." *Woman's Day* (February 1965): 41, 92.

———. *Spring Exhibition 1930: Whitney Studio Galleries.* New York: Whitney Studio Galleries, 1930.

Goodrich, Lloyd, and John I. H. Baur. *American Art of Our Century.* New York: Frederick A. Praeger, 1961.

Goodsell, Willystine. *A History of Marriage and the Family.* New York: Macmillan, 1935.

Gordon, Michael. "From an Unfortunate Necessity to a Cult of Mutual Orgasm: Sex in American Marital Education Literature, 1830–1940." In *The Sociology of Sex,* edited by James M. Henslin and Edward Sagarin, 59–83. New York: Schocken Books, 1978.

Grafly, Dorothy. "Murals at the Museum of Modern Art." *The American Magazine of Art* 25 (August 1932): 93–101.

Greenough, Sarah. "Alfred Stieglitz's Photographs of Clouds." Ph.D. diss., University of New Mexico, 1984.

———. "From the American Earth: Alfred Stieglitz's Photographs of Apples." *Art Journal* 41 (spring 1981): 46–54.

———. *Paul Strand: An American Vision.* (New York: Aperture Foundation, 1990).

Greenough, Sarah, and Juan Hamilton, eds. *Alfred Stieglitz: Photographs and Writings.* Washington, D.C.: National Gallery of Art, 1983.

———. *Georgia O'Keeffe: Art and Letters.* Washington, D.C.: National Gallery of Art, 1987.

Groves, Ernest R. *The American Family*. Chicago: J. B. Lippincott, 1934.

_____. *Case Book of Marriage Problems*. New York: Henry Holt & Co., 1941.

_____. *Conserving Marriage and the Family: A Realistic Discussion of the Divorce Problem*. New York: Macmillan, 1945.

_____. *The Family and Its Relationships*. Chicago: J. B. Lippincott, 1934.

_____. "Marriage." *American Youth* 19 (January 1920): 24.

Groves, Ernest R., and Phyllis Blanchard. *Introduction to Mental Hygiene*. New York: Henry Holt & Co., 1920.

_____. *Readings in Mental Hygiene*. New York: Henry Holt & Co., 1936.

Groves, Ernest R., and Gladys Hoagland Groves. *Sex in Marriage*. New York: Emerson Books, 1943.

Grumbine, Harvey Carson. "Reaction of a Layman to Psychoanalysis." *Scribner's Magazine* 68 (November 1920): 602–6.

Gubar, Susan. "Blessings in Disguise: Cross-Dressing as Re-Dressing for Female Modernists." *Massachusetts Review* 22 (autumn 1981): 477–508.

Hale, Nathan G. *Freud and Americans: The Beginnings of Psychoanalysis in the United States, 1876–1917*. New York: Oxford University Press, 1971.

_____. *The Rise and Crisis of Psychoanalysis in the United States: Freud and the Americans, 1917–1985*. New York: Oxford University Press, 1995.

Hambourg, Maria Morris. *Paul Strand Circa 1916*. New York: The Metropolitan Museum of Art, 1998.

Hamilton, Gilbert Van Tassel. *A Research in Marriage*. New York: A. and C. Boni, 1929.

Hamilton, Gilbert Van Tassel, and Kenneth MacGowan. "Marriage and Love Affairs: The Report of a Scientific Research." *Harper's Magazine* 157 (August 1928): 277–87.

Hartmann, Sadakichi. "Puritanism, Its Grandeur and Shame." *Camera Work*, no. 32 (October 1910): 17–19.

Haskell, Barbara. *Charles Demuth*. New York: Whitney Museum of American Art and H. N. Abrams, 1987.

Haviland, Paul B. "Marius De Zayas—Material, Relative, and Absolute Caricatures." *Camera Work* 46 (April 1914): 33–34.

_____. *291* 7–8 (September–October 1915): n.p.

Hemingway, Andrew. "To 'Personalize the Rainpipe': The Critical Mythology of Edward Hopper." *Prospects* 17 (1992): 329–404.

Hersey, Harold Brainerd. *Pulpwood Editor: The Fabulous World of the Thriller Magazines Revealed by a Veteran Editor and Publisher*. New York: Frederick A. Stokes, 1937. Reprint, Westport, Conn.: Greenwood Press, 1965.

Hills, Patricia. "John Sloan's Images of Working-Class Women: A Case Study of the Roles and Interrelationships of Politics, Personality, and Patrons in the Development of Sloan's Art, 1905–16." *Prospects* 5 (1980): 157–96.

Hills, Patricia, and Roberta K. Tarbell. *The Figurative Tradition and the Whitney Museum of American Art*. New York: Whitney Museum of American Art in association with the University of Delaware Press, 1980.

Hinkle, Beatrice M. "The Chaos of Modern Marriage." *Harper's Magazine* 152 (December 1925): 1–13.

Hobbs, Robert. *Edward Hopper*. New York: Harry N. Abrams, 1987.

Hoffman, Katherine. *An Enduring Spirit: The Art of Georgia O'Keeffe*. Metuchen, N.J.: Scarecrow Press, 1984.

_____. *Georgia O'Keeffe: A Celebration of Music and Dance*. New York: George Braziller, 1997.

Hoffman, Michael. *Gertrude Stein.* Boston: Twayne Publishers, 1976.

Hogrefe, Jeffrey. *O'Keeffe: The Life of an American Legend.* New York: Bantam Books, 1992.

Höltgen, Karl Josef. *Aspects of the Emblem: Studies in the English Emblem Tradition and the European Context.* Kassel, Germany: Edition Reichenberger, 1986.

Homer, William Innes. *Alfred Stieglitz and the American Avant-Garde.* Boston: New York Graphic Society, 1977.

———. "Picabia's *Jeune fille américaine dans l'état de nudité* and Her Friends." *Art Bulletin* 57 (March 1975): 110–15.

Hood, Raymond M. "The American Radiator Company Building, New York." *American Architect* 126 (19 November 1924): 467–74.

Hopper, Edward. "John Sloan and the Philadelphians." *The Arts* 11 (April 1927): 169–78.

"How I Saved My Husband: A Temperance Document." *The American Magazine* 76 (August 1913): 67–69.

"How to be Marriageable." *Ladies' Home Journal* (March 1954): 46–47.

Hughes, Robert. *American Visions: The Epic History of Art in America.* New York: Alfred A. Knopf, 1997.

"Intellectual Provocateur." *Time* 33 (26 June 1939): 59–62.

"Is Companionate Marriage Moral—A Debate." *Forum* 80 (July 1928): 7–10.

"Is Freudism Destined to Live?" *Current Opinion* 69 (September 1920): 355–58.

Iser, Wolfgang. "Indeterminacy and the Reader's Response in Prose Fiction." In *Aspects of Narrative: Selected Papers from the English Institute,* edited by J. Hillis Miller, 1–45. New York: Columbia University Press, 1971.

Iverson, Margaret. "In the Blind Field: Hopper and the Uncanny." *Art History* 21 (September 1998): 409–29.

"I Would Not Divorce Him Now." *The Reader's Digest* 39 (September 1941): 18–20. Condensed from *Harper's Magazine.*

Jackson, David. *Unmasking Masculinity: A Critical Autobiography.* London: Unwin Hyman, 1990.

Jastrow, Joseph. "The Freudian Temper and Its Menace to the Lay Mind." *Forum* 66 (November 1921): 29–38.

Jeansonne, Glen. "The Automobile and American Morality." *Journal of American Culture* 8 (summer 1974): 125–31.

Johnson, William. "The Silent Witness." *Time* 68 (24 December 1956): 35–39.

Jung, Moses. "The Course in Modern Marriage at the State University of Iowa." *Living* 1 (spring/summer 1939): 43.

Kandinsky, Wassily. *On Concerning the Spiritual in Art.* 1912. Reprint, New York: Solomon R. Guggenheim Foundation, 1946.

Kasson, John. *Amusing the Million: Coney Island at the Turn-of- the-Century.* New York: Hill and Wang, 1978.

Kay, Ellen. *Love and Marriage.* New York: G. P. Putnam's Sons, 1911.

Kaye, Joseph. "The Last Legs of Burlesque." *Theatre Magazine* 51 (February 1930): 36–37.

Keiley, Joseph T. "Gertrude Käsebier." *Camera Work* 20 (October 1907): 27–31.

Kendall, Richard, and Griselda Pollock, eds. *Dealing with Degas: Representations of Women and the Politics of Vision.* New York: Universe, 1992.

Kerrish, William E. "Companionate Marriage." *The Commonweal* 13 (25 March 1931): 580.

Keyserling, Count Hermann, ed. *The Book of Marriage.* New York: Harcourt, Brace & Co., 1926.

Kihlstedt, Folke T. "The Automobile and the Transformation of the American House, 1910–1935." In *The Automobile and American Culture,* edited by David L. Lewis and Laurence Goldstein, 160–75. Ann Arbor: University of Michigan Press, 1983.

Kinsey, Alfred, Wardell B. Pomeroy, and Clyde E. Martin. *Sexual Behavior in the Human Male.* Philadelphia: W. B. Saunders, 1948.

Knapp, Bettin. *Gertrude Stein.* New York: Continuum Publishing Co., 1990.

Kotz, Mary Lynn. "Georgia O'Keeffe at 90." *Art News* 76 (December 1977): 37–45.

Krutch, Joseph Wood. "Burlesque." *The Nation* 134 (8 June 1932): 647.

Kuh, Katherine. *The Artist's Voice: Talks with Seventeen Artists.* New York: Harper & Row, 1960. Reprint, New York: Harper & Row, 1962.

Lane, Rose Wilder. "Woman's Place Is in the Home." *Ladies' Home Journal* 53 (October 1936): 18, 94, 96.

Lanes, Jerrold. "Current and Forthcoming Exhibitions." *Burlington Magazine* 107 (January 1965): 42–46.

Larsen, Charles. "Ben Lindsey: Symbol of Radicalism in the 1920's." In *Freedom and Reform: Essays in Honor of Henry Steele Commager,* edited by Harold M. Hyman and Leonard W. Levy, 255–75. New York: Harper & Row, 1967.

_____. *The Good Fight: The Life and Times of Ben B. Lindsey.* Chicago: Quadrangle Books, 1972.

Lasch, Christopher. *Haven in a Heartless World: The Family Besieged.* New York: Basic Books, 1977.

Levin, Gail. *Edward Hopper: The Art and The Artist.* New York: W. W. Norton & Company and Whitney Museum of American Art, 1980.

_____. *Edward Hopper: A Catalogue Raisonné.* 3 vols. New York: Whitney Museum of American Art and W. W. Norton & Company, 1995.

_____. *Edward Hopper: The Complete Prints.* New York: W. W. Norton & Company and Whitney Museum of American Art, 1979.

_____. "Edward Hopper: Francophile." *Arts Magazine* 53 (June 1979): 114–21.

_____. *Edward Hopper as Illustrator.* New York: W. W. Norton & Company and Whitney Museum of American Art, 1979.

_____. "Edward Hopper as Printmaker and Illustrator: Some Correspondences." *Print Collector's Newsletter* 10 (1979): 121–23.

_____. "Edward Hopper: The Influence of Theater and Film." *Arts Magazine* 55 (October 1980): 123–27.

_____. *Edward Hopper: An Intimate Biography.* New York: Alfred A. Knopf, 1995.

_____. "Edward Hopper's "Nighthawks." *Arts Magazine* 55 (May 1981): 154–61.

_____. "Edward Hopper's 'Office at Night.'" *Arts Magazine* 52 (January 1978): 134–37.

_____. "Edward Hopper's Process of Self-Analysis." *Art News* 79 (October 1980): 144–47.

_____. "Edward Hopper's Railroad Imagery." In *The Railroad in American Art: Representations of Technological Change,* edited by Susan Danly and Leo Marx, 165–82. Cambridge, Mass.: MIT Press, 1988.

_____. "Hidden Symbolism in Marsden Hartley's Military Pictures." *Arts Magazine* 54 (October 1979): 154–58.

_____. "Hopper's Etchings: Some of the Finest Examples of American Printmaking." *Art News* 78 (September 1979): 90–93.

_____. *Hopper's Places*. New York: Alfred A. Knopf, 1985.

_____. "Josephine Verstille Nivison Hopper." *Woman's Art Journal* 1 (Spring/Summer 1980): 28–32.

_____. "The Office Image in the Visual Arts." *Arts Magazine* 59 (summer 1984): 98–103.

_____. "Symbol and Reality in Edward's 'Room in New York.'" *Arts Magazine* 56 (January 1982): 148–53.

Levy, John, and Ruth Monroe. *The Happy Family*. New York: Alfred A. Knopf, 1938.

Lewis, David L. "Sex and the Automobile: From Rumble Seats to Rockin' Vans." In *The Automobile and American Culture*, edited by David L. Lewis and Laurence Goldstein, 123–33. Ann Arbor: University of Michigan Press, 1983.

Lindsey, Ben B., and Wainwright Evans. *The Companionate Marriage*. New York: Boni and Liveright, 1927.

_____. *The Revolt of Modern Youth*. New York: Boni and Liveright, 1925.

_____. "What Do You Think It Is?" *Outlook* 148 (25 April 1928): 656–58, 661.

Lisle, Laurie. *Portrait of an Artist: A Biography of Georgia O'Keeffe*. New York: Washington Square Press, 1980.

Long, John C. "Ask Mother—She Knows." *Motor* (September 1923): 92.

Looney, Ralph. "Georgia O'Keeffe." *The Atlantic Monthly* 215 (April 1965): 106–10.

Lowe, Sue Davidson. *Stieglitz: A Memoir/Biography*. New York: Farrar Straus Giroux, 1983.

_____. "O'Keeffe, Stieglitz, and the Stieglitz Family: An Intimate View." In *From the Faraway Nearby: Georgia O'Keeffe as Icon*, edited by Christopher Merrill and Ellen Bradbury. Reading, Mass.: Addison-Wesley Publishing Company, 1992.

Lucic, Karen. *Charles Sheeler and the Cult of the Machine*. Cambridge, Mass.: Harvard University Press, 1991.

Lunbeck, Elizabeth. *The Psychiatric Persuasion: Knowledge, Gender, and Power in Modern America*. Princeton, N.J.: Princeton University Press, 1994.

"The Luncheon Meeting during the First Annual Meeting in the National Conference on Family Relations, Held in New York City, September 17, 1938." *Living* 1 (January 1939): 13–14.

Lynd, Robert S., and Helen M. Lynd. *Middletown: A Study in Contemporary Culture*. New York: Harcourt, Brace & Co., 1929.

_____. *Middletown in Transition*. New York: Harcourt, Brace & Co., 1937.

Lynes, Barbara Buhler. *Georgia O'Keeffe: A Catalogue Raisonné*. 3 vols. New Haven, Conn.: Yale University Press in conjunction with The National Gallery of Art and The Georgia O'Keeffe Foundation, 1999.

_____. "Georgia O'Keeffe and Feminism: A Problem of Position." In *The Expanding Discourse: Feminism and Art History*, edited by Norma Broude and Mary D. Garrard, 437–49. New York: Icon Editions, 1992.

_____. *O'Keeffe, Stieglitz and the Critics, 1916–1929*. Ann Arbor, Mich.: UMI Research Press, 1989.

Lyons, Deborah. *Edward Hopper and the Figure*. New York: Whitney Museum of American Art, 1993.

Macmonnies, Frederick. "French Artists Spur On American Art," *New York Tribune*, 24 October 1915, sec. 4, p. 2.

"Making Marriage Fit the Times." *Literary Digest* 105 (17 May 1930): 24.

Malinowski, Bronislaw. "Parenthood—The Basis of Social Structure." In *The New Generation: The Intimate Problems of Modern Parents and Children*, edited by V. F. Calverton and Samuel D. Schmalhausen, 113–68. New York: McCaulay, 1930.

Marling, Karal Ann. "*Early Sunday Morning.*" *Smithsonian Studies in American Art* 2 (fall 1988): 23–54.

"Marriage and Love Affairs: The Report of a Scientific Research by G.V. Hamilton, M.D. and Kenneth MacGowan." *Harper's Magazine* 157 (August 1928): 277–87.

"Marriage Riddle Studied Intensely." *Literary Digest* 123 (13 March 1937): 30–32.

Mathews, Patricia. "The Politics of Feminist Art History." In *The Subjects of Art History: Historical Objects in Contemporary Perspectives,* edited by Mark A. Cheetham, Michael Ann Holly, and Keith Moxey, 94–114. London: Cambridge University Press, 1998.

Matthews, F. H. "The Americanization of Sigmund Freud: Adaptations of Psychoanalysis before 1917." *Journal of American Studies* 1 (1967): 39–62.

Matthias, Blanche C. "Georgia O'Keeffe and the Intimate Gallery." *The Chicago Evening Post Magazine of the Art World,* 2 March 1926, 14.

Maurois, André. "The Art of Marriage." *Ladies' Home Journal* 57 (April 1940): 11, 45–52.

May, Elaine Tyler. *Great Expectations: Marriage and Divorce in Post-Victorian America.* Chicago: University of Chicago Press, 1980.

_____. *Homeward Bound: American Families in the Cold War Era.* New York: Basic Books, 1988.

May, Lary. *Screening Out the Past: The Birth of Mass Culture and the Motion Picture Industry.* New York: Oxford University Press, 1980.

McBride, Henry. "News and Reviews." *New York Herald,* 4 February 1923, sec. 7, p. 7. Quoted in Barbara Buhler Lynes, *O'Keeffe, Stieglitz and the Critics, 1916–1929.* Ann Arbor, Mich.: UMI Research Press, 1989.

McConaughy, James L. "Now That You Are Engaged." *Good Housekeeping* 105 (October 1937): 28–29, 209–16.

McDonnell, Patricia. "El Dorado: Marsden Hartley in Imperial Berlin." In *Dictated by Life: Marsden Hartley's German Paintings and Robert Indiana's Hartley Elegies,* edited by Patricia McDonnell, 15–42. New York: Distributed Art Publishers for Frederick R. Weisman Art Museum, University of Minnesota, 1995.

McGovern, James R. "The American Woman's Pre-World War I Freedom in Manners and Morals." *Journal of American History* 55 (September 1968): 315–33.

Menninger, Karl. "Pseudonanalysis: Perils of Freudian Verbalisms." *Outlook and Independent* 155 (9 July 1930): 363–65, 397–98.

Merrill, Christopher, and Ellen Bradbury, eds. *From the Faraway Nearby: Georgia O'Keeffe as Icon.* Reading, Mass.: Addison-Wesley Publishing Company, 1992.

Messinger, Lise Mintz. "Georgia O'Keeffe." *Metropolitan Museum of Art Bulletin* (fall 1984): 1–64.

Meyerowitz, Joanne. "Women, Cheesecake, and Borderline Material: Responses to Girlie Pictures in the Mid-Twentieth-Century U.S." *Journal of Women's History* 8 (fall 1996): 9–35.

"The Modern Wife's Difficult Job." *Literary Digest* 106 (30 August 1930): 18–19.

Modlin, Charles E., ed. *Sherwood Anderson's Love Letters to Eleanor Copenhaver.* Athens: University of Georgia Press, 1989.

Mowrer, Ernest R. *The Family: Its Organization and Disorganization.* Chicago: University of Chicago Press, 1932.

_____. "The Family in the Machine Age." *Living* 1 (November 1939): 67–68, 86.

Mrozek, Donald. J. "The Habit of Victory: The American Military and the Cult of Manliness." In *Manliness and Morality: Middle-Class Masculinity in Britain*

and America 1800–1940, edited by J. A. Mangan and James Walvin, 220–41. Manchester: Manchester University Press, 1987.

Mudd, Emily Hartshorne, and Elizabeth Kirk Rose. "Development of Marriage Counsel of Philadelphia as a Community Service, 1932–1940." *Living* 2 (May 1940): 40–41.

Mulvey, Laura. *Visual and Other Pleasures.* Bloomington and Indianapolis: Indiana University Press, 1989.

Mumford, Lewis. "The City." In *Civilization in the United States, an Inquiry by Thirty Americans,* edited by Harold E. Stearns, 3–20. New York: Harcourt, Brace & Co., 1922.

_____. "The Intolerable City: Must It Keep on Growing?" *Harper's Magazine* 152 (February 1926): 283–93.

_____. "The Metropolitan Milieu." In *America and Alfred Stieglitz: A Collective Portrait,* edited by Waldo Frank, Lewis Mumford, Dorothy Norman, Paul Rosenfeld, and Harold Rugg. New York: Doubleday, Doran & Co., 1934. Reprint, New York: Aperture, 1979.

Murphy, Carroll D. "Buying More with Each Wage-Dollar." *System: The Magazine of Business* 23 (March 1913): 227–36.

_____. "Living Up to Your Employment System." *System: The Magazine of Business* 24 (July 1913): 18–25.

Nead, Lynda. *The Female Nude: Art, Obscenity and Sexuality.* London: Routledge, 1992.

Newhall, Nancy. *From Adams to Stieglitz: Pioneers of Modern Photography.* Millerton, N.Y.: Aperture, 1989.

Nochlin, Linda. "Edward Hopper and the Imagery of Alienation." *Art Journal* 41 (summer 1981): 136–49.

_____. *The Politics of Vision: Essays on Nineteenth-Century Art and Society.* New York: Harper & Row, 1989.

_____. *Women, Art and Power and Other Essays.* New York: Harper & Row, 1988.

Norman, Dorothy. *Alfred Stieglitz.* New York: Aperture, 1989.

_____. *Alfred Stieglitz: An American Seer.* New York: Random House, 1960. Reprint, New York: Aperture, 1990.

_____. *Encounters: A Memoir.* New York: Harcourt Brace Jovanovich, 1987.

Norris, Kathleen. "A Laywoman Looks at 'Companionate Marriage.'" *The Catholic World* 127 (June 1928): 257–63.

Novak, Barbara. "The Posthumous Revenge of Josephine Hopper." *Art in America* 84 (June 1996): 27–31.

O'Doherty, Brian. *American Masters: The Voice and the Myth.* New York: Random House, 1973.

_____. "The Hopper Bequest at the Whitney." *Art in America* 59 (September/October 1971): 68–72.

_____. "Portrait : Edward Hopper." *Art in America* 52 (October 1964): 68–88.

O'Keeffe, Georgia. *Georgia O'Keeffe.* New York: Penguin Books, 1976.

_____. *A Portrait by Alfred Stieglitz.* New York: Metropolitan Museum of Art, 1978.

_____. "Stieglitz: His Pictures Collected Him." *The New York Times Magazine,* 11 November 1949, 24–26, 28–30.

Ogburn, William Fielding. "Eleven Questions concerning American Marriages." *Social Forces* 6 (1927): 11.

_____. "The Family and Its Functions." In *Recent Social Trends in the United States.* Report of the President's Research Committee on Social Trends. New York: McGraw-Hill, 1933.

O'Neill, William L. *Divorce in the Progressive Era*. New Haven, Conn.: Yale University Press, 1967.

Parker, Tyler. "Edward Hopper: Alienation by Light." *Magazine of Art* 41 (December 1948): 290–95.

Patten, Christine Taylor, and Alvaro Cardona-Hine. *Miss O'Keeffe*. Albuquerque: University of New Mexico Press, 1992.

Peiss, Kathy. *Cheap Amusements: Working Women and Leisure in Turn-of-the Century New York*. Philadelphia: Temple University Press, 1986.

"The Peril in the Declining Marriage Rate." *Literary Digest* 97 (16 June 1928): 30.

Peters, Sarah Whitaker. *Becoming O'Keeffe: The Early Years*. New York: Abbeville Press, 1991.

Picabia, Francis. "How New York Looks To Me." *New York American,* 30 March 1913, magazine section, p. 11.

Pisano, Ronald G. *A Leading Spirit in American Art: William Merritt Chase 1849–1916*. Seattle: Henry Art Gallery, University of Washington, 1983.

Pointon, Marcia. "Reading the Body: Historiography and the Case of the Female Nude." In *Naked Authority: The Body in Western Painting 1830–1908*. New York: Cambridge University Press, 1990.

Pollitzer, Anita. *A Woman on Paper: Georgia O'Keeffe*. New York: Simon and Schuster, 1988.

Pollock, Griselda. "Agency and the Avant-Garde: Studies in Authorship and History by Way of Van Gogh." In *Avant-Gardes and Partisans Reviewed,* edited by Fred Orton and Griselda Pollock, 315–42. Manchester: Manchester University Press, 1996.

_____. "The Gaze and the Look: *Women with Binoculars*—A Question of Difference." In *Dealing with Degas: Representations of Women and the Politics of Vision,* edited by Richard Kendall and Griselda Pollock. New York: Universe, 1992.

_____. *Generations and Geographies in the Visual Arts: Feminist Readings*. London: Routledge, 1996.

_____. *Vision and Difference: Femininity, Feminism, and the Histories of Art*. London: Routledge, 1988.

Pollock, Griselda, and Rozsika Parker. *Old Mistresses: Women, Art and Ideology*. New York: Pantheon Books, 1981.

"Pope Pius XI on Marriage and Morals: Full Text of the Encyclical." *Current History* 33 (February 1931): 797–808.

Popenoe, Paul. *Conservation of the Family*. Baltimore: Williams and Wilkins, 1926.

_____. *Marriage Before and After*. New York: W. Funk, 1943.

_____. *Modern Marriage: A Handbook*. New York: Macmillan, 1940.

President's Research Committee on Social Trends. *Recent Social Trends in the United States*. New York: McGraw-Hill, 1933.

Pringle, Henry F. "What Do the Women of America Think about Marriage and Divorce?" *Ladies' Home Journal* 55 (February 1938): 14–15, 94–97.

_____. "What Do the Women of America Think about Birth Control?" *Ladies' Home Journal* 60 (March 1938): 14–20.

"The Protestant Church View of Sex, Love and Marriage." *Current History* 29 (February 1929): 807–21.

"The Protestant Church's Survey of Marriage Evils." *The Literary Digest* 100 (23 February 1929): 26–27.

Pruette, Lorine. *Women and Leisure: A Study of Social Waste*. New York: Dutton, 1924.

"Psychoanalysis Fails to Account for the Artist." *Literary Digest* 83 (4 October 1924): 32.

Radar, Benjamin G. "The Recapitulation Theory of Play: Motor Behaviour, Moral Reflexes and Manly Attitudes in Urban America, 1880–1920." In *Manliness and Morality: Middle-Class Masculinity in Britain and America 1800–1940,* edited by J. A. Mangan and James Walvin, 123–34. Manchester: Manchester University Press, 1987.

"The Radiator Building." *American Architect* 126 (19 November 1924): 484.

Ramsey, Louise. "Education for Marriage and Family Life in the High School as a Means of Strengthening National Defense." *Marriage and Family Living* 4 (summer 1942): 52–55.

Rapp, Rayna, and Ellen Ross. "The Twenties' Backlash: Compulsory Heterosexuality, the Consumer Family, and the Waning of Feminism." In *Class, Race, and Sex: The Dynamics of Control,* edited by Amy Swerdlow and Hanna Lessinger, 93–107. Boston: G. K. Hall and Co., 1983.

Rathbone, Belinda. "Portrait of a Marriage: Paul Strand's Photographs of Rebecca." *The J. Paul Getty Museum Journal* 17 (1989): 83–97.

Read, Helen Appleton. "The American Scene." *The Brooklyn Daily Eagle,* 20 February 1927, p. 6E.

———. "Art Annual Statistics Prove U.S.A. Greatest Art Market in World." *The Brooklyn Daily Eagle,* 7 March 1926, p. 7E.

———. "Edward Hopper." *Parnassus* 5 (November 1933): 8–9, 30.

———. "Racial Quality of Hopper Pictures at Modern Museum Agrees with Nationalistic Mood." *The Brooklyn Daily Eagle,* 5 November 1933, p. 12 B-C.

Reaves, Wendy Wick. *Celebrity Caricature in America.* New Haven, Conn.: Yale University Press for the National Portrait Gallery, 1998.

Richardson, E. P. "Three American Painters: Sheeler—Hopper—Burchfield." *Perspectives USA* 16 (summer 1956): 111–19.

Risedorph, Allan E., and Jeannie R. Risedorph. "Education for Marriage and the Family as Means of Strengthening National Security in the Community." *Marriage and Family Living* 4 (summer 1942): 56–58, 62.

Riviere, Joan. "Womanliness as a Masquerade." In *Psychoanalysis and Female Sexuality,* edited by Hendrik M. Ruitenbeek, 209–20. New Haven, Conn.: College and University Press, 1966. First published in *International Journal of Psychoanalysis* 9 (1929): 303–13.

Robinson, Paul. *The Modernization of Sex: Havelock Ellis, Alfred Kinsey, William Masters and Virginia Johnson.* New York: Harper & Row, 1976.

Robinson, Roxana. *Georgia O'Keeffe: A Life.* New York: Harper Perennial, 1989.

Robinson, William. *Sex Morality.* New York: Critic and Guide, 1919.

Rockwood, Lemo Dennis. "The Development of Education in Family Life in the United States." In *Readings in Mental Hygiene,* edited by Ernest R. Groves and Phyllis Blanchard, 253–67. New York: Henry Holt & Co., 1936.

Rodgers, Timothy Robert. "Alfred Stieglitz, Duncan Phillips, and the $6,000 Marin." *Oxford Art Journal* 15 (1992): 54–66.

Rose, Barbara. "Edward Hopper: 'Greatest American Realist of the Twentieth Century." *Vogue* 158 (1 September 1971): 284–85.

Rosenberg, Charles E. "Sexuality, Class and Role in Nineteenth-Century America." *American Quarterly* 25 (1973): 131–54.

Rosenblum, Naomi. *A History of Women Photographers.* New York: Abbeville Press, 1994.

Rosenfeld, Paul. *Port of New York: Essays on Fourteen American Moderns*. New York: Harcourt Brace and Company, 1924. Reprint, Urbana: University of Illinois Press, 1961.

Ross, Dorothy. "The Development of the Social Sciences." In *The Organization of Knowledge in Modern America, 1860–1920,* edited by Alexandra Oleson and John Voss, 107–38. Baltimore: Johns Hopkins University Press, 1979.

Rozaitis, William. "The Joke at the Heart of Things: Francis Picabia's Machine Drawings and the Little Magazine 291." *American Art* 8 (summer/fall 1994): 43–59.

Rubinow, I. M. "Marriage Rate Increasing Despite Divorces." *Current History* 29 (November 1928): 289–94.

Russell, Betrand. *Marriage and Morals*. New York: Sun Dial Press, 1938.

———. "My Own View of Marriage." *Outlook* 148 (7 March 1928): 376–77.

Russell, Daniel. *Emblematic Structures in Renaissance French Culture*. Toronto: University of Toronto Press, 1995.

Ryan, Mary P. "The Projection of a New Womanhood: The Movie Moderns in the 1920s." In *Our American Sisters: Women in American Life and Thought,* edited by Jean E. Friedman and William G. Shade, 500–18. Lexington, Mass.: D. C. Heath and Company, 1982.

Safran, Stephen B., and Monty L. Kary. "Edward Hopper: The Artistic Expression of the Unconscious Wish for Reunion with the Mother." *Arts in Psychotherapy* 13 (1986): 307–22.

Santayana, George. *Winds of Doctrine, and Platonism and the Spiritual Life*. 1913. Reprint, New York: Harper and Brothers, 1957.

Sapir, Edward. "What Is the Family Still Good For?" *American Mercury* 19 (1930): 145–51.

Sartain, Geraldine. "You and Your Car." *Independent Woman* 18 (May 1939): 134–36, 146.

Scharff, Virginia. *Taking the Wheel: Women and the Coming of the Motor Age*. New York: The Free Press, 1991.

Schleier, Merrill. *The Skyscraper in American Art, 1890–1931*. Ann Arbor, Mich.: UMI Research Press, 1986.

Schmied, Wieland. *Edward Hopper: Portraits of America*. Munich: Prestel, 1995.

"A School of Marriage." *Literary Digest* 102 (7 September 1929): 26.

Sears, Robert S. "Personality Development in the Family." In *Marriage and the Family,* edited by Robert F. Winch and Robert McGinnis, 215–40. New York: Henry Holt & Co., 1953.

Seckel, Al. *Bertrand Russell on Ethics, Sex and Marriage*. Buffalo: Prometheus Books, 1987.

Seidman, Steve. *Romantic Longings: Love in America, 1830–1980*. New York: Routledge, 1991.

Seligmann, Herbert. *Alfred Stieglitz Talking: Notes on Some of His Conversations, 1925–1931*. New Haven, Conn.: Yale University Press, 1966.

"Sex O'Clock in America." *Current Opinion* 55 (July 1913): 113–14.

Sharpe, William. "New York, Night, and Cultural Mythmaking: The Nocturne in Photography, 1900–1925." *Smithsonian Studies in American Art* 2 (fall 1988): 2–21.

Sieberling, Dorothy. "The Female View of Erotica." *New York Magazine* 7 (11 February 1974): 54.

"Sigmund Freud." *Catholic World* 118 (March 1924): 787–96.

Silberman, Robert. "Edward Hopper: Becoming Himself." *Arts in America* 68 (January 1980): 45–47.

"The Silent Witness." *Time* 68 (24 December 1956): 28–39.

Simmons, Christina Clare. "'Marriage in the Modern Manner': Sexual Radicalism and Reform in America, 1914–1941." Ph.D. diss., Brown University, 1982.

Skolnick, Arlene. *Embattled Paradise: The American Family in an Age of Uncertainty.* New York: Basic Books, 1991.

Smith, Jacob Getlar. "Edward Hopper." *American Artist* 20 (January 1956): 23–27.

Smith-Rosenberg, Carroll. "The New Woman as Androgyne: Social Disorder and Gender Crisis, 1870–1936." In *Disorderly Conduct: Visions of Gender in Victorian America,* edited by Carroll Smith-Rosenberg, 245–96. New York: Alfred A. Knopf, 1985.

Sochen, June. *The New Woman in Greenwich Village 1910–1920.* New York: Quadrangle, 1972.

Spencer, Anna Garlin. *The Family and Its Members.* Philadelphia: J. B. Lippincott, 1923.

———. "What Makes a Home? The Problem as Youth Faces It." *Ladies' Home Journal* 46 (October 1929): 107, 131.

Stavitsky, Gail, ed. *Precisionism in America 1915–1941: Reordering Reality.* New York: Harry N. Abrams and Montclair Art Museum, 1995.

Stein, Gertrude. "Portrait of Mabel Dodge at the Villa Curonia." *Camera Work,* special issue (June 1913): 3–5.

Stein, Roger. "Charles Willson Peale's Expressive Design: *The Artist in His Museum.*" *Prospects* 6 (1981): 139–85.

Stein, Susan Alyson. "Edward Hopper: The Uncrossed Threshold." *Arts Magazine* 54 (March 1980): 156–60.

Steiner, Wendy. *Exact Resemblance to Exact Resemblance: The Literary Portraiture of Gertrude Stein.* New Haven, Conn.: Yale University Press, 1978.

Sterling, Philip. "Burlesque." *New Theatre* (June 1936): 18–19, 36.

Stieglitz, Alfred. "Modern Pictorial Photography in the United States." *Century Magazine* 64 (October 1902): 824–25.

———. "O'Keefe [sic] and the Lilies." *Art News* 26 (21 April 1928): 10.

Stone, Hannah, and Abraham Stone. *A Marriage Manual: A Practical Guide-Book to Sex and Marriage.* New York: Simon and Schuster, 1939.

Stott, Annette. "Floral Femininity: A Pictorial Definition." *American Art* 6 (spring 1992): 61–77.

Strand, Paul. "Photography and the New God." *Broom* (3 November 1922): 252–58.

———. "Stieglitz, An Appraisal." *Popular Photography* (July 1947): 62–98.

Sussman, Warren I. *Culture as History: The Transformation of American Society in the Twentieth Century.* New York: Pantheon, 1973.

Szarkowski, John. *Alfred Stieglitz at Lake George.* New York: The Museum of Modern Art, 1996.

Tashjian, Dickron. *Skyscraper Primitives: Dada and the American Avant-Garde, 1910–1925.* Middletown, Conn.: Wesleyan University Press, 1975.

"Ten Reasons for Marriage." *Ladies' Home Journal* 52 (June 1935): 58.

Terman, Lewis. *Psychological Factors in Marital Happiness.* New York: McGraw-Hill, 1938.

Thompson, Jan. "Picabia and His Influence on American Art: 1913–1917." *Art Journal* 34 (fall 1979): 14–21.

Thraser, Frederick. *The Gang.* Chicago: University of Chicago Press, 1923.

Tickner, Lisa. "Feminism, Art History, and Sexual Difference." *Genders* 3 (fall 1988): 92–128.

Tillim, Sydney. "Edward Hopper and the Provincial Principle." *Arts Magazine* 39 (November 1964): 24–31.

Todd, Ellen Wiley. *The "New Woman" Revised: Painting and Gender Politics on Fourteenth Street*. Berkeley and Los Angeles: University of California Press, 1993.

_____. "Will (S)he Stoop to Conquer? Preliminaries toward a Reading of Edward Hopper's *Office at Night*." In *Visual Theory: Painting and Interpretation,* edited by Norman Bryson, Michael Ann Holly, and Keith Moxey, 47–53. New York: HarperCollins, 1991.

Tompkins, Calvin. "The Rose in the Eye Looked Pretty Fine." *The New Yorker* 50 (4 March 1974): 40–51.

Trachtenberg, Alan. *Reading American Photographs: Images as History, Mathew Brady to Walker Evans*. New York: Hill and Wang, 1989.

"Traveling Man." *Time* 51 (19 January 1948): 59–60.

Trimberger, Ellen Kay. "Feminism, Men, and Modern Love." In *Powers of Desire: The Politics of Sexuality,* edited by Ann Snitow, Christine Stansell, and Sharon Thompson, 132–52. New York: Monthly Review Press, 1983.

Tsujimoto, Karen. *Images of America: Precisionist Painting and Modern Photography*. Seattle: University of Washington Press, 1982.

Turner, Elizabeth Hutton. *Georgia O'Keeffe: The Poetry of Things*. New Haven, Conn.: Yale University Press with Phillips Collection, Washington, D.C., and Dallas Museum of Art, 1999.

Udall, Sharyn R. "Beholding the Epiphanies: Mysticism and the Art of Georgia O'Keeffe." In *From the Faraway Nearby: Georgia O'Keeffe as Icon,* edited by Christopher Merrill and Ellen Bradbury. Reading, Mass.: Addison-Wesley Publishing Co., 1992.

_____. *Carr, O'Keeffe, Kahlo: Places of Their Own*. New Haven, Conn.: Yale University Press, 2000.

Updike, John. "Hopper's Polluted Silence." *The New York Review of Books* (10 August 1995): 19–21.

Van de Velde, Theodore H. *Ideal Marriage: Its Physiology and Technique*. Translated by Stella Browne. London: W. Heinemann, 1926. Reprint, New York: Random House, 1930.

Villard, Oswald Garrison. "Sex, Art, Truth, and Magazines." *Atlantic Monthly* 137 (March 1926): 388–89.

Wagner, Anne Middleton. *Three Artists (Three Women): Modernism and the Art of Hesse, Krasner, and O'Keeffe*. Berkeley and Los Angeles: University of California Press, 1996.

Waller, Willard. "The Rating and Dating Complex." *American Sociological Review* 2 (1937): 727–34.

Walters, Ronald G. *Primers for Prudery: Sexual Advice to Victorian America*. Englewood Cliffs, N.J.: Prentice-Hall, 1974.

Watson, Steven. *Group Portrait: The First American Avant-Garde*. Washington, D.C.: National Portrait Gallery, 1991.

"The Week." *The New Republic: A Journal of Opinion* 65 (21 January 1931): 255–56.

Weeks, Jeffrey. *Sex, Politics and Society: The Regulation of Sexuality since 1800*. London: Longman, 1989.

Weinberg, Jonathan. *Speaking for Vice: Homosexuality in the Art of Charles Demuth, Marsden Hartley, and the First American Avant-Garde*. New Haven, Conn.: Yale University Press, 1993.

_____. *Ambition and Love in Modern American Art.* New Haven, Conn.: Yale University Press, 2001.

Weisman, Celia. "O'Keeffe's Art: Sacred Symbols and Spiritual Quest." *Woman's Art Journal* 3 (fall 1982/winter 1983): 10–14.

Wembridge, Eleanor Rowland. "Petting and the Campus." *Survey* 54 (1 July 1925): 395.

Westermarck, Edward. *Three Essays on Sex and Marriage.* London: Macmillan, 1934.

Whelan, Richard. *Alfred Stieglitz: A Biography.* New York: Little, Brown, 1995.

White, Kevin. *The First Sexual Revolution: The Emergence of Male Heterosexuality in Modern America.* New York: New York University Press, 1993.

White, Ray Lewis, ed. *Sherwood Anderson's Secret Love Letters.* Baton Rouge: Louisiana State University Press, 1991.

Whyte, William, Jr. "The Wife Problem." *Life* (7 January 1952): 32–43.

Wilcox, Leonard. *V. F. Calverton: Radical in the American Grain.* Philadelphia: Temple University Press, 1992.

Wilson, Elizabeth. *The Sphinx in the City: Urban Life, the Control of Disorder, and Women.* Berkeley and Los Angeles: University of California Press, 1991.

Winsten, Archer. "Wake of the News. Washington Square North Boasts Strangers Worth Talking To." *New York Post,* 26 November 1935, p. 15.

Wolfe, W. Béran. "The Twilight of Psychoanalysis." *American Mercury* 35 (August 1935): 385–94.

Wood, Charles W. "What Is Happening to Marriage?" *The Nation* 128 (20 March 1929): 341–44.

"Working Wives and Others' Bread: Married Women in Jobs Stir Sociological Controversy." *Literary Digest* 123 (15 May 1937): 25–26.

Wright, Elizabeth, ed. *Feminism and Psychoanalysis: A Critical Dictionary.* Cambridge, Mass.: Basil Blackwell, 1992.

Yellis, Kenneth A. "Prosperity's Child: Some Thoughts on the Flapper." *American Quarterly* 21 (1969): 44–64.

Zurier, Rebecca, Robert W. Snyder, and Virginia M. Mecklenburg. *Metropolitan Lives: The Ashcan Artists and Their New York.* Washington, D.C.: National Museum of American Art, 1995.

automobiles (*continued*)
144, 187–88, 200, 244n. 27; sexuality impacted by, 69–72, 222n. 57; Stieglitz on, 188
avant-garde movement, 2, 133

Baber, Ray E., 35, 63–64, 66, 68
Baigell, Matthew: on Hopper, 60, 96–97, 205n. 2; on Hopper and O'Keeffe, 2–3
Bal, Mieke, 10
Barnes, Djuna, 178
Barr, Alfred, 3, 207n. 17
Barthes, Roland, 10
Bath, Michael, 154
Baur, John I. H., 5
Beatty, Jerome, 222n. 57
Beinecke Rare Book and Manuscript Library (Yale University), 11–12
Bement, Arthur, 162
Benedek, Therese, 233n. 69
Benét, Stephen Vincent, 6, 24
Benton, Thomas Hart: Hopper on, 205–6n. 4; works: *Burlesque,* 107
Bergson, Henri, 231n. 46
biography, culture and formalism linked to, 10–11
Blake, Doris, 102–3
Blonde Venus (film), 26
Bluemner, Oscar, 231n. 35
Bowman, Henry A., 69
Brace, Ernest, 53–54, 219n. 3
Bragdon, Claude, 165
Brennan, Marcia, 126
Bride's School, 17
Brigman, Annie, *Soul of Blasted Pine, 131,* 131–32
Brill, Abraham A., 133
Britten, F. L., 102
Bromley, Dorothy, 102
Brooklyn Museum, 5, 47, 207n. 17
Brooks, Van Wyck, 135
Broun, Heywood, 48
Bryson, Norman, 10
Bureau of Social Hygiene, 16, 101, 226n. 38
Burgess, Ernest W.: on apartment living, 64; on automobiles, 67, 69, 71, 73, 75; on extramarital affairs, 40; on marriage, 25, 47; on urbanization, 19; on working women, 20
Burlesque Artists Association, 88
burlesque theater: legislation against, 88–89; masturbation and, 228n. 63; narrative implicit in, 113; power relations and, 106–10; structure of performances in, 90; suggested

decline of, 223–24n. 2. *See also Girlie Show* (Hopper)

Cades, Hazel Rawson, 101
Calverton, Victor F.: on automobiles, 69; on Freudian discourse, 132; on industrialization, 19; on marriage and family, 16, 23–24; on sexual revolution, 102, 212n. 56, 226n. 32
Camera Notes (magazine), 166, 239n. 34
Camera Work (magazine): cityscapes and, 166–67; De Zayas's abstract portraits in, 156–57; funds absent for, 158; Kandinsky's writing in, 162; on sexual attitudes, 135; Stein's abstract word portraits in, 155–56; technological refinements evident in, 239n. 34
capitalism, 6, 18. *See also* commercial art sector
Carr, Martha, 102–3
Chase, William Merritt, 3
Chauncey, George, 103
Chave, Anna C., 127–28
Cherry, Deborah, 148
Chicago, Judy, 127
Child Study Association, 17
Christian symbols, as influence on O'Keeffe, 184–86, 243n. 19, 243n. 18
Clark, T. J., 6
Collier, Virginia MacMakin, 214n. 87, 214n. 90
commercial art sector: Hopper's work in, 3, 63, 99–100, *100,* 206n. 7; O'Keeffe's work in, 3; Stieglitz and, 164, 165, 169, 177, 190, 240n. 43
Comstock Law, 21
Connor, Celeste, 240n. 43, 241n. 66
Content, Marjorie, 41
contraception: advocates of, 21, 38, 101; as cause of marriage and family in crisis, 19, 21–22; as norm, 104; O'Keeffe-Stieglitz marriage and, 35–36
Coolidge, Calvin, 159
Copenhaver, Eleanor Gladys, 28
Corn, Wanda, 128, 165, 179, 202
Cowley, Malcolm, 24, 59
creativity: gender and, 132, 231n. 46; hands as symbol of, 143, 235n. 98; male artist as symbol of, 93–94
cultural context: formalism and biography linked to, 10–11; Hopper and O'Keeffe in, 6–8; marriage and family crisis in, 15–19; Stieglitz's photographs of O'Keeffe in, 8–9

estranged couple in context of, 81–86; Hopper's representations of, 62–67, 70–71, 73, 78–86; hotel linked to, 76; modernity's isolation and, 53, 59–61; road as contrast to, 73–75; single-family vs. multidwelling apartments, 61–67

homes: Hoppers' building of, 83; O'Keeffe's purchase of, 35; O'Keeffe-Stieglitz's in Shelton Hotel, 128, 130, 191. *See also* apartment houses

Hood, Raymond M., 154

Hoover, Herbert, 16, 21, 209n. 11

Hoover, J. Edgar, 75–76

Hopper, Edward: **artistic elements:** automobiles and road, 67, 71–75, 222n. 69; estranged couples, 78–86, 223n. 85, 223nn. 80–81; horizontality, 54; hotels, 75–78; isolation, 53–61, 99–100, 193, 196–97, 219n. 3, 220n. 12, 223n. 82; light, 193–95; models, 87–101, 113–14; O'Keeffe's compared to, 2–4; perspective, 63; railroads, 220n. 11; single-family homes vs. multidwelling apartments, 61–67, 76–77, 85–86; stilled-action techniques, 111–14, 228n. 70; **career:** American Scene and, 205–6n. 4; beginnings, 3, 206n. 7; commercial illustrations, 63, 99–100, *100,* 206n. 7; commissions, 63, 220n. 26; consistency, 193–94; cultural context, 6–8; legacy, 201–2, 204; O'Keeffe's compared to, 4–6; post-WWII, 9–10, 200; **exhibitions:** Armory Show (1913), 4, 207n. 15; Arts Club of Chicago, 207–8n. 25; Brooklyn Museum, 5, 207n. 17; MacDowell Club (1912), 207n. 14; Museum of Modern Art (1929-30), 207n. 17; National Academy (1908), 207n. 14; posthumous, 202; Whitney Studio Club and Gallery, 4, 60, 207n. 18; **life:** automobiles, 74–75, 200; death, 1, 200, 202; illness, 46, 199; love of theater, 197–99; marital attitudes, 44–46; personal characteristics and preferences, 43–44. *See also* marriage, Hoppers'; **works:** *Apartment Houses, Harlem River,* 59, *59; Cape Cod Evening,* 78, *79,* 81; *Cape Cod Sunset,* 65, *65; Cars and Rocks,* 71–72, *72; Chop Suey,* 196; *Compartment C, Car 293,* 55–56, *56; Les Deux Pigeons,* 81, *82; Early Sunday Morning, pl. 1,* 53, 61, 219–20n. 8; *Eleven A.M., pl. 6,*

96–97, 111–12, 114; *Evening Wind,* 2, 95, *95,* 96, 114; *Excursion into Philosophy,* 197, *197; Gas,* 55, 56–57, *57,* 71, 195; *High Noon,* 109–10, *110; High Road,* 73, *73; Hotel by a Railroad, 196,* 196–97; *Hotel Lobby,* 76, *76,* 78; *Hotel Room, pl. 4,* 76–77, 109–10, 111; *House by Squam River, Gloucester,* 73, *73; House by the Railroad, pl. 2,* 55, 61, 62; *House in Provincetown,* 73; *Intermission, 97,* 97–98; *Jo Hopper, 92,* 92–93; *Jo in Wyoming, 74,* 74–75, 200; *MacArthur's Home "Pretty Penny," pl. 3,* 62–63; *Manhattan Bridge Loop,* 54, *54,* 59; *Mansard Roof,* 47; *Meal Time,* 44, *45,* 46; *Moonlight Interior,* 95; *Morning in a City, 96,* 96–97, 114; *New York Movie, 112,* 112–13; *Nighthawks,* 78, *80,* 81; *Non-Anger Man and Pro-Anger Woman,* 44–45, *45; Nude Crawling into Bed,* 95, *95; October on Cape Cod, 70,* 70–71; *Painter and Model,* 93–94, *94; Pennsylvania Coal Town,* 55, *55; Prospect Street, Gloucester,* 71, *72; Railroad Crossing,* 62, *62; Reclining Nude, 92,* 93; *Room in New York,* 78, *79; Rooms for Tourists,* 76, 77; *The Sacrament of Sex (Female Version),* 44, *45,* 46, 105; *Sea Watchers,* 98; *Second Story Sunlight,* 194–96, *195; Solitude #56, 60,* 61, 73; *Standing Female Nude with Painter in Background, 94, 94; Standing Nude, 93, 93; Status Quo,* 44, *45,* 46; *Summer Evening,* 70–71, 81–82, 109–10; *Summer Interior,* 93, *93,* 96, 97, 114; *Summer in the City,* 78, *80,* 81; *Summertime,* 109–10, *110; Summer Twilight,* 81, *82; Sun in an Empty Room, 193,* 193–94; *Sun on Prospect Street (Gloucester, Massachusetts), 62,* 62–63, 71; *Two Comedians,* 9–10, 197–99, *198,* 200; *A Woman in the Sun,* 193–94, *194. See also Girlie Show* (Hopper); *Office at Night* (Hopper)

Hopper, Josephine Nivison: **career:** artistic, 5, 47–48, 83, 109, 131, 199; comments on Hopper's work, 76–77, 82, 195; as Hopper's business manager, 5, 6, 207–8n. 25; Hopper's legacy controlled by, 201–2, 204; **life:** death, 200; diary, 46, 199, 204; femininity, 150; hunger strikes, 48, 219n. 103; love of theater, 197–99; personal characteristics

Hopper, Josephine Nivison (*continued*)
and preferences, 43, 44, 83; sexuality, 105. *See also* marriage, Hoppers';
model work: dynamics of, 97–98, 114, 117, 200–202, 204; for *Girlie Show,* 8, 91–93, 98, 106–10; for *Intermission,* 97; for *Jo Hopper, 92,* 92–93; for *Jo in Wyoming,* 74–75; for *Office at Night,* 98–99, 105, 108–10; for *Reclining Nude, 92,* 93; for *Second Story Sunlight,* 195–96; for *Two Comedians,* 197–99; for *A Woman in the Sun,* 194; **works:** *Campground for the Battle of Washington Square,* 83, *84; Cape Cod Bedroom,* 83, *85*
hotels, anxieties about, 8, 75–78
Howells, William Dean, 107–8
humor, in abstract portraits, 163–64

Ibsen, Henrik, 203
industrialization: as negative force, 19–20, 62–63, 81; New Woman ideal and, 6–7. *See also* mechanization
Institute of Arts and Letters, 4–5
Institute of Family Relations, 26
International Council of Religious Education, 18
Intimate Gallery, 38, 164
Iser, Wolfgang, 112–13
isolation/alienation as theme: automobile as symbol of, 71, 74–75; estranged couples as symbol of, 78–86; homes as symbol of, 62–63, 77; Hopper's use of, 53–61, 99–100, 193, 196–97, 219n. 3, 220n. 12, 223n. 82; hotels as symbol of, 77–78; mechanization as cause of, 55
Iverson, Margaret, 60–61

Jewell, Edward Alden, 125
John Hayes Holmes Community Church (New York City), 212n. 56
Johnson, William, 200

Kalonyme, Louis, 172
Kandinsky, Wassily, 3, 4, 162, 203, 239n. 28
Kary, Monty, 61
Kennerley, Mitchell, 6, 239n. 41
Key, Ellen, 102, 149
Keyserling, Herman, 31, 33, 48
Kinsey, Alfred, 102, 104
Krutch, Joseph Wood, 88
Kuh, Katherine, 205–6n. 4, 223n. 82

Ladies' Home Journal (magazine): on companionship marriage, 24, 27; on contraception, 22; illustrations of,

66; on marriage and family crisis, 15; on single-family homes vs. apartments, 66
La Guardia, Fiorello H., 88
Lanes, Jerrold, 225n. 22
Lasch, Christopher, 18
Lawrence, D. H., 6, 133, 135
lesbianism: androgyny as reflection of, 150–51, 236n. 119; attitudes toward, 178; implications of condemning, 227n. 55
Levin, Gail: on estranged couples, 223n. 85, 223nn. 80–81; exhibitions and, 202; on Hoppers' fighting, 46; on Hopper's interests, 220n. 11, 228n. 70; on Hopper's themes, 111, 223n. 85, 223nn. 80–81, 245n. 50; on isolation, 78; on Jo Hopper, 5, 47, 199; on *Office at Night* (Hopper), 225n. 21; on *Two Comedians* (Hopper), 197–98
Levy, John, 23
Lewis, Sinclair, 54–55
Life magazine, 193
Lindsey, Ben B.: on companionate marriage, 22–24, 42; on procreative marriage, 213n. 67; in public debate, 102, 149, 212n. 56
Lisle, Laura, 37, 203, 244n. 33
Literary Digest (magazine), 15, 27, 132
literature: abstract portraits in, 154–56, 159–60; on automobiles, 69; on companionship marriage, 24, 27–29, 81, 83, 85; on Freudian discourse, 132; on New Woman, 6; serialization of, 112–13; on sexual revolution, 102–3; on single-family homes vs. apartments, 65–66; women's bodies in popular, 106
Locke, Harvey J.: on apartment living, 64; on automobiles, 67, 69, 71, 73, 75; on extramarital affairs, 40; on marriage, 25, 47; on working women, 20
Long, John C., 68
Lopez, Judy, 245–46n. 61
love: nude photographs as public act of, 135–49; O'Keeffe and Stieglitz on, 42. *See also* marriage, companionship
Lowe, Sue Davidson, 133
Luhan, Mabel Dodge: Freudian discourse of, 133; marriage of, 40; O'Keeffe's relationship with, 183, 236n. 119; salon of, 4; Stein's abstract word portrait of, 155–56
Luhan, Tony, 40, 187

Lynd, Helen M. and Robert S. (Middletown study): on automobiles, 68–69, 71, 188; on homes, 64; on marriage and divorce, 21, 24; on working women, 26

Lynes, Barbara Buhler: on Mumford's review, 230n. 18; on O'Keeffe's art, 162, 235n. 101, 239n. 41; on O'Keeffe's illness, 244n. 23; on vocabulary for O'Keeffe's art, 117, 125–26, 230n. 21, 236n. 113

MacArthur, Charles, *pl. 3,* 62–63
MacDowell Club, 207n. 14
MacGibbon, Elizabeth, 101
MacGowan, Kenneth, 16, 39
Macmahon, Arthur, 35, 118, 124, 134
male artist in his studio: audience as surrogate for, 106, 107–9; as symbol of creativity, 93–94
male body, manipulation of, 174–79
male/female binary: anxieties about sexuality in, 103–5; *Manhattan* (O'Keeffe) in context of, 189–90; power relations in, 105–10; in Stieglitz's discourse, 126; tensions in, 94. *See also* eroticism; female sexuality
Mannes, Marya, 230n. 20
Manning, William T., 23
Marin, John, 164
marriage: **about:** changing concept of, 1–2, 6–7; companionate type of, 22–24, 42, 102; factors in successful, 47; institutional type of, 33; norms in 1920s, 24, 25; post-WWII changes in, 192–93; preparation for, 17–19; procreative type of, 213n. 67; studies of, 16–17, 102–3. *See also* marriage and family in crisis; **companionship:** absence of, 78; anxieties over, 27–29, 46; Hoppers' marriage and ideal of, 48, 74, 81, 86; ideology of, 2, 7, 24–25, 36–37, 63, 66, 169, 199–201; O'Keeffe-Stieglitz's marriage and ideal of, 41–43; sexuality encouraged in, 101–5; **Hoppers':** automobile and road in context of, 74–75, 200; beginnings of, 43, 47–48; combativeness in, 46–47, 75, 83; conflict in, 7, 8; controlling perceptions of, 43–44, 200–202, 204; estranged couples in context of, 83–86; home as symbol in context of, 63; Hopper's attitudes toward, 44–46; isolation/loneliness theme in

context of, 61; O'Keeffe-Stieglitz's marriage compared to, 48–49; overt painted references to, 197–99; period of, 1–2, 5; in post-WWII years, 192–200; power dynamics in, 87, 105–10; resolution in, 9–10, 199; sexuality in, 105, 114; as success/failure, 12, 48, 86; **O'Keeffe-Stieglitz:** beginnings of, 33–34, 118, 125–26, 134–35, 136; as companionship type, 36–37; controlling perceptions of, 8–9, 201–4; finances of, 37; Hoppers' marriage compared to, 48–49; O'Keeffe's conflictive feelings about, 177–79; O'Keeffe's independence and, 183–92; period of, 1–2, 5; power dynamics in, 143; sexualization in context of, 117–18; Stieglitz's attitudes toward, 31–32, 33, 42; Stieglitz's extramarital affairs and, 7, 31, 37–43, 125, 153, 178–79, 186, 191, 216n. 40, 216n. 42, 244n. 22; stresses of, 34–36; as success/failure, 11–12

marriage and family in crisis: anxieties about, 27–29, 46; apartment as symbol of, 61–67; automobile as symbol of, 67–75; causes of, 19–22; creating and managing, 16–19; different resolutions to, 48–49; estranged couples as symbol of, 78–86; external/internal factors in individual, 42–43; hotel in context of, 76–78; popular perceptions of, 7, 9, 12, 15–16; women and work in context of, 19, 20, 25–26. *See also* extramarital affairs

Marriage Consultation Center (New York City), 18
Marriage Council (Philadelphia), 17, 18
Marsh, Reginald: exhibitions of, 4; works: *Gaiety Burlesque, 106,* 107; *Irving Place Burlesque,* 107; *Minsky's Chorus,* 90
Martin, Clyde E., 102
masculinity: fetishism linked to, 201; manifested in artworks, 10–11; O'Keeffe's appropriation of, 177–79; skyscrapers linked to, 170, 174, 176–77, 190, 242n. 80; underworld primitive type of, 102, 107
Matisse, Henri, 155, 156
May, Elaine, 193
McBride, Henry, 126, 127, 132, 149, 184
McConaughy, James L., 66
Mead, Margaret, 212n. 56
mechanization: as negative force, 19–20, 55;

mechanization (*continued*)
 photographs of, 124; as positive
 force, 211n. 38; secretarial work
 in context of, 100–101; Stieglitz's
 link to, 163, 239n. 34. *See also* auto-
 mobiles
men: anxieties of, 27–29, 109–10; attempt
 to control art, 128, 130–32, 177,
 232n. 58; attitudes toward working
 women, 26, 214n. 90; ideal type of,
 24, 103; Jo Hopper's attitudes
 toward, 44; masturbation during
 striptease, 228n. 63; post-WWII
 roles for, 192–93; women as
 represented by, 148
Merrill, Christopher, 244nn. 22–23
Messinger, Lisa Mintz, 243n. 18, 244n. 24
Meyer, Agnes Ernest, 157
middle class, composition of, 7. *See also*
 marriage
Middletown. *See* Lynd, Helen M. and
 Robert S. (Middletown study)
Miller, Kenneth Hayes, 4
Mitchell, Tennessee, 28
mobility, symbols of, 67–75, 77
modernism (art): capitalism's link to, 6;
 emblematic portrait in, 154–65;
 Hopper as alternative to, 205n. 1,
 207n. 13; mysticism and, 121;
 realism and abstraction in, 3–4;
 Stieglitz as founder of, 202–3. *See
 also specific movements*
modernity: *The Radiator Building* as icon
 of, 169. *See also* industrialization;
 isolation/alienation as theme;
 mechanization; urbanization
Modern Quarterly, 23
Monroe, Ruth, 23
motels. *See* hotels
Motor (magazine), 68
movies and film: erotic imagery in, 102;
 female masquerade in, 236n. 119;
 as influence, 112–13, 228n. 70; *New
 York Movie* (Hopper), *112*, 112–13;
 working women in, 26
Mowrer, Ernest R., 19, 20, 35, 64, 71
multidwelling homes. *See* apartment
 houses
Mulvey, Laura, 11, 148
Mumford, Lewis: on apartment living,
 61–62; on O'Keeffe, 125, 230n. 18;
 on public amusements, 66–67; on
 Stieglitz, 149, 160
Muncie (Ind.). *See* Lynd, Helen M. and
 Robert S. (Middletown study)
mural, O'Keeffe's commission for, 9, 41,
 186, 188–91, 244n. 33

Museum of Modern Art, 164, 190, 207n.
 17
mysticism, O'Keeffe's interest in, 121,
 184–86, 229n. 10

National Academy, 207n. 14
National Conference on Family Relations,
 16, 18
National Council of Parent Education, 17
National Woman's Party, 130
The Nation (magazine), 65–66, 132
nature: houses separated from, 195;
 O'Keeffe's art in context of, 232n.
 64; skyscrapers integrated with,
 170–73, 241n. 74, 242n. 81; sky-
 scrapers separated from, 188–91;
 women linked to, 131–32
New Man: ideal type of, 24; Stieglitz as, 40
New Mexico: O'Keeffe's paintings of,
 183–88, 192; O'Keeffe's visits to, 3,
 35, 36, 43, 178
New Woman: automobile and, 187–88; as
 cause of marriage and family in
 crisis, 23; as challenge to Victorian
 codes, 133–35; emergence of, 6–7;
 Jo Hopper's rejection of, 109–10;
 possible regrets of, 35–36; psycho-
 analytic approach to, 176–77,
 201–2; realities for, 40–41; sexual
 demands of, 103–4; strategies of, 9;
 symbols subverted by, 153
New York City: artists' paintings of,
 128–32, 153–54; changing imagery
 of, 165–73; Hopper's views of, *59*,
 59–60; O'Keeffe's feelings about,
 167, 169, 170, 183–84, 192, 241n.
 66; Stieglitz linked to, 162;
 Stieglitz's feelings about, 166–67;
 working in, 3, 4
New York Daily News, 102–3
New York Evening Graphic, 102
New York School of Art, 5, 43
New York Times, 125
night, cityscapes set at, 172–73
Nivison, Josephine. *See* Hopper, Josephine
 Nivison
Norman, Dorothy: activities of, 38; as
 mother, 135; on Stieglitz, 160, 162;
 Stieglitz's affair with, 7, 9, 37–41,
 42–43, 153, 178–79, 186, 191,
 244n. 22; Stieglitz's photographs of,
 136, *137*, 203
Norman, Edward, 39
Novak, Barbara: on Hopper's character,
 46–47, 75; on Hopper's marriage,
 43–44; on Jo Hopper, 48

Pollitzer, Anita: clothing of, 234n. 80; O'Keeffe biography by, 203; as O'Keeffe's confidante, 118, 125, 229n. 11, 233n. 73, 235n. 101; role in O'Keeffe-Stieglitz relationship, 34; on Rossetti, 148

Pollock, Griselda, 6, 10, 11

Pomeroy, Wardell, 102

Popenoe, Paul, 26

Precisionists: exhibition of, 4; O'Keeffe as, 166, 188–91

Presbyterian Church, 17–18

prostitution: automobile linked to, 71; commercialism linked to, 164; hotels/motels linked to, 75–77

Protestant Episcopal Church, 17

Pruette, Lorine, 26

psychoanalytic theory: androgyny and, 150–51, 177, 236n. 119; feminist application of, 9, 11; on fetishism, 201; implications of discourse of, 233n. 69; as influence, 102, 133; *Manhattan* (O'Keeffe) in context of, 189–90; on New Woman, 176–77, 201–2; O'Keeffe's rejection of, 126–27; O'Keeffe's work interpreted through, 132–33; *The Radiator Building* (O'Keeffe) in context of, 153, 174–79; Riviere on, 150, 176–77, 201–2; skyscrapers as phallic symbols in, 170, 174, 176–77, 190, 242n. 80; Stieglitz's photographs in context of, 148–49; uncanny in, 60–61

public amusements: as influence, 103; as threat to family, 63, 66–67. *See also* burlesque theater; movies and film

public/private spheres: breakdown of, 20, 211n. 44; marriage and family in crisis discourse in, 16–19; Stieglitz's photographs in context of, 135–49

Radiator Building, 154, 237n. 3

The Radiator Building: Night, New York (O'Keeffe), *pl. 9*; context of, 9; as emblematic portrait, 163–65, 178; O'Keeffe on, 153–54; O'Keeffe's feelings embodied in, 124, 174, 176, 177–79, 204; psychoanalytic theory as context of, 153, 174–79; urban imagery as context of, 165–73

Radio City Music Hall, mural commissioned for, 9, 41, 186, 188–91, 244n. 33

Rapp, Rayna, 227n. 55

Read, Helen Appleton: on American Scene painting, 2, 205–6n. 4; Freudian discourse of, 132; on Hopper's themes, 59–60, 65, 219n. 3

Reader's Digest (magazine), 21, 27

realism: exhibitions of, 4; Hopper in context of, 2, 205n. 2; Hopper's definition of urban, 205–6n. 4; photography compared to, 201

Redbook (magazine), 22

Regionalists, exhibitions of, 4

religion: commerce as, 159; marriage and family crisis in context of, 16, 17–18. *See also* Christian symbols

Rhoades, Katherine, 133

Rice, Elmer, 53

Riviere, Joan, 150, 176–77, 201–2

road, home as contrast to, 73–75. *See also* automobiles

Robinson, Roxana, 37, 217n. 46, 244n. 33

Robinson, William, 104

Rockefeller, John D., Jr., 101

Rockefeller family, 164

Rodin, Auguste, 3

Roosevelt, Eleanor, 24, 130

Rosenfeld, Paul: commercialism and, 165; on O'Keeffe, 126, 231n. 32, 236n. 113; on Stieglitz, 149, 159–60

Ross, Ellen, 227n. 55

Rossetti, Dante Gabriel, 148

Roullier, Alice F., 207–8n. 25

Rugg, Harold, 160

Safran, Stephen, 61

St. Louis Dispatch, 102–3

Sanger, Margaret, 21, 38, 101

Santayana, George, 170

Sapir, Edward, 65, 66, 67

Schapiro, Miriam, 127

Schleier, Merrill, 241n. 66, 241n. 74

Scribner's Magazine, 132

Seligmann, Herbert J., 34, 164, 234n. 93, 239n. 34

Seven Americans (show), 128, 159

sexuality: automobile's impact on, 69–72, 222n. 57; challenging Victorian codes of, 133–36; companionship marriage's implications for, 27–29, 46; in different marriage models, 48–49; education about, 101–2; *Girlie Show* (Hopper) in context of, 87; openness about, 22–24, 39, 42–43, 101, 103–4; in post-WWII years, 192–93; revolution in attitudes toward, 101–5, 108, 114, 117–18, 125, 149. *See also* female sexuality; psychoanalytic theory

Sheeler, Charles: exhibitions of, 4; works: *American Landscape,* 57, *58*

Shelton Hotel: location of, 237n. 3;
O'Keeffe-Stieglitz's home in, 128,
130, 191; O'Keeffe's view from,
167, 171–72
Simmons, Christina, 23
Skolnick, Arlene, 7
Sloan, John: Hopper on, 5, 205–6n. 4,
207n. 22; on O'Keeffe, 4–5; works:
The Cot, 95; *Turning Out the Light,*
95, *95*
Social Hygiene (periodical), 101
Spencer, Anna Garlin, 16–17, 66, 210–11n.
28
Spencer, Lilly Martin, *Shake Hands?,* 111,
111
Stein, Gertrude: abstract word portraits of,
154, 155–56, 237–38n. 14;
Demuth's visit to, 158; O'Keeffe on,
165, 240n. 47
Stein, Susan Alyson, 77, 225n. 24
Stella, Joseph, 4
Sterling, Philip, 90
Stetson, Caleb R., 21
Stieglitz, Alfred: **artistic elements:** abstract
portraits, 160, 161–62, 238n. 23;
cityscapes, 166–67, 172, 179, 184;
cropping and touching up, 135–36,
147; nudes, 135–49, 234n. 89,
236nn. 117–18; photographic
effects, 170; **career:** commercialism,
164, 165, 169, 177, 190, 240n. 43;
exhibitions, 4, 128, 159; gendered
discourse and, 126; as influence,
8–9; legacy of, 202–4; models, 38;
modernist circle, 4; on O'Keeffe as
child and artist, 36, 190–91; on
O'Keeffe's art, 34, 117, 125–26; as
O'Keeffe's business manager, 5–6,
35, 39, 164, 190, 239n. 41, 244n. 33;
others' abstract portraits of, 156–58,
159–60, 162–65; technology and,
163, 239n. 34; **galleries:** An Ameri-
can Place, 37, 38, 136, 191; Intimate
Gallery, 38, 164; O'Keeffe sales in,
35, 39, 164, 239n. 41; "291," 4, 5–6,
34, 126; **life:** death, 1, 184, 202;
extramarital affairs, 7, 31, 37–43,
125, 153, 178–79, 186, 191, 216n.
40, 216n. 42, 244n. 22; favorite
colors, 162; first marriage, 7, 32–33,
37, 42–43, 215n. 7; illnesses, 35,
185, 191; marital attitudes, 31–32,
33, 42; objectified in painting, 9,
163–65, 178; O'Keeffe's conflictive
feelings about, 177–79; sexual
attitudes, 135. *See also* marriage,
O'Keeffe-Stieglitz; *The Radiator*

Building: Night, New York (O'Keeffe);
works: *City of Ambition, 166,* 167;
Dorothy Norman, 136, *137; Equiva-*
lents (series), 42, 160, 161; *Flat-Iron*
Building, 166, 166–67; *Main*
Room—Wall, Next to Door, Right,
145; Old and New York, 167;
Rebecca Salsbury Strand (photo-
graphic series), 135, *136, 137; Songs*
of the Sky and the Trees, 160; *Songs of*
the Sky No. 2, 42, 160, *160,* 161–62;
Songs of the Sky No. 3, 160. *See also*
Georgia O'Keeffe—A Portrait
(photographic series by Stieglitz)
Stieglitz, Kitty, 33, 34, 35, 43, 236n. 119
Stone, Abraham, 102
Stone, Hannah, 102
Strand, Paul: abstract portraits and, 161–62;
arrest of, 135; automobile of, 200;
focus of, 124–25, 131; O'Keeffe's
feelings for, 124–25, 134, 229n. 11;
O'Keeffe's letter to, 176; as
Stieglitz's friend, 33, 34; works:
Double Akele, New York, 124, *124*
Strand, Rebecca Salsbury: arrest of, 135;
automobile and, 187; mentioned,
36, 38, 42; O'Keeffe's relationship
with, 236n. 119; Stieglitz's affair
with, 37, 125, 216n. 40, 216n. 42;
Stieglitz's letter to, 167; Stieglitz's
photographs of, 135, *136, 137*
Street Scene (Rice), 53
striptease. *See* burlesque theater
Stuart, Gilbert, *Lanesdowne Washington,* 155
Sullivan, Louis, 174
System, The Magazine of Business, 99–100,
100, 206n. 7

Terman, Lewis, 102
Time magazine: on Freudian discourse,
132; on Hopper, 67, 200, 205n. 1;
on O'Keeffe, 125
Tittle, Walter, 43
Todd, Ellen Wiley, 100, 105
Tomkins, Calvin, 188
Toomer, Jean, 38, 41, 167, 191
True, Dorothy, 234–35n. 97
True Story (magazine), 69
Twice a Year (journal), 38
"291" (gallery), 4, 5–6, 34, 126
"291" (magazine), 157–58, 239n. 34
Tyrrell, Henry, 132

Udall, Sharon, 243n. 19
Underworld Masculine Primitive, concept
of, 102, 107
Updike, John, 228n. 70

urbanization: imagery of, 165–73; as nega-
tive force, 19, 63–67, 81, 169. *See
also* apartment houses; automobiles
urban realism, 4, 205–6n. 4
U.S. Agriculture Department, Extension
Service of, 17
U.S. Food and Drug Administration, 21
U.S. Public Health Service, 21–22

Van De Velde, Theodore H., 103, 104
Vanity Fair (magazine), 157
Vassar College, 26

Wagner, Anne Middleton, 132, 242n. 80
Washington Square Players (New York), 98
Weinberg, Jonathan, 234n. 89, 240n. 43
Westermarck, Edward, 174
Whelan, Richard, 215n. 7, 239n. 41, 244n.
33
White, Kevin, 102, 214n. 90, 225–26n. 31
Whitney, Gertrude, 164
Whitney Museum, 5, 164, 202
Whitney Studio Club and Gallery, 4, 60,
207nn. 18–19
Whyte, William H., Jr., 193
Williams, William Carlos, 158, 163
Wilmerding, John, 2
Wilson, Elizabeth, 169–70
Woman Rebel (periodical), 101
women: as artists, 128, 130–32; automo-
bile's impact on, 68–70, 74–75;
dilemma for, 104–5; education of,
26; Hopper's attitudes toward, 44,
48, 195–96; identity of, 48; roles of,
11, 25, 192–93; sexual attitudes of,
102, 103, 149; urbanization as
detrimental to/opportunity for,
170; virgin/whore typos of, 108–9.
See also female sexuality; lesbianism;
working women
Wood, Charles W., 19–20, 65–66
Woolf, Virginia, 178
working women: attitudes toward, 26,
214n. 87, 214n. 90; as cause of
marriage and family in crisis, 19,
20, 25–26; earnings of, 37; in
secretarial positions, 100–101, 105,
108–10. *See also* New Woman
Wright, Elizabeth, 11

Yale University, Beinecke Rare Book and
Manuscript Library, 11–12
YMCA, 17
YWCA, 17